Encyclopedia of Practical Photography

Volume 12

Prod-Sli

Edited by and published for
EASTMAN KODAK COMPANY

AMPHOTO
American Photographic Book Publishing Company
Garden City, New York

Note on Photography

The cover photos and the photos of letters that appear elsewhere in this encyclopedia were taken by Chris Maggio.

Library of Congress Cataloging in Publication Data

Amphoto, New York.
 Encyclopedia of practical photography.

 Includes bibliographical references and index.
 1. Photography—Dictionaries. I. Eastman
Kodak Company. II. Title.
TR9.A46 770'.3 77–22562

ISBN 0–8174–3050–4 Trade Edition—Whole Set
ISBN 0–8174–3200–0 Library Edition—Whole Set
ISBN 0–8174–3062–8 Trade Edition—Volume 12
ISBN 0–8174–3212–4 Library Edition—Volume 12

Manufactured in the United States of America

Editorial Board

The *Encyclopedia of Practical Photography* was compiled and edited jointly by Eastman Kodak Company and American Photographic Book Publishing Co., Inc. (Amphoto). The comprehensive archives, vast resources, and technical staffs of both companies, as well as the published works of Kodak, were used as the basis for most of the information contained in this encyclopedia.

Symbol Identification

 Audiovisual

 Biography

 Black-and-White Materials

 Black-and-White Processing and Printing

 Business and Legal Aspects

 Chemicals

 Color Materials

 Color Processing and Printing

 Equipment and Facilities

 Exposure

 History

 Lighting

 Motion Picture

 Optics

 Picture-Making Techniques

 Scientific Photography

 Special Effects and Techniques

 Special Interests

 Storage and Care

 Theory of Photography

 Vision

Guide for the Reader

Use this encyclopedia as you would any good encyclopedia or dictionary. Look for the subject desired as it first occurs to you—most often you will locate it immediately. The shorter articles begin with a dictionary-style definition, and the longer articles begin with a short paragraph that summarizes the article that follows. Either of these should tell you if the information you need is in the article. The longer articles are then broken down by series of headings and sub-headings to aid further in locating specific information.

Cross References

If you do not find the specific information you are seeking in the article first consulted, use the cross references (within the article and at the end of it) to lead you to more information. The cross references can lead you from a general article to the more detailed articles into which the subject is divided. Cross references are printed in capital letters so that you can easily recognize them.
Example: *See also:* ZONE SYSTEM.

Index

If the initial article you turn to does not supply you with the information you seek, and the cross references do not lead you to it, use the index in the last volume. The index contains thousands of entries to help you identify and locate any subject you seek.

Symbols

To further aid you in locating information, the articles throughout have been organized into major photographic categories. Each category is represented by a symbol displayed on the opposite page. By using only the symbols, you can scan each volume and locate all the information under any of the general categories. Thus, if you wish to read all about lighting, simply locate the lighting symbols and read the articles under them.

Reading Lists

Most of the longer articles are followed by reading lists citing useful sources for further information. Should you require additional sources, check the cross-referenced articles for additional reading lists.

Metric Measurement

Both the U.S. Customary System of measurement and the International System (SI) are used throughout this encyclopedia. In most cases, the metric measurement is given first with the U.S. customary equivalent following in parenthesis. When equivalent measurements are given, they will be rounded off to the nearest whole unit or a tenth of a unit, unless precise measurement is important. When a measurement is considered a "standard," equivalents will not be given. For example: 35 mm film, 200 mm lens, 4″ × 5″ negative, and 8″ × 10″ prints will not be given with their customary or metric equivalents.

How Articles are Alphabetized

Article titles are alphabetized by letter sequence, with word breaks and hyphens not considered. Example:

Archer, Frederick Scott
Architectural Photography
Archival Processing
Arc Lamps

Abbreviations are alphabetized according to the letters of the abbreviations, not by the words the letters stand for. Example:

Artificial Light
ASA Speed

Contents
Volume 12

Product Photography

Product photographs are most often used in advertisements or catalogs. They are usually made under tightly controlled studio situations so that time will not be wasted in achieving the desired image for the ad or catalog.

In making product photographs, the photographer frequently works from an art director's layout or picture idea. Since the arrangement of product and supporting elements is often set, the photographer can usually contribute the most by utilizing creative lighting to display product features. Control of lighting is the key to good product photography.

Natural-Lighting Effects

Outdoor lighting is the standard of comparison for most lightings. By proper arrangement of lights, you can create natural, attractive lighting that simulates a natural outdoor lighting effect. Consider briefly how this standard can influence our indoor lighting procedures:

1. It is important for light from the main source to come from above, usually at a 40- to 60-degree angle to the subject, because that is the angle of the sun by which most objects are viewed by most people outdoors.
2. If indoor studio lighting is to appear natural, it should have one dominant source light and one set of dominant shadows. Although perhaps obvious, this is one of the most important basic concepts for creating satisfactory studio lightings. You can see how easy it is to violate this principle. Simply take two lights of similar intensity and place them approximately equal distance from a subject. The result is twin pairs of highlights and "butterfly" shadows —an effect that, of course, could not be found outdoors.
3. Regardless of how contrasty the sunlight becomes, shadow detail can always be discerned outdoors. Therefore,

the average studio lighting setup should have sufficient shadow illumination. Outdoors the fill-in is supplied by the general sky; indoors it must be simulated with reflectors or auxiliary lights. Note that the fill-in illumination for the shadows must be completely subservient to the basic source light. While the ratio between the main light and the fill-in light can vary in accordance with several factors, including the nature of the subject and the judgment of the photographer, most commercial and catalog illustrations use a highlight-to-shadow ratio of about 3 or 4 to 1.
4. The outdoor effect of overcast days when the sun does not shine has its studio counterpart in lighting for shiny-object photography.

Backlighting. There is one additional aspect of basic studio lighting that will influence a majority of setups: Backlighting will often help to preserve the three-dimensional form of subjects better than frontlighting. There are two main reasons for this:

1. Since the shape of the object is duplicated in the shape of the foreground shadow, identification is easier.
2. Because the object is better separated from its background, delineation of its form is improved. For example, in photographing a ball, the subject will probably look like a round object if frontlighting is used, but it will look *spherical* with the use of backlighting.

Basic Lighting. Most basic studio lighting for product photography consists of a high, single, main-source backlight plus adequate fill-in illumination for the shadows. This generalization must be modified as the nature and shape of subjects demand.

Two basic modifications that might be used for cubical or box-shaped subjects and for spherical or round subjects are shown in the illustrations accompanying this article. These basic lighting procedures can apply to an infinite number of rectangular or curved products.

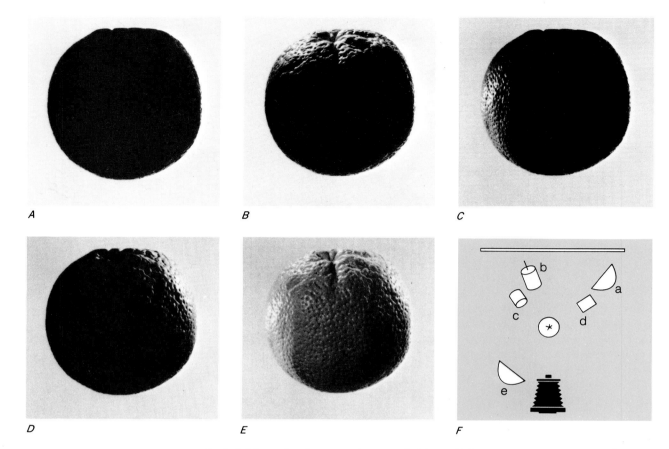

Basic lighting setup for a round, textured object. (A) Background light only; no light on the orange. In black-and-white photos, the orange appears as a hole cut in the background paper. (B) The main light, a spotlight, is added high, behind, and to the left of the subject. (C) Another, smaller, spotlight is positioned to the left rear of the set at subject level. (D) Additional roundness is obtained from a third spotlight, low, from right rear. This places a brilliant highlight on top of the main-lighted area. (E) The combined effect of the three backlights—plus a weak fill from beside the camera—completes the lighting. (F) The diagram shows the placement of the complete lighting setup used to photograph the orange. Letters next to the lights refer back to the steps detailed in the photograph captions (A–E).

Lighting Product Surfaces

The texture, tone, and general surface characteristics of a subject almost automatically dictate modifications of basic lighting techniques. Thus, when a competent photographer is handed a polished, metallic object to photograph, he or she begins immediately to think in terms of tent lighting. If the object has a matte, textured surface, several undiffused spotlights are going to be required. If the subject has both polished and textured areas, then a combination of these two extreme lighting methods will probably be needed.

It is important to realize that no one lighting setup will be best for subjects with different surface characteristics even if they are similar in size and shape. This point is illustrated where you can observe the effect of lighting techniques which range from extreme contrast to extreme flatness. In other words, no single lighting technique is best for all objects. It is impossible to generalize that either a spherical or a cubical object should always be lighted in one specific way. Instead, it is necessary to correlate the lighting demands of the subject shape with those of its surface characteristics.

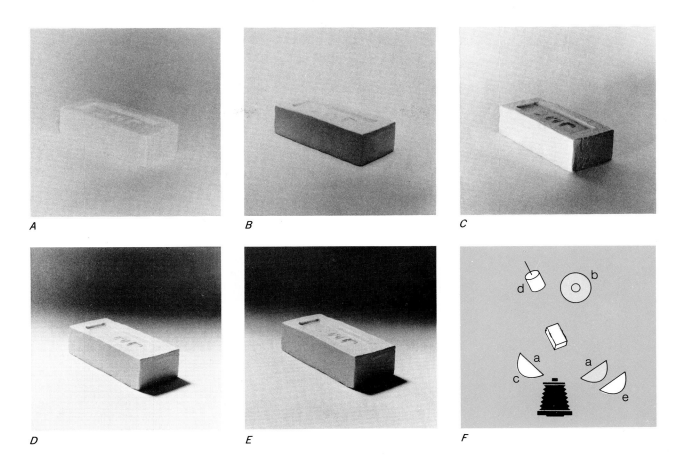

Three-step lighting for box-shaped objects. (A) Two equally brilliant floodlights at camera flatten the subject, making it almost invisible. (B) Soft light from above or bounce light does not provide difference in contrast between the two front planes. (C) The effect of placing the first light is shown. Here is the left front flood. (D) A spotlight is placed at the left rear of the brick. (E) The third and final light—a floodlight at the right front—is added. This light should have about half the intensity of the left floodlight. This basic lighting procedure applies to any product or subject of a similar shape such as a radio, a cake of soap, or a cereal box. (F) A schematic diagram shows the placement of lights for photographing a box-shaped object (photos C, D, E). Dotted outlines show incorrect lighting, described in photos A and B.

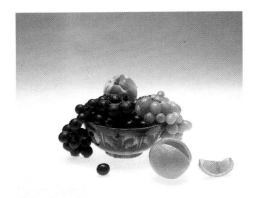

(Far left) No single lighting setup is best for subjects with different surface characteristics, even if they are similar in shape. This photograph combines lighting of extreme contrast and extreme flatness. (Left) Lighting setup used in making photograph at far left. Note that bounce light was used for overall illumination and a pair of floodlights for both backlighting and crosslighting. Three individual spotlights provide bright highlights.

Texture Lighting for Round Objects

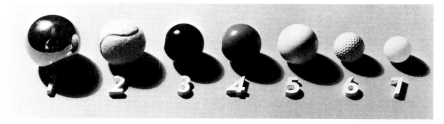

Extreme lighting contrast produced by one backlight and no fill-in lighting. The setup is rarely used; but it is excellent for the ping-pong ball because it is somewhat translucent.

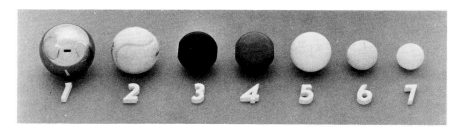

The effect of making a complete tent of white paper and using only indirect lighting. The polished ball (No. 1) and the black billiard ball (No. 3) are rendered best.

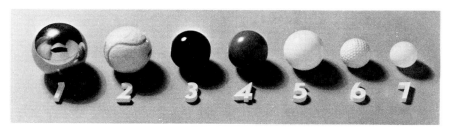

A modified tent lighting used a main backlight but retained the reflectors in front. The golf ball (No. 6) looks best; its surface is preserved, texture is shown, and its shadow area has adequate detail.

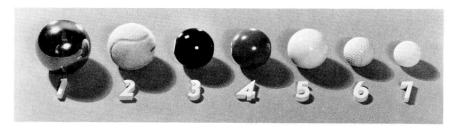

This is a no-reflector, all-direct lighting setup that favors the surface of the tennis ball. But, multiple highlights spoil the rendition of balls with glossy surfaces.

Lighting for Texture. Lighting that will properly emphasize the surface irregularities known as "texture" must have two attributes:

1. The dominant main light should glance obliquely across the surface of the subject at a low angle in relation to the surface. Think of skidding this main illumination off the subject's surface and across the texture to be emphasized.
2. A weaker amount of fill-in shadow illumination should be used than is nor-

mally the case. However, in most instances, the fill-in illumination is vitally necessary to create the feeling of smooth, desirable texture; otherwise, the lighting would be too contrasty.

An accurate representation of a product, with emphasis on its good features, is of utmost importance. For example, if a pair of boots features a new type of tread, the lighting should do its part to emphasize this feature. The texture can be minimized

Product Photography

with flat frontal lighting. Or, it can be overemphasized with strong oblique lighting and lack of fill-in illumination. Or, the two sources can be in excellent balance to give the desired, as well as accurate, impression of the product.

One of the most helpful ways to become proficient in creating lighting arrangements is to reconstruct mentally the lighting that must have been used in any commercial illustration. Look through magazines and catalogs so that you can study their good photographs. In doing so, use the reflections and the shadows as clues to answer the following questions:

1. How many lights were used?
2. What kinds of lights were used?
3. Where were they placed?

With practice, you should be able to envision the lighting setup for nearly any picture. Furthermore, this should help you to clarify your thinking and actually save studio time in setting up lights for future assignments.

Highly Polished Products. One of the most difficult categories of subjects for commercial illustration are objects with an extremely high polish. Usually such objects can be successfully photographed by using tent lighting or by spraying the object with a matting spray. Sometimes a combination of the two techniques is required. Details for using these techniques are covered in the articles SILVERWARE AND JEWELRY, PHOTOGRAPHING and TENT LIGHTING.

Glassware. Conventionally, glassware is photographed simply by placing it in front of an illuminated background. Frontal illumination is not generally used because of the problem of multiple— and consequently distracting—reflections. White paper or translucent plastic is usually used as the

Glassware is usually photographed by placing it in front of an illuminated background of white paper or translucent plastic. This avoids the reflection problems that may be caused by front-lighting. Large areas of background can be covered with a floodlight; spotlights are used for highlights. Photo by Michael Waine.

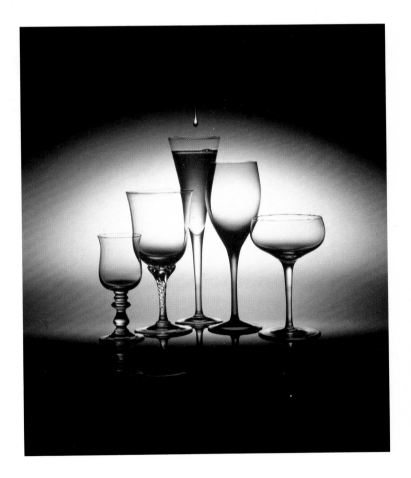

One of the most helpful ways to become proficient in creating lighting arrangements is to mentally reconstruct the lighting that must have been used in an illustration. Use the reflections and shadows to determine how many lights were used, their placement, and the kind of lights that must have been used. Photo by Michael Waine.

There are often several equally good ways of lighting and photographing a product. The question of how to light a specific subject is then determined by the client's wishes and the ultimate use of the picture. Photo by Michael Waine.

Product Photography

background. A flood lamp can be used to cover a large area of the background, and if desired, a diffused spotlight can be used to create the smaller circle of illumination at the base of the object. (*See:* GLASS, PHOTOGRAPHING.)

Highlights

The main job of the highlights is twofold: The edge-light reflection highlight helps to separate subject planes, as well as to differentiate between the subject and its surroundings. The second type of highlight delineates subject textures and gives a clear impression of the subject's surface.

The problem of positioning lights to create these desirable subject highlights can be even more painstaking than finding the main-light position itself. Usually, several small lights are needed to do an adequate job of highlighting, especially if the subject has a complex shape.

Especially avoid making endless trips between the camera and the lighting units, modifying their positions slightly, and then rechecking the exact effect on the ground glass. Rather, efficiently determine the location of all the highlighting units as follows.

Procedure. Keep in mind the familiar principle that the angle of incidence equals the angle of reflection. Apply this principle practically by placing a small spotlight exactly in front of the lens and aligning it so that its axis is the same as that of the lens.

Next, examine the subject carefully as you walk around the setup. Check the subject from all sides and from low, intermediate, and high vantage points. If, from a particular viewing position, you see a desirable highlight—perhaps in the form of improved surface texture—stop your inspection and position an actual lighting unit at precisely the spot where your face was when you saw the highlight. This light will recreate the same effect for the camera to photograph. The search for additional highlights can continue with the placement of an actual set light each time a desirable effect is found. When the subject has been highlighted in this way, the small spotlight in front of the lens can be removed, and the total effect achieved thus far can—and should—be checked on the ground glass. As might be expected, some modification of the highlights probably will be necessary from the standpoint of intensity or character, but not placement.

Fill-in Light

Fill-in illumination that provides adequate shadow detail can be supplied optionally by a diffuse flood lamp, a reflector, or a mirror. The single most important requirement of a fill-in light is that it should cast no identifiable shadow of its own. This problem is most prevalent with flood lamps and is generally solved by using the fill lights at a low angle.

Small Objects. Perhaps one of the most overlooked fill-in techniques in small-product photography is the use of mirrors. They have the principal advantage of being able to be positioned in places where it would be physically impossible to position large lighting units to accomplish the same effect. Non-hardening modeling clay makes an ideal non-skid positioning medium for smaller mirrors. There is always the possibility of masking the mirrors with pieces of matte black paper, thus making the mirror into a reflector of any desired shape without actually cutting it.

High Subject Contrast

Having to photograph a black subject and a white one in the same picture presents a problem that is difficult to solve. With general, flat frontlighting, the subject's tonal extremes are difficult to satisfactorily reproduce in the same photograph. If two separate pictures could be made—one of the light subject and another of the dark one—the problem would be greatly minimized since the negative or print exposures could be adjusted according to the subject's needs.

This problem of tonal extremes within the same subject area is usually solved by a combination lighting-and-processing technique.

Film and Processing. Select a moderate-contrast film with a long toe. Intentionally overexpose the film somewhat, and then give less-than-normal development in a soft-working developer. These procedures will bring the subject's tonal extremes closer together photographically.

Lighting. Proper lighting can also help solve the high-subject-contrast problem. Keep the illumination off the light-toned areas while adding additional illumination to the darker parts of the subject.

In setting up the lighting for high-contrast subject matter, it is most logical to illuminate the dark object first. Spotlights set at narrow beam, barn

doors, and "snoots" are helpful in keeping the light off the light-toned parts of the subject. There will usually be just enough spill from these lights so that only a moderate amount of additional fill illumination will be needed.

The Customer's Wishes

Often there is not a single best way to light a product—there will be several equally good ways. The question of which to use, of course, should be the result of the customer's wishes. For example, if a catalog is to be illustrated with a series of matching low-key photographs, high-key pictures would be unacceptable in spite of their technical excellence. As far as possible, you, the photographer, should have a clear impression of your client's wishes and objectives, and the final use for the photograph. In the creation of any product illustration, clarify these points before you begin the photography.

• *See also:* ADVERTISING PHOTOGRAPHY; COMMERCIAL PHOTOGRAPHY; GLARE AND REFLECTION CONTROL; GLASS, PHOTOGRAPHING; LIGHTING; SILVERWARE AND JEWELRY, PHOTOGRAPHING; TABLETOP PHOTOGRAPHY; TENT LIGHTING; TEXTURE EFFECTS; TEXTURE LIGHTING; UMBRELLA LIGHTING.

Further Reading: Bennett, Edna. *Tabletop and Still Life Photography.* Garden City, NY: Amphoto, 1970; Jenkins, Nicholas. *Photographics: Photographic Technique for Design.* Florence, KY: Van Nostrand Reinhold Co., 1973.

 Projection, Audiovisual

The suggestions and data provided here will aid in producing effective audiovisual presentations in most facilities. Although these steps are in logical order, in practice it is often necessary to compensate for less-than-ideal equipment and facilities by backtracking and modifying earlier decisions. This information is not intended for application to commercial theater projection, nor does it cover projector operation or showmanship techniques.

Room Facilities

When the ideal room is not available, modifying existing conditions will improve a mediocre room.

Size. The room should be large enough for the greatest number of viewers expected. Large auditoriums or meeting rooms with folding chairs need approximately 0.5 square metre (5 to 6 square feet) of floor space per person within the good viewing area. Conference rooms or classrooms with fixed seating require about twice that area—approximately 1 square metre (10 to 12 square feet) per viewer within the good viewing area.

Light Control. The room should permit suitable light control. For daytime projection in rooms with outside windows, ordinary window shades are usually suitable for images composed of contrasting colors or black-and-white (no grays). Opaque shades (two thicknesses of ordinary shades), ordinary venetian blinds, or drapes will suffice for images with limited shadows and details. In most cases, complete darkening is needed for images that show a range of color hues or grays. Temporary opaque drapes, portable blackboards, or other makeshift devices can be used to block light from the screen when the room cannot be adequately darkened. In some cases, a permanent shadow box around the screen may be desirable.

Special light control may not be needed for the extra-bright images obtainable with small screens (found in study carrels) or with high-gain screens, such as Kodak Ektalite projection screen, model 3.

Illumination. Light sources that provide some illumination during projection, but not directly on the screen, permit note-taking and help maintain a social atmosphere. However, during projection, the screen-image highlights should be brighter than any other surface within the viewers' field of view. Hot spots on or around the screen caused by the glare from bare bulbs, reflections from shiny surfaces, or gaps in window covering should be eliminated.

Electrical Control. Preferably, room lights should be controllable from a point near the projector or the speaker's stand. Or arrangements can be made for someone to turn off the lights as soon as an image appears on the screen. The electrical outlet for the projector must remain live when the room lights are turned off.

Ventilation. The ventilation should be independent of the room-darkening devices. If smoking is permitted, a generous supply of fresh air will be needed.

Acoustics. The room should be acoustically good. Check reverberation by a clap of the hands. A sharp, ringing echo indicates too much reverbera-

tion for good intelligibility. A live room (with objectionable echoes) is improved acoustically when filled with people. Any high-volume noises or clearly intelligible speech at any level coming from outside the room should be controlled or eliminated. Low-level background noise does little or no harm.

The Ceiling. The ceiling should be high enough to allow putting up the screen image where all members of the audience can see it. Here a stepped or sloping floor would be helpful. (See the section Screen and Image Size in this article.)

Rear Projection

Rear-projection images have the same requirements for image brightness, size, and contrast as front-projected images. Rear projection has advantages in some situations, disadvantages in others.

The most common form of rear projection involves a rear-projection cabinet or console, and some cabinets also provide for a front-projection arrangement. Many examples of both kinds are on the market. (*See:* REAR PROJECTION.)

Screen and Image Size

All screen and image dimensions given here apply to picture-aspect ratios commonly used in audiovisual materials. These range from squares to rectangles with the longer dimension no more than 1½ times the shorter.

When using multiple images, consider each image or image area individually, whether the images are on the same or different screens. That is, the requirements for size, brightness, and legibility will usually be the same for each image (as if there were only one image). Practicality may, however, dictate a compromise. In spite of the requirements for optimum quality of each image, the room size and the seating arrangement may limit the size and type of screen (*See:* PROJECTION SCREENS.)

Screen size should be such that it will permit the back row of viewers to be eight times the image height (8H) from the screen, with the following exceptions:

1. Certain materials, including many teaching films, are designed with titles and important picture elements bold enough to permit satisfactory viewing at distances of 11 to 13 times the image height. If this is true for the materials to be projected, the projector can be moved closer to the screen to give a smaller and brighter image. Moving the projector closer to change the back row from 8H to 11H will approximately double the image brightness and allow the front row to be moved a little closer to the screen.

2. In some situations, materials that limit maximum viewing distance to less than 8H are commonly used. Typewritten material projected with an opaque projector is an example. For showing the full area of an 8½″ × 11″ page, pica type calls for a maximum viewing distance of 4H.

For legibility, members of the audience should be seated within the specified angles for the screen material being used and should not be seated closer to the screen than two times the height nor farther than eight times the height of the projected image. Minimum image height for legibility can be determined by dividing the distance from the screen to the rear of the back row of seats by eight. For visual effect, it is sometimes desirable to project an image somewhat larger than legibility standards specify. To avoid obstruction of the screen image by the seated audience, the ceiling height should permit the bottom edge of the image to be located at least 1.2 m (4 feet) above the floor.

Determination of the maximum viewing area depends on the material used for the screen. The Kodak Ektalite projection screen has excellent brightness characteristics within a viewing area of 60 degrees. Most matte and some lenticular front-projection screen materials can provide good brightness levels for viewing areas up to 90 degrees wide. Beaded front-screen projection materials and commonly used rear-projection screen materials can give good brightness in a viewing area of up to 50 degrees, the recommended maximum viewing angle for the beaded screens.

If vertical or square pictures are to be shown, a square screen is preferable. If only horizontal pictures are to be shown, either a horizontal screen with

proportions of about 3:4, or a square screen masked or partially opened, is usually preferred.

Requirements for Two-Image Presentations

Programs of two or more simultaneous images are increasingly being used to present information. A two-image format offers some special opportunities—two side-by-side images can show comparison of two different products, before and after conditions, or the progress of two different but related processes. A two-image presentation can help show details in perspective by allowing a close-up view on the screen beside an overall reference view or an actual photograph beside a schematic diagram. The considerations discussed here pertain primarily to presentations intended to teach, train, or inform. Different considerations will apply when the goal is to entertain or to motivate, and the desired effect may be an impression or an emotion rather than the assimilation of all the information and detail in each image. Essentially the same advantages and requirements apply to three or more images used side by side.

A two-image format will need a little extra forethought and may mean some different equipment—particularly screens. Some slight modification of projection technique is necessary. For example, diagram A shows two screens, the same size as the screen in the diagram on this page, placed side by side in a flat plane along one wall of a room. The satisfactory viewing area is shown for each screen, corresponding to that shown for the single screen in the aforementioned diagram. It is only in the cross-hatched area that viewing is satisfactory for both screens, and that area is rather restricted. Diagram B shows the effect of angling the screens slightly, so the axis of each projection beam originates from the center of the back wall. The good viewing area for *both* screens has increased a great deal, until it approximates the good viewing area for one screen. Two flat screens or a single curved screen can be used. Usually a curved screen should have a radius of about the same length as the maximum viewing distance or up to 1½ times that distance. Curvatures of this depth will not create focus problems with most multiple-image presentations—the depth of field of the projection lenses will be more than enough to permit sharp images. (Depth of focus is another matter; a slight movement of the projection lens in relation to the transparency will have much more effect on screen-image sharpness than will the curvature of the screen.)

When matte screen surfaces are used with curved or angled screens, there may be a problem with stray light reflected from one end of the screen to the other. That is, a bright image projected on one end of a curved screen or on one angled screen may reflect enough light to degrade the image on the opposite end of a curved screen or on the other angled screen—particularly if there is a dark image there. This problem does not usually occur with non-matte screen surfaces; it can be reduced with matte screens by embossing the surface to make it slightly rough or by making the surface of a moderately rough material, such as plaster.

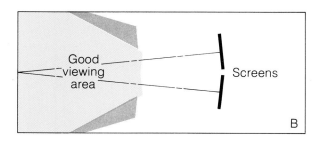

(Top) In this two-image format, two screens are placed side by side in a flat plane along one wall. Only in the blue area is the viewing satisfactory for both screens. (Bottom) When the screens are angled slightly, the axis of each projection beam originates from the center of the back wall. The good viewing area of both screens increases, creating a larger satisfactory viewing area.

If a deeply curved screen is used or if flat screens are very sharply angled to each other, there may be increasing problems with light from one projected image degrading the other image. Using deeply curved screens may also cause focus problems and a noticeably different magnification between the image ends and the center of the image. Keeping the screen radius close to the 1- to 1½-times viewing distance mentioned above will normally prevent these problems.

Placement of the projectors will be determined by the angle of flat screens to each other, or the radius of a curved screen. The projectors should be set up so that the projection beams are at right angles to the screens, or to the chords of the image areas if a curved screen is used. If the crossover point of the projector beams is within the room, with the projectors at the back of the room, the left projector should project the right image and vice-versa. On the other hand, if the crossover point occurs near the back of the room or outside the room, it is usually preferable to have the right projector on the right screen and the left projector on the left screen,

Most of the time, multiple images should be projected to be about the same size and brightness. For instance, the images may all be slides, preferably well matched in size, brightness, and contrast. If dissimilar images are combined (for example, an overhead projector image with a projected slide or a motion picture with a slide), try to get them close to each other in both size and brightness—unless they are especially designed for some effect requiring different sizes.

Loudspeaker Location

Sound quality is usually quite satisfactory if the loudspeaker is near the screen and high enough to be seen by everyone. Low placement causes loss of intelligibility for all except those in the front row. Where acoustics are poor, a corner location or extra speakers placed in the back of the room may help. Extra speakers should ordinarily be aimed toward the back of the room to avoid interference between separate units.

Proper tone-control adjustment can help greatly in any room. In a room that is acoustically poor, the best intelligibility is usually achieved with the tone or balance control near maximum treble. These settings do not give the most pleasing reproduction of music, but they do reduce reverberation and make speech more understandable.

Projector Location

For an undistorted image, the projector lens should be on a line extended at right angles, vertically and horizontally, from the center of the screen surface. For overhead and opaque projectors at the front of the room, this usually requires that the top of the screen be tilted toward the viewers. Projectors should be high enough so that their beams will clear obstructions, such as the heads and hats of viewers.

Excessive upward or downward projection angles will cause keystoning of the image unless the screen is tilted. A slight degree of keystoning is not objectionable. With most lenticular screens, a change in screen angle that introduces only slight keystoning will often improve the image by rejecting stray light and increasing image brightness as viewed by the audience.

The distance from the projector to the screen is determined by the size of the area being projected, the focal length of the projection lens, and the image size needed. Distance can also be affected by certain lens designs, particularly at low magnifications.

Image Brightness Required

Brightness (the amount of light the viewer sees) depends on the viewing angle; the screen type; the projector design; the wattage, life rating, and age of the lamp; the character of the material being projected; the image size; the line voltage; and the design and cleanliness of the optics. Lamp wattage alone gives little indication of image brightness; using it as a measure of image brightness is like rating an engine by the fuel consumed rather than the work done.

The work done by a projector, in terms of image brightness, is lumen output. Lumen output divided by image area (in square feet) gives the footcandles falling on the screen from the projector. Footcandles of illumination multiplied by the reflectance of the screen (about 0.85 for a good matte screen) gives footlamberts—the measure of brightness of the image seen by the viewer. The corresponding (but not equivalent) metric terminology for footlamberts is candelas per square metre; for footcandles, it is lumens per square metre. Thus, a projector with a 120-lumen output provides 10 footcandles of illumination for a 3 × 4-foot (12-square-foot) screen

PROJECTION DISTANCES FOR VARIOUS FORMATS AND FOCAL LENGTHS

Format and Type of Material	Lens Focal Length (in.)	(mm)	Desired Image Size — inches: Projector Gate-to-Screen Distance (feet—nearest ½ foot)					metres (metres—nearest ¹⁄₁₀ metre)		Factor
2:3 ratio			26¾×40	33½×50	40×60	47×70	64×96	0.67×1	1.17×1.75	
2 × 2 slides (135)	2½	65	6½	8	9½	11½	15½	2.0	3.5	1.9
0.902 × 1.346 in.	3	78	8	10	11½	13½	18½	2.3	4.0	2.2
(22.9 × 43.2 mm)	4	102	10½	13	15½	18	24½	3.1	5.3	2.9
mask opening	5	127	13	16½	19½	22½	30½	3.9	6.6	3.7
	6	152	16	19½	23½	27	36½	4.7	8.0	4.4
	7	177	18½	23	27	31½	43	5.6	9.6	5.3
	9	230	24	29½	35	40½	55	7.2	12.2	6.7
	11	280	29	36	42½	49½	67	8.8	14.9	8.2
3:4 ratio			30×40	37½×50	45×60	52½×70	72×96	.75×1	1.32×1.75	
16 mm motion pictures	1½	38	13½	16½	20	23½	32	4.0	7.0	3.9
0.286 × 0.380 in.	1⅝	41	14½	18	21½	25	34½	4.4	7.6	4.2
(7.26 × 9.65 mm)	2	51	18	22½	26½	31	42½	5.4	9.3	5.2
projector mask	2½	63	22½	28	33½	39	53	6.7	11.6	6.7
	3	78	27	33½	40	46½	63½	8.0	14.0	7.8
	4	102	36	44½	53½	62	85	10.7	18.6	10.4
Super 8 motion pictures	⅞	22	14	17½	21	24½	33½	4.2	7.3	4.1
0.158 × 0.209 in.	1.1	28	18	22	26½	31	42½	5.3	9.3	5.2
projector mask	0.6 to 1.2	15 to 30	9½–19	12–23½	14–28½	16½–33	22½–45½	2.9–5.7	5.0–9.9	2.8–5.6
	0.8 to 1.25	20 to 32	12½–20½	16–25½	19–30½	22–35½	30½–48½	3.8–6.1	6.6–10.6	3.7–6.0
Filmstrip release print	2½	65	10	12	14½	17	23	3.0	5.2	2.9
0.669 × 0.886 in.	3	78	12	14½	17½	20½	27½	3.5	6.0	3.3
(16.97 × 22.48 mm)	4	102	15½	19½	23	27	37	4.6	8.0	4.4
maximum frame	5	126	19½	24½	29	34	46	5.8	10.0	5.6
on film	7	177	27½	34	40½	47½	64½	8.4	14.4	8
30 × 30 mm slides	2½	63	14	17	20½	24	32½	4.2	7.3	4.1
(110)	2	51	11	13½	16½	19	26	3.3	5.6	3.2
0.472 × 0.622 in.	3	78	16½	20½	24½	28½	39	4.9	8.5	4.7
(12 × 15.8 mm)	4	102	22	27½	33	38	52	6.5	11.3	6.3
mask opening	5	126	27½	34	41	47½	65	8.2	14.1	7.9
1:1 ratio			40×40	50×50	60×60	70×70	104×104	1×1	1.75×1.75	
2 × 2 slides (126)	2½	65	8½	10½	12½	14½	19½	2.6	4.4	2.5
	3	78	10	12½	15	17½	23½	3.0	5.1	2.8
	4	102	13½	16½	20	23	31½	4.0	6.8	3.8
	5	126	17	21	25	29	39	5.0	8.5	4.7
	6	152	20	25	30	34½	47	6.0	10.2	5.7
1.043 × 1.043 in.	7	177	23½	29	34½	40½	55	7.2	12.2	6.8
(26.5 × 26.5 mm)	9	230	30½	37½	44½	52	70½	9.1	15.7	8.7
mask opening	11	280	37	46	54½	63½	86	11.1	19.1	10.6

NOTE: Apparent discrepancies in some focal lengths appear because of rounding. For instance, the *Kodak* projection *Ektanar* lens, 3-inch *f*/3.5, for slide projectors has an actual focal length of 78 mm (about 3¹⁄₁₆ inches). Similarly, factors given in right column are rounded to nearest tenth, two additional digits were used in determining projection distances before rounding to the nearest ½ foot or ¹⁄₁₀ metre.

image; that is, 8.5 footlamberts of image brightness for the viewer of a good matte screen.

Light output of a projector is measured with no film in the projector but with the standard aperture in place; and for motion-picture projectors, with the shutter running. Image brightness needed is not an absolute value; it depends primarily on the brightness needed to override the non-image brightness of the screen in order to give satisfactory image quality.

Non-image brightness of a screen is the result of all the light falling on the screen other than that actually forming the image. High non-image brightness makes it difficult to obtain good blacks or dark areas in the projected image. The principal sources of non-image brightness are ceiling and exit lights in the room, or incompletely darkened windows, doors, and skylights. Light escaping from within the projector itself, as well as from improperly designed or dirty projection optics, also contributes to non-image brightness.

Determining Projection Distance, Image Size, or Lens Focal Length

The accompanying table shows projection distances (projector-gate-to-screen distances) for selected image sizes, formats, materials, and lens focal lengths. The factor permits you to find approximate projection distances or image dimensions not shown in the table by using these formulas:

$$\text{Larger dimension of image} = \frac{\text{Projector-gate-to-screen distance} - (2 \times \text{lens focal length})}{\text{Factor}}$$

$$\text{Projector-gate-to-screen distance} = (\text{Factor} \times \text{larger image dimension}) + (2 \times \text{lens focal length})$$

The Projector-Lens-Lamp Combination

When the required lumen output of the projector and focal length of the lens are determined, the equipment most nearly meeting those requirements should be selected.

Adapting to Requirements. Obviously, the projection equipment available for a given situation will not always meet the exact lumen-output requirements for good projection. In order to have adequate image brightness, lumen output should be at least as great as specified.

A reasonable excess in lumen output is permissi-
ble. Because of the variable-image brightness (depending on the viewing angle) of beaded screens, they cannot tolerate as great an excess in lumen output as a matte or lenticular screen. An excess of 50 percent in lumen output should be the maximum for a beaded screen. This will give an image approximately 4½ times as bright, near the projection axis, as the desired brightness reflected at 20 degrees from the projection axis. For a matte or lenticular screen, the light output can be four times the specified brightness level, giving an image brightness from all viewing angles about four times as great as specified.

Image Not Bright Enough. The difficulty most often recognized is insufficient light output. As previously suggested, one possibility for producing brighter and smaller images is to move the projector closer to the screen. Cutting the distance in half will increase image brightness four times. However, this solution is satisfactory only when the material being projected is so designed that the information it contains can be discriminated in the smaller size.

Light output can often be increased (with possible sacrifice in lamp life) by substituting a lamp of increased wattage, or by using a higher lamp switch setting when the projector provides one. Lamps of a higher wattage than the maximum recommended for a given projector are likely to cause damage, even though they may physically fit into the machine.

Screen characteristics can be utilized to obtain a brighter image. For example, if a specially treated aluminum-foil screen permits a large enough image and is properly aligned, the image will be at least six times as bright over the normal viewing area as an image of the same size projected on a regular commercial, matte, beaded, or lenticular screen.

When stray-light levels are high, locating the screen so that it is seen against the darkest part of the room may help. A high-gain screen, however, will produce the best results when placed *opposite* the darkest area. There it can provide the best rejection of non-image light and a bright image.

It may also be possible to increase image brightness and obtain better rejection of stray light by using a metallic screen—either a flat one, or one with ribs or lenticules. Most portable metallic screens are highly directional. The projector and screen must be placed and aimed very carefully to take advantage of their special characteristics and to obtain good images with even brightness.

If a visual test of the equipment specified does not demonstrate satisfactory brightness, check these common causes for reduced brightness:

1. When the equipment is operating, the line voltage at the projector plug should be within the range specified for the projector. A lamp rated at 115 volts produces 15 percent less light when the voltage drops from 115 to 110. At 104 volts, the loss is 30 percent. A light-weight extension cord can easily cause such a voltage drop.

2. All equipment and materials in the optical system should be clean. The optical system includes reflectors or mirrors, lamp envelope, condensing lenses, heat-absorbing glass, cover glasses or glass pressure plates, the material being projected, the projection lens (all surfaces), and the screen.

3. Old and darkened projection lamps produce less light. A lamp improperly centered or not locked in position may reduce brightness and cause uneven illumination. (Tungsten-halogen lamps usually darken little with age.)

4. Unusually dense (dark) transparencies give less bright images. Some photographers consistently and intentionally produce dense transparencies, often because they project them regularly on a small screen with a powerful projector. In such a situation, properly exposed transparencies can look washed out. Thus, the photographer may underexpose reversal film to obtain denser-than-normal transparencies that look good with a particular piece of equipment but are too dense for normal projection.

5. Even though they are clean, old projection screens may have become yellowed or darkened so that they are not satisfactory.

Image Too Bright. While the need for greater light output is usually recognized, the need for reducing light output can be as great and may be neglected. Overbright images can cause a dazzling effect and make flicker more apparent in motion pictures. The problem of too much brightness is encountered most often with Category C materials.

A good means of reducing light output is the substitution of lower-wattage lamps or the use of a lower lamp-switch setting. It is usually possible to use a 300- or 500-watt lamp in a projector designed for a 750- or 1000-watt lamp, or to use a longer-life lamp.

Reducing lamp voltage or using a lamp intended for a higher line voltage is a satisfactory way of reducing light output, up to a point. Reducing the lamp voltage 10 or 15 percent will reduce light output 30 or 40 percent and prolong lamp life 3 to 5 times. Reducing the lamp voltage much more than 10 or 15 percent can result in an objectionable shift in color quality toward yellow and red, and can shorten the life of tungsten-halogen lamps. Only the voltage on the lamp should be reduced. Reducing the voltage to a projector motor or amplifier below its minimum-design voltage can cause overheating, unsatisfactory operation, and consequent damage.

Raising the general room illumination will often serve the same purpose as reducing image brightness, since it is the brightness ratio, rather than absolute image brightness, that is pertinent. This is especially useful in reducing the dazzle effect of excess brightness in showing negative or reverse-text slides.

• *See also:* ANAMORPHIC SYSTEMS; AUDIOVISUAL PLANNING; MOVIE FILMS, STORAGE AND CARE OF; PROJECTION CABINETS; PROJECTION SCREENS; REAR PROJECTION; RESOLVING POWER; SPLICING FILM; XENON ARC LAMP.

Further Reading: Eastman Kodak Co. *Legibility—Artwork to Screen,* pub. No. S-24. Rochester, NY: Eastman Kodak Co., 1974; ———. *Reflection Characteristics of Front-Projection Screen Materials,* pub. No. S-18. Rochester, NY: Eastman Kodak Co., 1974; ———.*The* KODAK *Projection Calculator and Seating Guide,* pub. No. S-16. Rochester, NY: Eastman Kodak Co., 1974.

Projection Cabinets

There are a number of advantages to having projection equipment and a screen in one unit or cabinet.

1. Persons or objects in front of the screen do not interfere with the projection beam.

2. Maximum safety is afforded to equipment and materials.
3. Sound-producing equipment can be easily housed in the cabinet also.

Because projection cabinets lend themselves to a variety of functions, they are useful for exhibits, carrels, displays, previews, individual study, training programs, and advertising. Moreover, most of these cabinets can offer the advantages of good image quality—even under unfavorable lighting conditions in areas with high room illumination or ambient levels.

This article discusses cabinets for both front- and rear-projection systems. Rear-projection systems are more widely used in self-contained units, so these cabinets will be discussed first.

REAR PROJECTION

Rear projection is capable of providing good image quality when used in a well-designed rear-projection cabinet. As with front projection, a rear-projection system depends upon selection of components suited to their application.

Advantages of Rear Projection

The following are advantages of using a rear-projection system.

1. Rear projection provides free access to the viewing side of the screen.
2. The mechanism of projection can be unobtrusive or hidden, which avoids the possibility of distracting the viewer.
3. A picture approximately 1 m (3 feet) wide or smaller can be projected in displays, exhibits, and similar situations. At the same time, close examination of the screen image is possible.
4. In a lighted area, the use of a dark screen material will often yield results that are desirable to many people— namely, dark blacks or shadow areas in the image.

Avoiding Problems

There can be some snags in the use of rear-projection cabinets; it is best to be aware of them so that they can be allowed for, or avoided. Included are the following:

The Use of Makeshift Rear-Projection Screens. The fact that there is a wide variety of diffusion materials available can lead to poor results with rear-projection equipment. It is easy to choose the wrong screen. Ground glass, for example, is not designed for this purpose and will almost always yield poor image quality. Such a broad selection of screen materials does, however, permit the choice of a screen that is correct for a specific purpose—in reference to picture size, image brightness, and image contrast. It also allows the use of projectors equipped with low-wattage, long-life lamps. Further, this selection makes it possible to take advantage of a particular screen characteristic—such as low reflectivity for daylight viewing, or high gain where projection light is meager—to solve a special projection problem.

Using an Image Size that is Too Large. (Doubling the width of the image requires four times the projector light output to maintain the same brightness.) When conventional projectors are used, most rear-projected images in a lighted area are apt to be unsatisfactory if they are wider than 1 to 1.2 m (3 to 4 feet). For optimum quality, the picture in most cases should not be more than 50 to 75 cm (20 to 30 inches) wide, if the cabinet is in a brightly lighted area.

Disregard of Narrowness of Viewing Angle. With rear projection, as with most front-projection systems, the image will be brightest when viewed from squarely in front of the screen, and brightness will diminish as the viewer moves away from center.

Uneven Images. Pictures that are rear-projected will usually be less evenly bright than those that are front-projected on a matte, lenticular, or other non-beaded screen. The unevenness will vary, depending on the angle of view, the diffusion characteristics of the screen, and the projection lens that is being used. When viewed from directly in front of the screen, the image will be brighter in the center than at the edges, and the brighter area will tend to follow the observer as he or she moves in front of the screen.

Differences in brightness can be lessened by the use of a long-focal-length lens. Such a lens transmits light rays with a smaller angle of divergence from the lens; consequently, the screen does not have to "bend" the light as much. The result is a more uniform spread of light across the screen.

Also, the brightness variation of a picture can be reduced by the projection of a very bright image, because as the objects viewed become brighter, the eye becomes less sensitive to variations in brightness.

Bright Light. The area behind the screen should be dark to prevent stray light from being transmitted through the screen along with the image light. Sunlight falling directly on the screen will degrade the image, even with a dark rear-projection screen. Similarly, bright light falling on light-colored surfaces near the screen can make the projected picture look dull by comparison. No surface near the screen should appear brighter than whites being shown on the screen.

Screens

Ideally, a rear-projection screen should transmit all of the light reaching it from the projector, diffuse the image light evenly to all viewing locations (but not outside the viewing area), and reflect no room light falling on it. Such a screen should be unbreakable, unscratchable, and easy to clean; it should not transmit sound, and in most cases would need to be rigid. Unfortunately, however, no such screen exists.

Consequently, the choice of a "best" screen will be the result of compromise—balancing the characteristics of available screens to meet most adequately the needs of a particular installation. (*See:* PROJECTION SCREENS.)

Mirrors

When mirrors are used in a projection system, high-quality reflecting surfaces are essential to good image quality. Any mirrors located near the lens should be the front-surface type of good optical flatness and preferably should have a protective overcoating to give longer life without tarnishing and to permit cleaning. Mirrors situated closer to the screen than to the lens can be rear-surface mirrors. Optical flatness is not as important for these mirrors, and those in which reflections appear without distortion are likely to be satisfactory. However, rear-surface mirrors also will produce better images if they are constructed of high-quality components.

Metal mirrors can be substituted for the larger glass mirrors, but they frequently do not have the optical quality that is required for the smaller mirrors nearer the lens. Heavy chrome ferrotype tins are occasionally satisfactory for secondary mirrors, if they have no imperfections.

Also considered satisfactory for some applications are mirrors consisting of a thin plastic film, stretched over a metal frame, to which a mirror backing has been applied. Although these mirrors do not have the optical flatness of good-quality glass mirrors, they will suffice in situations where large, lightweight front-surface mirrors are a necessity.

Cabinets

Many excellent commercially produced rear-projection screens and cabinets are available. Some can be used with a variety of projectors; others are special-purpose units for use with special and modified slide and motion-picture projectors; and some also provide for sound. One source of suppliers is the *Audio-Visual Equipment Directory,* published by the National Audio-Visual Association, Inc., 3150 Spring St., Fairfax, Va. 22030. If you have need for a rear-projection cabinet, check the commercially made models. However, the exact cabinet needed to fill specific requirements is not always available, and local fabrication may be practical and economical. It is usually desirable in such cases to keep the cabinet as small as is practicable, and this can be accomplished by designing the system for a

Most conventional rear-surface mirrors produce secondary ghost images displaced slightly from the primary image. Usually, the secondary image is about 1/20 as bright as the primary image, often noticeable only where white or light-colored symbols appear against a dark background.

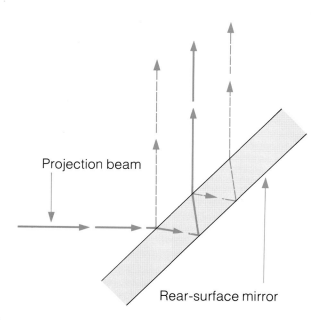

Projection beam

Rear-surface mirror

specific projector and one image format (for example, only horizontal 135-size transparencies, or only super-slides, or only 126-size transparencies).

Single mirrors are commonly used in rear-screen systems. They serve two purposes: to save space and to reverse the image position for correct reading from the audience side of the screen without changing the orientation of the film in the projector. When the arrangement incorporates two mirrors, or no mirror, the film must be oriented differently than it is for normal front projection. This is not possible, of course, in the case of sound motion pictures (unless special reversed prints are used).

Generally, a 50 × 50 mm (2″ × 2″) slide projector system using either no mirror or a single mirror will be very compact with a short-focal-length lens—75 mm (3-inch) or less. The cabinet can be made slightly more compact by using a moderately short-focal-length lens (75 to 100 mm [3 to 4-inch]) and two mirrors, and can be made even smaller by utilizing three mirrors and a 100 mm (4-inch) focal-length lens.

The use of extremely short-focal-length lenses (less than 75 mm) can result in simpler construction and easier alignment of components, but will produce less uniformity of image brightness because of the greater bend angle required of the screen. Also, such lenses usually cost more than those of longer focal length. Sometimes the use of lenses having a focal length longer than 75 mm will result in gains in brightness and image quality, even though additional mirrors may be required.

Design Suggestions. Designing a rear-projection cabinet by means of a strictly mathematical approach is difficult. An alternative is to make paper templates and use them for determining the location of the projector and screen, as well as for the size and placement of mirrors. The following suggestions permit considerable flexibility in the designing of such cabinets and indicate some possibilities in rear-projection systems utilizing projectors such as Kodak Ektagraphic or Carousel slide projectors. All of the diagrams are scaled for horizontal 135-size transparencies, 75 or 100 mm (3 or 4-inch) focal-length lenses, and 34 × 50 cm (13½″ × 20″) images.

Using Paper Templates as Guides. Make paper templates representing the projector, projection

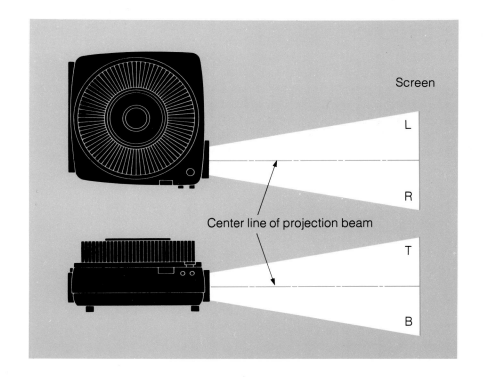

Make paper templates to represent the projector, projection beam, and screen. Usually it is best to make the templates full size, but if the drawings are accurate, ½- or ¼-scale templates will be acceptable. Label the top and bottom (T–B) or left and right (L–R) image edges, particularly if the projected image is to be sound 16 mm or any 8 mm or super 8 motion picture. At the surface of the lens, the width of the projection beam is approximately equal to the diameter of the front lens element.

Screen

L

R

Center line of projection beam

T

B

beam, and screen. Most often it is best to make the templates full size, but if the drawings are made accurately, ½- or ¼-scale templates will be satisfactory. If the beam is to be folded vertically, the template for it should represent an elevation view; if the beam is to be folded horizontally, the template should resemble a plan view. You will find it helpful to label the top and bottom (T-B) or left and right (L-R) image edges, as illustrated, particularly if the projected image is to be a sound 16 mm or any 8 mm or super 8 motion picture. Note that at the surface of the lens, the width of the projection beam is approximately the same as the diameter of the front lens element.

Template dimensions can best be determined by setting up the projector—complete with lens and the type of transparency to be used—and making the necessary measurements for the image height required. Alternatively, use the formula:

$$T = f\left(\frac{H}{h} + 2\right)$$

in which T = projection distance; f = lens focal length; H = image height; h = projector aperture height.

All dimensions are in the same units; centimetres or inches are suggested. Therefore, h = 7.21 mm (0.284 inch) for 16 mm motion pictures; 4.01 mm (0.158 inch) for super 8 motion pictures; 16.94 mm (0.677 inch) for filmstrips; 22.91 mm (0.902 inch) for horizontal 135-size slides.

The above formula will yield the projection distance from the projector gate (film position) to the screen image.

Another possibility is to obtain the information on projection distance and image size from projection tables, calculators, or publications. However, since figures derived in this way are frequently rounded and because projection dimensions vary, actual measurement is preferable.

The screen end of the template should be the same size as the image dimension at the screen. For nontheatrical motion pictures or for filmstrips, the height of the image will be approximately ¾ of the width. Whenever both horizontal and vertical 135-size transparencies are to be projected, use the maximum image dimension for both height and width (of the screen). If only horizontal 135-size transparencies are to be projected, the height will be ⅔ of the width; if only vertical 135-size transparencies are to be projected, the height will be 1½ times the width.

Fold the paper template to determine the location for screen, projector, and mirror(s), as indicated in the accompanying illustration. The template can be moved around on a scale layout of the cabinet space available. Note that the "L-R" or "T-B" labels on the template can be used to determine whether the image will be reversed or inverted, as seen from the viewer's side of the screen.

Each template fold represents the reflecting surface of a mirror. Trace the folds on the plan or elevation of a scale drawing of the cabinet; the traced lines will indicate the location, angle, and one dimension of each mirror. Obtain the other dimension of each mirror by unfolding the template and measuring the distance across it where the fold intersects the edge nearest the screen end. See the accompanying illustration.

MIRROR DIMENSION ADJUSTMENTS FOR RECTANGULAR IMAGES			
Image Orientation	Format	Type of Template	Across-the-Beam Measurement Change
Horizontal only	Motion pictures or filmstrips	Elevation plan	Plus ⅓ for mirror width Minus ¼ for mirror height
	135-size transparencies	Elevation plan	Plus ½ for mirror width Minus ⅓ for mirror height
Vertical only	135-size transparencies	Elevation plan	Minus ⅓ for mirror width Plus ½ for mirror height

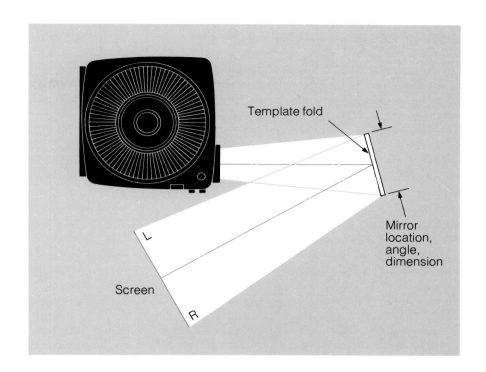

Mirrors can be used to fold the projection screen for special, compact arrangements. Fold the paper template to determine the location for the screen, projector, and mirror(s), as indicated here. The template can be moved around on a scale layout of the cabinet space available. The "L–R" or "T–B" labels on the template can be used to see whether the image will be reversed or inverted as seen from the viewer's side of the screen. Trace the template folds on the plan or elevation of a scale drawing of the cabinet; the traced lines indicate the location, angle, and one dimension of each mirror.

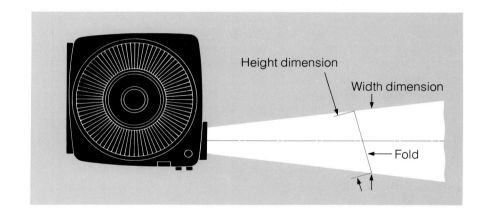

The traced lines of the template folds indicate the location, angle, and one dimension of each mirror. The other dimension of each mirror can be obtained by unfolding the template and measuring the distance across it where the fold intersects the edge nearest the screen end.

Choosing and Positioning Mirrors. Whenever desired, several mirrors can be added, but the practical limit is three. The use of more than three mirrors can cause complications of alignment and loss of brightness and sharpness. Using two mirrors often requires that the transparency be reversed or inverted to obtain a correctly oriented rear-projection image. Ordinarily, one or three mirrors can be used to give a correct-reading image with slides or mo-

tion-picture film positioned normally in the projector. Be alert to the fact that using three mirrors does not insure proper image positioning; check the L-R and T-B labels of the templates.

Each mirror should be angled in only one plane (i.e., to bend the beam sideways but not vertically, or vertically but not sideways). If the mirror is both angled and tilted, the image will be rotated to some extent and will require either the tilting of the pro-

jector away from level or the complicated angling of additional mirrors.

If a mirror is located too near the screen, room light passing through the screen from the viewer's side may be reflected back onto it and degrade the image.

If the image is to be square, or if both horizontal and vertical images (135-size transparencies) are to be projected, the mirror dimensions obtained by the above method will be correct. Also, it is possible to reduce the mirror's surface area somewhat by employing a trapezoidal shape, with the size of the smaller end being determined by the distance across the beam where the fold intersects the beam image nearest the lens. Observe that the drawing of lines across the beam template does not give the shape or complete mirror dimensions, but gives only the lengths of the two parallel sides. The nonparallel length must be as long as the fold.

The projection beam can cross itself with no interference problems, but make sure that parts of the projector, cabinet, or mirrors do not interrupt the beam.

Alterations to the across-the-beam mirror dimensions must be made for some applications. If only rectangular images are to be projected, and if they will always be either horizontal or vertical, the mirror dimensions should be adjusted. (See the table on page 2074.

The dimensions resulting from these instructions and the accompanying table represent *minimum* mirror sizes. They should be increased by one or two inches to facilitate alignment and to provide space for mounting or clamping the mirrors. Be certain that the increased mirror sizes will not interfere with the edges of the projection beam.

Considerations. In most cases, the locations of projector, mirrors, and screen are of primary importance in the designing and building of a rear-projection system. There are some other requirements:

Materials. Construction materials that will provide the physical characteristics needed, such as thickness, strength, rigidity, and sound isolation.

Ventilation. Adequate ventilation, which can involve the ducting of warm exhaust air to the outside of the cabinet, as well as the provision for auxiliary blowers, air filters, and air inlets.

Equipment Accessibility. Accessibility of equipment such as speakers, tape recorders, or other items within the cabinet. Allowance for the rearrangement, adjustment, and servicing of components.

Light Shields. Light shields to prevent nonimage light from striking the back of the screen, either directly or by reflection from mirror surfaces. (Such light can come from sources outside the cabinet or from the gate or lamphouse of the projector.) Any shields that are added should not restrict the ventilation of the projector.

Inside Cabinet Surfaces. Inside surfaces of the cabinet finished in flat black.

Projected Image Brightness. Image brightness is one of the major factors to be considered in the effective projection of visual materials. Without satisfactory image brightness, a projected message can be so difficult to perceive and understand that it is misinterpreted.

Curved-Field or Flat-Field Lens. Both curved-field and flat-field projection lenses are available in some of the focal lengths. Kodak curved-field lenses have a C designation on the lens barrel.

There are situations with self-contained projection cabinets (front or rear) in which a curved-field lens will provide better center-to-corner image sharpness than a flat-field lens. This fact is important with self-contained cabinets because of the short viewing distances involved. The advantages accrue when open-frame mounts (cardboard or plastic) are used with 135-size, 126-size, and 30 mm square transparencies, and the emulsion side of the transparency is toward the projection lens. If the slides are reversed (emulsion toward the lamp), results will be worse with a curved-field lens.

Flat-field lenses will provide better center-to-corner image sharpness than curved-field lenses when used with glass-mounted slides. The same is true of open-frame mounts (cardboard or plastic) when the emulsion side of the transparency is toward the projection lamp. With larger transparencies (such as super-slides) and smaller ones (such as 110-size transparencies in 2″ × 2″ mounts), one type of lens offers no significant advantage over the other.

Safety. Electrical wiring should conform to local code requirements and standards of acceptable practice. *If projectors are to be operated in an enclosed area or are to be left unattended, it is advisable to use equipment that will shut off automatically in the event of overheating or mechanical failure.*

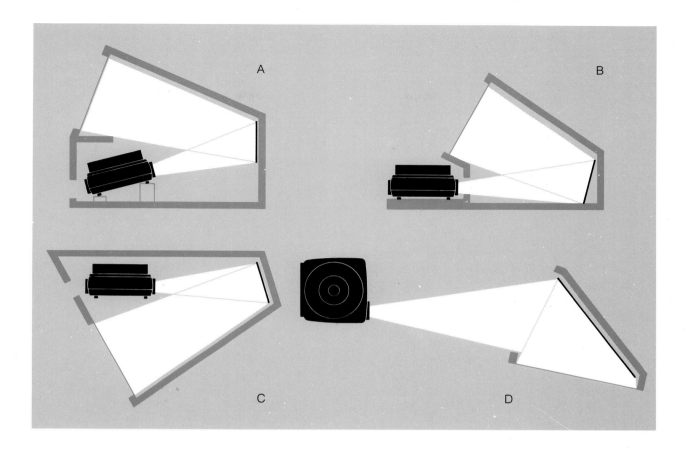

In this system, a single mirror is used with a moderately short- (75 to 100 mm [3-to 4-inch]) focal-length lens. (A) Because of the angled screen, the cabinet can be positioned well below eye level and still be seen by standing viewers. In areas with bright overhead lights, a hood over the top edge of the screen may be needed. The cabinet can be tilted for a more nearly vertical screen. (B) In this variation of A, because the projector is outside the cabinet, it is quickly accessible for counter demonstrations, changing of trays, etc. (C) This setup is similar to the one shown in A, but it is best for use where viewers look up to see the screen image. (D) This cabinet can be built to accommodate only the mirror and screen, or it can be extended to include the projector. When a long- (100 mm [4-inch] or more) focal-length lens is used, this system can project across a room onto a mirror/screen combination angled toward the audience. This setup can be made smaller by placing the projector closer to the screen, folding the projection beam nearer its midpoint, and using a smaller mirror.

Mirror and Projector Alignment

Mirrors can be mounted in frames or secured with fasteners, such as clips. They can also be cemented in place—preferably using adhesives specially prepared for this purpose, which are available from many glass and mirror stores. This type of adhesive should be used if the bonding agent touches the coated side of the glass since, unlike some contact cements, it will not react with the coating.

Mounting can be permanent; often, though, it is desirable to allow for some two-way angle adjustment for the mirror nearest the projector lens, and to provide for slight changes in projector position and angle.

If the cabinet is carefully made, using accurate templates, you should have no major difficulties in the alignment of mirrors or projector. Alignment can usually be simplified by placing the projector

and mirrors in their approximate positions. To do this, turn on the projector and cover the first mirror with a sheet of paper; then relocate the mirror or projector so that the light beam falls within the paper representing the mirror surface. Next remove the paper and cover the second mirror. Now tilt the first mirror until the light beam is within the area of the second mirror surface. Proceed in the same fashion to the third mirror (if one exists). The center of the screen can be established by punching a hole in the center of a mounted transparency and then aligning it accurately (both horizontally and vertically) in the projector.

Minor positioning adjustments of the image can be accomplished by tilting the projector, changing its side-to-side angle, or shifting its location. A slightly tilted image frequently can be corrected by tilting the projector sideways. If the image is skewed (sides not parallel), the center line of the projector beam probably is not perpendicular to the screen surface. In this event, slightly adjust the angles of the mirrors or the angle or location of the projector.

The accompanying illustrations are schematic diagrams showing some possible types of rear-projection systems. The cabinets shown will permit the usual projection sequences of slides, and in each case normal slide orientation is possible, unless otherwise indicated.

FRONT PROJECTION

A self-contained projection cabinet—containing screen, projector, and perhaps tape recorder or control device—can be used successfully for front, as well as for rear, projection. And in some applications, a front-projection unit offers definite advantages over rear projection—particularly if the front-projection cabinet contains a high-gain, aluminum foil screen such as a Kodak Ektalite projection screen, because this screen will provide a brilliant image with good color rendition, sharpness, and rich dark colors and blacks.

Advantages

The following are advantages of using a front-projection system.

1. The aluminum foil screen will produce an image that is five or six times brighter than medium-gain, rear-projection screen materials commonly used. As a result, the image can be bright and attention-getting in most indoor (and even in some outdoor) situations where projected images might not have been practical before.

2. The hot-spot effect (part of the image noticeably brighter than other parts), characteristic of rear-projection images, can be avoided. This is true regardless of which type of front-projection screen is used.

3. An aluminum foil screen used in a front-projection cabinet will yield excellent contrast and color saturation, even with high levels of room illumination, because of the control and rejection of ambient light. The result is an image with rich dark colors and solid blacks.

This setup uses no mirror and a moderately short- (75 to 100 mm [3- to 4-inch]) focal-length lens. A complete cabinet or a shadow box can be built to keep stray light from the back of the screen. Slides should be reversed in the tray. If the projector is positioned on the same plane as the bottom of the screen, the image will be slightly keystoned.

Disadvantages

There are disadvantages to using the front-projection system.

1. A mirror or projector is located in front of the screen.
2. The viewing angle is narrow. With front-projection cabinets using an aluminum foil screen, the viewing angle (for optimum viewing) is about ±30 degrees horizontally, and ±15 degrees vertically from the center of the reflected beam. (Matte screens and lenticular screens will provide wider horizontal and vertical viewing angles; however, they will not reflect as bright an image on or near the projection axis.

Front-Projection Cabinets

Front-projection cabinets, utilizing aluminum foil screens such as Kodak Ektalite projection screens, are available from commercial suppliers. If you should decide to create any original cabinet designs, keep the following points in mind:

1. Determine the suitability and availability of the screen.
2. The projected light and the ambient light should reach the screen from angles that are as widely separated as possible.
3. Each mirror used in a front-projection system will reverse the image (i.e., the first mirror reverses it, a second corrects it, and a third reverses the image again). A reversed image on the screen can be corrected by reversing slides in the projector; however, this is not usually possible with motion-picture projectors.
4. The image can become inverted (bottom of image at the top). The bottom of the beam as it leaves the projector lens should be on the bottom of the screen. This, too, can be corrected by reorienting slides, but not motion pictures.

• *See also:* PROJECTION, AUDIOVISUAL; PROJECTION SCREENS; REAR PROJECTION.·

 Projection Screens

This article deals with the characteristics of screens for both front and rear projection. For further information on projection systems, see PROJECTION, AUDIOVISUAL; FRONT PROJECTION; and REAR PROJECTION.

Whatever method you choose for projection, you will need a screen on which to project the image. The screen is often the weakest link in a projection chain. A projection screen intercepts the light falling on it from the projector (or other sources) and diverts it to the viewers' eyes. The efficiency with which it does this affects image brightness, evenness of image brightness, color saturation, and contrast of the image.

Screen Gain

A screen is assigned a "gain factor," which mathematically describes its brightness. In a sense, however, the word "gain" is a misnomer when applied to a screen, since a screen cannot generate or amplify light. It can only reflect the light that falls on its surface or, in the case of rear-projection screens, spread the light into the audience area. A front-projection screen that reflects light evenly in all directions (theoretically possible) is assigned a gain of one and is considered to be an ideal diffuser. A screen is said to have a gain of two if the image directed to the viewer is twice as bright as that produced by an ideal diffuser (front projection).

Screens that direct light evenly throughout an area cause some of the image-forming light from the projector to be wasted above, below, and on either side of the audience space. If some of this otherwise wasted light (as far as the viewer is concerned) can be directed back into the audience viewing area, it will effect a brighter overall image.

Image brightness variation will be reduced and the viewing area increased by the use of a low-gain screen, but the image will be dimmer and more susceptible to being affected by stray light. High-gain screens are most useful in situations where the viewing area is quite small, such as in learning carrels, microfilm readers, and television news broadcasting where the TV camera is located at the best viewing position.

Front-Projection Screens

Ideally, a projection screen should reflect the projected light (the image) only into the audience. It should not reflect light toward unoccupied viewing locations; neither should the screen reflect ambient or stray light into the audience. Extra light detracts from the image and produces a washed-out appearance. It also causes a loss of contrast and discernible detail, especially in shadow areas.

Non-image brightness of a screen is the result of all the light falling on the screen other than that actually forming the image. High non-image brightness makes it difficult to obtain good blacks or dark areas in the projected image. The principal sources of non-image brightness are ceiling and exit lights in the room or incompletely darkened windows, doors, and skylights.

Selection of a screen depends upon the size and shape of the viewing area, characteristics of the projection system, and the amount of stray light in the projection area. The following are descriptions of screen materials and their suitability for particular applications.

Each diagram indicates the image brightness (reflected-light distribution) of one type of screen material. The shading represents image brightness seen from different viewing angles: the lighter the shading, the brighter the image. This brightness information is averaged for each indicated viewing area, and there are no sharp fixed lines of view beyond which brightness changes abruptly. Any comparisons of one diagram with another must be based on the assumption that the intensity and uniformity of projector light falling on the screen is the same for each condition being evaluated.

Matte Screens. Matte screens reflect light evenly in all directions, and the images appear almost equally bright at any normal viewing angle. From the standpoints of sharpness and evenness—and in most respects except brightness—the image on a smooth, completely matte screen will be better than the image on any other surface.

The matte screen is most appropriate when extreme viewing angles are necessary. However, if possible, viewers should be seated no more than 30 degrees from the lens axis to avoid image distortion.

Some matte screens have a slightly glossy surface, usually broken up by an embossed random pattern or texture. Compared with a true matte surface, screens of this type provide a slightly brighter image on or near the projection axis, somewhat less brightness for viewing from the sides, and slightly better rejection of stray light falling on the screen from outside the viewing area. In addition, they usually are more washable than a non-textured screen.

Any reasonably smooth, non-glossy surface makes a good matte screen; for example, a plastered wall or flat white paint on wallboard, composition board, or some other fairly smooth surface. The screen can be rigid or flexible, flat or curved, and it is available in any reasonable size. When a matte screen is being used and a medium-size image (under 3 m [10 feet] wide) is to be projected, the room should be quite dark. With a matte screen, ambient light or stray light should be avoided since the screen will reflect it evenly in all directions and degrade the image.

Most matte screens are about 85 percent efficient. That is, an illumination level of 10 footcandles (108 lux) on the screen provides a screen surface brightness of 8.5 footlamberts (29 cd/m²), regardless of viewing angle or the angle at which light strikes the screen.

Beaded Screens. Beaded screens are made of white surface material on which small, clear glass beads have been embedded or attached. Most of the

A matte screen reflects light evenly in all directions; the images appear almost equally bright at any normal viewing angle. The image on a completely matte, smooth screen will be sharper and more evenly lighted than on any other surface; brightness may be somewhat degraded.

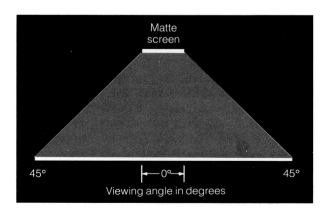

projected light reaching the beads is reflected back toward its source. The pattern of the reflected light from the screen is a fan-shape area approximately 50 degrees deep and 50 degrees wide. This concentration of light produces a very bright image (up to four times the brightness of that from a matte screen) but only in a restricted area.

Beaded screens are useful in long, narrow rooms or other locations where most viewers are near the projector beam. At about 25 degrees from the projector beam, the image brightness on a beaded screen

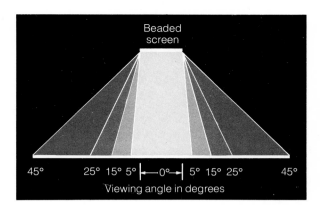

The pattern of reflected light from a beaded screen is a fan-shaped area about 50 degrees deep and 50 degrees wide. A very bright image is produced from this concentration of light, but only in a restricted area. The brightest area is within about 25 degrees from the projector beam.

Typical square (40" × 40") folding projection screen with highly reflective glass-beaded surface. This screen format is particularly useful when projecting a mixture of horizontal and vertical 35 mm slides.

will be about the same as that on a matte screen. Beyond this angle it will be less bright than on the matte screen.

Beaded portable screens are popular because they do not need to be kept flat and they are available in many sizes.

With beaded screens, stray or ambient light is reflected back in the general direction of its origin, so stray light originating from the viewing area can be quite troublesome. Stray light originating outside the audience area may be a problem for viewers at marginal viewing angles.

Aluminum-Foil Screens. Specially treated aluminum screens are made of thin sheets of specially treated and rolled aluminum foil that are permanently mounted in a slightly concave, noncollapsible, lightweight frame.* Such screens reflect the projected light in a fan-shaped area approximately 30 degrees high and 60 degrees wide. This concentration of light and the high reflection efficiency of the material make an extremely bright image (about ten times the image brightness of a matte screen).

When this type of screen is aimed properly, stray or ambient light originating away from the projector is reflected outside the viewing area and does not degrade the image. This results in excellent

*Such a screen is the Kodak Ektalite projection screen, model 3, available in 1.0 × 1.0 m (40" × 40") size.

Metallic lenticular screens have a metal-coated surface with a raised pattern that acts as a set of small mirrors. The viewing area of such screens is about 40 degrees high and 70 degrees wide. In this area, image brightness is more than double that of a matte screen.

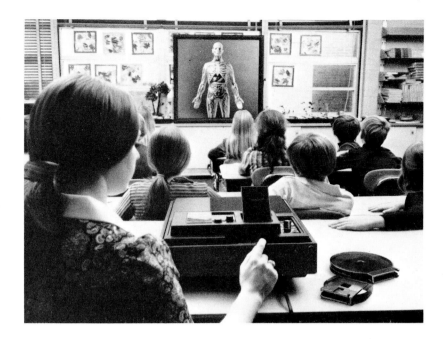

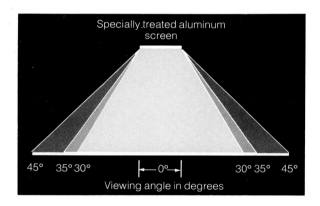

image contrast and color saturation, even in brightly lighted rooms or areas. Unwanted light originating near the projector and aimed directly toward the screen will be reflected back into the viewing area and degrade the image. The special surface characteristics of the screen and the proper curvature without irregularities are both necessary for good results with these aluminum screens.

Metallic Lenticular Screens. Metallic lenticular screens have a metallic-coated surface with a raised pattern that acts as small mirrors and is invisible at normal viewing distances. Such screens reflect most of the projected light in a fan-shaped area, usually about 40 degrees deep and 70 degrees wide. In this viewing area, image brightness is more than double that of a matte screen. Metallic lenticular screens are available in sizes up to 1.8 × 1.8 m (6 × 6 feet). They are rigid or flexible (if flexible, they must be under tension) and are generally mounted flat. Ambient light originating from the viewing area will be reflected back to the viewing area and degrade the image. Ambient light originating outside the viewing area will be, in part, reflected outside the viewing area.

Nonmetallic Lenticular Screens. Nonmetallic lenticular screens have a patterned surface similar to that of the metallic lenticular screen but without a metallic coating. The raised pattern of the surface acts as small mirrors and is invisible at normal viewing distances. Such screens will reflect most of the

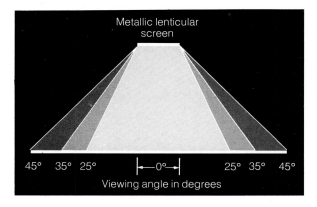

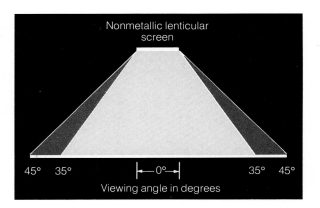

(Left) The metallic lenticular screen reflects most of the projected light in a fan-shaped area about 40 degrees deep and 70 degrees wide. In this area, image brightness is more than double that of a matte screen. (Right) The nonmetallic lenticular screen reflects most of the light from the projector in an area approximately 40 degrees deep and 90 degrees wide. In the viewing area, image brightness is about double that of the matte screen.

projected light in a fan-shaped area approximately 40 degrees deep and 90 degrees wide. The brightness in this viewing area is approximately double that of a matte screen. Nonmetallic lenticular screens are available either rigid or flexible (if flexible, they must be under tension) and are generally flat. They can be obtained in most standard sizes, although special order may be needed for screens larger than 1.8 × 1.8 m (6 × 6 feet). Ambient light originating from the viewing area will be reflected back to the viewing area and degrade the image. Some of the ambient light from outside the viewing area will be reflected outside the viewing area.

With both metallic and nonmetallic lenticular screens, the surface texture and mirror shape can be controlled in manufacturing. For this reason, the characteristics of lenticular screens may vary from manufacturer to manufacturer to a greater extent than is common with most other screen types.

Rear-Projection Screens

Rear-projection images have the same requirements for image brightness, size, and contrast as front-projected images. Rear projection has advantages in some situations, disadvantages in others.

Rear projection may provide advantages in image contrast and color saturation in a lighted room. A dark-colored rear-projection screen will re-duce image brightness. But if stray light is prevented from falling on the back of the screen, a dark-colored screen may provide darker shadow areas in the image, giving an impression of improved contrast and color saturation.

Rear-projection screen materials are generally more directional than front-projection screen materials, and usually are much brighter on the projection axis than off the axis. Consequently, part of the image picture area is brighter than another part (sometimes 50 to 1 or more).

Since the light from the projector must be transmitted through the screen material and spread into the audience space for all parts of the image to be visible, the rear-projection screen has a light-scattering material added to the clear backing (glass, acrylic plastic, flexible plastic, and the like). This coating transmits some light, absorbs some light, and reflects some of the image light back toward the projector. If a rear-projection screen material is used to spread the light more evenly, the brightness distribution is improved and the light is spread over a larger viewing area. Some of the light is, however, reflected and absorbed by the screen material, thus reducing the overall image brightness.

The greater the density of the light-scattering particles in the coating, the greater the scattering and reflection. Since the scattering takes place with

light that enters the material from any direction, the greater the scattering (wider viewing area), the greater the reflection of stray light. Increasing the viewing area of a rear-projection screen by adding scattering material, then, results also in increasing the screen's reflection of stray light, thus reducing this advantage of rear projection (as the scattering is increased).

Makeshift rear-projection screens are seldom satisfactory. Just as the satisfactory viewing angle of lenticular screens can be controlled, so the dispersion (viewing) angle of rear-projection screens can be controlled. A narrow-angle screen will give a bright image for viewers almost directly in front of the screen, but a dim image for people at the sides of the viewing area. As the angle is increased, the image will become less bright, within limits, for the viewer squarely in front of the screen and brighter for viewers toward the sides.

Another important consideration in rear projection is the darkness of the screen as seen by reflected light. As with front projection, the highlight brightness of the image should be as bright as, or brighter than, other areas within the viewers' peripheral vision.

If the image is to be viewed in a well-darkened room, there is no advantage in a dark-colored screen. If the image is to be large, a light-colored screen is usually preferable since it will absorb less image light than a dark-colored screen.

With most projectors using tungsten lamps, images as wide as 1 or 1.2 m (40 or 48 inches) will be satisfactory on a dark-colored rear-projection screen in moderately lighted rooms. For larger images, a light-colored screen in a darkened room is usually needed. In very brightly lighted rooms, images should usually be no more than 51 or 76 cm (20 or 30 inches) wide.

Choosing a Rear-Projection Screen Material. Many factors influence the selection of a suitable screen for a particular application. In many situations, a screen must be engineered to fit the specifications for a given rear-projection system. Furthermore, the performance of rear-projection screens is highly dependent on the manner in which the screen is used, on the projection equipment, on the design of the system, and on ambient light levels.

The choice of a "best" screen will be the result of compromise between the characteristics of available screen materials and the needs of a particular installation. Following are some general considerations:

1. A screen with a wider light distribution (bend angle) will yield a dimmer image, but will permit wider viewing angles, allow the use of wider-angle (short focal length) projection lenses, provide more uniform image brightness, or result in a combination of these.

2. Dark screens (green or black) will give less image brightness than light-colored ones, but will yield better color saturation and image contrast for viewing in a lighted area, because they will reflect less room light.

3. A matte or dull surface facing the viewers will eliminate or subdue specular (mirror-like) reflections of bright lights or objects in the room, but will provide less image contrast than will a smooth surface in a lighted room.

4. The most rigid and dimensionally stable screens are constructed with a glass base. They are the flattest and least susceptible to scratching (on the glass side), but they are heavier and more subject to breakage than flexible screens or screens coated on rigid plastic.

5. Thin, flexible screens, although usually lightest in weight, must be stretched over a frame to achieve flatness. This type of screen will have elasticity that will help to prevent some types of damage; however, it will transmit sound easily, and it may vibrate.

6. A semi-rigid plastic screen is intermediary between a glass-base and a flexible screen.

7. Screen materials can be mounted on or in wooden, metal, or other frames, which then can be attached to the cabinets or placed in suitable grooves. Aluminum-frame channels and corners (available from most hardware stores for use with house screens and windows) provide a simple means of mak-

ing frames for both flexible and rigid screens. Allowance must be made for slight expansion and contraction when mounting semi-rigid screens.

8. The size of the screen image required is dependent upon the type of information to be presented, the viewing angles, and the audience's proximity to the screen. It is usually better to have a small, bright, sharp picture than a weak and over-enlarged one.

TABLE OF VALUES FOR TYPICAL REAR-PROJECTION SCREEN MATERIALS

Screen Type	On-Axis Gain	Angle for ½ Brightness	Angle for ⅓ Brightness
High-gain	5	15°	20°
Medium-gain	2½	20°	30°
Low-gain	1	40°	55°

• *See also:* BACK PROJECTION; FRONT PROJECTION; PROJECTION, AUDIOVISUAL; REAR PROJECTION.

 Projectors

Most photographic projectors are made to project transparent materials such as slides, transparencies, film strips, or motion-picture films onto screens for viewing. Technically, such projectors are called *diascopes,* from the Greek roots meaning "seeing through." Projectors that use opaque materials are called *episcopes* because they "see upon" the surface being imaged. A projector that can accommodate both kinds of material is an *epidiascope.* In common usage, however, projectors are simply identified by the kind of material they accept: slide projector, opaque projector, 16 mm projector, and so on.

Basic Projector Features

All projectors have the same major components:

1. A stage or gate to hold the material being projected.
2. A light source.
3. A lens system to project the image.
4. A mechanism, manually operated or automatic, to change the material on the stage or in the gate.

Most transparency projectors hold the film or slide in a vertical position so that light passing through is focused directly onto a screen in a straight-line path. This is practical because the maximum size of the original is small enough to permit each frame to be held sufficiently flat for good-quality projection. Opaque projectors usually are designed to accept larger materials that must be supported on a horizontal stage to prevent their curling or sagging out of the focal plane of the lens. Light from the image passes upward where it is reflected at 90 degrees to be projected by the lens system onto a screen. Because of this arrangement—which is also used with a transparent or translucent stage for large transparencies—such projectors are often described as "overhead projectors."

Whether an in-line (horizontal) or overhead imaging arrangement is used, a transparency projector will always provide a brighter screen image—for the same amount of illumination—than an opaque projector, because of the light lost to the reflection and absorption characteristics of the opaque material being projected.

Aside from the major distinctions of still/motion, transparency/opaque, and format, projectors differ primarily in the number of operating features they offer. These may include (1) automatic focusing, (2) automatic image changing, (3) random access to images, (4) remote control operation, (5) forward-reverse operation, (6) timed-sequence operation, (7) multiple formats, (8) synchronization with tape, other projectors, or auxiliary equipment, and (9) for motion-picture projectors, forward motion, reverse motion, slow motion, fast motion, single-frame (freeze-frame) operation, and sound.

Still Projectors

The most common type of still projector accepts transparencies in 51 × 51 mm (2″ × 2″) mounts. It is sometimes called a 35 mm slide projector because that is the film size most often used for slides, but in fact it can project any image that can be

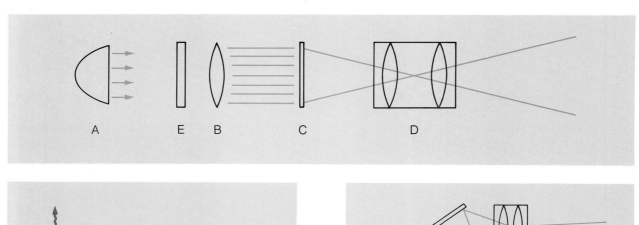

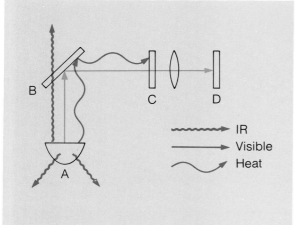

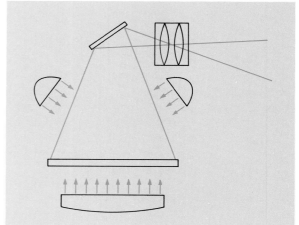

(Top) The basic projection illumination system includes a high-intensity lamp (A) and a con-denser (B) to direct the light in essentially parallel paths through the film (C) in the gate. Lens (D) focuses the illuminated image onto the screen. Heat-absorbing glass (E) is permanently in place in most slide projectors and moves into position to protect the film in movie projectors when slow speeds are used. This diagram represents a small-size projector that uses a reflector bulb to spread the light over the transparency area. (Left) Most projection light sources produce visible, infrared, and heat radiations. A sophisticated projector system protects the slide by using a lamp (A) with a reflector that transmits some infrared and reflects other radiations to an IR-transmitting "cold mirror" (B). Heat reflected by the mirror toward the image is greatly reduced by heat-absorbing glass (C) so that while nearly all the visible energy reaches the slide (D), much of the heat is removed from the beam and does not reach the slide. (Right) The overhead projector uses an angled mirror or prism over the stage to reflect the image to the lens. The light source must be above the stage for opaque materials, and below a translucent stage for transparent materials. A horizontal stage provides support for larger materials.

placed in a standard mount, from a 16 mm or 110-size frame to a 127-size "super slide" (with image area of 38 × 38 mm). Similar projectors are made for 30 × 30 mm (1⅛″ × 1⅛″) 110-size slides, for 70 × 70 mm (2¾″ × 2¾″) mounts (with image size up to 6 × 6 cm, or 2¼″ × 2¼″), and for 3¼″ × 4″ glass slides. This last size is seldom used

except in large auditoriums and other situations with great projector-to-screen distances, where a large original is required to maintain projected image quality and brightness.

Filmstrip (so-called "slide-film") projectors use lengths of 35 mm film in which 17.5 × 23 mm frames are printed in sequence. The frame size is

almost exactly the same as that produced by most 35 mm half-frame still cameras.

Overhead projectors usually are designed for transparencies in 10″ × 10″ mounts; they may also accept opaque materials up to 11″ × 14″ or larger. This large format has a number of advantages. Original material can often be used, without the need to photograph it to obtain a smaller size image for projection. It is possible for the operator to reach into the stage area to point out details in the image, or even to draw or write on the material as it is being projected. It is also possible to add or remove overlays, cutouts, and other elements to change the image.

Illumination. A major problem with very large-format projectors is illumination. As the stage size increases, more and more light is required to maintain screen brightness. This can cause serious heat problems, especially with opaque projectors, which must be enclosed to prevent stray light from degrading the screen image. Without adequate cooling, the projector may become too hot to touch, or the material being projected may curl, fade, become scorched, or be affected in other ways.

Almost all small- and medium-format transparency projectors use a quartz-halogen lamp for high light output with no significant change in color balance or light output throughout the life of the lamp. Various reflection paths can be used to reduce the amount of infrared and heat radiation reaching the film. In addition to heat-absorbing glass, fans or blowers are used to cool the lamp as well as the transparency. (See the accompanying diagrams.)

Slide Loading and Changing. As illustrated, a variety of methods are used to change slides during projection. Trays, magazines, and stack loaders all arrange slides in a fixed order; manual slide changing is slower and more cumbersome, but permits changing the order of images at any time. Some projectors accept a random-access control that provides completely free choice of any image in a tray or magazine. Each time a dial on the control is turned to a given number, the projector moves the tray or magazine to select the slide stored at the corresponding number position. Random-access projectors are often used in educational and sales applications.

Trays and magazines with the greatest capacity will accept small-format slides only in mounts up to

Some projectors accept a random-access control that provides free choice of any image; the setting of the dial causes the projector to select the slide stored at the corresponding number position.

1.6 mm (1/16″) thick; only cardboard mounts and a few glassless plastic and metal mounts are this thin. Wider slots or compartments are required for most glass or metal mounts, which may be up to 3.2 mm (1/8″) thick; consequently the total number of slides a tray can accommodate is significantly reduced. Stack and cube loaders generally have a maximum capacity of 40 thin (cardboard) mounted slides.

The physical force used to change slides can significantly shorten the useful life of the mounts. In particular, rough handling of cardboard mounts will cause fraying, bending, or other distortions that can lead to jamming of the projector or tray, with the likelihood of permanent damage to the image. Kodak Ektagraphic and Carousel projectors minimize the chance of damage by using gravity to drop each slide into projection position; an arm with a nylon bearing plate lifts the slide from below to return it to its tray slot when the projector change mechanism is activated. Most other projectors require a push-rod or pulling device both to move a slide into position and to move it out of the way for the next slide. The greatest amount of damage is likely to occur with manual slide changing because of the excessive handling it requires.

Whatever changing method is used, with a single projector there is no way to avoid either having the screen go black between images or seeing one image move off the screen as the next moves on. However, two projectors can be interconnected with an instant-change or a dissolve control so that images change on the screen without interruption or unwanted movement.

Lenses for Still Projection. Both fixed-focus and zoom lenses are available for projecting slides.

Typical focal lengths for average projection distances with standard formats are:

Mount size — 30 × 30 mm, 51 × 51 mm, 70 × 70 mm
Lens focal length— 50 to 75 mm, 65 to 150 mm, 85 to 165 mm

Tables showing the relationship of screen size, lens focal length, and projection distance for various slide sizes are included in the articles PROJECTION, AUDIOVISUAL and SLIDE PRESENTATION.

A projection lens must be corrected for a very short subject (slide) distance and great image (projection) distances. Because it has no diaphragm, it must also be corrected for the best possible edge sharpness at maximum aperture. Image sharpness also depends on whether the film remains flat during projection. If it is not mounted in glass, the film is likely to curve as it heats up; in that case, a specially designed curved-field—rather than a flat-field—lens will give better results.

Curved-Field versus Flat-Field Lenses. Curved-field lenses can provide greatly improved image sharpness for most projection situations. But it should also be realized that they can provide less sharp images if used inappropriately.

Slide projector lenses have traditionally been the flat-field type. If the slide really is flat, the lens provides a flat image of it on the flat projection screen; this is shown in illustration *A*. Often, however, the slide is *not* flat because of certain characteristics of photographic film.

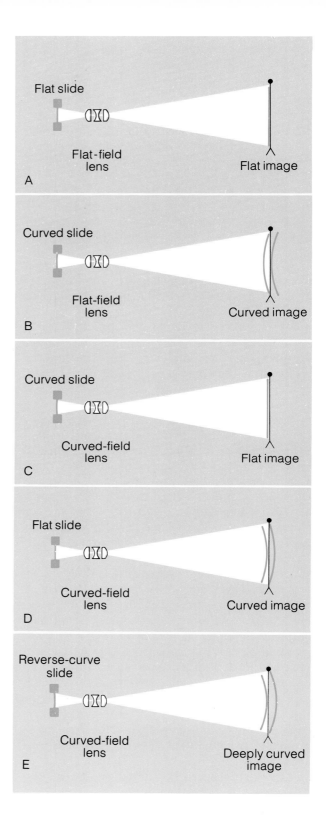

(A) When a slide projector lens is of the flat-field type, if the slide is really flat, the lens provides a flat image of it on the flat projection screen. (B) When a curved slide is projected with a flat-field lens, a curved image results at the screen. With critical focus, either the center of the image or the edges can be sharp, but not both simultaneously. (C) With a curved-field lens, although the film is curved, a flat image is projected, permitting center-to-corner sharpness on the screen. (D) If the slide is flat, and a curved-field lens is used in the slide projector, the image will be curved. This direction of curvature is opposite that shown in B. (E) When the film is curved in the opposite direction (toward the lens) of that shown in B and C and a curved-field lens is used, a deeply curved image results. The center of the image is markedly out of focus when the corners are sharp, and vice versa.

The transparency is basically a sheet of clear plastic, with the image-bearing gelatin emulsion on one side. The plastic base and the gelatin emulsion have different rates of expansion and contraction with heating and cooling, particularly when changes in humidity or moisture occur in the transparency.

At one time, "popping" of slides during projection was a serious problem. If the transparency were in an open-frame mount, it would often spring from being curved one way to the opposite curvature, as the radiant energy from the projection lamp was absorbed by the dyes or silver in the image and moisture was dried by the resulting heat. Today, improved filmmaking and mounts have virtually eliminated the tendency of a slide with a cardboard or other open-frame mount to pop. Instead, only a slight change in the film curvature may result. Often the change is so slight that the image does not appear to go out of focus, especially with projectors that warm the film before it is projected or those that have quick-acting automatic focusing mechanisms. Even with the improvements in filmmaking and slide mounts, film is still curved to some extent when used in an open-frame mount.

Screen image quality can be improved and at the same time the film curvature can be overcome. Illustration *B* shows that the curved transparency, when projected with a flat-field lens, results in a curved image at the screen. Practically, this means that if you move up close to the screen and focus critically, you can have the center of the image sharp, or the corners and edges—but not both at the same time.

Kodak investigated this situation, determined the average curvature of slide transparencies, and designed projection lenses to compensate. The result is the introduction of curved-field lenses. Illustration *C* shows that although the film is curved, a curved-field lens provides a flat image, permitting center-to-corner sharpness on the screen. The improvement can be dramatic, particularly with subjects having much fine detail and texture.

Two other conditions should be mentioned concerning slide projection with curved-field lenses. The first condition occurs when the slide is actually flat, as in illustration *D*. If a curved-field lens is used with a flat transparency, the image will be curved. The result is about the same as shown in illustration *B*, except that the image in this case is curved in the opposite direction (compare illustrations *B* and *D*).

The other condition occurs if the transparency curves the opposite way from normal, that is, toward the lens (normally the film curvature is toward the lamp). Projection of reverse-curl transparencies with curved-field lenses will provide an even more deeply curved image, with the center markedly out of focus when the corners are sharp and vice versa, as in illustration *E*.

All Kodak original film slides, duplicate slides, and slides printed from color negatives have the emulsion at the front when projected. This results in a concave curve toward the front that matches the direction of curvature of the curved-field lenses.

Recommendations. The Kodak curved-field lenses can be used in any Ektagraphic or Carousel slide projector for 2″ × 2″ slides made in the United States or Canada, and also in Kodak Cavalcade projectors.

The following table will help determine whether a curved- or flat-field lens is the better choice:

PROJECTION-LENS SUITABILITY		
Slide Type	Image Quality Flat-Field Lens	Curved-Field Lens
Open frame, emulsion toward lens	Acceptable	Recommended
Glass-mounted, cemented to glass, or glass plate	Recommended	Acceptable
Open frame, emulsion away from lens	Acceptable	Not recommended

For unknown or mixed slides, the flat-field lenses are preferable. The advantages of curved-field lenses lie primarily in the use of these lenses with 135- and 126-size slides or with slides from negatives and duplicate transparencies. There is little or no advantage in using curved-field lenses with larger transparencies (such as super-slides) or smaller ones (such as half-frame 135- or 110-size transparencies).

Special Cases. Although most projection slides are made with the emulsion toward the lens, in certain applications the film is oriented with the emul-

sion facing the lamp. Film with this reversed position (the film curl also becomes reversed) is usually projected in one of two ways.

First are slides used in rear-projection applications that are turned around in the projector tray so the image will have the normal left-to-right orientation for viewers. This reversing of slide orientation is usually necessary for rear-projection facilities when no mirror, or an even number of mirrors, is used in the projected beam.

The second application involves certain slide production techniques. For example, when a negative is contact-printed onto print film, the two emulsions are in direct contact for the printing operation. Such transparencies provide a right-reading normal image for *front* projection when the emulsion is toward the lamp and the film curves *toward* the lens, as in illustration *E*. But if this type of transparency is used for rear projection with no mirror or an even number of mirrors, then of course it should be inserted into the tray in its reverse position and projected with a curved-field lens as in illustration *C*.

There is little advantage in using curved-field rather than flat-field lenses of small relative apertures ($f/5.6$, $f/8$, and smaller), because with the smaller aperture there is usually enough depth of focus (even with curved film) to provide sharp screen images.

Short-focal-length, flat-field lenses (75 mm/3″, or less) are frequently used for rear-screen projection, for projection of glass-bound slides, or for other projection situations where the curved-field design is not an advantage.

If the recommended lens type is unavailable, if mixed slide types are to be shown, or if the image is brighter than necessary, center-to-edge sharpness differences can be reduced or eliminated by stopping down the lens (either flat- or curved-field). A thin metal or opaque paper diaphragm can be placed against either the front or back lens element to mask it. The opening in such a diaphragm should not be smaller than about ½ or ⅔ the diameter of the lens opening, or else uneven illumination can result.

Motion-Picture Projectors

Three sizes of film are used for almost all motion pictures: 8 mm, 16 mm, and 35 mm. Larger sizes, such as 70 mm, are sometimes used for special theatrical productions. Some widescreen movies, in which the picture has different proportions than the film frame, are made with anamorphic lens systems that optically squeeze the image onto the film in the camera and unsqueeze it upon projection.

A separate projector is required for each film size, but many modern amateur projectors accept both super 8 and 8 mm format movies. Although these have different frame sizes and sprocket-hole spacings, the film itself is 8 mm wide in both cases. Professional-quality sound movie projectors for all film sizes operate at a standard projection rate of 24 frames per second (fps). Silent movie speed for 16 mm and 35 mm projectors is 16 fps. Super 8 projectors have a slow speed of 18 fps, which provides film economy while permitting acceptable sound reproduction of voices for home movies. Slower and faster speeds are available on some projectors for special purposes. When speeds of less than about 10 fps are used, a heat-absorbing glass must be inserted in the light path to protect the film. This is essential during freeze-frame operation when a single frame is held in the gate for prolonged viewing, as if it were a slide. Many projectors position a heat-absorber automatically when a slow speed is selected.

Most projectors accept film on a supply reel and wind it up on a take-up reel. Since this leaves the film with the last part (the tail) outermost on the reel, it must be rewound onto a different reel before it can be projected again. Rewinding is commonly accomplished by operating the projector in high-speed reverse with the film bypassing the normal projection path. Some projectors accept film in self-contained, drop-in cartridges that do not require rewinding, so that projection can be repeated immediately if desired.

Projectors are usually designed to throw an image on a separate screen; the size of the image varies with the focal length of the projection lens and the distance to the screen. Some projection units have small built-in screens. A special projector that has a television camera tube can be connected to the antenna terminals of a standard receiver so the picture can be viewed on the TV screen.

Projector Functioning. The essence of a motion-picture projector is a continuous, intermittent film-transport system and a synchronized shutter. The shutter cuts off the projected beam each time a frame is moved into or out of the gate; it also pro-

(Above) Projectors are generally designed to throw an image on a separate screen; the size of the image varies with the focal length of the lens and the distance to the screen. Some projection units also include a small built-in screen and may also offer recording capability.

(Below) Special projectors incorporate a television camera tube. These units connect directly to the antenna terminals of a standard TV receiver, and the motion picture film can be viewed on one or more TV screens.

vides the required number of image-flashes on the screen for the eye to see flicker-free movement.

Film Transport. During projection, the film rolls continuously off the supply reel or spool and onto the take-up reel, but in between these points it must move intermittently through the gate so that each frame is stopped while its image is flashed onto the screen. The continuous movement is accomplished by toothed sprocket wheels (or by edge-pressure rollers in super 8 and 8 mm projectors). Intermittent movement is achieved by a variety of devices; two of the most widely used, a claw and a pin-shuttle, are shown in the diagrams on the following page.

To prevent damage to the film and provide a smooth transition between the two kinds of movement, the film path forms loops between the sprocket wheels (or rollers) and the film gate. The loops grow in size as film is pushed into the projection path, and diminish as film is pulled away; in both cases they provide slack so that the film is not jerked against the feed sprockets as it is moved stop-and-go through the gate.

Shutter. In order for the eye to blend separate images into a convincing illusion of movement, it must see at least 16 images per second; thus the basic movie operating speed was established. But in order

for the picture to appear sharp, the individual images must be motionless on the screen when they are glimpsed. A revolving shutter in the projector allows light to pass through the film and to the lens only when each frame is halted in the gate during its intermittent movement. When the shutter cuts off the light, the film is moved to bring the next frame into the gate.

Although this procedure produces continuous movement at 16 fps, the eye can detect the instants when the shutter cuts off the light; as a result the picture on the screen varies in brightness, or flickers. Flicker disappears and the projected image has a constant visual brightness when the eye receives 48 or more impressions a second. This is achieved without increasing the rate of film travel by using a shutter with three openings. The shutter revolves once for each frame, flashing the image on the screen three times; in this way, at a rate of 16 fps, the eye actually sees $16 \times 3 = 48$ images per second. The standard 18 fps slow speed for super 8 projectors produces $18 \times 3 = 54$ screen images per second for improved brightness and freedom from flicker.

High-quality sound reproduction requires a projection speed of 24 fps to avoid distortion and loss of high frequencies; this is essential for the reproduction of music on the sound track. Sound pro-

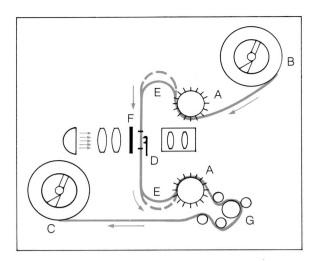

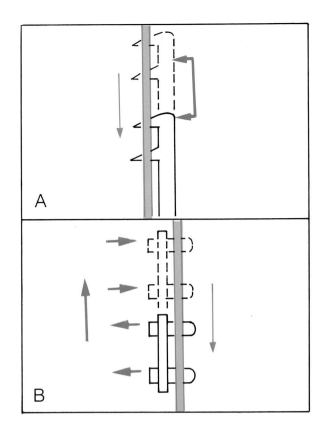

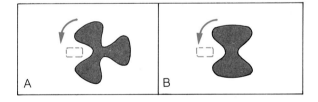

(Above) In basic motion-picture projector operation, sprocket wheels (A) move the film continuously from the supply reel (B) onto the take-up reel (C). The intermittent mechanism (D) moves the film frame by frame through the gate; loops (E) in the film path provide slack for transition between the two kinds of movement. The shutter (F) is located between the film and the light source to stop heat as well as light each time it closes. Various follower rollers help keep sound film snugly in contact with the pickup head (G); a precise number of frames must lie between the pickup and the picture gate for sound to be exactly synchronized with the picture. (Above right) In intermittent movements, (A) a single- or double-fingered claw engages the sprocket holes to pull the film down. It then backs out of the holes and moves up and in to engage the film again and pull the next frame down into the gate. (B) Pin-shuttle movement provides steadier registration and less wear on the sprocket holes than a claw. After the shuttle pulls the film down, the pins retract, the shuttle moves up, and the pins extend to engage the film again. (Right) (A) A three-bladed shutter flashes the image of a single frame on the screen three times with each revolution, producing 48 screen images per second at 16 fps, and 54 images at 18 fps. (B) A two-bladed shutter provides 48 screen images per second when film moves at standard sound speed of 24 fps.

jectors commonly use a two-section shutter so that each frame is projected twice for a screen rate of 48 images per second.

Sound Projectors. Super 8 and 8 mm films record sound on a continuous magnetic-tape stripe laid alongside the picture frames. Larger format films may use either a magnetic or an optical sound track. The sound that accompanies a particular frame is located quite a few frames ahead of the picture. This is because it is not possible to position the sound pickup head directly alongside the film

gate in the projector, both for reasons of space and because the track must move continuously past the pickup while the picture moves intermittently through the gate.

In the projector, the film must lie smoothly and snugly across the pickup head, or the sound will be garbled. In addition, the film loop at the bottom or exit side of the gate must be exactly the right length. If it is too short the sound will reach the pickup before the corresponding picture is seen on the screen; if the loop is too long, the picture will have

passed through the gate before its sound is heard. Many projectors made for amateur use have automatic loop formers that solve this problem when the film is threaded into the projector.

Projectors with magnetic systems may also permit recording onto the track as the film passes through, so music or narration can be added after a film has been edited. Care must be taken that the noise of the projector is not also picked up by the microphone used for recording. (*See:* MAGNETIC SOUND FOR MOTION PICTURES.)

Lenses and Screens. Like still-projection lenses, both fixed-focal-length and zoom lenses are available for movie projection; for tables of projection distances and image sizes, see the article PROJECTION, AUDIOVISUAL. Both front- and rear-projection screens can be used for motion-picture presentation. Because the film cannot usually be laterally reversed in the projector, the picture must be reflected by a mirror or prism to accomplish the reversal required for rear projection.

• *See also:* ANAMORPHIC SYSTEMS; MAGNETIC SOUND FOR MOTION PICTURES; MOTION-PICTURE PRODUCTION; MULTIMEDIA PRESENTATIONS; OVERHEAD PROJECTION; PROJECTION, AUDIOVISUAL; PROJECTION CABINETS; PROJECTION SCREENS; SLIDE PRESENTATION; SLIDES AND FILMSTRIPS.

 Proof

A photographic proof is a sample print made to show what is on a negative. It is used to help a photographer or a client decide which pictures are to be made into finished prints, or to provide an image for filing. A proof, or a proof sheet of several negatives, is seldom corrected beyond adjusting basic exposure and—in color—basic filtration; no local dodging or burning-in is used, and the full negative is printed without cropping. (The sample prints made to try various printing controls and interpretations in the course of arriving at a finished version of a particular image are called work prints.)

The most common kind of photographer's proof is a contact sheet of all the exposures on a roll of film, or several sheets of film, ganged together. Por-

trait studios may give customers proofs made on printing-out paper to reduce the work involved at the approval stage of a job. Because the proof is a strong reddish brown and is unfixed, it will fade in a short time, which avoids the possibility of a customer simply accepting the proofs and not ordering any finished prints.

Because important decisions are based on the information and impressions conveyed by proofs, they should be made on fresh paper of the proper contrast grade, and they should be exposed properly and processed normally in fresh solutions. The aim is to get the best-quality image possible in the most straightforward manner.

• *See also:* CONTACT SHEET; PRINTING-OUT PAPERS.

 Push Processing

Push processing is the technique of intentionally giving extra development to a film to compensate for the loss of contrast that results from exposing the film at a higher than normal exposure index. Black-and-white negative films and color reversal films can be push-processed; color negative films cannot be usefully push-processed.

A film usually produces photographs of highest quality when exposed at its normal ASA speed and processed according to normal development recommendations. However, sometimes there is not enough light to use a film at its rated ASA speed. For example, the camera lens may not be fast enough to permit using a certain technique, such as taking pictures while hand-holding the camera or using a fast shutter speed to stop action. These problems are most often encountered when taking pictures under low levels of existing light. One solution is to use a higher-speed film. If that is not possible, it is necessary to underexpose to take the picture and then push-process the film. Although that will get the picture, it will cause a loss of some quality in tone reproduction and an increase in graininess. With many kinds of subjects, this lowering of quality is considered acceptable when the alternative is no picture at all. Push processing is, therefore, considered a valuable technique in extending photography's capabilities.

Although some shadow detail and image quality will be lost when black-and-white film is push-processed, these slight reductions may be acceptable, providing the overall result is favorable, or if it might have been otherwise impossible to take the picture at all.

How to Expose and Push-Process Black-and-White Films

When conditions do not permit normal exposure, you can obtain acceptable quality in black-and-white pictures by underexposing 1 stop and then push-processing the film. To do this, use a film-speed number that is twice the ASA speed of the film. For example, expose Kodak Tri-X pan film at a film-speed number of 800 instead of its rated speed of ASA 400. However, as explained in the section "How Push Processing Affects Film Speed," this procedure does not actually increase the speed of the film.

To push-process the film, increase the recommended normal development time by 50 percent. This is only a general rule, since the limit for push processing varies according to the film and developer combination and the contrast of the scene. You can successfully push-process a film in any of the normal developers specified for the film except fine-grain developers such as Kodak Microdol-X developer. Developers such as Kodak HC-110 developer that are made with Phenidone or Dimezone as a developing agent tend to have more effective pushing capabilities than other developers. While the quality of these underexposed and overdeveloped pictures will not be as good as that of pictures exposed under better lighting conditions at the ASA speed of the film and processed normally, the quality will usually be acceptable if the scene has average or low contrast. Pictures underexposed by more than 1 stop will show greater losses of image quality.

Black-and-white films underexposed by 1 stop and push-processed for 50 percent more than the recommended time will give negatives that have increased contrast and graininess overall, and normal to increased density in all areas of the negative except underexposed shadow areas as compared with normally exposed and processed negatives. To get acceptable contrast in your prints, use a printing paper that matches the negative density range. The prints will probably have poor shadow detail, but they should show good detail in the highlights and middletones.

Although some shadow detail and image quality will be lost when you underexpose and push-process black-and-white film, chances are that you will accept these slight reductions in quality when the overall result is better than it would have been if you had used a less favorable camera technique or if you had been unable to take the picture at all because of exposure limitations.

Scene Contrast. The contrast of the scene, which is a combination of both the lighting and subject contrast, has a great effect upon the minimum acceptable exposure and largely determines whether you should push-process the film. When you expose and process the film normally, it has sufficient latitude in most situations to give excellent quality for scenes of low, average, and high contrast.

Low-contrast scenes have a short range of tones, or a short brightness range. These scenes have mostly middletones, mostly highlights, or mostly shadows. Average-contrast scenes have a longer range of tones, or a medium brightness range, including highlights, middletones, and an average amount of shadows that include details important to the picture. High-contrast scenes have an extreme brightness range—from brightly lighted highlights to deep black shadows.

For high-contrast scenes with important shadow detail—for example, a stage scene that includes a spotlighted performer and other performers in darker areas—*do not* push-process the film. Since push processing increases negative contrast, negatives of such scenes would be extremely contrasty and difficult to print, and the prints would probably be unacceptable.

To photograph low-contrast scenes, such as subjects under fluorescent lighting or in diffuse daylight where there are few shadows and you cannot expose the film normally, you can get by with less than the normal exposure. By taking advantage of the exposure latitude of the film, you can usually take the picture at 1 stop less exposure than the exposure determined by using the ASA speed of the film, and process the film normally. If you push-process the film by increasing development 50 percent, you can use 2 stops less exposure than normal. However, to underexpose to this extent, be sure that the scene is of low contrast. If it contains middletones, for example, it should not have important shadow detail. Otherwise, the picture quality will be unacceptable because of too much underexposure.

How Push Processing Affects Film Speed

While push-processing black-and-white film does improve the quality of underexposed pictures in some respects, it does not fully compensate for underexposure. Consequently, push processing does not significantly increase the speed of the film.

The speed of a film indicates its sensitivity to light. Film speed for black-and-white films used for general picture-taking is based on a camera exposure only slightly greater than the minimum required to produce a negative capable of yielding an excellent print of a scene that has average contrast. This exposure includes a small safety factor of ⅓ stop. The speed of a specific film is determined by the manufacturer and is measured according to the specifications in American National Standard PH2.5-1972. One of the requirements in determining film speed according to this standard is that the film be processed to a specified degree that can be expressed as contrast index. The film speed derived by the standard method is called the ASA speed and is identified by the general form ASA 400, for example. Because the speed of the film is an inherent characteristic determined during manufacture, you cannot change the speed by changing exposure (using a higher film-speed number), or significantly increase the speed by increasing the development time.

Since the ASA speed is based upon the *minimum exposure* (except for the ⅓-stop safety factor) required to produce an excellent picture, less exposure than the minimum threshold of exposure will not allow the shadow areas to receive enough light to be developable. As a result, shadow detail is lost. Merely increasing development by push-processing the film will not make these underexposed areas developable. Some of the shadow areas, however, may be on the border line. These areas may develop, resulting in a slight speed increase of about ⅓ stop. But this change in speed is too small to be an important consideration. For these reasons, push processing cannot be said to increase the speed of the film significantly.

Push-processing pictures of low-contrast scenes can be misleading because they seem to show a significant increase in film speed. All the areas in the push-processed negative have adequate density, and the print does not look underexposed. This happens because typical low-contrast scenes have no significant shadow detail for the film to record. Therefore, since the brightness range of a low-contrast scene is shorter, you have more camera exposure latitude. In such low-contrast situations, you can expose the film at a film-speed number higher than its ASA speed, within practical limits, without a significant reduction in quality. However, this is not an increase in

film speed; you have just taken advantage of the film's exposure latitude under the favorable conditions of a low-contrast scene.

Changing the Film-Speed Number

The ASA speed system has been designed to give excellent results for most picture-taking situations with average equipment. You can get acceptable results by using a higher film-speed number and push-processing the film. If your results are consistently unsatisfactory with either normal processing or push processing, you should use a different film-speed number. If your negatives are consistently too light and give poor picture quality, increase exposure by using a lower film-speed number; if they are consistently darker than they need to be for good quality, decrease exposure by using a higher film-speed number. The film-speed number that works best for you can be affected by a number of factors, some of which are the accuracy of the camera's shutter speed and lens opening; the accuracy of your exposure meter; the way you use your exposure meter; elements in the scene that mislead the meter, such as bright lights or surroundings much lighter or darker than the subject; scene contrast; and your own standards of picture quality.

Determining a Film-Speed Number for Push-Processed Black-and-White Film

You can make exposure tests to determine the film-speed number that is best for your own conditions. Use two rolls of black-and-white film from the same emulsion batch. Check this by looking at the expiration date and the letters and/or numbers printed near this date on the film carton. They should be the same on both cartons.

Next select a scene typical of those you want to photograph; or for more general use, select a scene with average contrast. A medium close-up of a person under illumination that produces an average distribution of shadows is a good scene for the tests. If there is a lamp in the scene, exclude it when you use a reflected-light exposure meter.

Set the ASA speed of the film on the film-speed dial of your exposure meter or built-in camera meter. Carefully determine the exposure by means of the meter. Then make a series of exposures in ½-stop increments from 1 stop more exposure to 4 stops less exposure than the meter indicates. Include identification in each picture to indicate the exposure used for each one. Next make an identical series of exposures of the same subject on the second roll of film.

If the lens-aperture control has click settings at half-stop intervals, it is a simple matter to change settings for the various exposures. Otherwise, reset the meter to an adjusted film speed and take a new meter reading to determine the proper settings for each exposure. Consult the accompanying table to determine how to adjust the ASA number.

To determine camera settings for more or less exposure, multiply the ASA rating of the film by the indicated factor. Reset the meter to the adjusted exposure index and take a reading in the normal manner; expose at the indicated settings. Repeat, using a new factor, for each desired exposure change.

To determine what film speed was used for a given exposure: If the above method is used to obtain camera settings, simply keep a record of the speed to which the meter is set for each exposure and match it to the processed results. If no record is kept,

DETERMINING FILM-SPEED NUMBERS FOR EXPOSURE TEST

Camera Exposure— Change in f/stops	More Exposure		Normal Exposure (ASA)	Less Exposure							
	+1	+½		−½	−1	−1½	−2	−2½	−3	−3½	−4
Multiply film speed (ASA) by appropriate factor to obtain film-speed number	.5	.7	1	1.4	2	2.8	4	5.6	8	11	16

Push Processing

or if exposure is changed by adjusting the lens aperture to various click-stop positions, determine how many stops more or less than normal a given exposure was, and multiply the ASA speed by the indicated factor. For example, if the exposure was made on ASA 200 film at 3 stops less than normal, the effective film speed for that exposure was 200 × 8 = 1600.

Process both rolls of film in the same developer, one roll at the normal, recommended development time and the other roll at a 50 percent increase in development time. From both rolls select those negatives that look as though they will make reasonably good prints and those in which failure from underexposure—a loss of shadow detail—begins to appear. Make the best print possible from each negative by using photographic paper of the proper contrast grade. Do not use any burning-in or dodging techniques during the print exposure.

When the prints are dry, examine them and make quality comparisons between the prints from the normally processed roll and those from the push-processed roll to determine the highest film-speed number that gives you the results you want. The normally processed roll should provide a print of excellent quality from the negative that was exposed at the ASA speed of the film. Use this excellent print for comparison with other prints made from negatives that received different exposure or development. Then when you evaluate the prints, those which show loss in quality will be apparent.

If the film-speed number that gives an excellent print from the normally processed roll (of an average scene) is much different from the ASA speed of the film, your camera or exposure meter may be inaccurate or you may not be using the meter in the manner suggested by the manufacturer. This could lead you to believe that you have been able to expose the film at an inflated film-speed number and get good results.

You can check the accuracy of your equipment and the proper use of your meter by making a similar exposure series on a roll of color-slide film. Color-slide films have less exposure latitude than black-and-white negative films and are therefore better for checking exposure accuracy. The slide with the best exposure should be the one that was exposed at the ASA speed of the film. If this is not the best slide and these results are consistent with slides you have been

getting under similar conditions, either you are using your exposure meter incorrectly or your equipment is in need of repair, and you should have it checked by a repair service. However, one such test for exposure accuracy is not conclusive; film and process, for example, can vary within manufacturing and processing tolerances.

Push-Processing Color Films

Color reversal (slide or transparency) films can be push-processed to compensate for underexposure; some compensation can also be made for overexposure, if necessary. The adjustment is made by changing the time of first development. Recommended adjustments are given here for Kodak Ektachrome (process E-6) films. Equivalent changes for other films can be determined by test, or in some cases by inquiring of the manufacturer. Kodachrome film is not normally push-processed.

A color film should always be exposed at its stated effective film speed for the best results. Compensating for under- or overexposure with process adjustments produces a loss in picture quality. Underexposed and overdeveloped film shows a loss of maximum density (creating weak shadow areas), a decrease in exposure latitude (increasing the likelihood of burned-out highlights), a color-balance shift, and a significant increase in contrast. If these losses can be tolerated, and if the processing equipment has the flexibility, the first development-time adjustments in the accompanying table can be used as a guide to compensate for abnormal exposures.

PROCESSING ADJUSTMENTS, *KODAK EKTACHROME* (PROCESS E-6) FILMS

Camera Exposure	Equivalent Film Speed	First Development Time Adjustment
−2 stops	ASA × 4	Increase 5 ½ minutes
−1 stop	ASA × 2	Increase 2 minutes

NOTE: Kodak processing laboratories in the United States offer a special processing service for Ektachrome films to increase the speed to 2 times

Push-processing color transparencies reduces photographic quality to some extent. Graininess and contrast are increased; maximum blackness is reduced slightly, and a slight change in color is usually evident. This small reduction in quality is often acceptable when the extra film speed is needed.

normal (+1 stop). To obtain this service, purchase a Kodak special processing envelope, ESP-1, which prepays the extra charge. Insert one roll of exposed film into this envelope and either take it to a dealer for processing by Kodak, or mail it to a U.S. Kodak laboratory in the appropriate Kodak mailer. The ESP-1 envelope can be used only for Ektachrome professional films and Ektachrome films (daylight or tungsten) in 135 (20 and 36 exposures) and 120 sizes; and, in an emergency, Kodak Ektachrome 64 films, 135 or 120 sizes. The films submitted for processing must have been exposed at these speeds:

ASA 400 for Ektachrome 200 films (daylight).

ASA 320 for Ektachrome 160 films (tungsten).

ASA 125 for Ektachrome 64 films.

Color Film Speed Increase Explained. Although it is not possible to achieve a true film-speed increase by push-processing black-and-white films, a speed increase is obtained with color slide films. The reason for this is that color slide film is a reversal film—the same film that is exposed in the camera is processed first to a negative, then to a positive.

In a reversal film, those areas that did not receive enough exposure to show detail go black. For shadow detail to be visible, there has to be less blackness, or less density. With a negative film, the situation is reversed; there has to be an increase in density in the negative from the film's minimum density (density of an unexposed processed film) for shadow detail to be visible in the print. The shadow densities on a black-and-white negative film that is exposed at the ASA speed of the film are only slightly more dense than the density of an unexposed processed film. When underexposure occurs, shadow detail is lost and cannot be replaced by an increase in development. Push processing cannot produce an image where none exists.

With a color reversal film, on the other hand, the shadow densities of a properly exposed slide are significantly less dense than the maximum blackness, or density, of an unexposed processed film. In properly exposed color slides that are projected under average viewing conditions, the full density potential of the film is not used to record important elements of the scene because the slides would appear too dark, or underexposed. Therefore, when color slide film is underexposed by 1 stop, for example, since the film has the potential to record detail at higher densities, shadow detail is recorded on the film even though the resulting slide appears too dark. This is the reason you can increase the speed of a color slide film by push-processing it.

When shadow detail has been recorded on the film, push processing, which is accomplished by increasing the first development time, lightens all the exposed areas on the film—including the shadow areas—and restores shadow detail. Thus, it compensates fully for underexposure. An effective increase in film speed results.

However, while push-processing color slide film does increase the speed of the film, it also reduces photographic quality to some extent. Graininess and contrast are increased; maximum blackness, or density, is reduced slightly; and a slight change in color is usually evident. This small reduction in quality is often acceptable when you need the extra film speed.

• *See also:* COLOR FILM PROCESSING; CONTRAST; CONTRAST INDEX; DEVELOPERS AND DEVELOPING; EXPOSURE TECHNIQUES; SPEED SYSTEMS; ZONE SYSTEM.

Pyrocatechin

Pyrocatechol, catechol, 1, 2-benzenediol, orthodihydroxybenzene

Developing agent, an isomer of hydroquinone (which is 1,3-benzenediol). Pyrocatechin is similar to hydroquinone in its action, but has certain other properties, such as its ability to tan gelatin while forming a silver image. This makes it useful in tanning developers for producing dye-transfer matrices, and other gelatin-relief processes. As a paper developer it gives warm-black to brown tones, depending upon the formula. With caustic soda, it produces a high-contrast developer.
Formula: $C_6H_4(OH)_2$
Molecular Weight: 110.11
Colorless crystalline needles or scales. Very soluble in water, alcohol, ether, and benzene.

Pyrogallol

Pyrogallic acid, 1, 2, 3-benzenetriol, pyro

One of the earliest known developing agents. Pyro has the ability to tan gelatin while developing the image, hence it is used in tanning developers for gelatin-relief processes. It also produces a stain image along with the silver image. It is possible to vary the activity of a pyro developer over a wide range by changing the dilution and by using more or less alkali. Pyro can also be used in combination with Metol and other developing agents.
Formula: $C_6H_3(OH)_3$
Molecular Weight: 126.11
Fine, white, powdery crystals or heavy prismatic crystals, depending on the method of manufacture. It is freely soluble in water, alcohol, and ether, but oxidizes very rapidly in solution; an acidic preservative is usually used, generally sodium bisulfite or potassium metabisulfite. The preservative must be fully dissolved before adding the pyro.

NOTE: Avoid skin contact. Prolonged contact may cause irritation. Chemical may be absorbed through the skin. Repeated contact may result in allergic skin reaction.

Q Factor

A semi-transparent material, such as a suspension of dyes, carbon, or silver particles in gelatin, causes some scattering of transmitted light. The amount of scattering that takes place is largely dependent upon the nature and density of the suspended particles and the intensity and quality (specular or diffuse) of the incident light.

As illustrated in the article CALLIER EFFECT, the transmitted light can be measured to determine both specular and diffuse density. The ratio between the specular density (D_S) of a sample and its diffuse density (D_D) provides an indication of the light-scattering properties of a material known as the *Q factor:* $Q = D_S \div D_D$.

• *See also:* CALLIER EFFECT; DENSITOMETRY.

Quartz-Iodine Lamp

The quartz-iodine lamp is actually an incandescent, tungsten-filament lamp. It differs from the ordinary tungsten lamp in that it contains a small amount of iodine in addition to the normal inert filling gases. In the conventional tungsten-filament lamp, some of the tungsten from the incandescent filament evaporates and is deposited on the relatively cool walls of the lamp envelope. When iodine is present, the evaporated tungsten combines chemically with the iodine gas. The high temperature of the filament decomposes the resulting tungsten-iodine gas, redepositing the tungsten on the fila-

ment and freeing the iodine to repeat the cycle. Thus, unlike conventional tungsten lamps, the globe of the tungsten-iodine lamp does not blacken with use, and the lamp maintains its color temperature within narrow limits throughout its life.

While the first lamps of this type had quartz envelopes to withstand the high temperature necessary for the iodine cycle to operate, later versions use special glasses, such as a high-silica material similar to Vycor and Pyrex. Furthermore, while the iodine filling has little effect upon the light output, there is a slight tendency for the light to be peaked in the blue-violet. For cases where this is undesirable, lamps are also made containing bromine rather than iodine. Thus, a better term for this type of lamp is "tungsten-halogen lamp."

It would appear that since the evaporated tungsten is redeposited upon the filament of the lamp, the life of the lamp ought to be greatly extended. This would be true except that the tungsten does not necessarily return to the same spot on the filament from which it was emitted. Thus, these lamps eventually will fail because a weak spot develops in the filament. Nonetheless, there is some gain in life from the tungsten-halogen cycle. In most cases, it is utilized not to extend the usage of the lamp, but to permit it to be burned to produce a higher color temperature. This increases the efficiency of the lamp in terms of light output for a given current consumption.

The main benefit of the tungsten-halogen cycle is in the maintenance of color temperature. Lamps for color photography in the studio can be used for their entire burning lives, instead of being discarded because of blackening.

• *See also:* INCANDESCENT LAMPS; LIGHTING.

Radiography

Radiography is the recording of images on photographic materials by means of very short wavelength exposing energy—specifically, x-rays and gamma rays. These rays can penetrate virtually all materials—including some metals—that are opaque to light. A radiograph is created by placing a patient or an object between a point or spot source of exposing energy and a suitable piece of photographic film. Variations in the anatomic structures or in the object material allow differing amounts of gamma or x-radiation to reach the film, with the result that a shadow picture of the internal structure of the subject is recorded. Radiographs are always viewed as negative transparencies, so the more radiopaque portions of the subject appear light against the darker background of the more radiolucent portions.

Production of X-rays

X-rays are produced when electrons, traveling at high speed, collide with matter. In a typical x-ray tube, an incandescent filament supplies the electrons and thus forms the cathode, or negative electrode, of the tube. A high voltage applied to the tube drives the electrons to the anode, or target. The sudden stopping of these rapidly moving electrons in the surface of the target results in the generation of x-radiation.

Different voltages are applied to the x-ray tube to meet the demands of various classes of radiographic work. The higher the voltage, the greater the speed of the electrons striking the target. The result is a decrease in the wavelength of the x-rays emitted and an increase in their penetrating power and intensity. The higher-voltage x-rays are used to penetrate thicker and heavier subjects.

Gamma rays have the same physical characteristics as x-rays and are frequently used in industrial radiography. Gamma rays are emitted by radioactive isotopes. The energy (wavelength) of gamma rays depends entirely on the nature of the emitter and is not variable at the will of the operator. The isotopes most commonly used in industrial radiography are Cobalt-60, Iridium-192, and Thulium-170. Radiography with gamma rays has the advantages of simple apparatus, compactness, and independence from power sources.

Applications of Radiography

Radiography is widely used in medicine, dentistry, and veterinary medicine to aid in establishing a diagnosis. Radiographs are used to help diagnose diseases such as pneumonia, cancer, heart and circulatory diseases, and digestive and urinary diseases, as well as for locating fractures and foreign objects such as bullets.

Radiography is used in industry to detect flaws in metal castings and welds, to detect improperly connected wires, and to inspect grain for weevil infestation, among a myriad of other uses. The great advantage of radiography in industry is that all of these determinations can be made without damaging the object.

Medical Radiography

Medical radiography depends upon the differences in absorption of x-rays by various structures in the body and upon the differences in absorption

coating material called a phosphor on a sheet of plastic or cardboard. The phosphor emits light when excited by x-rays, the intensity of the emission being proportional to the intensity of the x-rays. Thus, the film "sees" a pattern of light, the intensities of which vary according to how much of the exposing radiation was absorbed by the various structures of the body. In modern medical radiography, about 95 percent of the exposure to the film is by the light emitted from the screens. Some intensifying screens emit blue light, and some are designed to emit blue and green light. The latter screens are intended for use with an orthochromatic film. Two emulsions and two screens are used to take advantage of the radiation that passes through the screen and the emulsion on the patient side of

(Below) In this radiograph of a human colon (large intestine), the light areas are the image of a barium sulphate suspension administered by enema. The darker areas are the result of insufflation of air. The contrast between the absorption of radiation by the barium and the transmission of the radiation by the air visualizes the colon clearly.

(Above) In this radiograph of a sting ray, the support structures of the rays are clearly shown. Also visible are the structures in the rudimentary hind limb and the animal's digestive tract.

between normal and abnormal tissue. It must be recognized that all exposure to penetrating radiation is harmful and that such exposures should be made only by experts trained in the use of x-rays and in the interpretation of radiographs. The compromise must be made between the danger of exposure to radiation and the danger of failing to find a potentially lethal lesion in time. In the hands of experts, x-rays have contributed enormously to alleviation of human suffering.

In medical radiography, the vast majority of the radiographs are made with a film coated with emulsion on both sides of the base. The film is sandwiched tightly between two intensifying screens. The intensifying screens are made by

the sandwich. By this means, excellent radiographs are made in as little as $1/120$ second. This short exposure reduces exposure to the patient and stops involuntary motion, which is extremely important for examination of the chest and abdomen.

Because many tissues absorb radiation to the same degree as surrounding structures, materials that absorb radiation to a much different degree—either more or less—are frequently used to provide contrast in certain organ systems. For instance, a suspension of barium sulfate administered either orally or by enema is used in examination of the stomach and digestive system; the organs filled with this material appear as areas of low density on a radiograph because the barium absorbs radiation. Iodinated organic chemical compounds can be injected directly into the bloodstream to opacify the arterial and venous systems. In certain examinations, either air or a gas may be insufflated to make a structure that is less absorbent of x-rays and which will appear darker on the radiograph than the surrounding structures. These materials are collectively known as contrast media.

All dental radiographs made inside the mouth are exposed without intensifying screens. The emulsion of the film designed for this purpose is thicker than the emulsion on medical films in order to yield a diagnostic radiograph with minimal exposure.

Industrial Radiography

The term industrial radiography is used to designate radiographic examinations made of inanimate objects. A tremendous variety of materials has been examined by radiography, including welds in pipelines, aircraft frames, transistors, electronic tubes, metal castings, rocket propellants, nuclear fuel rods, armor plates up to 12 inches thick, art objects such as paintings and statues, the Liberty Bell, grain and plants. Most medical radiographs are made at 30 to 350 kilovolts, but industrial radiographs are made at 5 kV to several million volts or by exposure to gamma rays.

Industrial radiography also depends upon differences in absorption by the various parts of an object. These differences are primarily related to differences in thickness of the parts—the thicker the part, the more radiation it will absorb and

The welded area of a joint between two pieces of metal is clearly visualized in the radiograph because the thickness of the weld absorbs more radiation than the metal plates. The black spots and light spots are, respectively, images of impurities and gas bubbles; either could weaken the weld and cause failure.

hence the lower the radiographic density. Different materials also absorb differently. For example, a given thickness of aluminum absorbs less radiation than the same thickness of steel, and copper absorbs even more radiation than steel. The inclusion of foreign material will, in effect, reduce the thickness in a particular area, thereby altering absorption and producing a radiographic image of the inclusion. The inclusions may be in the form of trapped bubbles of gas or slag in a weld, either of which will result in a difference in absorption.

The great majority of industrial radiographs are made by using lead intensifying screens. The energy levels (kV) used in industrial radiography are sufficient to cause lead to emit electrons that expose the film. The lead may be in the form of foil

or a lead compound coated on a suitable support. Even so, many industrial radiographic exposures are several minutes or even hours long. A few industrial radiographs are made without screens or by using fluorescent screens of the type used in medical photography.

Specially designed papers are used in some industrial applications, especially when there is no need to retain the radiograph for a long period of time. For example, if a defect is found in a casting, the piece may be salvaged by grinding out the defect and filling in by welding. Paper radiographs may be made to guide the grinder.

Making and interpreting industrial radiographs is a very highly skilled occupation. This technology is very carefully detailed in codes and specifications established to set standards for the industry.

Processing X-ray Film

The emulsions used in x-ray films are very similar to ordinary black-and-white emulsions except that they are coated much more thickly. The great majority of medical x-ray films are processed in mechanical processors, especially the roller-transport type, most of which deliver a fully processed, dry radiograph in 90 seconds. These units require a specially formulated developer solution containing a hardener in order to prepare the film for transport through the rollers. Many industrial radiographs are similarly processed except that the cycle is longer (12 minutes) because of the thicker emulsion. Those x-ray films used in medicine, industry, and dentistry which are manually processed are treated with solutions very similar to those used in processing black-and-white films. Special reversal-type films are available for making same-tone duplicates of radiographs for use in teaching and referrals.

The films used in medical radiography have a maximum density in the order of 3.3; the average density of a medical radiograph is about 1.5, but many areas of diagnostic importance may have a density of 2.5 or higher. Many industrial radiographs, on the other hand, are developed to densities over 4.0 and require high-intensity illuminators for viewing.

Adequate processing of x-ray films is critical because it may be necessary to retain the radio-graphs for several years. In medicine, the radiologist (the medical specialist trained in the use of x-rays) may wish to compare a current radiograph with one several years old to determine the progress of a disease or to evaluate treatment. Industrial radiographic codes frequently require that radiographs of critical welds or structures be retained for many years.

Viewing Radiographs

All radiographs, except those made on paper, are viewed by transmitted light and require the use of specially designed viewers with uniform light output. It is important that the viewers have an output of consistent quality and intensity.

• *See also:* BIOMEDICAL PHOTOGRAPHY; CLINICAL PHOTOGRAPHY; DENTAL PHOTOGRAPHY; INFRARED PHOTOGRAPHY; MEDICAL PHOTOGRAPHY; SCIENTIFIC PHOTOGRAPHY; THERMAL PHOTOGRAPHY; ULTRAVIOLET AND FLUORESCENCE PHOTOGRAPHY; WAVELENGTH; X-RAY.

Rangefinder

A rangefinder is a device for determining the distance from the camera to a subject without having to leave the position from which the measurement is being made. The rangefinders used in most photographic applications are optical instruments built into cameras. The distance is measured by visual observation through an eyepiece. Rangefinders for specialized applications—in which camera systems may or may not be employed—often use light generated by a laser, or energy at microwave frequencies (radar) for extremely precise ranging at distances far beyond the limits of visual observation.

In photography, rangefinders are used as an aid to focusing. At one time, separate, accessory rangefinders were common. The distance to a desired focal point was measured, and then the lens focusing scale was set correspondingly. Today, rangefinders are nearly always coupled to the camera lens so that as focusing is changed, the rangefinder adjustment also changes; when the rangefinder image of the subject appears properly aligned, the lens is sharply focused on the subject.

Rangefinder Principles

A typical camera rangefinder views the subject from two directions. One is along a direct, straight-line axis; the other, achieved by an adjustable reflecting element, is from an angle. As the accompanying diagram shows, the total optical path is a right triangle with a constant base (width) and a reflected viewing angle that varies with the subject distance. Mathematically, that distance is equal to the base dimension multiplied by the tangent of the viewing angle. In practice, no calculating is necessary; the rangefinder shows two images, and all that is necessary is to adjust the lens focus (or other coupled function) until the two images overlap. Since this automatically results in the lens being sharply focused on the subject, it is seldom necessary to know the actual distance. If knowledge of the distance is required (for example, for use with a flash guide number), it can be determined from the lens distance scale after the rangefinder has been adjusted.

Rangefinder Images

There are two types of rangefinders. In one, the coincident-image type, focusing is accomplished by making two images coincide. In the other, a split image is adjusted until the two halves align to form a single, unbroken image. As the function suggests, this type is called a split-image rangefinder.

In a coincident-image rangefinder, the direct line or primary image is seen through a semi-transparent mirror, which also reflects the secondary image from the angular viewing element. A yellow, or otherwise colored, filter is often used in the secondary image path so that the two images can be distinguished more easily. As focus is adjusted, the secondary viewing angle changes; when the two images coincide exactly, the camera is focused. A coincident-image rangefinder may be a part of the viewfinder or may be separate.

In a split-image rangefinder, a fully silvered mirror obstructs part of the direct view and reflects the secondary image. When the camera is not focused on the subject, the secondary image is displaced from the primary image, making the subject appear broken or split. Focusing aligns the secondary image with the primary so that subject edges or lines are unbroken. A disadvantage of this

Rangefinder principles. The subject (A) is seen along a straight line from a primary viewpoint (B) and at an angle from a secondary viewpoint (C). The secondary angle can be adjusted for subjects that are nearer or more distant (D, E); a reflecting element relays the secondary view to the eyepiece at the primary viewpoint. The subject distance (A–B) is equal to the tangent of the secondary viewing angle (at C). When the subject is at infinity, the two lines of sight are parallel as shown by the line C–F.

method is that the camera may have to be turned at an angle between horizontal and vertical in order to include a line or edge suitable for observing the focus adjustment.

Because of the direct view, a rangefinder image is brighter than that of a through-the-lens system, since even at maximum aperture, a camera lens reduces the light from the subject. For this reason, rangefinder focusing is often preferred for low-light situations.

Rangefinder Accuracy

Rangefinder focusing is highly precise for subjects in a range from about 0.6 to 8 metres (approximately 2 to 26 feet), which covers the vast majority of picture situations. But physical limitations prevent a rangefinder from being used at much closer distances, and at greater distances accuracy falls off rapidly because only fractional changes in the secondary viewing angle are required. In practice, this is balanced by the fact

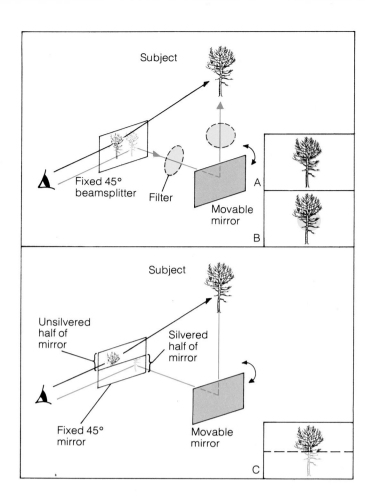

Rangefinder Images

(Top) Coincident-image rangefinder. The subject is seen through a semi-transparent mirror beam-splitter along with the reflection of the view from the secondary angle. When both images coincide (A), the rangefinder is focused on the subject. A filter may be placed in the secondary path (either of the broken-circle positions) to give the reflected image a distinctive color. When the rangefinder is part of the viewfinder (B), proper focus is achieved when the two images align in the colored circle in the center of the finder field. (Bottom) Split-image rangefinder. Half of the viewing screen is fully silvered, half is transparent. The image appears split until the rangefinder is focused on the subject.

Typical built-in combined rangefinder and viewfinder. Viewing, framing, and focusing are combined in a single unit mounted atop the camera. Windows admit images along the primary (A) and secondary (B) angles. The viewing angle of the second reflective element (C) is adjusted by the coupled lens focus control. Its image (colored line) is reflected in a semitransparent mirror (D) that also passes light (broken line) from a translucent window (E) to illuminate the bright-line mask (F) that indicates the field of view of the lens in use. The combined secondary image and frame lines are reflected by a mirror (G) to the combining element (H) which presents them along with the primary image (solid line) to the eyepiece (I). Other elements, not shown, may include a filter to color the secondary image and various lenses.

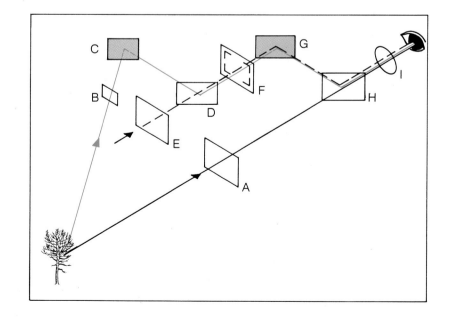

that the lens has increased depth of field at the greater distances. With long-focal-length lenses, however, which produce significant image magnification, focusing errors in rangefinders may be significant. In addition, the longest focal lengths are commonly used with small-format negatives that require a significant degree of enlargement simply to produce standard-size prints, and this further emphasizes any focusing error. For these reasons, through-the-lens focusing is preferred for close-ups and photomacrography, and is definitely better for high-magnification telephotography.

Two interrelated factors limit rangefinder accuracy: base width (the distance separating the primary and secondary viewpoints) and the secondary viewing angle. At the present time, almost the only use of rangefinder focusing is in some 35 mm and other small-format cameras and some press-type cameras. The length of the camera body limits the maximum possible rangefinder base width to about 75 to 100 mm (3 to 4 inches) in most cases. This in turn severely restricts the change in the secondary viewing angle between distant subjects. For example, the accompanying data are for a typical rangefinder with a 100 mm base. Note that the same amount of change—about two-thirds of a degree, or 40′—is required when the distance doubles for subjects at 4 and 8 metres, and when it increases sixteen times between subjects at 8 and

128 metres. If a pivoted mirror is used as the secondary viewing element, it has to shift position only half that much, or 20′ for a 40′ change of viewing angle.

This movement is so slight that only a millimetre or two would be traveled on the face of a cam that linked the mirror to the lens focusing control. It is simply not practical to produce a cam that precise, and one with equal precision for subjects at all intervening distances. Further, as the subject gets more and more distant, the secondary angle comes closer and closer to (but never equals) 90 degrees (89° 60′), and the mirror movement is even more fractional.

The opposite problem arises at close distances—the angular shift is too great. In the example data, the angle changes more than 4 degrees between subjects at 4 and 1 metres, almost another 4 degrees for a subject at 60 cm, and more than another 24 degrees for a subject at 15 cm. There is hardly enough space in a small camera for a cam to provide the necessary change in mirror position; in addition, the edges of the secondary viewing port would obstruct part of the view.

Parallax imposes a further limitation on close-up rangefinding. Because a rangefinder has different optical axes from the camera lens, the difference in its field of view becomes significant at close subject distances. Although some compensation can be provided by a mechanism that tilts the viewing elements or shifts the framing mask in the rangefinder, this reaches a practical limit at about 0.6 metre (26 inches). The superiority of through-the-lens viewing and focusing at close distances cannot be disputed.

Secondary Viewing Elements

Some of the most severe problems of adjusting the secondary viewing angle are overcome by using a device other than a pivoted mirror. As the accompanying diagrams show, various optical wedges that rotate, swing, or shift have been found suitable. They produce great changes of viewing angle with slight movement for close-range subjects and require greater movement to produce very slight changes of angle for distant subjects. In both cases, this eases the problem of accurate mechanical linkage between the camera lens and the rangefinder.

SECONDARY VIEWING ANGLES*

Subject (Distance)		Secondary Angle (1° = 60′)
129 m	(420.0 ft)	89° 58′
100 m	(328.0 ft)	89° 56′
64 m	(210.0 ft)	89° 55′
32 m	(105.0 ft)	89° 49′
16 m	(52.5 ft)	89° 38′
8 m	(26.3 ft)	89° 17′
4 m	(13.0 ft)	88° 34′
2 m	(6.6. ft)	87° 8′
1 m	(39.4 in)	84° 17′
60 cm	(23.6 in)	80° 31′
30 cm	(11.8 in)	71° 34′
15 cm	(5.9 in)	56° 18′

*For a rangefinder with base width equal to 100mm.

A Rangefinder in Reverse

A rangefinder is focused on a subject when two optical paths from a point on the subject converge at a common point in the rangefinder. The paths can be traced back to the subject with equal accuracy. This principle was employed at one time in a focusing rangefinder for use when the illumination was so dim that the subject could not be seen clearly enough for precise focusing.

The Kalart Focuspot was a rangefinder in reverse; it projected two beams of light from a single, high-intensity, battery-powered source. The camera was aimed so that the beams projected two spots of light on the subject. The camera was focused by adjusting the coupled lens until the two spots coincided. For a time exposure, the rangefinding light was turned off, but this device was most commonly used with press cameras for photographs by flash, which washed out the spot of light on the subject.

• *See also:* CAMERAS; FOCUSING SYSTEMS; VIEWING AND FOCUSING.

Rapid Processing

In many photographic applications it is necessary to obtain a processed image for inspection or use as quickly as possible—within 60 seconds in some cases, in less than 5 minutes in others. The demand is greatest in newspapers and television news departments, in industrial and scientific monitoring and testing, and in sports for determining the finishing order in races without delay.

Processing laboratories, studios, photo departments, and other concerns that have high-volume processing requirements achieve efficiency by using automatic processing machines. While these provide rapid processing in comparison with manual methods, their maximum speed is seldom used because a certain level of quality and uniformity must be maintained. More immediate access to images generally requires specialized materials, or changed processing procedures.

Self-processing materials such as Polaroid and Kodak instant print films can meet the need for immediate results if the small image size and (except in a few cases) the lack of a negative are acceptable limitations. Certain rapid-access applications, such as oscillograph recording and reprographics, use other materials designed for special, unconventional processing; they are seldom adaptable for general photographic use.

It is possible, however, to process conventional black-and-white films manually in as little as one-fourth the normal time. Prints made on activation or stabilization papers can be processed in less than 60 seconds. These procedures and materials make it possible for the individual and the small-volume studio or department to obtain rapid access to images economically and conveniently whenever required.

It is not feasible to speed up the processing of color materials to any significant degree. The greater complexity of color emulsions and of the chemical steps required in their processing demand longer times than black-and-white materials. The use of various processors can produce consistent results in the minimum time, but the time cannot be further reduced if acceptable results are desired. (*See:* DRUM PROCESSING.)

Rapid Film Processing

At one time, when small-format films were used almost exclusively by amateurs, news photographers developed sheet films in one or two minutes, using a paper developer such as Kodak developer D-72 or its approximate equivalent, Kodak Dektol developer. Because these were usually 4″ × 5″ or 5″ × 7″ films, they required only slight enlargement and thus the increased graininess produced by such development was of little consequence.

Although the same method may be used today, better results and greater convenience are obtained by the use of a fast-working developer such as Kodak developer DK-50 or HC-110. Kodak films can be processed rapidly at a temperature of 24 C (75 F). This is the highest temperature at which films may be processed safely without the need for a hardening bath to protect the emulsion, which would extend the processing time. Emulsions are extremely susceptible to damage at this temperature, and films must be handled with great care. In addition, it is essential that the stop bath, fixer, and wash water be at the same temperature as the

developer in order to avoid possible reticulation. (A few films are available with prehardened emulsions for extremely rapid processing at temperatures of 29 C [85 F] or higher. These are used for photo-finish and aerial photography and other very-rapid-access applications; they are not suitable for general photography. Kodak recording and RAR films are intended for these applications.)

Rapid development should be followed by a standard acid stop bath and an ammonium thiosulfate rapid fixer with hardener in order to keep time to a minimum. (*See*: FORMULAS FOR BLACK-AND-WHITE PROCESSING.) Where permanence of the image is not important, fixing can be considered adequate as soon as the milky appearance has cleared from the emulsion.

Processing is completed by washing the film for a few minutes in a rapid stream of water and drying with currents of warm air directed against both sides of the film. To hasten drying and prevent the formation of water marks on the film, all drops of surface water should be removed by wiping both sides of the film with a photo chamois or soft viscose sponge. (For other methods of rapid-drying films, see DRYING FILMS AND PRINTS.)

Where the need for speed is urgent, prints can be made before negatives are dried. (*See:* WET NEGATIVES, PRINTING.) Whether they are used wet or dry, after the rush prints have been made, the negatives should be returned to the fixing bath for the remainder of the normal fixing time, and then washed thoroughly and dried in the usual manner to prevent fading or staining.

Negative Quality

Rapid processing is not optimum processing; although it produces images quickly, they are not the very best-quality images. Rapid film development produces an increase in graininess and a decrease in sharpness. In addition, tank development times of less than 5 minutes are likely to produce poor uniformity, in part because even a slight error in timing or temperature measurement will significantly affect the results. The smaller the film format, the more apparent all of these factors will be in print. It is important to evaluate the need for speed carefully. Often it is possible to give a film normal development and save time in printing.

This provides images fairly quickly without any sacrifice in quality.

Rapid Printing

An autofocus enlarger will speed the operation, and a higher-wattage bulb will reduce the required exposure time. However, the development time of papers designed for conventional processing cannot be reduced significantly by using a more concentrated developer, and raising developer temperature is likely only to produce muddy prints. The use of a water-resistant, resin-coated paper and a rapid fixer will reduce both fixing and washing times, of course, but maximum speed can be obtained only by using rapid-processing papers.

Two kinds of papers are available: those designed for stabilization processing, and those designed for activation processing. Each paper requires a special processor for rapid use, but each may also be processed conventionally when speed is not important.

Both types of papers have a developing agent included in the emulsion. The stabilization papers are on conventional paper base. Prints pass through the stabilization processor at a rate of about one inch per second. In the processor, an activator solution spread over the emulsion causes the image to develop almost instantly. Each print then passes through a stabilizer solution, which charges the emulsion with chemicals that will prevent image fading for a moderate period of time. An 8″ × 10″ print emerges damp-dry in 15 seconds; it air dries in a few minutes. The print can be viewed in white light immediately and put to any required use. Its permanence is likely to range from a few days to several months, or more, depending upon a variety of factors such as ambient temperatures and humidities. However, it can be made completely permanent by conventional fixing, washing, and drying at any time after its immediate use, but before the image has begun to change. (*See:* STABILIZATION PROCESS.)

Activation papers take slightly longer in processing, but emerge thoroughly fixed and washed, and completely dry. Thus they combine speed with the same optimum print stability produced by conventional processing. Like stabilization papers, activation papers have a developing

agent built into their emulsions. The emulsion is prehardened and is coated on a water-resistant base. A print first passes through an activator solution in the processor, which causes the image to develop in less than 9 seconds. It then passes through a stop bath, which halts development in about 5 seconds, and across a series of fountain jets that wash the emulsion with concentrated rapid fixer at a high temperature; the print is fixed in about 10 seconds. Rollers remove fixer from the print surfaces as it moves into a wash chamber where fountain jets rinse the back of the paper and flush all silver-thiosulfate compounds out of the emulsion. More rollers remove surface water from the print and transport it for about 15 seconds through a drying chamber where heated air is blown across it to evaporate all absorbed water. When a Kodak Royalprint processor is used, a dry 8″ × 10″ print can be obtained 55 seconds after processing has begun.

Some stabilization processors are economically within the reach of even the individual small darkroom. Activation processors are somewhat more expensive, but well within the budget range of small studios and moderate-volume applications. Both methods provide extremely rapid print processing with excellent uniformity of results.

• *See also:* DEVELOPERS AND DEVELOPING; DRUM PROCESSING; DRYING FILMS AND PRINTS; FORMULAS FOR BLACK-AND-WHITE PROCESSING; HIGH-TEMPERATURE PROCESSING; JET-SPRAY PROCESSING; PHOTO-FINISH PHOTOGRAPHY; STABILIZATION PROCESS; WET NEGATIVES, PRINTING.

Rayleigh, Lord (John William Strutt)

(1842-1919)
English physicist

J. W. Strutt, who became third Baron Rayleigh in 1873, was a brilliant student in sciences at Cambridge University, graduating first in his class in mathematics. He chose a career in research, and in 1879 succeeded James Clerk Maxwell as Cavendish Professor at Cambridge, which made him director of the most important scientific laboratory in England.

Rayleigh was especially creative in devising experiments to investigate dynamic phenomena. He performed research and made original contributions in virtually every area of physics, including electrodynamics and electromagnetism; sound; wave theory; hydrostatics and hydrodynamics; capillarity, viscosity, and the flow of liquids; the density and kinetics of gases; and optics, color vision, light scattering, and photography. His work in electricity led to units for measuring resistance, current, and electromotive force (voltage).

Among Rayleigh's contributions of value to photography were: (1) the mathematical analysis of the resolving power of prisms and diffraction gratings, (2) a method for determining the maximum resolving power of an optical system based on the radius of the Airy disc, and (3) the discovery of the primary scattering of light.

Primary scattering explains the blue color of the sky as seen through a clear atmosphere. When light waves encounter very small bodies (air molecules), they are scattered in all directions, with the short (blue) wavelengths being scattered more than the long (red) wavelengths. In addition, if the incident light is unpolarized, the scattered light will be polarized. (The basic fact of the polarization of skylight had been discovered in 1809 by D.J.F. Arago, who was to be of great assistance to Daguerre 30 years later in making public the first practical method of photography.) Rayleigh's explanation of light scattering established a fundamental principle, but not a general theory. In most cases, the primary scattered light encounters additional particles and is scattered again many times; multiple scattering thus becomes the dominant factor in most atmospheric optical phenomena.

Real-Estate Photography

In many communities, real-estate multiple-listing systems require that each listing be supported with a photograph of the property. These are usually in the form of black-and-white prints perhaps made by an agent or sales representative with an instant print camera. Individual real-estate agencies may also feature color photographs, often attractively enlarged, to preview properties with customers.

Owners of extensive or valuable properties frequently require photographs that document the structures, grounds, and condition of the property. This is for tax and insurance purposes and can also serve for advertising when sale is contemplated.

A commercial photographer seeking to increase the volume of business or an advanced amateur with the required skills might offer to improve the quality of photographs used by real-estate agents and private property owners. The picture files of real-estate firms need constant updating as new listings are added. Owner surveys of property may include home interiors and furnishings as well as exterior photographs.

While it may be relatively easy for the experienced photographer to improve upon the quality of photographs compared with the salesperson's instant prints, the photographer must learn quickly what is important to the salesperson in terms of viewpoint, time of day, and perspective. Deliberate distortion should be avoided, but the property should be shown as attractively as possible. Obviously, real-estate photography will require knowledge of many photographic skills. The interested photographer should review the following articles for more information.

• *See also:* ARCHITECTURAL PHOTOGRAPHY; AVAILABLE-LIGHT PHOTOGRAPHY; COMMERCIAL PHOTOGRAPHY; INSURANCE PHOTOGRAPHY; LANDSCAPE PHOTOGRAPHY; PANORAMIC PHOTOGRAPHY; PERSPECTIVE; VIEW CAMERA.

Rear Projection

During rear projection, the image-forming light is transmitted through a translucent screen material from the side of the screen opposite the viewer. A person or object in front (on the viewer side) of a rear-projected image does not interfere with the projection beam. This makes rear projection useful for situations in which the mechanism of projection must be unobtrusive or hidden (as in displays), as it permits close examination of the screen image.

Rear projection may provide advantages in image contrast and color saturation in a lighted room. A dark-colored rear-projection screen will reduce image brightness. But if stray light is prevented from falling on the back of the screen, a dark-colored screen may provide darker shadow areas in the image, giving an impression of improved contrast and color saturation.

Rear projection can also have disadvantages. With conventional projection, the space over the heads of viewers is usually used for the projector beam. With rear projection, the projection beam is wholly or partially on the opposite side of the screen from the viewers. Consequently, space for the beam must be provided behind the screen.

To reduce space requirements in rear projection, short-focal-length lenses are sometimes used. Mirrors are often employed to fold the projection

Rear projection images are generally much brighter on the projection axis than off the axis. Consequently, part of the projected image is brighter than other parts—sometimes by a ratio of 50-to-1 or more.

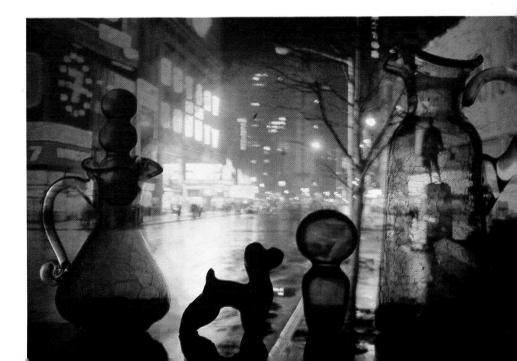

beam. Either procedure is likely to reduce image brightness and quality.

Image Brightness Variation

Image brightness (or luminance) is one of the major factors to be considered in the effective projection of visual materials; it is roughly comparable to providing adequate illumination for the reading of printed matter. Without satisfactory image brightness, a projected message can be either unintelligible or so difficult to perceive and understand that it is misinterpreted.

Rear-projection screen materials are generally more directional than front-projection screen materials, and usually are much brighter on the projection axis than off the axis. Consequently, part of the image picture area is brighter than another part (sometimes 50 to 1 or more).

For clarification, a light axis is defined as an imaginary line from the projector through the screen to the viewer. A practical example of a light axis can be produced by making a small hole (approximately 3.2 mm [⅛ inch] in diameter) in the center of an opaque slide and then projecting

A viewer positioned on the light axis will see the brightest spot. As he or she moves away from the axis, the brightness of the spot decreases. For most common rear screen materials, the spot will have about one-third on-axis brightness at about 32 degrees from the light axis.

A practical example of a light axis, showing the directional properties of rear screen materials, can be produced by making a small hole (approximately 3.2 mm [⅛ inch]) in the center of an opaque slide and then projecting the slide onto a rear projection screen. The screen will bend the light as shown.

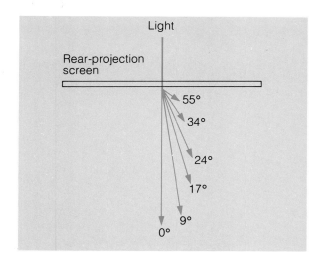

the slide onto a rear-projection screen. The light from the hole will travel in a beam to the screen and appear as a bright spot. The screen will then bend the light, spreading it into the room (see the accompanying diagram). A viewer positioned on the light axis (looking back into the projector through the screen) will see the brightest spot. As the viewer moves at an angle away from this light axis, the brightness of the spot on the screen will decrease. For the most commonly used rear-projection screen material, the spot will have about one-third on-axis brightness at about 32 degrees from the light axis. As a viewer moves about the room, the brightness of this spot on the screen will vary considerably, depending on how much the screen material has bent the light (see the accompanying illustration).

A second hole near the edge of the blank slide will produce a second beam of light, which will project as a bright spot at the edge of the screen. The light axis of the second beam connects the bright spot at the edge of the screen to the projector. This second bright spot on the screen will give a viewer a brightness variation similar to the first hole. When the viewer moves at an angle to the light axis, the light will have to be increasingly bent, causing the perception of the spot to decrease in brightness (see the accompanying diagram).

An observer will be unable to find one position from which to look back through both bright spots

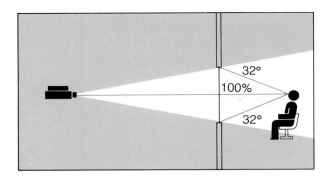

A second hole near the edge of the blank slide will produce a second beam of light that will project as a bright spot at the edge of the screen. An observer will be unable to find one position from which to look back through both bright spots to the projector.

to the projector. Alignment of vision will be possible with only one of the light axes at a time; the other axis will be at an angle and hence will not appear as bright on the screen. If the viewer is aligned with the center of the screen, the edge spot will be dimmer. If the viewer is aligned with the edge, the center spot will be dimmer, and if a third light spot is projected on the opposite edge, it will be even dimmer than the center, since the light from it will have to be diffused at a greater angle. A projected picture can thus be imagined as a group of bright spots on a screen (see the accompanying illustration). In rear-screen projection, the images will have varying brightness levels, depending on the angle of the viewer, the light-bending characteristics of the screen, and the projection lens that is used.

As described earlier, the image brightness variation across the rear-projection screen produces a condition called a "hot spot," which tends to follow the viewer when moving from one position to another in front of the screen. The resulting effect is that a viewer on one side of the screen will see the hot spot on that side, while another viewer at the other side of the screen will see one on that side.

Screen Composition. Since the light from the projector must be transmitted through the screen material and spread into the audience space for all parts of the image to be visible, the rear-projection screen has a light-scattering material added to the clear backing (glass, acrylic plastic, flexible plastic, and so forth). This coating transmits some light, absorbs some light, and reflects some of the image light back toward the projector. If a rear-projection screen material is used to spread the light more evenly, the brightness distribution is improved, and the light is spread over a larger viewing area. Some of the light is, however, reflected and absorbed by the screen material, thus reducing the overall image brightness.

The greater the density of the light-scattering particles in the coating, the greater the scattering and reflection. Since the scattering takes place with light that enters the material from any direction, the greater the scattering (wider viewing area), the greater the reflection of stray light. Increasing the viewing area of a rear-projection screen by adding scattering material, then, results also in increasing the screen's reflection of stray light, thus reducing this advantage of rear projection (as the scattering is increased).

Brightness variation of an image can also be reduced by using a long-focal-length lens (as illustrated in the accompanying diagram). This moves the projector as far from the screen as is practicable and reduces the angle of spread of the light from the projector; the consequence is that the

A long-focal-length lens reduces brightness variation. Because such a lens enables movement of the projector farther from the screen, the angle of spread of light is reduced and the screen does not have to bend the light as much.

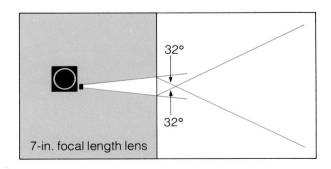

screen material does not have to bend the light as much. The improvement realized with a long-focal-length lens may require the use of a mirror (or mirrors) to "fold" the beam into the space available. Usually the improvement more than offsets the brightness losses (about 12 percent per mirror) introduced by the mirrors.

Brightness Ratios

Two factors must be taken into consideration in order to determine what minimum image brightness is required for a particular application: (1) screen-brightness ratio, and (2) the type of material to be projected.

The projection of light onto a screen will not subtract illumination already reflecting from the screen surface because of light from other sources. The dark area of the image can only be as dark as the screen is without an image projected on its surface. Black in the image may project as only a light gray. With excess stray light, details in the shadow areas are lost unless the projected image is made extremely bright so that it overpowers the stray light. The alternative is, of course, to reduce the stray-light level. A useful term, therefore, for specifying image brightness in areas with noticeable stray light is *screen-brightness ratio*.

The screen-brightness ratio is the ratio of stray light reflected from the screen divided into the image brightness. In other words, if the image brightness measurement is 50 cd/m$^2$ (15 fL) and the stray light is 10 cd/m$^2$ (3 fL), the brightness ratio would be 5:1.

Stray light may also be transmitted through the screen from the projector side. Sometimes, it is actually room light transmitted through the screen, reflected from behind the screen, and transmitted back through the screen to the viewing area. It makes no difference whether the stray light is reflected or transmitted—it is the total stray light, compared with image light, that is important.

It may not always be possible to reduce the amount of stray light reflecting from the projection screen to the conditions recommended by ANSI and the SMPTE (less than one percent of image brightness). In such a case, the minimum image brightness recommended will have to be increased to compensate for the presence of stray (non-image) light.

Categories for Projection Materials. Because most photographic subjects vary widely in color range, degree of shading, and shadow detail, it will be helpful to think of photographic materials as falling into one of the three following categories:

Category A—Images that exhibit a full range of colors (or grays in black-and-white photographs) and have good shadow detail. Examples: portraits and landscapes.

Category B—Images that show a full range of colors (or grays in black-and-white photographs) but are limited in shadows and details; that is, they have a flat, two-dimensional appearance. Examples: cartoons and flatly lighted photographs of subjects with limited brightness ranges and no important details in dark or shadow areas.

Category C—Images composed of contrasting colors or blacks and whites (no grays) with little or no detail in the dark areas. Examples: photographs of text, charts, and other similar line artwork for use with slide and overhead projectors.

Being able to see color or density gradation and detail in the shadow (or dark) areas is obviously quite important with Category A images, less important with Category B materials, and of little significance with Category C visuals. As a consequence, the minimum brightness ratio required for effective projection of each of these image categories is different. Category A materials require 100:1; Category B, 25:1; and Category C, 5:1.

Brightness ratios of 100:1 are very difficult to obtain with rear-projection screen materials, even under perfect conditions. Since the projected light must pass through the base or support material, it is subject to reflections in the base. The result is the reflection of light from the light areas of an image onto the dark areas. This reduces the brightness ratio of the projected image by creating stray light in the screen base. Due to these conditions, the maximum brightness ratio for ground glass is 39:1. There are two good high-contrast screen

materials that give values of 85:1 and 53:1. Note that for Category A materials, a value of 100:1 is recommended. The ratios can be improved by using a base material that absorbs a greater amount of light. A screen with a ratio of 53:1 was found to have a ratio of 480:1 when a 60 percent transmitting neutral acrylic plastic base was used, but the image brightness was reduced by 40 percent.

The ratios that have been given are for perfect conditions; that is, no stray light except that produced by the image light in the base material. If stray light is added, the situation deteriorates quickly. For example, if the brightness of the image is 34 cd/m² (10 fL) and the screen without an image is 0.34 cd/m² (0.1fL), the brightness ratio is:

$$\frac{34 \text{ cd/m}^2}{0.34 \text{ cd/m}^2} = 100:1$$

But, if an added stray light level of 1 fL is reflected from the screen, the image brightness measurement will now be 38 cd/m² (11 fL) and the screen without an image will be 3.8 cd/m² (1.1 fL). This will give a new reduced brightness ratio of:

$$\frac{38 \text{ cd/m}^2}{3.8 \text{ cd/m}^2} = 10:1$$

The advantage of rear projection in some situations is that a dark screen material, which will absorb much of the light falling on it, can be used. Most dark rear-projection screen materials reflect only about one-tenth, or less, of the light falling on them, thus decreasing the non-image brightness resulting from stray light falling on the screen.

It is often thought that when a dark rear-projection screen material is used, the low amount of stray light reflectance characteristic will make it possible to have a normally lighted room. Such is not the case, unless the image is very small, or a projector with very high light output is used. The dark screen does help by absorbing stray light, but it also absorbs projection light, resulting in a dimmer image. The image may look very poor, even if a high-brightness ratio is obtained, when the image is not substantially brighter than other bright objects in the field of view. (The projector open-gate brightness should be at least 10 times brighter than the surrounding brightness; however, 15 to 20 times is preferable.)

Viewing Area

Not only does the choice of lens focal length affect brightness variation, as was mentioned earlier, but it also has an influence on the viewing area that is usually considered acceptable.

An acceptable viewing area can be determined by drawing two light axes from the projector, one through the left edge and the other through the right edge of the screen. Then, on either side of these lines, draw a line (on viewer side of screen) angularly displaced 32 degrees from the point where the axis touches the screen (see the accompanying diagram). This is for the most commonly used screen material, which has one-third brightness at 32 degrees.

Each rear-projection screen material has its own characteristics and its own one-third brightness angle. The area where the two angles overlap indicates the acceptable viewing positions. There is no position in this area with a brightness less than one-third of the on-axis brightness. When the

An acceptable viewing area can be determined by drawing two light axes from the projector, one through the left edge of the screen and the other through the right edge of the screen. Draw a pair of lines on the viewer side of the screen, angularly displaced 32 degrees from the point where the axes touch the screen. This is suitable for the most commonly used screen material, which has one-third brightness at 32 degrees.

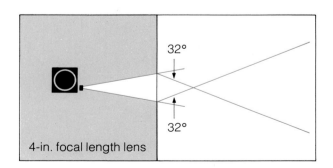

4-in. focal length lens

32°

32°

analysis is done for 4-inch and 7-inch focal-length lenses, used in conjunction with a 2″ × 2″ slide projector, the 4-inch focal-length lens will give an acceptable viewing area of about 25 degrees each side of a perpendicular line from the center of the screen, and the 7-inch focal-length lens will yield an area of about 30 degrees each side (see the accompanying diagram).

The seating area that falls within the range of good viewing conditions can be seriously limited by the directional properties of the screen material that is employed.

In the event that the designer wishes to hold the brightness variation to a 2:1 ratio, it will be necessary to determine the angle that will give one-half the on-axis brightness for the screen material selected and use that angle to determine the seating area.

Short-Focal-Length Lenses. Two disadvantages of using short-focal-length lenses have been explained: increased hot-spot effect and reduced acceptable viewing area. A problem with lenses that have a focal length beyond the design range of the projectors is reduced brightness. Slide projectors are usually designed to be used with about a 5-inch lens. When lenses with longer or shorter focal lengths than these are used, full utilization of the projector light is not possible and a dimmer image results. Since increased brightness helps the eye compensate for brightness variation, the short-focal-length lens aggravates its own problem of increased hot-spot effect caused by the reduction of brightness.

Screen Brightness

Multiple Screens. Brightness variation makes rear-projection multi-screen facilities, capable of providing good image quality, nearly impossible to design. A series of images side by side means that persons to the side of the room will see a series of hot spots. At the side where the image on one screen dims, the image next to it will be the brightest. Since the brightness variation is now a sudden change rather than a gradual one for the viewers at each side, the resulting images make the brightness variation quite noticeable and often objectionable. When making side-by-side comparisons, the eye can detect as little as 5 percent difference in brightness. Having a bright part of an image next to the dim part of the adjacent image will make the dim image appear more obvious and objectionable.

Scintillation. This effect is a sparkling or twinkling of various colors when light strikes a rear-projection screen material. The cause of this effect is somewhat in question.

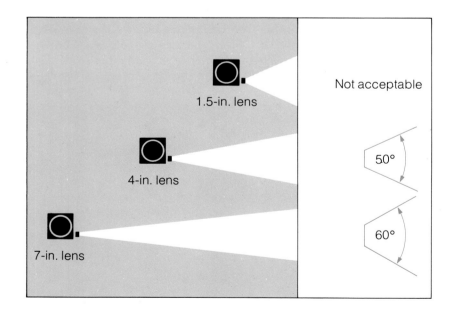

The seating area that falls within the range of good viewing conditions can be seriously limited by the directional properties of the screen material. The most commonly used screen material, for example, illuminated by a 1.5-inch focal-length lens, will yield no acceptable seating. When the analysis is done for 4-inch and 7-inch lenses, the acceptable seating area will be respectively 25 degrees and 30 degrees on each side of the center line.

The size and brightness of the colored light spots vary greatly and in some screens can be quite noticeable and distracting. Scintillation is usually more of a problem with microfilm readers and other equipment in which the viewer is close to the screen and needs to resolve detail. Unfortunately, the most objectionable amount of scintillation is usually associated with high-gain screens (which are often used in microfilm readers).

In most projection facilities, where the usual audiovisual viewing rules are followed, scintillation will probably not be a problem.

Conclusion. Obtaining good, even rear-projection screen brightness is usually a very difficult task—one of balancing the parameters of seating area, lens focal length, screen gain, brightness ratio, image size, image brightness variation, and stray light in order to obtain a satisfactory result. Since the only gain (in terms of brightness) in using rear-projection screen material is its better rejection of stray light than most front-projection screens are capable of, and due to the fact that stray light still should be controlled because of the low maximum brightness ratio inherent in rear-projection screens, it is often much less costly and easier to design a good front-projection system.

• *See also:* BACK PROJECTION; FRONT PROJECTION; PROJECTION, AUDIOVISUAL; PROJECTION CABINETS; PROJECTION SCREENS; PROJECTORS.

Reciprocity Effect

All photographic emulsions are subject to an effect often called reciprocity-law failure. The reciprocity law states that *intensity of the illumination falling on a film times the exposure time equals the amount of exposure* (E = I × T). This law does apply for most black-and-white films from exposure times of from about 1/5 sec. to 1/1000 sec. and for color films over a narrower range. Thus, where the law holds, an exposure of 1/60 sec. at $f/11$ is equivalent to an exposure of 1/30 sec. at $f/16$.

For times outside this range, the effect of reciprocity-law failure can be seen as underexposure, a change in contrast, a color shift, or all three. The word *failure,* in this connection, does not imply a shortcoming of the film, but merely that the reciprocity law does not hold for very short or very long exposure times.

In other words, the effective sensitivity of a film emulsion varies with illumination level and exposure time. Each emulsion has its greatest response at a particular level of illumination. On either side of this level, the response decreases so that extra exposure is needed to obtain normal density.

Low-Intensity Reciprocity Effect

If the normal calculated exposure is given, long exposure times at low illumination levels result in thin negatives that lack shadow detail. If, in order to correct for this, the exposure time is lengthened still more, the density in the highlight areas becomes disproportionately greater than that in the shadows, resulting in an increase in effective contrast. This is because the reciprocity effect is more severe in areas of the scene where the illumination is relatively low. With black-and-white films, this is compensated for by decreasing the amount of development. In other words, *for low-intensity reciprocity correction, increase the exposure and decrease the development.*

High-Intensity Reciprocity Effect

The high-intensity reciprocity effect has a somewhat different photographic result. If a film is exposed for a very short time, say 1/1000 sec. or less, a loss of density in the highlights and possibly the denser middletones will be observed. This loss is characteristic of the high-intensity reciprocity effect. Only a slight increase in exposure is usually necessary with extremely short exposure times, but an increase in development will usually be desirable. *For high-intensity reciprocity correction of black-and-white films, increase the exposure and increase the development.*

Correction Table

Most Kodak continuous-tone films respond in a similar manner to very long and short exposure-time conditions. There are some variations between types of film, and there may be some variations between batches of the same film type. Practicing the recommendations given in the following table will usually give adequate compensation for

BLACK-AND-WHITE FILMS RECIPROCITY CORRECTION

If Indicated Exposure Time Is (seconds)	Use			And in Either Case, Use This Development Adjustment
	Either This Lens Aperture Adjustment	Or	This Exposure Time Adjustment (seconds)	
1/100,000	1 stop more		Use aperture change	20% more
1/10,000	½ stop more		Use aperture change	15% more
1/1,000	None		None	10% more
1/100	None		None	None
1/10	None		None	None
1	1 stop more		2	10% less
10	2 stops more		50	20% less
100	3 stops more		1200	30% less

This table and the accompanying graphs apply to most Kodak black-and-white roll and sheet orthochromatic and panchromatic films for regular camera use.

Reciprocity Effect Exposure Time Adjustment Curves

Average adjustment for most Kodak general-purpose black-and-white films. To use this graph, determine the normal exposure time, including adjustments for bellows extension, filter factor, and so forth. Find this indicated exposure time across the bottom of either graph. Trace up from that point to intersect the curve, then trace horizontally to the adjusted exposure time required for reciprocity compensation. These data may also be used as a starting point for reciprocity compensation for similar films of other manufacturers.

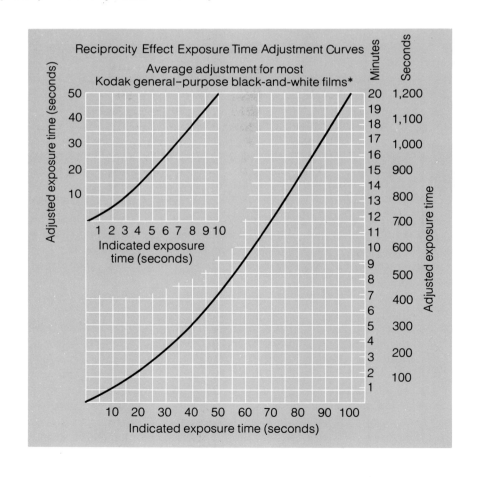

reciprocity effects. However, if exposure and negative contrast are critical, run tests on samples of t'ie film emulsion that will be used for the critical µictures and make corrections if necessary.

Whenever correcting for reciprocity, first determine the normal exposure; next, add in all necessary adjustments for bellows extension, filtration, and other factors that affect exposure. Then, as the final step, determine the required compensation for reciprocity.

Correction Graph. From the table figures, it is difficult to estimate the adjusted exposure times for indicated exposure times between 1 and 100 seconds. The accompanying graph will help to find the times between the table values. While the film latitude will generally compensate for variations in the reciprocity characteristics of different film emulsions, it is advisable to purchase a quantity of film and run tests if considerable long-exposure-time work is to be done. The tests should be based on the values found in the graph, with corrections being made as necessary. The stock of film should be frozen to minimize changes in the reciprocity characteristics and can be used over a period of time with a high level of confidence in the results.

Color Film Reciprocity

The comparatively great latitude of general-purpose black-and-white films minimizes reciprocity effect except under relatively extreme exposure conditions. In addition, development as well as exposure can be adjusted to compensate for changes in contrast. Color films, however, have little exposure latitude, and processing is essentially invariable.

Because color films have multiple emulsion layers of different spectral sensitivity and contrast characteristics, the reciprocity effect is far more complex than it is with black-and-white films. Sensitivity changes due to reciprocity effect may be different for each layer, causing changes in color rendition as well as contrast. Compensation can be achieved only by increased exposure and, in some cases, color compensating filtration. Because there are great fundamental differences among the color films of various manufacturers, specific recommendations cannot be given.

• *See also:* COLOR FILM PROCESSING; CONTRAST; DEVELOPERS AND DEVELOPING; EXPOSURE; INTENSIFICATION; PUSH PROCESSING.

Red Eye

In some color flash pictures, the subject's eyes may look red; in black-and-white photographs, the eyes may look white. This phenomenon in color images is due to a reflection from the blood-rich choroid layers of the retina. Red eye usually occurs when the subject is looking directly at the camera and when the light level is relatively dim.

Reducing the Red Reflections

The following techniques can be used to reduce red eye:

1. The best way to minimize red reflections is to move the flash away from the camera lens. Remove the flash from the camera hot shoe and use the flash cord. If your camera accepts magicubes or flashcubes, you can minimize this effect at distances up to 15 feet by using an extender. There are two kinds of extenders—one designed for use with magicubes and another for flashcubes. Be sure to get the right one for your camera.

2. If your camera has an integral flash unit that cannot be removed, increase

(Right) Red eye usually occurs when the subject is looking directly at the camera and when the light level is relatively low. It is caused by reflections from blood vessels in the retina. (Left) Moving the flash unit away from the camera usually solves the problem. There are extenders for cameras using flashcubes or magicubes and flash cords for other cameras. Both serve to separate the source of light from the camera lens.

the level of light in the room by turning on all the room lights. This helps to reduce red reflections because the added light will cause the subject's pupils to contract, reducing the reflective surface that causes red reflections.

3. Have the subject look at a bright light (for example, a room lamp) just before you take the flash picture. The bright light will reduce the size of the subject's pupils.

4. Avoid flash. Use available-light techniques.

• *See also:* AVAILABLE-LIGHT PHOTOGRAPHY; EXISTING-LIGHT PHOTOGRAPHY; FLASH PHOTOGRAPHY; PORTRAITURE.

 ## Reduction

Reduction is the process (usually chemical) of removing density from a photographic image in order to improve the printing characteristics of a negative or the appearance of a print. When carried to an extreme, reduction can completely eliminate an image or part of an image. In some retouching methods, an image is physically reduced by rubbing it with an abrasive to remove part of the silver image. Knife etching is another technique of physical density reduction. However, the most common procedure is to use a chemical solution that dissolves silver. Another term for chemical reduction is *bleaching*. Both negatives and prints are reduced, or bleached. The same solutions are used on both negatives and prints, but the print solutions are usually diluted.

Depending on the solutions and techniques employed, an image can be reduced over its entire area, or only in selected, local areas. Local area reduction can be achieved by painting or dabbing reducer into the selected area. This technique is often used to remove black specks from an image; it works best with a dry emulsion on a horizontal surface (to minimize running and streaking). Local action can also be achieved by painting over areas that are to be unchanged with a dilute solution of rubber cement or frisket lacquer before the image is immersed in the reducer. Diffusion within the emulsion makes it difficult to restrict the chemical action to a sharply defined area, however.

Reduction is most commonly carried out with black-and-white negatives. The primary controls are choice of reducer action and length of time of treatment. Since reduction is carried out in white light, progress can be observed visually.

Negative Reduction

Negative reducers are classified in one of three categories, depending on the way in which they affect the material being reduced:

1. *Subtractive or cutting reducers.* These remove nearly equal quantities of silver from the high, intermediate, and low densities, respectively. They are useful for treating fogged or overexposed images. Kodak reducer R-2 and *Kodak* Farmer's reducer R-4a are in this category.

2. *Proportional reducers.* These cut density proportionally, removing an equal percentage of silver from each image area. Thus, a very dense area will lose quantitatively more density than will a less dense area, although it will not lose a greater percentage of its density. Proportional reducers thus lower both contrast index (printing contrast) and visual contrast, and correct for overdevelopment. *Kodak* Farmer's reducer R-4b, Kodak reducer R-5, and Kodak reducer R-8a are in this category.

3. *Super-proportional reducers.* These remove proportionally more silver from a dense area than from a thin one. The denser an area of the image, the more vigorously the reducer acts on it. Super-proportional reducers are therefore useful for reducing highlight density without destroying shadow detail, and for treating overdeveloped negatives of contrasty subjects. Kodak persulfate reducer R-15 is in this category.

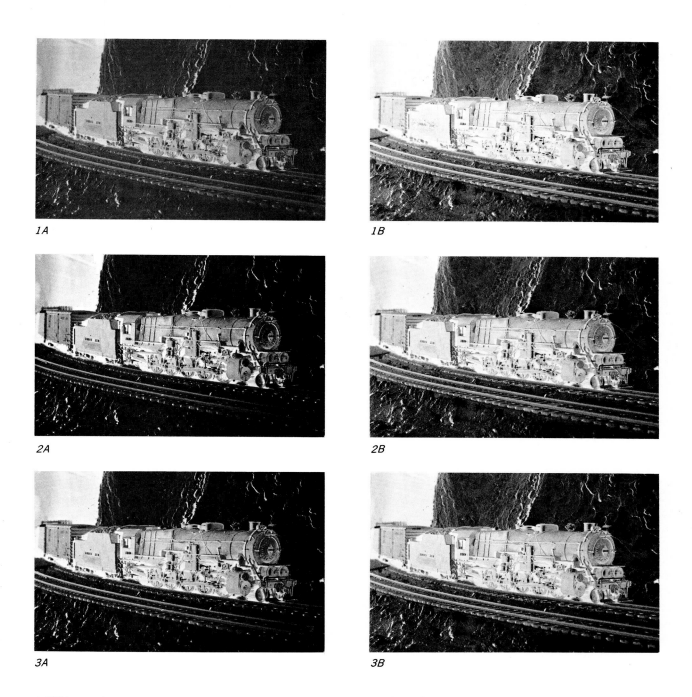

1A

1B

2A

2B

3A

3B

(1A) This negative was overexposed and correctly developed. Its density and lack of contrast can be improved by a subtractive reducer. (1B) After treatment with Farmer's reducer, the negative is contrasty enough to print well on normal paper. (2A) This overexposed and overdeveloped negative is heavy and contrasty. A proportional reducer is needed. (2B) Reduction yields a negative that will print well on normal paper. (3A) This negative was correctly exposed but overdeveloped. A super-proportional reducer using a persulfate salt will lower the highlight density without much loss of shadow detail. (3B) The super-proportional reducer allows a good print on normal paper.

Precautions. Reduction always involves some danger of ruining the image. Therefore, the best possible print should be made before attempting treatment. In addition, to reduce the likelihood of staining or other damage, observe the following precautions:

1. Fix and wash the negative thoroughly before treatment, and make sure it is free of scum or stain.
2. Harden the emulsion in a formalin hardener such as Kodak prehardener SH-1 before treatment. (*See:* HARDENING BATHS.)
3. Handle only one negative at a time, and agitate it thoroughly during treatment.

Following reduction, wash each negative thoroughly and wipe it carefully before drying.

Ammonium Thiosulfate Reducer. This very useful reducer is easily prepared by adding citric acid to an ammonium thiosulfate rapid fixing bath, such as Kodafix solution.

The reducer gives off a strong odor of sulfur dioxide and should be used in a well-ventilated room. Do not use it near sensitized photographic products. Before reducing the negative or print, clean it thoroughly; use Kodak film cleaner, if necessary, to remove any surface grease left from handling. Thoroughly prewet the material in diluted Kodak Photo-Flo solution, in order to promote uniform reducing action.

Since the reducer is colorless, the course of the reducing action can be observed easily. When the desired degree of reduction is obtained, wash the material thoroughly, and dry.

Normal Ammonium Thiosulfate Reducer. This reducer is for use in the removal of silver stains and dichroic fog, and for the reduction of prints and fine-grain negative materials.

To make the reducer, dilute 1 part of Kodafix solution with 2 parts of water, or dilute Kodak rapid fixer and add hardener, as recommended for the rapid fixing of negatives. To each litre of the diluted fixer add 15 grams of citric acid (anhydrous).*

For removal of silver stains and dichroic fog, immerse the negative or print in the solution and swab the surface with absorbent cotton to hasten removal of surface scum. The action is usually complete in 2 to 5 minutes. Remove the negative or print from the solution immediately if any reduction of low-density image detail is noted.

The normal reducer can be used for reduction of prints and fine-grain negative materials. This solution is particularly useful for correcting slight overexposure or overdevelopment; strong reduction may cause loss of image quality.

Strong Ammonium Thiosulfate Reducer. This reducer is for the reduction of negative materials.

To make this strength reducer, dilute the Kodafix solution or rapid fixer as directed above, but add 30 grams of citric acid (anhydrous)* per litre, instead of the 15 grams recommended.

The time of treatment will depend on the type of material and the degree of reduction desired. The reaction is slow with high-speed materials.

***Kodak* Reducer R-2.** The following solutions are used to make this negative reducer.

Stock solution A

Water 1.0 litre
Potassium permanganate 52.5 g

Completely dissolve the permanganate crystals in a small volume of hot water (about 80 C or 180 F); then dilute to volume with cold water.

Stock solution B

Water 1.0 litre
†Sulfuric acid (concentrated) .. 32.0 ml

To use, mix 1 part of solution A, 2 parts of solution B, and 64 parts of water. Once mixed, the reducer must be used immediately. Place the negative in the solution, allowing it to remain there until the desired degree of reduction is attained. Next, immerse the negative for a few minutes in a fresh acid fixing bath (Kodak fixing bath F-5) to remove yellow stains. Wash the negative thoroughly, and dry it.

*Possible sulfurization of the thiosulfate in the fixer can be avoided by dissolving the citric acid in a portion of the water used for dilution.

†CAUTION: Always add the sulfuric acid to the water slowly, stirring constantly, and never the water to the acid; otherwise the solution may boil and spatter the acid on the hands or face, causing serious burns.

If the reduction proceeds too rapidly, increase the volume of water in the reducer.

Do not use this reducer as a stain remover; it tends to attack the image before it removes the stain. Use Kodak stain remover S-6 for removing stains. (*See:* STAINS, REMOVING.)

NOTE: Negatives *must* be thoroughly washed before they are reduced; any hypo present will adversely affect the reducer. Hypo contamination in the permanganate solution will cause the formation of a surface scum; hypo in the reducer, left by poorly washed negatives, causes the formation of a reddish curd.

If proper precautions are observed, the separate stock solutions will keep and work perfectly for a considerable length of time. Do not attempt to store the combined solutions; they will not keep for long.

Follow the preceding instructions carefully. Otherwise, an iridescent scum may appear on the reduced negatives after they dry; this scum will be difficult, if not impossible, to remove.

***Kodak* Farmer's Reducer R-4a.** To make this reducer use the following stock solutions and procedures.

Stock solution A
Potassium ferricyanide
 (anhydrous) 37.5 g
Water to make 500.0 ml

Stock solution B
Sodium thiosulfate
 (pentahydrated) 480.0 g
Water to make 2.0 litres

To use the solutions, take 30 millilitres of solution A, 120 millilitres of solution B, and water to make 1 litre. Add A to B, add the water, and *immediately* pour the mixed solution over the negative to be reduced, which should preferably be contained in a white tray. Watch the action closely. When the negative has been reduced sufficiently, wash thoroughly and dry.

For less rapid reducing action, use one-half the above quantity of solution A, with the same quantities of solution B and water.

Solutions A and B should not be combined until they are to be used. They will not keep long in combination.

***Kodak* Farmer's Reducer R-4b.** Farmer's reducer can also be used as a two-bath formula (R-4b) to give almost proportional reduction and correct for overdevelopment. The single-solution Farmer's reducer (R-4a) gives only cutting reduction and corrects for overexposure.

Solution A
Potassium ferricyanide
 (anhydrous) 7.5 g
Water to make 1.0 litre

Solution B
Sodium thiosulfate
 (pentahydrated) 200.0 g
Water to make 1.0 litre

Treat the negatives in solution A with uniform agitation for 1 to 4 minutes at 18.5 to 21 C (65 to 70 F), depending on the degree of reduction desired. Then immerse them in solution B for 5 minutes and wash thoroughly. The process can be repeated if further reduction is desired.

***Kodak* Reducer R-5.** This reducer cuts density proportionally.

Stock solution A
Water 1.0 litre
Potassium permanganate 0.3 g
*Sulfuric acid (dilute solution) 16.0 ml

Stock solution B
Water 3.0 litres
Potassium persulfate 90.0 g

To use, add 1 part of solution A to 3 parts of solution B. When sufficient reduction is secured, clear the negative in a 1 percent solution of sodium bisulfite (10 g bisulfite in water to total 1000 ml) or potassium metabisulfite. Wash the negative thoroughly before drying.

*To make, take 1 part of concentrated sulfuric acid and, with caution to avoid contact with the skin, add it slowly to 9 parts of water with stirring. *Never add the water to the acid* because the solution may boil and spatter the acid on the hands or face, causing serious burns.

Kodak **Reducer R-8a.** The following chemicals, plus water, make up this reducer.

Water, about 32 C (90 F) ... 600.0 ml
Citric acid (anhydrous) 20.0 g
Ferric ammonium sulfate 45.0 g
*Potassium citrate 75.0 g
Sodium sulfite (anhydrous) 30.0 g
Sodium thiosulfate
 (pentahydrated) 200.0 g
Water to make 1.0 litre

Dissolve chemicals in the order given.

Use full strength for maximum rate of reduction. Treat negatives 1 to 10 minutes at 18.5 to 21 C (65 to 70 F); then wash thoroughly. If slower action is desired, dilute 1 part of solution with 1 part of water. The reducer is especially recommended for the treatment of dense, contrasty negatives made on sheet films.

This is the only single-solution reducer that keeps well in a tank.

Kodak **Persulfate Reducer R-15.** The following solutions make up this reducer.

Stock solution A
Water 1.0 litre
Potassium persulfate 30.0 g

Stock solution B
Water 250.0 ml
†Sulfuric acid (dilute solution) ...15.0 ml
Water to make 500.0 ml

To use, take 2 parts of solution A and add 1 part of solution B. Only glass, hard rubber, or impervious and unchipped enamelware should be used to contain the reducer solution during mixing and use.

Treat the negative in the Kodak special hardener SH-1 for 3 minutes and wash thoroughly before reduction. (*See:* HARDENING BATHS.) Im-

merse in the reducer with frequent agitation and inspection (accurate control by time is not possible), and treat until the required reduction is almost attained; then remove from the solution, immerse in an acid fixing bath for a few minutes, and wash thoroughly before drying. Used solutions do not keep well and, therefore, should be discarded promptly.

For best keeping in storage, the persulfate stock solution A should be kept away from excessive heat and light. Keeping life of stock solution A is about 2 months at 24 C (75 F).

Print Reduction

Usually, the best way to improve a print that is too dark is to make another print. However, there are good reasons to reduce prints overall. Some workers always make prints slightly dark and reduce them slightly to give better tone separations in the highlights, for example. It is sometimes difficult to judge how much dry-down in density will occur with a print, and a valuable print may dry slightly darker than expected. Overall reduction will lighten up the print, especially in the light-tone regions.

Farmer's reducer R-4a is almost always used on prints. Although the exact dilution is not critical, it is necessary to have the solution quite weak in order to control the degree of bleaching. The following dilution is a good starting point:

Solution A 3.0 ml
Solution B 12.0 ml
Water to make 1.0 litre

Soak the dry print(s) in water for about 10 minutes before reducing.

Place the wet print in the reducing solution for 5 to 10 seconds and agitate continuously. Place the print on the back of a tilted tray in the sink and rinse it in running water. Repeat the process, checking the progress of the reduction.

When the desired degree of reduction has occurred, wash the print for 1 minute in running water, and fix for 5 minutes in an acid hardening fixer, such as Kodak fixer, Kodafix solution, or Kodak fixing bath F-5. Wash for 1 hour. Use of Kodak hypo clearing agent will reduce the wash time.

*Sodium citrate should not be used in place of potassium citrate, because it will slow the rate of reduction considerably.

†To make, take 1 part of concentrated sulfuric acid and, with caution to avoid contact with the skin, add it slowly to 9 parts of water with stirring. *Never add the water to the acid,* because the solution may boil and spatter acid on the hands or face, causing serious burns.

To locally reduce relatively large areas, place the soaked print on the back of a tray. Apply the reducer with a wad of cotton, or if the area is somewhat smaller, with a cotton swab. Allow the reducer to work for 5 to 10 seconds and rinse off with running water. Repeat until the desired degree of reduction has occurred. Fix and wash as described above for prints that have been reduced overall.

For very small areas, squeegee the area to be reduced so that there is no surface water on the area. Apply the reducer with a spotting brush, but have the brush only damp with reducer so that it can be contained within the area to be reduced. It is difficult to control the reducer if the brush is loaded with solution. Keep the reducer off the metal on the brush, and thoroughly wash the brush after using for reduction. The rinse-and-repeat procedure should be followed, squeegeeing the area before each successive application. When reduction is complete, fix and wash as above.

Black spots on prints that are the result of pinholes or dust specks in the negative will not reduce down to the surrounding densities in Farmer's reducer without a resulting permanent yellow stain.

One way of handling this type of problem is to spot-in the defect on the negative so that it will print white on the print. Opaque or a strong dye solution is one way to retouch dust specks when the negative has adequate size. Retouchers often place the point of an etching knife on a pinhole and twirl the knife to make an opaque spot.

However, when the negative is small, it is sometimes necessary to reduce these black specks on the print. Iodine reducers have the facility of removing all the print density and when fixed leave no stain.

Iodine Reducers

A simple form of an iodine reducer is the tincture of iodine available in drug stores for treating cuts. It can be diluted with denatured (methylated) alcohol if desired. Glycerine can be mixed with a working solution to thicken the solution so that it will not run on the print. The reducer is applied with a spotting brush or the point of a toothpick. After the spot has been reduced, the print is fixed in either a simple fixing

bath (200 grams sodium thiosulfate crystals in 1 litre of water), or a fixing bath to remove the stain, and washed as usual.

A reducer sometimes used to remove black spots on prints is the following iodine reducer.

Water 100.0 ml
Potassium iodide1.5 g
Iodine crystals0.5 g

Completely dissolve the potassium iodide crystals in the water. (The iodine crystals will not dissolve in plain water, but will dissolve in an iodide solution.) Then dissolve the iodine crystals. Wet a spotting brush with the solution and apply a small drop to the black spot on a soaked, squeegeed print. Wash and repeat as for local reduction. This can be used straight to remove black specks on prints, or diluted to reduce large areas. After reduction, fix for 5 minutes in a plain hypo fixing bath to remove the stain.

Sodium thiosulfate crystals ... 200.0 g
Cold water to make 1.0 litre

Wash as usual.

Iodine reducers are also useful to remove part or all of a print image for photographic drawing or to make a pure white background, as in catalog illustrations.

A suitable reducer is a two-solution formula:

Solution A
Iodine crystals10.0 g
Denatured (methylated) alcohol 250.0 ml

Solution B
Thiocarbamide20.0 g
Water 250.0 ml

Dissolve the two chemicals and keep solution A and solution B separate. To use, mix equal quantities of A and B. For spot removal, add glycerine and use as above. Dilute for large-area treatment. After bleaching is complete, fix the print in plain hypo solution or a fixing bath and wash as usual.
• *See also:* BLEACHING; HARDENING BATHS; INTENSIFICATION; RETOUCHING; STAINS, REMOVING.

Reflectance

Reflectance is a measure of the relative amount of light or other electromagnetic form of energy that a material directs away from its surface compared with the amount of energy falling on (incident upon) the surface. Mathematically, reflectance is the ratio of the total amount of reflected light (measured hemispherically, or over a solid angle of 180 degrees), divided by the total amount of light incident upon the surface.

$$\text{Reflectance} = \frac{\text{Reflected flux}}{\text{Incident flux}}$$

Reflectance, therefore, contains light that is reflected both specularly and diffusely.

In photography, the interest is generally in the amount of light reflected in a given direction. In a subject surface, for example, that direction is toward the camera lens; in a photographic print, it is toward the eye. This directional type of reflectance is called the *reflectance factor*.

Method of Measurement

In calibrating the reflectance factors of various surfaces, the incident light is not measured directly. Instead, a standard white surface that reflects almost perfectly diffusely and is spectrally neutral in color (reflects all wavelengths equally—magnesium oxide, for example) is illuminated from a 45-degree angle, and the amount of light it reflects is measured perpendicular to the surface.

The amount of light reflected from the sample surface is measured in the same way. The ratio of the sample measurement divided by the magnesium-oxide measurement is the reflectance factor. In photographic terms, the reflectance factor is commonly called the reflectance of the surface.

The similarity of the method of measurement just described to the measurement of reflection density is obvious. If the reflection density of a surface is known, the reflectance (reflectance factor) can be calculated using the following equation:

$$\text{Reflectance} = \frac{1}{\text{Antilog reflection density}}$$

The accompanying table gives the reflectances (reflectance factors) of a number of reflection density values.

The RAT Law

Since no surface reflects all of the light, some light is lost because of surface absorption, and possibly some (in the case of transparent or trans-

REFLECTANCE FACTORS OF REFLECTION DENSITY VALUES

Reflection Density	Reflectance	Reflection Density	Reflectance	Reflection Density	Reflectance
0.00	1.000	0.65	0.224	1.90	0.013
0.01	0.977	0.70	0.200	2.00	0.010
0.02	0.955	0.75	0.178	2.10	0.008
0.03	0.933	0.80	0.158	2.20	0.006
0.04	0.912	0.85	0.141	2.30	0.005
0.05	0.891	0.90	0.126	2.40	0.004
0.10	0.794	1.00	0.100	2.50	0.003
0.15	0.708	1.05	0.089	2.60	0.0025
0.20	0.631	1.10	0.079	2.70	0.0020
0.25	0.562	1.15	0.071	2.80	0.0016
0.30	0.501	1.20	0.063	2.90	0.0013
0.35	0.447	1.30	0.050	3.00	0.0010
0.40	0.398	1.40	0.040	4.00	0.0001
0.45	0.355	1.50	0.032	5.00	0.00001
0.50	0.316	1.60	0.025		
0.55	0.282	1.70	0.020		
0.60	0.251	1.80	0.016		

lucent objects) by transmission of the light as well. This relationship is expressed by the *R*eflectance, *A*bsorptance, *T*ransmittance (RAT) law.

Total Incident Light = Reflected Light +
Absorbed Light + Transmitted Light

Stated another way:
Reflectance + Absorptance +
Transmittance = 1.00

For example, if a material reflects 70 percent of the light (reflectance = 0.70) and absorbs 20 percent (absorptance = 0.20), it must transmit 10 percent (transmittance = 0.10), that is, since:
$$1.00 = 0.70 + 0.20 + T$$
$$\text{then: } T = 1.00 - 0.70 - 0.20 = 0.10$$

Spectral Reflectance

Reflectance and reflectance factors are measured with white light, and in the case of reflectance factors, with magnesium oxide, which is practically spectrally neutral. Therefore, these represent the average reflectance of all wavelengths.

Colored objects reflect light chromatically— that is, they reflect more light of some wavelengths than they do of others. The spectral reflectance of a surface is the reflectance (factor) at one wavelength. A spectral reflectance curve shows the spectral reflectance at all wavelengths, usually from 400 to 700 nanometres (nm)—(the usual limits of light)—but often from 200 or 250 nm to over 1000 nm to include some of the ultraviolet and near-infrared regions as well.

Typical Spectral Reflectance Curves

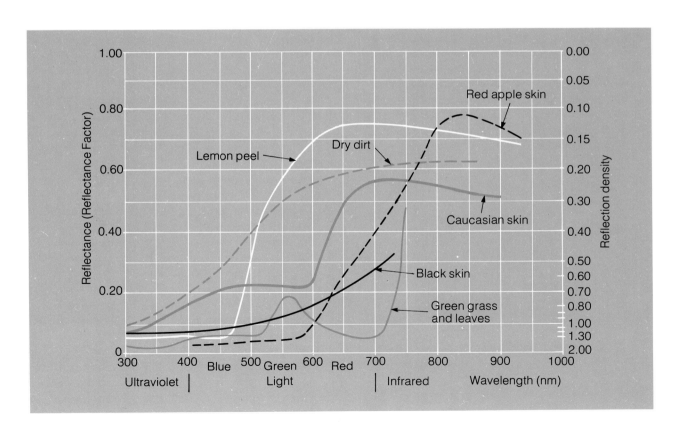

In color photography, the interest is often in the reflectance in the red, green, and blue bands of wavelengths. Color densitometers have narrow-cutting primary filters (status filters) that measure the density, and hence, the reflectance (factor), in these three bands. The red, green, or blue reflectance (factor) can be calculated from the red, green, and blue densities by use of the equation given earlier.

• *See also:* DENSITOMETRY; GRAY CARD; LIGHT: UNITS OF MEASUREMENT; REFLECTION DENSITY; SENSITOMETRY.

Reflection Density

The degree to which a photographic image on paper or other opaque-base material absorbs light is not measured by shining a light through it, as is the practice with images on film. (*See:* DENSITOMETRY.) Instead, it is necessary to measure the light reflected from the surface of the image. In most cases this is done by directing a light at the image from a 45-degree angle and measuring the diffuse reflected light from a 90-degree angle directly above the print (see the accompanying diagram).

There is no practical point in measuring the specular reflected light, because its intensity tends to obscure image detail. However, when print densities are measured to evaluate their character-istics in relation to average room viewing conditions, a densitometer cell that collects about four-fifths diffuse and one-fifth specular reflected light can be used. As in transmission densitometry, when color images are measured, separate readings are taken through red, green, and blue filters.

Calculating Reflection Density

The *reflectance* (R) of a measured area is the ratio of the reflected light intensity divided by the incident light intensity:

$$R = \frac{E_R}{E_I}$$

The opposite ratio (incident:reflected) is the *absorptance* of that area; it is the same as the reciprocal of the reflectance (1/R). Absorptance is the characteristic of a reflection material that is analogous to the opacity of a transmission material.

The logarithm of absorptance (log 1/R) is the *reflection density* of the measured area. As with the transmission densities of film images, reflection densities can be used to plot characteristic curves, determine contrast, derive speed and exposure data, and reveal other characteristics of a print emulsion.

Numerically, if a paper base has 100 percent reflectance and a given area reflects exactly half of the light that falls upon it, the reflectance of the area is 50/100=½, or 0.5. The absorptance is the reciprocal, 1/0.5=2. And the reflection density is \log_{10} of 2 = 0.3.

Paper-Base Reflectance

In actuality, a paper base never does reflect 100 percent of the light falling on it. Therefore, it is usually necessary to take a separate reading for the density of the paper base itself and subtract that from the measured density of a particular area to get the net reflectance density of the area. Paper-base density is usually determined by a comparison reading with a diffuse white standard material such as magnesium oxide. For example, if a paper base has a 90 percent reflectance, its absorptance is 100/90=1.11. The log of 1.11 = 0.05 (approximately), which is the reflection density of the paper base. If an image area produces a reflection-density reading of 0.3, its actual net density is 0.3−0.05 = 0.25.

Reflection density is measured from the diffuse reflected light collected at a 90-degree angle to an image surface that is illuminated from a 45-degree angle

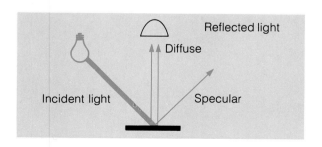

Two methods of dealing with the paper-base value are commonly practiced. In one, the densitometer is always zeroed on the paper base, and the net densities are measured directly. In the other, the densitometer is zeroed using a standard (such as magnesium oxide), so that zero density equals 100 percent reflection. Then the readings represent actual gross densities of the areas measured.

• *See also:* DENSITOMETRY; REFLECTANCE; SENSITOMETRY.

Reflectors

Two types of reflectors are used in photography. The first type, a lamp reflector, is used directly with artificial light sources—incandescent, chemical flash, electronic flash. The second type is used to redirect light from any kind of source into shaded areas, to soften shadows in backlighted photographs, and for other purposes. Mirrors are also reflectors, but reflector is a more general term. All mirrors reflect light in a specular manner, while reflectors may reflect either specularly or diffusely.

Lamp Reflectors

The use of a reflector behind a light source to redirect and concentrate the illumination is about as old as the history of artificial light. In antique shops, there are domestic oil lamps, intended to be hung on the wall, that have large tin reflectors behind the lamp chimney. All sorts of reflectors are used in theatrical lighting equipment; they are shaped like truncated cones (much like a dishpan, and about as effective) or like complete cones, or sometimes simple square or oblong boxes, such as the well-known Olivet. The major utility of such forms is merely to keep the light from spilling where it is not wanted; because of their inefficient optical design, such reflectors do not reinforce the strength of the main beam to any great extent.

Optically, there are only three efficient shapes for a lamp reflector: spherical, ellipsoidal, and paraboloidal. Each has a specific function, which comes about because of its optical properties. In the accompanying diagrams, the true shape of each is shown, as nearly as possible, but it must be pointed out that commercial reflectors are often only a small section of the entire shape. A small piece of an ellipsoid, or a small piece of a paraboloid, taken near the pole, can hardly be distinguished from a sphere with the naked eye, but the difference is there, just the same, and is carefully utilized in practical equipment.

The Spherical Reflector. The spherical reflector has its focus at its center of curvature. When an object is placed at the center of the sphere, it will produce an image of itself, full size on itself. In other respects, the spherical reflector acts like a spherical lens, and it is possible to shift the position of the object and get images at different distances. However, at all distances other than the center of the sphere, there is a great deal of spherical aberration. Other aberrations appear when the object is at the focal point, and the object itself is

These drawings are cross-sections and, as shown, are plane figures. If rotated about the optical axis, the plane figures generate solid, three-dimensional shapes that are sections of a cone. Solid equivalents of the plane figures "circular," "elliptical," and "parabolical" are, respectively, "spherical," "ellipsoidal," and "paraboloidal."

Spherical Ellipsoidal Paraboloidal

larger than a theoretical point. Optically, spherical mirrors can only be used in lenses and telescopes by the use of elaborate correction devices: the Schmidt plate, the Maksutov corrector, or a modification of the shape of the mirror itself to a more nearly paraboloidal shape. The mirror then ceases to be spherical.

In its simplest form, the spherical mirror is used in projection equipment. If such a mirror is placed directly behind the projection lamp, with the lamp filament at its focus, then an image of the lamp filament will be formed at the same place. If the mirror is correctly adjusted, the images of the filament coils will fall between the actual coils themselves, and will be picked up by the condenser lenses just as if they were additional coils of lighted filament. Obviously, this will increase the total illumination available to the projector by almost twice as much.

The Ellipsoidal Reflector. The ellipsoidal reflector is used in projection systems, and to some extent in spotlights of certain special types. In projectors, it takes the place of the condenser lenses ordinarily used to direct the light through the slide or film to the objective lens.

The principle of the ellipsoidal reflector is simple. An ellipse has two focal points; any object placed at one focal point of an ellipsoidal reflector is imaged at the other. In practical lamps, only a small part of the entire ellipse is used, but this is ample for lenses of practical apertures. The ellipsoidal reflector can produce very large magnifications, and a relatively tiny filament, as, for instance, the 8-volt 50-watt lamp used in 8 mm movie projectors, is all that is needed. If this filament can be magnified sufficiently to fill the aperture of the objective lens, then the screen illumination will be just as great as that produced by a much larger lamp with the conventional condenser system. An ellipsoidal mirror has no spherical aberration per se, so the light will be quite uniform. The ellipsoidal mirror does have a fair amount of coma, which causes a spreading of light at the margins of the filament image; however, this is harmless, and some manufacturers claim it actually improves the marginal illumination of the projector.

Inevitably, the question arises: If the use of the ellipsoidal mirror, with a very small lamp (from 50 to 150 watts), produces as much screen illumination as a 500-watt or 750-watt lamp with conventional condensers, why could you not use such a reflector system with more powerful lamps, such as the 750-watt or 1000-watt lamp, and secure truly formidable light outputs? The answer should be clear from the above. The ellipsoidal reflector merely enlarges the image of a small lamp filament (which is just as bright as the larger filament of the big lamps) to equal the less magnified filament image of the larger lamp. If, then, a 1000-watt lamp is placed at the focus of an ellipsoidal reflector, the image of the filament will be much bigger than the aperture of the projector lens. Only the light that passes through the aperture of the projector lens can reach the screen; all the remainder of the enlarged filament image is wasted, and the screen illumination is no greater than it would be with a smaller lamp.

The Paraboloidal Reflector. The paraboloid may be considered to be similar in its action to the ellipsoid except that one of the two focal points is at infinity. Then, since a point light source placed at its focus is imaged at infinity, the light beam from a paraboloidal reflector, if everything is perfect, is parallel.

Paraboloidal reflectors are used with incandescent lamps, flashlamps, and electronic flashtubes; they are also used in searchlights that have arc lamps as the light source.

The beam of light from a paraboloidal reflector is only even approximately parallel when the light source is very small; with light sources of any appreciable size, there is some spreading of the beam. This is taken advantage of in flash reflectors; if a small flashbulb or flashtube is used in a deep paraboloidal reflector, the spread can be limited to, say, 40 degrees, which just about covers the picture area of an ordinary camera with its normal lens. A great deal of light that would otherwise be wasted is returned to the beam by such small, deep reflectors, and the light gain over a bare bulb can be as high as 10 times. Large light sources, such as the bigger flash lamps, are usually used in shallower reflectors, and the light gain is much less.

To some small extent, a paraboloidal reflector can be focused, and its beam spread adjusted accordingly. In most small electronic flash units,

however, this is not done. Instead, small, weak, negative lenses are supplied to be placed over the front of the lamp; they increase the beam spread to cover the picture area of a wide-angle lens, for example.

The Plane Mirror. A plane mirror can be considered to be a spherical mirror of infinite radius. This being the case, its magnifying power is zero, and its only purpose is to redirect a light beam and change its orientation (mirrors reverse images, for instance). In optical systems, mirrors (and prisms, which are the equivalent of glass plates) are used for just such purposes—the pentaprism of the single-lens reflex camera directs the image of ground glass to the back of the camera and turns it right-way-around at the same time. The swinging mirror of the SLR serves to turn the light rays to a vertical direction; it also inverts and reverts images.

Plane reflectors that more or less approximate mirrors are used in outdoor photography to redirect light beams as needed.

Sun Reflectors

Outdoors when only sunlight is available, it is possible to control the lighting and to produce highlight and fill-light effects by using reflectors.

Sun reflectors have to be large to be of much use. The reason is that, since the sun is 93 million miles away, it is substantially at infinity for optical purposes. Thus, a plane reflector will have little or no beam spread, and a reflected beam of sunlight from a mirror will be practically parallel. This means, though, that if you have a mirror a foot in diameter, the reflected light beam will also be a foot in diameter and will not cover much useful area.

In practice, the reflectors used by cinematographers are usually about 4 feet square; in use, they are held and aimed by an assistant. Although they can often be simply set up in place, the sun is constantly in motion and the beam may require frequent aiming. For convenience in transporting, these reflectors are usually made of two light wooden frames, covered with wall-board and hinged together so they fold to a 0.61 × 1.22 m (2′ × 4′) size, with the polished surface inward.

Cinematographers classify reflectors as "soft" or "hard." A soft reflector is simply painted with white paint and throws a general glow, useful for fill light in shadows. Because of the diffusion the beam is much wider than the reflector itself, but it is correspondingly less bright.

A hard reflector is made in exactly the same way, but its surface is covered with polished aluminum foil; it serves the same purpose as a mirror.

Reflectors intermediate between soft and hard are made by covering the reflector with foil that has been crumpled before applying. This scatters some light, giving a beam that is still fairly strong but somewhat wider in spread and less concentrated. Also, a painted reflector can be coated with aluminum paint instead of white paint to produce a soft reflector that is somewhat brighter than the white one.

A whole line of reflecting materials is available (supplied by firms like Rosco*) with which almost any kind of reflector can be fabricated. They have smooth foils, stippled foils, rough crumpled foils, and other textures. In addition, there are colored foils that are used for special effects; for instance, a gold-colored foil produces a warm, sunset type of light. Old-time cinematographers often used gold foil reflectors with black-and-white films to secure softer effects. With color films, the effect of gold, silver, and blue foils will be pretty much the same as the effect seen by the eye. In professional photography, the sun reflector is substantially obsolete; motion-picture companies generally carry large arc lamps and generator trucks for outdoor photography. The sun reflector still is useful to amateur and professional still photographers, though even here the use of fill-in flash has largely eliminated any need for reflectors.

Reflectors are used in studios in much the same way as outdoors. Large, vertical reflectors 1.22 × 2.44 m (4′ × 8′) are mounted on rollers and used both with studio incandescent lights and electronic flash to fill in the shadows. The umbrellas used with electronic flash are reflectors used to soften the light.

• *See also:* ARTIFICIAL LIGHT; ELECTRONIC FLASH; FLASH PHOTOGRAPHY; LIGHTING; MIRRORS; MIRROR LENSES; PROJECTORS.

*Rosco Labs, 36 Bush Avenue, Port Chester, NY 10573.

Reflex Camera

A reflex camera is one in which a mirror or prism system reflects the image from a lens for viewing or recording.

In a single-lens reflex camera, a mirror in the exposure path reflects the image to a screen for viewing and focusing; the mirror is moved out of the way in order to make the actual exposure. In a twin-lens reflex camera, a mirror-and-lens system provides an image for viewing, while a separate matched lens forms the image that is actually recorded on the film. Some document copiers and process cameras are reflex cameras in which image viewing is not the primary aim; rather, the reflex system is used to "fold" the optical path of the exposing beam for space-saving purposes.

• *See also:* CAMERAS; FOCUSING SYSTEMS; SINGLE-LENS REFLEX CAMERAS; TWIN-LENS REFLEX CAMERAS; VIEWING AND FOCUSING.

Reflex Copying

Reflex copying is a method of image or document reproduction in which no camera is required; exposure is made through the back of the sensitized material in contact with the original being copied. It is widely used in various office copiers and in photomechanical applications where same-size reproductions are required with minimum time and effort.

A sheet of sensitized material (the negative sheet) is placed with its emulsion side in contact with the document to be copied. This may be in a printing frame or on the platen of a copier. The exposing light passes through the back of the negative sheet and is reflected from the light-colored base of the original (see the accompanying diagram).

The negative sheet has a low-sensitivity, high-contrast emulsion that forms a developable latent image only in response to the additional exposure created by reflection from the original. When processed, the negative is reversed in tone and in

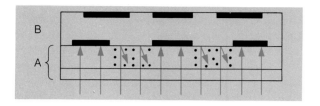

Exposure for reflex copying is made through the base of the negative sheet (A). Light is absorbed by the ink of the document being copied (B), but is reflected from the base wherever there is no image. The negative sensitivity is so low that only the additional exposure from the reflected light creates a latent image. Reflex exposure permits copying a document printed on both sides without interference between the two images.

left-right orientation in comparison to the original. A positive, right-reading image can be obtained by using the negative to make a print on another piece of sensitized material.

In practice, additional exposure and processing steps are not required. With materials such as Kodak PMT® reflex paper, diffusion transfer processing is employed to obtain negative and positive images simultaneously without further exposure. The exposed negative sheet is fed into a processor face-to-face with a receiving (positive) sheet. In a few seconds they emerge, held together by the activator solution, which their emulsions have absorbed. After 30 to 45 seconds, depending upon the materials used, they are peeled apart. The receiving sheet—which may have either a paper or a film base—has a positive, right-reading image. With some materials, the negative may be reused to produce additional copies.

• *See also:* DIFFUSION TRANSFER PROCESS.

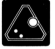

Refraction

Refraction is the bending of a ray of light when it passes the boundary between two optical media of different densities.

In illustration A, it is assumed that the line YY' is the flat surface of some optical medium—

glass, for example. Then the space N to the left is composed of air, the space N' to the right is glass. A ray of light, striking the surface so as to make the angle a to the perpendicular (or "normal") will be bent as it enters the glass and will no longer follow its original path (shown as a broken line). Instead, it is bent toward the normal, and makes a new angle, b, with it. In general, a ray traveling from a lighter to a denser medium is bent toward the normal, and of course, one traveling from a denser to a lighter medium will be bent away from the normal.

Obviously, in the case of a flat surface, the angles could as easily be measured from the actual surface. Most lenses, however, are not flat; they are sections of spheres, and in this case, it is easier to locate the normal to the surface, rather than the surface itself. Elementary geometry shows that the normal to a spherical surface is always a radius, drawn from the center of curvature, point C as shown in illustration B.

There is a simple relation that makes it possible to calculate the exact amount of refraction at any surface, and by means of which you can, with a few simple trigonometric formulas, calculate the path of a ray of light through any number of surfaces, of any curvatures.

This relationship is (illustration A):

$$N \sin a = N' \sin b$$

(A) A ray of light (R-R¹) striking a flat surface (Y-Y¹) at an angle will be bent from its original path (dotted line) to a new angle (b), which is closer to the normal. (B) With a spherical surface, it is easier to locate the normal to the surface than the surface itself; this is done by drawing a radius from the center of the curvature (C).

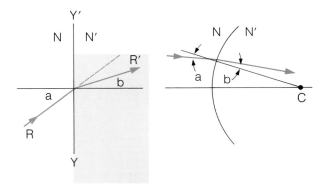

and the N and N' are known as the *refractive indexes* of the media in question. In glass catalogs, N is given for each type of glass, and in this case, it is always measured with respect to air as a standard. Strictly speaking, the standard should be a vacuum, which has a refractive index of exactly 1.000, but it is difficult to make the measurement in a vacuum. Since careful measurement shows that air has a refractive index with respect to vacuum of 1.00029, the difference is trifling, and in any case, is taken care of by the fact that the final lens will practically always be used in air.

• *See also:* LENSES; OPTICS.

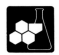 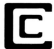 **Regeneration**

In photographic processing, regeneration of certain solutions is used to keep them at optimum activity. Regeneration differs from replenishment: In regeneration, the solution is actually restored to its original composition by chemical treatment; in replenishment, chemicals are merely added to an existing bath to maintain its level of activity, but the resulting bath will not be of the same composition as it was when first mixed. Regeneration is mainly used for certain bleaches in color processes. It is not possible to regenerate a developer, and only theoretically possible to regenerate a fixing bath.

Bleach Regeneration

In the color negative process C-41, the bleach can be continually regenerated within the processing tank by aeration. The oxygen in the air converts the reduced iron complex that results from the bleaching action—iron-2 (ferrous) complex to the iron-3 (ferric) complex—which makes the solution suitable for further bleaching use.

Despite the regenerative effect of aeration, some concentration changes occur as the bleach is used. Bleach is carried out of the tank by the film, and the bleach solution is diluted by carry-in of developer to the bleach tank. To restore the proper chemical balance, bleach regenerator must be added to the collected overflow.

Aeration of the machine-tank bleach solution with oil-free air is necessary for optimum bleach-

ing. Failure to aerate properly can create undesirable dye characteristics and increased amounts of retained silver on machines where the bleach is diluted or underreplenished. Proper aeration of the bleach-tank solution will provide:

1. Bleach solution completely oxidized. (Inadequate oxidation leads to increased ferrous ion concentration and eventually leuco cyan dye.)
2. Adequate bleach agitation for uniform development stopping action and optimum bleaching rate.
3. Complete oxidation of any developer carry-over into the bleach tank.

Bleach-Fix Regeneration

With the Kodak Ektaprint R-100 chemicals, bleaching and fixing take place simultaneously in one chemical solution called the bleach-fix. In this solution, metallic silver formed by development is converted to ionic silver, which is subsequently removed from the paper by the fixing agent in the bleach-fix.

The bleach-fix can be desilvered and discarded or it can be desilvered and regenerated for use as replenisher. In medium- and large-scale processing, the recovery of silver is profitable and helps to conserve a natural resource. Moreover, silver recovery may be necessary to meet water purification standards. Regeneration of the bleach-fix effects a saving in the cost of chemicals used, as well as reducing the amount of solution discharged into the drains.

The bleach-fix regeneration cycle comprises three steps:

1. Overflow from the bleach-fix processor tank is desilvered by the silver/iron replacement method.
2. The desilvered bleach-fix is then aerated to convert the iron-2 complex to the iron-3 complex.
3. Bleach-fix regenerator chemicals are added to the desilvered and aerated solution to make replenisher.

• *See also:* BLEACH-FIX; COLOR FILM PROCESSING.

Relative Aperture

The relative aperture of a lens is defined as $F \div D$, where F is the focal length of the lens and D the true aperture as explained below. This aperture value is correct, of course, only as long as the lens is focused on infinity; the error is very small when the lens is focused on fairly distant objects. When, however, you are photographing objects at close distances, the added extension of the lens causes a serious change in the values of the apertures, and at 1:1 or full-size copying, the difference amounts to two full lens stops.

In the great majority of camera lenses, the diaphragm is placed somewhere between the elements, and in all but retrofocus designs, the front element of most lenses is more or less strongly converging. Under these circumstances, the amount of light admitted by a given lens stop is greater than would be calculated from the actual diameter of the lens diaphragm. This can be seen from the accompanying diagram, where the actual diameter of the diaphragm is A, but the pencil of rays admitted by the front lens is D and is considerably larger.

Hence, it is not correct to try to deduce the aperture of a lens by measuring the actual diameter of the diaphragm. It is necessary, to secure the

In most lenses, the entrance pupil (D) is considerably larger than the lens diaphragm (A). Consequently, the amount of light admitted at D is greater than would be calculated from the actual diameter of the lens diaphragm.

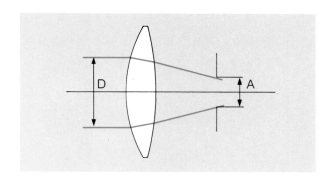

true value, to measure the *entrance pupil,* which is the diameter of the diaphragm as seen through the front element of the lens. This measurement is made in the laboratory by the use of a cathetometer telescope. A simple method for those not equipped with laboratory instruments is to focus the lens on infinity and place a very small light source at the focal plane of the camera. A parallel beam of light will be projected from the front of the lens and will form a circle on a piece of ground glass or tissue paper placed close to the front element; the diameter of this circle is the true aperture of the lens.

A great many different systems for numbering lens apertures have been proposed and used at various times and in various places. Today, only one has survived, and that is the well-known f-number system: Starting from $f/1$, the apertures proceed in steps of the square root of 2, and thus each aperture has half the area and admits half as much light as the preceding one. The scale is: 1.0, 1.4, 2.0, 2.8, 4.0, 5.6, 8.0, 11.2, 16, 22, 32, 45, 64, 90, 128.

A different scale, based on $f/9$, was used for a time in Europe, but the principle was the same, and the apertures merely fell between those of American and English scales. This system, though, made it possible to include such values as $f/3.5$ and $f/6.3$ in the series.

All other systems are obsolete and will not be encountered on any camera made today. There are, however, many old cameras, some of them collector's items, that used one of two fairly common systems, and for those who wish to try making some exposures with these old instruments, the apertures are listed below, and their values in the f-number scale.

The most common of these systems was known as the U.S. apertures (U.S. stood for *Uniform System,* not United States). U.S. markings will almost always be found on rapid rectilinear lenses. The scale begins with U.S. 1, equivalent to the modern $f/4$. Each succeeding U.S. number doubles to indicate an aperture that reduces exposure by one-half.

One other fairly common system was used on low-priced folding cameras having simple meniscus achromatic lenses ("landscape" lenses). Usually these were marked with a simple scale of 4 succes-

f-number	U.S. number	Simple lenses
4.0	1	—
5.6	2	—
8.0	4	—
11	8	1
16	16	2
22	32	3
32	64	4
45	128	—
64	256	—

sive numbers, as 1, 2, 3, 4, starting at the equivalent of the modern $f/8$.

• *See also:* DIAPHRAGM; OPTICS; T-STOP.

Rem-Jet Backing

Rem-jet (removable-jet) backing, which is used on certain films, is an exceedingly efficient antihalation layer. Because it is composed of colloidal carbon, it has antistatic properties as well.

Films with rem-jet backing are designed for machine processing. The machines provide for a film prebath that softens the backing, and they employ a scrubbing device that rubs the backing off the film before it enters the processing baths. Such films include professional color negative and print films used in motion-picture photography. Those color films intended for tank or machine processing, such as Kodacolor and Ektachrome films, have a different type of antihalation backing, usually a dye that is decolorized or washed out in processing.

It is not too easy to hand-process films with rem-jet backing. Even when it is completely removed from the base, the backing remains suspended in the solution. If any should deposit on the emulsion side and remain there after drying, it is not removable and will make a permanent black spot. For this reason, it is strongly suggested that amateurs refrain from attempting to process such films as Eastman color negative II film 5247 in Kodak Flexicolor chemicals.

Amateur astronomers may acquire Kodak spectroscopic emulsions on rem-jet-backed acetate

support (such as types 103a-O and 103a-F) instead of on the standard Estar base for these emulsions. The following instructions will be helpful to them in processing these films by hand.

Prior to its application to the support, rem-jet backing is a colloidal suspension of carbon particles. Having served its purpose, this backing must be removed completely. Three steps are essential to its removal:

1. Wetting with an alkaline solution to soften the binder.
2. Buffing or rubbing the back of the film to remove the softened backing.
3. Rinsing with water to remove any particles of backing from both the emulsion and base sides of the film before it enters the acid stop bath or acid fixer—both of which tend to harden the now-softened backing layer.

In commercial processing facilities, of course, rem-jet backing is removed in the automated processing sequence either by using an alkaline prebath before the developer or by using the alkaline developer itself. When manually processing, one must adapt this treatment to the length of film being processed and to the type of equipment being used—for example, tray or reel-in-tank.

An alkaline prebath of pH 9.3 can be prepared by dissolving 15 grams of borax and 100 grams of sodium sulfate in a litre of water. This pH is high enough to effectively soften the backing but not sufficient to initiate development in the emulsion layer. Under proper darkroom safelight conditions for the product being processed, soak the exposed film in the prebath at 18 to 22 C (64 to 72 F) for several minutes. While it is in the prebath, rub the base side of the film with a gauze or cotton swab to hasten removal of the rem-jet backing. Use a water-spray rinse or rinse in running water for a few seconds before transferring the film to the developer solution.

If a prebath is not used, gently rub the base of the film with a gauze or cotton swab while it is in the developer. Here again, use a water-spray rinse or rinse in running water to remove any loosely adhering backing particles from both the base and emulsion sides of the film before transferring the film to the acid stop-bath solution. Note that the carbon particles do not dissolve but remain in particulate form. Therefore, it is advisable to filter the developer solution before using it again or, preferably, to discard it so that backing particles suspended in the developer will not contaminate other films processed later.

Before hanging up the film to dry, inspect it for traces of stubborn carbon particles. Such spots can usually be removed with a soft swab moistened with methyl or ethyl alcohol. Remember to work carefully because the emulsion layer is still soft and can be damaged. Note that if rem-jet backing is to be removed from only an occasional piece of film, it can be removed with methyl or ethyl alcohol before development, without an alkaline prebath.

Finally, this reminder to users of Kodak spectroscopic films: These films do not have a hardened emulsion; be sure all solutions and washes do not exceed a temperature of 22 C (72 F).

• *See also:* PROCESSORS.

Replenishment

For small-scale, infrequent processing, it is best to use a fresh developer for each roll of film and to discard the used solution at once. This avoids any chance of non-uniformity from roll to roll and is probably the safest method, especially where valuable pictures are concerned.

However, the photographer working on a large scale will find it necessary to maintain a large tank of developer to handle many films at one time; such a quantity of chemicals cannot be economically replaced at short intervals. A large tank of developer, used over a period of time, suffers a gradual loss of activity due to depletion as well as to the accumulation of bromides and other by-products of the reaction. This loss of activity depends upon a number of factors, including the amount of film processed, the amount of developer surface exposed to the air, and to a lesser extent, even the nature of the negatives developed; overexposed images deplete a developer more rapidly since more silver is reduced. If, then, results are to be consistent day to day, some method of maintaining the activity of

the developer at a constant level must be employed. The usual method is to add measured amounts of a replenisher bath at specific intervals.

Factors Affecting Replenishment Systems

Replenishment systems depend upon a number of factors:

1. Loss of developer volume due to carry-out on processed film.
2. Increase of developer concentration due to evaporation of water.
3. Loss of developer activity due to exhaustion of developing agents.
4. Loss of developer activity due to liberation of soluble bromides from the processed film.

Of the four factors, the second—evaporation loss—is usually ignored, because it is very small in proportion to the others with moderate temperature processes. The remaining factors have to be taken into account.

If very much developer is lost by carry-out, it may be replaced with an equal quantity of fresh developer. In most systems, though, drainage or squeegeeing is employed to minimize carry-out; thus, it is often necessary to *remove* some developer from the system at intervals to make room for replenisher.

The design of a replenisher, then, depends mainly upon the last two factors. Loss of developer activity due to exhaustion of developing agents may be compensated for by the use of a replenisher that contains a larger-than-normal quantity of the developing agents than the original formula. Loss of activity due to accumulation of soluble bromides is compensated for by the omission of bromide from the replenisher.

Replenisher Composition

The exact composition of a replenisher, though, depends upon the system in which it is to be used. In automatic processing machines, a metering device automatically removes a definite quantity of used developer from the tank and replaces it with replenisher in a quantity sufficient to maintain the correct level of solution in the tank. In such systems, equilibrium is maintained by

periodically developing a test strip and measuring the gamma obtained. If the gamma is found to be diminishing, the replenisher system is adjusted to feed more replenisher and drain off more used developer. If, on the other hand, the gamma is rising, then less replenisher is fed and less developer runs to waste. Obviously, such a system can only be maintained where complete sensitometric control is available, as in a motion-picture developing laboratory or a large photofinishing plant.

For the average professional photographer, whose daily requirements are more modest, the replenisher formula is designed on a slightly different basis; its strength is adjusted so that it is only necessary to maintain the level of the tank by periodic additions of replenisher. The amount of replenisher added, then, is dictated by the amount of film processed and the quantity of developer carried out of the tank by the film. Under normal circumstances, this simple system can maintain a fairly constant level of developer activity for a period of several weeks. Generally, such systems are maintained on a periodic basis; replenishment is carried out for a limited time, generally until a quantity of replenisher equal to the original volume of the basic bath is used up. As an example, using a standard 3½-gallon tank, when 3½ gallons of replenisher have been used up, the system is drained and refilled with fresh solution.

Such a system cannot be maintained indefinitely, and this periodic refilling is essential. This is because the build-up of soluble bromides from the film eventually reaches a point at which loss of shadow detail becomes serious. Even if the replenisher contains no bromide at all, not enough old developer is being carried out of the tank, and the bromide level increases to an unacceptable degree. Furthermore, since recirculation is usually not used in small tank systems, there is no continuous filtering of solutions; eventually dirt and sludge in the developer tank reach a concentration that demands removal and cleaning.

For most consistent machine processing, it is common to "prime" a fresh tank with a portion of old developer added to the new. A developer that is being continually replenished is not the same in composition as either the original developer or the replenisher. There is a point at which the system stabilizes, where soluble bromide levels, developing

agent exhaustion, and other factors reach a desirable level. If, then, a machine with a fresh bath is started up, it will, until it becomes stabilized, produce either excessive contrast, excessive density, or both. Although it is possible to analyze a used developer and devise a formula for a starting bath that corresponds to it in activity, plants that do not have analytic facilities simply start each new run with about one-quarter of a tank of old developer, filled to level with fresh bath. The old developer is, of course, thoroughly filtered before being put back into the tank.

Where analytic facilities are available, the ideal system would be to analyze the developer at frequent intervals and to add then a specially formulated replenisher designed to bring the solution back to its normal composition. This is done, in fact, in the largest motion-picture processing plants, but it is not practical on a small scale.

• *See also:* DEVELOPERS AND DEVELOPING; DEVELOPMENT; FORMULAS FOR BLACK-AND-WHITE PROCESSING.

Reproduction Ratio

The relationship between the size of an image and the size of the original object (or document) is called the reproduction ratio. It is always stated in the order, *image size:object size.* For example, if a copy negative contains an image 75 mm (3 inches) long of a print that was 225 mm (9 inches) long, the reproduction ratio is 75:225, or 1:3. (This may also be expressed as a scale, or magnification, of ⅓X or 0.33X. All three designations have the same meaning.) If the original being copied were only 25 mm (1 inch) long—a slide perhaps—reproduction ratio would be 75:25, or 3:1 (magnification = 3X). A ratio of 1:1 indicates that the image and the object are the same size; this is called life-size reproduction.

True Reproduction Scale

In photography it is important to distinguish whether the ratio refers to the image size in a

REPRODUCTION RATIO AND EXPOSURE COMPENSATION			
Reproduction Ratio	Scale or Magnification	Percent Reproduction	Exposure Compensation*
1:20	1/20X (0.05X)	5	—
1:15	1/15X (0.067X)	6.7	—
1:10	1/10X (0.1X)	10	—
1:5	1/5X (0.2X)	20	1.4X
1:4	1/4X (0.25X)	25	1.6X
1:3	1/3X (0.33X)	33	1.8X
1:2	1/2X (0.5X)	50	2.3X
1:1.5	1/1.5X (0.67X)	67	2.8X
1:1	1X	100	4X
1.5:1	1.5X	150	6X
2:1	2X	200	9X
3:1	3X	300	16X
4:1	4X	400	25X
5:1	5X	500	36X
6:1	6X	600	49X
7:1	7X	700	64X
8:1	8X	800	81X
9:1	9X	900	100X
10:1	10X	1000	121X

*The indicated increase provides compensation only for the degree of magnification; additional exposure may be required to compensate for filtration, reciprocity, and other factors. These increases are for simple or symmetrical lenses. Compensation for other lenses should take into account their pupillary magnification. (*See:* MAGNIFICATION.)

negative, or in an enlarged print. For example, a photomacrograph that records an insect at twice life size (2:1) on a negative provides a reproduction ratio of 16:1 when the negative is enlarged 8× in a print. For a further discussion of this and other important factors in determining the true scale of reproduction, see the article MAGNIFICATION.

Exposure Compensation

In close-up and copy photography, the reproduction ratio recorded in the camera determines the exposure compensation required. As the accompanying table shows, additional exposure is required results at ratios beyond about 1:5.

Percentage Reproduction

In graphic design, layout work, Photostat machine copy, graphic arts photography, and copy photography, it is common to mark the original with the percentage size that is desired in the reproduction. For example: A 1:1 copy reproduces the original at 100 percent of its size; a 1:2 copy is a half-size, or 50 percent, reproduction; a 2.5:1 copy is two-and-a-half times, or 250 percent, larger. This system avoids arithmetic errors and eliminates the need to measure the image size in the camera for every exposure. Most cameras designed for this kind of work are marked with percentage settings so that a desired reproduction ratio can be achieved quickly, regardless of the actual dimensions of the original.

• *See also:* MAGNIFICATION; SCALING PRINT SIZES.

 Resin-Coated Papers

Resin-coated papers, also known as water-resistant papers, are made by coating the paper base on both sides with a resin layer. The coating on the emulsion side, which replaces the baryta coating on conventional papers, is pigmented white, or the same color as the paper tint. This pigmenting is unnecessary on the base side. Water does not penetrate the resin coating, and thus the conventional processing of resin-coated papers requires a shorter time.

Because the fixer solution, with its dissolved silver-salt content, does not penetrate the paper base, the wash time is shortened considerably—to 4 minutes. The developing and stop bath times are essentially the same as for conventional papers. The fixing time, however, is typically reduced from 10 minutes to 2 minutes.

The big saving in processing time for water-resistant papers occurs in the washing step. Instead of the minimum of an hour wash for conventional papers (10 minutes with hypo clearing agent), a 4-minute wash time is recommended, in which time prints attain optimum stability. Further, prints made on water-resistant papers air-dry much faster than prints made on conventional papers.

Accelerated aging tests indicate that, when storage conditions are carefully controlled (approximately 21 C [70 F], 50 percent relative humidity, and infrequent exposure to light), prints made on resin-coated papers should last as long as prints made on conventional papers. However, these tests also indicate that when prints are displayed for long periods (several years) or displayed in direct sunlight, or stored under uncontrolled environmental conditions, non-resin-coated papers can be expected to have a longer useful life than resin-coated papers. Therefore, non-resin-coated papers are recommended for long-term display and for long-term storage.

Repeated display of prints made on resin-coated paper to alternate periods of sunlight and darkness and to varying relative humidity conditions, can shorten their life considerably. Absorption of radiant energy reduces the moisture content of the emulsion layer, and reabsorption of moisture can occur during the dark period. This causes severe stress, which produces repeated dimensional changes in the emulsion layer and paper base. These changes can, in turn, hasten a degradation process and can eventually produce cracks.

In addition to protecting the paper base from absorption of processing chemicals (thus permitting easier working), the resin layers restrict the flow of gases. When prints are stored or displayed in a confined atmosphere (such as being framed under glass), any oxidants present may react with the silver and result in image discolorations. Such oxidants might result from the environment, resid-

ual processing chemicals, adhesives used in frame construction, cleaning agents, or base degradation. Whenever prints are to be stored or displayed in this manner, it is recommended that they be toned or treated in gold protective solution.

• *See also:* PAPERS, PHOTOGRAPHIC; PRINTING, PHOTOGRAPHIC; PROCESSING FOR PERMANENCE; RAPID PROCESSING.

Resolving Power

Resolving power, or resolution, is a measure of the ability of a lens to image, or an emulsion to record, fine, closely spaced subject details distinguishably. It is measured by observing or photographing resolution charts (targets) under exacting test conditions. Emulsions are usually exposed to the image of a resolving-power target made by means of a highly corrected lens. Although resolution figures are given in the literature individually for various lenses and films, it is the overall definition of a given lens-film (and processing) combination that has the most practical meaning for the working photographer. In conventional photography, both films and lenses affect resolving power.

Resolution is only one of several factors that contribute to the overall impression of clarity (definition) in a photographic image. Other measures include detail contrast, graininess and granularity, acutance (sharpness), and the system modulation transfer function. These are discussed together in the article SHARPNESS.

Resolution Charts

The charts or targets used to measure resolving power have several series of groupings of parallel lines. A typical three-bar chart is illustrated in the accompanying diagram; a five-bar chart was used for the actual emulsion test shown. The intervening spaces are the same width as the lines in each group, and a line-space pair constitutes a "line" in the target. The targets may be

(Left) A standard resolving-power test object. (Right) An enlarged view of the film images of a five-line resolving-power target as imaged by a photographic lens. Astigmatism causes the resolving power to be slightly higher for radial lines (A) than for tangential lines (B).

Resin-Coated Papers

Two typical resolution test charts. The numbers in chart at left represent lines per mm when copied at 12× magnification. The numbers in chart at right represent lines per mm on the original chart itself.

reflection targets—black lines on white paper—or may be transparent targets, which are images made on high-contrast film. The latter are generally used unless the lens and/or film being tested is to be used for copying documents.

Each grouping differs in size from the next smaller and the next larger by a constant factor, such as $\sqrt{2}$ (1.414), for example. The charts are imaged at great reduction—which requires precise adjustment of lens-target distance for accuracy—so that the lines become equivalent in size to patterns of so many lines per millimetre. Most charts have numbers printed on them so that the resolving power in lines per millimetre can be read directly when the results are evaluated; other charts provide data from which resolving power can be calculated from the image reduction.

When an emulsion is being evaluated, it may be sufficient to image only a single resolution chart; multiple charts are required for measuring the resolving power of a lens. Lens performance

varies across the field of coverage, and resolution is usually significantly less at the edges of the field than at the center. In addition, aberrations may selectively differ for radial lines (those parallel to "spokes" radiating outward from the center) and tangential lines (those at right angles to the radials). An X-like array of targets permits these factors to be measured with a single exposure. It is essential that the target plane and the film plane be absolutely parallel.

Lenses may be tested through red, green, and blue filters so that the resolution and primary colors can be measured individually.

Evaluating Resolving Power

The processed results are viewed through a low-power microscope in order to identify the smallest group in which the bars are clearly distinguishable from the spaces. The resolution of that group is the reciprocal of the actual width of one bar in the exposing image plus the width of one

space. For example, if a bar in the smallest resolved group has an image width of .025 mm, the space has an equal width, and the calculation is:

$$R = 1 \div (0.025 + 0.025) = 20 \text{ lines per mm}$$

Since it is costly to actually measure bar width in the image falling on the emulsion, resolution is calculated from the known image reduction and original group size or, as noted previously, is read directly from numbers on the chart.

In some cases, as the groups get progressively smaller, one will be completely blurred, only to be followed by a smaller group in which bars and spaces can be distinguished. This is spurious resolution, and it can be identified by the fact of the intervening blurred group, as well as by counting the number of visible bars. Because of lens aberrations, this group will have one more bar than the actual test-chart group. The true resolution is indicated by the larger group just before the one that is blurred.

Factors Affecting Resolution Measurements

It is assumed that tests are performed with precise optical alignment, fresh materials and solutions, and properly calibrated meters. The resolving-power value of a film depends on the contrast of the test target, the exposure, and to some extent upon the development. Resolving powers for films are generally given in terms of the maximum achieved with the manufacturer's recommended exposure and processing. Figures for lenses have meaning only when the test film and processing method are identified.

Resolution falls off greatly at high and low exposure values, reaching a maximum at some intermediate value; it is for this exposure that resolving-power figures are given. Obviously, the loss in resolution that accompanies under- or overexposure is an additional reason for exposing pictures as close to correctly as possible.

Resolution is dependent on the contrast of the image, hence the contrast of the target itself. It is usually measured with both a high-contrast and a low-contrast target. The luminance ratios of the targets used to evaluate Kodak films are 1000:1 and 1.6:1. Resolution is always higher when the image contrast is higher. Film data sheets include values for both kinds of targets because actual photographic subjects are more nearly low- than high-contrast. The accompanying table gives descriptive terms for high-contrast resolving-power values.

RESOLVING-POWER CLASSIFICATIONS FOR *KODAK* FILMS*

Low	50 lines/mm or below
Medium	63, 80 lines/mm
High	100, 125 lines/mm
Very high	160, 200 lines/mm
Extremely high	250, 320, 400, 500 lines/mm
Ultra high	630 lines/mm or above

*High-contrast (1000:1) target.

System Resolution

A lens, the camera body that holds it in alignment with the film, and a given emulsion form a photographic system. It is their combined performance that determines the quality of the final image. The maximum resolution that you can obtain in practical photographic work is limited by the camera lens as well as by the film, and is lower than either one alone. The formula often used to predict the resolution of negatives is:

$$\frac{1}{(R_S)^2} = \frac{1}{(R_F)^2} + \frac{1}{(R_L)^2}$$

R_S = Resolution of the system (lens + film)
R_F = Resolution of the film
R_L = Resolution of the lens

In practice, other real factors, such as camera movement, poor focus, and aerial haze, also decrease resolution from the possible maximum.

• *See also:* ACUTANCE; SHARPNESS.

Restoring Photographs

Photographers are often asked to copy and restore old or damaged pictures that are in poor condition due to age, damage, or other causes. Originals submitted for restoration vary greatly. Some are old, faded, stained, cracked, or torn photographs. Some are cracked or broken glass negatives or transparencies. Others are film negatives damaged in processing or in some other way. Wedding pictures, for example, are irreplaceable; if the negatives are damaged, restoration must be undertaken.

Each type of original must be prepared carefully and then copied by a method that will yield a printable negative. Restoration involves a considerable amount of skillful negative retouching and print finishing to get a presentable result. If you are not skilled in this work, you may find it more economical of your time and effort to send it to a specialist.

Preparing the Original

Before taking any step to prepare an original for restoration, make a good copy negative from it as insurance against loss or damage in subsequent treatment.

To prepare the print, clean it carefully with a wad of cotton moistened with a solution of 1 part denatured alcohol and 1 part water. Marks and stains that do not come off easily with this treatment should be let alone; you may do more harm than good by trying to remove them at this stage.

If an unmounted original is cracked, wrinkled, or torn, mount it on a piece of card. A badly damaged print is best mounted with a mounting cement, rather than being dry-mounted. It is easier to smooth out wrinkles and match torn edges by using a liquid mountant. If the original is already

mounted and the mount is cracked or broken, do not attempt to strip the print from the mount. However, if the old mount is torn or broken, you can feather the torn edges slightly to help bring the torn parts of the picture together.

At this stage, tone down any white or light spots on the original to match the surrounding image tone.

Making the Copy Negative

Make the best possible copy negative from the prepared original. A suitable film, developer, and filter—if one is needed—can be selected from the accompanying table. For example, if the original print has faded to an overall yellowish brown, a good negative can be made on a high-contrast, blue-sensitive film. If the image is very faint, however, use a high-contrast, ortho-sensitive film with a blue filter, and process for moderately high contrast. To make retouching easier, the negative should be as large as convenient, say, 5″ × 7″. Marks and cracks that will be too dark on the print should be retouched with dye or pencil. Marks that are dense on the negative will print white; they are best finished on the print.

Finishing the Print

Make an 8″ × 10″ print on an N-surface, conventional-base paper with a semi-matte surface. This surface is suitable for both finishing and copying. The print should be fairly low in contrast and a little darker than normal. Finish the print carefully to remove all spots and marks. In some cases, airbrushing aids in smoothing out large areas, adding clouds to a sky, or making a background.

One of the main difficulties in restoration work is to finish a print with a partially obliterated face and still preserve a reasonable likeness of the sitter. Before you undertake to restore a portrait, talk to the customer to find out what is expected and to make him or her aware of what can or cannot be done to restore a true likeness. Facial expression is contained in the eyes and mouth. If these features are intact, do as little finishing on them as possible. Confine your work to removing spots and strengthening detail.

When parts of the eyes or mouth have been obliterated, it is easy to make the face appear very

FILMS, DEVELOPERS, AND FILTERS FOR COPYING

Type of Original	Film	Development	Filter
Continuous-tone black-and-white	Blue, ortho, or pan	Medium contrast	None
Prints faded to overall yellow	Blue or ortho	Moderately high contrast	None; blue (with ortho film)
Black-and-white image with faded yellow patches in black	Pan	Medium contrast	Blue
Black-and-white combined line and continuous tone	Blue or ortho	Medium to high contrast	None
Prints stained with colored material, such as ink or dye	Pan	Medium contrast	Use deep color filter of same hue as the stain
Daguerreotypes	Ortho	High contrast	None
Ambrotypes (collodion positive on black background); Tintype or ferrotype	Ortho	High contrast	None

different from what the customer expects. It is a good idea to finish these features first, and then show the result to your customer. He may be able to offer some suggestions that will enable you to improve the likeness. At the least, he will be aware of any difficulty before he sees the finished result. Finally, make a copy negative from the finished print. You can then make any number of prints in the size or sizes the customer wants.

Cracked or Broken Glass Plates

If the glass plate is merely cracked, tape it to a piece of clean glass; if the plate is broken in several pieces, bind it between two sheets of glass.

If the original plate is a negative, place it in an enlarger and make a print on a semi-matte conventional-base paper. This print should be suitable for copying. Finish the print and make a further copy negative in the manner described for restoring old and damaged prints.

• *See also:* AIRBRUSH; COPYING; RETOUCHING.

Restrainer

A restrainer, usually potassium bromide, is commonly used in development to reduce the formation of chemical fog, which is silver produced by action of the developer on unexposed silver halide. The bromide also assists in producing more uniform development. Although the addition of

potassium bromide to a photographic developer may affect the rate of development of the image, it usually depresses the rate of fog formation to a greater degree than the rate of development. As a result, more efficient development is obtained.

The chemical action of potassium bromide is quite complex and cannot be fully explained without considering in detail the proposed theories of photographic development. However, the general course of the action seems to be as follows:

1. When the photographic material is placed in the developer solution, bromide ions are formed by the ionization or dissociation of the potassium bromide in the developer solution.

2. These ions adsorb—that is, become attached—to the surfaces of the silver halide crystals.

3. The presence of these bromide ions (Br^-) on the crystal surfaces helps to keep the developer from attacking the unexposed silver halides, and therefore helps to retard fog formation.

Developer additives for additional control of fog are called antifoggants; they act by restraining the activity of the developing agents. Several organic compounds are now commonly used, the most common being benzotriazole and 6-nitrobenzimidazole nitrate. These restrain fog, especially on printing papers, without causing a change of image color to an unpleasant greenish black, which

Restoring Photographs

may result with the addition of excess potassium bromide.

Negative developers seldom require organic antifoggants, except when Phenidone is used as a developing agent, or in certain metol-hydroquinone formulas intended for use at higher-than-normal temperatures.

• *See also:* ANTIFOGGANT; CHEMISTRY OF PHOTOGRAPHY; DEVELOPERS AND DEVELOPING.

 Reticulation

Reticulation is a distortion of the emulsion layer of a film, characterized by an irregular surface pattern of wrinkles. The pattern is produced by swelling and buckling of the emulsion when it is subjected to extreme temperature variations in processing. For instance, when too high a developer temperature is used and the soft, swollen emulsion is plunged into a cool fixing bath, the emulsion quickly shrinks back to its original state. The drastic change causes reticulation. This ruins the film for normal photographic purposes.

However, reticulation can enhance some photographs with the texture that it adds. The texture can add interest, particularly to photo-graphs having strong design with large plain areas. It can also enhance the mood of a scene, such as a seascape or a sunset.

Because reticulation is undesirable unless you are trying to produce special effects, photographic manufacturers have worked to improve films so that they resist reticulation. In the past, reticulation occurred often and easily if the temperature of the processing solutions varied slightly. Today, black-and-white and color films have been improved so much that moderate variations in temperature will not damage film or cause it to reticulate. It is necessary to create extreme temperature changes during processing to achieve reticulation.

Since the techniques described in this article are strictly experimental and the film might be ruined in the process, it would be a good idea to copy your original photograph and reticulate the copy negative or slide.

Reticulating Black-and-White Films

A little knowledge of the film's structure and what happens during processing can help you to obtain successful results with reticulation.

A black-and-white negative is composed basically of grains of silver suspended in a gelatin emulsion and spread on a clear plastic base. When

A print made from Tri-X pan film, which was reticulated using the process described. Photo by Bob Clemens and Frederick C. Enrich.

To make this picture, Kodak Ekta-
chrome-X film was reticulated to
produce a marble effect and then
frozen for 15 minutes. Photo by
Frederick C. Enrich.

(Above) Kodak Ektachrome-X film was reticulated by the dou-
ble prehardener method and 15 minutes freezing. Photo by
Frederick C. Enrich. (Right) Reticulation is most effective in
photographs of strong design with large, plain areas such as
these windows. Photo by Bob Clemens and Frederick C.
Enrich.

the film emulsion is wet, it becomes very soft. A
hardener is usually included in the fixer to harden
the emulsion and make it less fragile. Extreme
changes in temperature while the film is in its
softest state will cause uneven swelling and shrink-
ing of the gelatin and produce a relief pattern in
the emulsion called reticulation.

Try such films as Kodak Plus-X pan or Kodak
Tri-X pan for reticulation.

Reticulation

In total darkness:

1. Develop the film according to the film or developer instructions.
2. Rinse the film in an *acetic acid* stop bath for 1 minute at a temperature of 60 to 65 C (140 to 150 F).
3. Immerse the film in a cold water bath below 4 C (40 F) for 1 minute.
4. This step is optional; it emphasizes the reticulation pattern of the emulsion, but does not change the pattern. It just makes it more prominent. Immerse the film in hot water at 80 to 90 C (about 180 to 190 F) for 1 minute. Then quickly immerse it in another cold water bath below 4 C (40 F).
5. Fix the film in the normal way with a fixer that contains a hardener, such as Kodak rapid fixer.
6. Wash the film in running water for 20 to 30 minutes.
7. Do not use a wetting agent, such as Kodak Photo-Flo solution. Dry the film quickly with a portable hair dryer. Lay the film emulsion-side up on a clean, lintless cloth and direct the warm air back and forth across the surface of the film. You can also freeze the film before drying or when it is partially dry.

Reticulating Color Films

Color films have essentially the same structure as black-and-white films, but they are more intricate because they contain many layers of emulsion. Three emulsion layers that are sensitive to blue, green, and red light are coated on a clear plastic base to make color film. The yellow, magenta, and cyan color dyes that the respective emulsion layers produce are developed along with the silver while the film is in the color developer.

Heating and chilling the film affects these layers differently, and the top yellow dye layer is affected the most. Because the layers react differently during the reticulation process, a reticulated negative or slide will show a slight shift in color balance.

With color negatives, you can compensate for this shift during the printing process. With color-

Since reticulation is strictly experimental, it is best to copy the original photograph and then reticulate the copy. The reticulation on this color slide was processed by the double prehardener method and then frozen for 15 minutes. Photo by Frederick C. Enrich.

slide films, the color change must be compensated for when the film is exposed in the camera if you want the final slide to show a normal color balance.

There are two ways to reticulate negative films and each method produces different reticulation patterns:

1. Reticulating the film before processing produces a fine pattern of black lines marbled throughout the image.
2. Reticulating the film during processing gives a coarse pattern with tiny patches of yellow visible when the pattern is examined closely. These

patches indicate that the yellow dye layer has reticulated to a much greater extent than the magenta or cyan layers. Follow the same steps given earlier to reticulate the film during processing.

• *See also:* ERRORS IN PROCESSING.

Retouching

Broadly speaking, all the handwork that is done on negatives, prints, or transparencies is called retouching. The object of such handwork may be as simple as hiding pinholes or scratches, or as complex as the total reconstruction of major areas of a photograph. The art of retouching lies in doing these things in such a way that the photographic quality is not altered, and the work does not show in the final image.

Before beginning, the retoucher must be able to evaluate the existing image and to predict the effect of retouching on the finished work. The best way to learn retouching is to take a course of instruction under a skilled retoucher. Retouching calls for visual and mechanical skills that are difficult to acquire simply through reading instructions. The rudiments are best learned with the aid of a teacher. Proficiency then comes by constant practice.

The retouching techniques outlined here for black-and-white materials are generally applicable to a wide range of currently available films and papers. As new products are introduced, the techniques may have to be modified to suit thinner and harder emulsions or improved surfaces and substrates.

Because of their greater complexity, color materials require closer adherence to the manufacturer's recommendations for retouching techniques. When in doubt as to the technique to follow, consult the manufacturer. The color retouching procedures detailed here are those found generally useful with Kodak materials current at the time of this writing. They *may* also be useful for work with other color materials.

While transparencies can generally be retouched satisfactorily for viewing purposes, the same techniques may not yield acceptable results for photomechanical reproduction. No attempt has been made to detail the dye retouching techniques required for such transparency use.

Black-and-White Negatives

In retouching black-and-white negatives, it is helpful to examine a proof print before starting to work on a negative. In this way, you can judge the amount of handwork that needs to be done. Also, it is helpful to have a print made afterwards so that you can see the effect of your work.

Equipment and Materials. The following equipment and materials are needed for retouching black-and-white negatives:

Retouching desk
Etching knife
Retouching fluid
Several retouching-pencil holders
Leads (for above) varying from 2B to 3H
Farmer's reducer
Abrasive reducer
Spotting and coloring brushes
Red dye such as new coccine (Kodak crocein scarlet)
Green filter
Opaque (black or red)
Cotton (sterile not necessary)
Emery polishing paper, 4/0
Sandpaper, 4/0
Colorama pencil no. 8001
Film cleaner
Cotton gloves

Obtain or construct a retouching desk. This should contain a 60-watt blue-daylight bulb. Use a reflector or paint the inside surfaces of the desk to distribute the light evenly through the negative. A sheet of opal glass is required between the light source and the negative, with a sheet of heat-absorbing glass between the light source and the opal glass. The heat-absorbing glass helps to prevent heat from the lamp from reaching the negative. To reduce eyestrain due to extraneous light, tape a cardboard mask of suitable size to the opal glass. Do not attempt retouching in a completely darkened room because this causes rapid eye fatigue. Adjust the angle of the retouching desk and the height of your chair to find a

comfortable posture; working in a strained or stooped position is tiring.

Removing Density. Negative density may be removed by etching or "knifing," abrasive reduction, or chemical reduction.

Etching. Place the negative, emulsion up, on the retouching desk, and examine it carefully to see if there are any dense spots that need to be reduced with the etching knife. There may be blemishes or other skin imperfections in a portrait negative that appear as dense spots; shave these areas down until they match the density of the surrounding skin tone.

If there is more than one catchlight or reflection in the eyes, it is customary to remove all but one in each eye. It is preferable to leave the catchlight positioned at 1 o'clock or 11 o'clock, depending on the placement of the main light. Make sure that the catchlight is in the same position in both eyes; otherwise, the eyes may appear to be crossed.

In some cases, it is desirable to modify the shape of certain features, such as a too prominent or crooked nose, a double chin, or perhaps a bulging neckline. To do this, use a knife to remove sufficient density to obtain the desired shape or line. Reflections in eyeglasses can also be etched or shaved down until they match the density of the surrounding area.

To sharpen the etching knife, use 4/0 emery polishing paper, and stroke firmly. Place the polishing material on a pad of paper, not on a hard surface. A really keen blade is necessary for good etching; otherwise, the results may be scratchy. If you inadvertently obtain a scratchy effect, the unevenness can be minimized by first rubbing the affected area with an abrasive reducer, and then spotting-in with pencil or dye.

(Left) An unretouched portrait. (Right) After retouching, reflection at hair line and from eyeglasses has been eliminated. Shine on nose and double eyelights have been corrected. Natural character lines and wrinkles have been softened while remaining natural for a mature, male subject.

Abrasive Reduction. Pick up a small amount of the abrasive reducer on a tuft of cotton. Before applying this to the negative, work it into the cotton by rubbing it on a glossy surface such as a piece of glass, and then lightly rub the area to be reduced until the desired density is obtained. Take care not to over-reduce; too little is better than too much. To reduce small areas, apply the reducer with a twist of cotton on the end of an orange stick. To prevent print-through of knife marks where a negative has been etched, rub the area gently with abrasive as described above.

Abrasive reducer can also be used to remove unsatisfactory pencil work from local areas, as well as scum and fine scratches from the negative surface. When the work is complete, remove any excess reducer with a tuft of clean cotton.

Chemical Reduction. For controlled reduction of either large or small areas, particularly when detail must be preserved, Farmer's reducer is recommended.

Store two-part Farmer's reducer solutions in separate stoppered containers. When you have mixed a working solution, use the reducer immediately, because the working solution remains active for only a few minutes. Once the reducer becomes exhausted, discard it and mix a fresh solution.

Tape the negative to the glass of the retouching desk or an illuminator with the emulsion side upward and in a convenient position for working on the area to be reduced. With a ball of cotton moistened with water and a wetting agent, gently sponge the whole surface of the negative for about 2 minutes. Squeeze the excess water from the cotton, and then wipe away the water droplets from the area to be reduced. If the area is small, pick up the reducer on a brush; if the area is large, use the reducer on a ball of cotton on the end of an orange stick. Remove the excess from the brush or cotton; then apply the remaining solution over the area to be reduced with a continuous movement. To stop the reducing action, pick up the reducer with several applications of water-moistened cotton. Observe the progress of reduction, and sponge the *entire* negative with clean water at regular intervals to prevent water spots. Repeat the procedure until the desired degree of reduction is obtained. Take care not to over-reduce; otherwise you may need to restore the density with pencil or

dye. Wash the negative for 10 minutes in running water, bathe it in a wetting solution, and hang the film up to dry.

NOTE: For uniform results when sponging or picking up dye and chemicals, moisten a ball of cotton with a wetting solution.

Adding Density. Negative density may be added by using either dye retouching or pencil retouching techniques.

Dye Retouching. Dye retouching is usually done before pencil work and after chemical reduction. Therefore, you must decide before starting the work which procedure you intend to adopt. Density can be added to large areas of a negative more quickly and easily with dye than with pencil. Furthermore, dye work is less obvious on an enlargement from a small negative than is pencil work. In portrait retouching, density can be added to the highlights on cheeks, forehead, and chin to give extra brilliance to the picture. Also, density can be added to weak shadow detail to get better printing quality in thin parts of a negative.

There are many applications for dye retouching in commercial and industrial photography. Areas of a picture that need to be held back in printing can be dyed instead, with the results that detail is preserved, and the necessity to dodge a number of prints in exactly the same way is avoided.

Red dye. Dye retouching is usually done with a red dye. The bright color makes the progress of the work easy to observe. Some retouchers use a gray or neutral dye, but this is a matter of individual preference. The beginner is advised to use the red dye because it is easier to see if the work is being confined to the appropriate area.

When red dye is used, judge the printing density of the dyed area by viewing it through a green filter. If the application of dye is heavy, a more accurate assessment of printing density is obtained by using a blue filter.

Applying the dye. To apply the dye, make a stock solution of red dye, following the manufacturer's directions. This stock solution can be used undiluted to spot pinholes, to make vignettes, and to opaque backgrounds. For normal retouching, dilute 1 part stock solution with 10 parts water.

Applying the dye to the negative is basically the same as applying Farmer's reducer, with some minor differences. Apply the dye to the *base* side of the negative, and moisten only the area to be worked. Remove water droplets after sufficient dye has been applied, and leave the negative to dry. If you have added too much dye, sponge the area with water to reduce dye slowly, or use a 3 percent solution of sodium hydrosulfite (sodium dithionite) to reduce it rapidly. Sponge the treated area thoroughly with water to remove all traces of the sodium hydrosulfite and stop the reducing action. If complete removal of the dye is necessary, immerse the negative in a 3 percent solution of sodium hydrosulfite until the dye disappears. Wash the negative for 10 minutes in running water at 20 C (68 F); then bathe it in wetting solution and hang it up to dry.

Pencil Retouching. Although professional films usually have retouching characteristics incorporated on both base and emulsion surfaces, some additional tooth in the form of retouching fluid is needed to accept the graphite pencil smoothly, and to build up density gradually. Use a brush to place a small quantity of the fluid on a selected part of the negative, and then, using a circular motion, spread the liquid with a tuft of cotton. Include an area slightly larger than that to be retouched. With light but uniform pressure, rub the area quickly until the fluid is dry. At the same time, feather the edges of the treated area to prevent a sharp outline from showing in the print.

An additional application of retouching fluid can be used to remove unsatisfactory pencil work; however, repeated applications of fluid may make the surface tacky. In this case, clean the negative with turpentine. If the fluid in the bottle becomes too thick, it can be thinned with a small amount of turpentine.

Sharpening pencils. To sharpen the pencil to be used for retouching, fold a 4½-inch square piece of fine sandpaper or emery paper in half, abrasive side inward. Close both ends with adhesive tape; now you have a small envelope, the inside surface of which is abrasive. Expose about 1 inch of the pencil lead from its holder, and insert it in the open side of the abrasive envelope. Work the pencil up and down with a slight twirling motion until a sharp needle point is obtained.

For most retouching work you need pencil leads ranging from 2B to 3H. Pencil lead is graded according to its hardness; 2B is very soft and 3H is very hard. The soft leads are for highlight regions or parts of a negative that require heavy density, the intermediate grades are for midtones, and the hard leads are for shadow areas that need only a slight increase in density.

If you cannot get sufficient density by pencil work on the emulsion side of the negative, turn the negative over and apply retouching fluid to the base side in the same way as directed for the emulsion side; then use a soft lead to obtain the required density.

Pencil technique. In retouching with a pencil, the strokes most commonly used are the circular and short zigzag types. Regardless of the type of stroke used, it is seldom advisable to use so heavy a stroke that the result stands out (even after a slight amount of diffusion) when the negative is printed.

Keep the size of the pencil strokes generally in proportion to the size of the area being retouched. A delicate touch is necessary in shadows or thin portions, while a slightly heavier stroke can be used in dense areas.

Seldom should highlights, shadows, or uneven skin tones be left too sharply defined in a portrait.

Blocking-Out. For completely removing backgrounds or preventing certain areas of the negative from printing, red or black opaque is recommended. This is a water-soluble paint with remarkable adhering characteristics. When applied to a negative, it will effectively prevent light from passing through. Both red and black opaque are suitable for black-and-white negative work. Only black opaque should be used for color negatives—applied to the base side. Its neutral tone prevents color shifts from occurring at feather-edges or at possible thin spots.

The negative to be opaqued should be clean. Use a little film cleaner on a ball of cotton to remove all traces of grease or oily fingerprints from the base side of the negative. Stir the opaque thoroughly. It should have a smooth, heavy-cream consistency and can be thinned with water if necessary. To prevent the opaque from drying, keep the cover on the jar when it is not in use. Keep

the threads of the lid and jar-top clean, and there will be no difficulty in reopening the jar the next time.

Place the negative, emulsion down, on the retouching desk. With a camel's-hair brush, apply the opaque smoothly and evenly. If a second application is necessary to cover pinholes or thin spots, dry the first thoroughly before applying the second. Some retouchers outline the objects to be retained in the negative with a soft retouching pencil first and then work the opaque up to the pencil line. This method gives a slightly softer edge to the block-out and reduces the "cut-out" appearance in the print. Straight lines or curves can be achieved with a ruling pen and a straightedge or French curve. Fill the ruling pen with the point of a brush instead of dipping the pen in the opaque. Straight lines can also be followed by using an opaque adhesive tape. Choose a thin tape that has a sharp edge and is dimensionally stable. Opaque can be applied over the outside edge without cracking when dry.

If further retouching is necessary on the retained portion of the negative, be sure to protect the opaqued area from moisture. Opaque can be removed by washing the negative in running water at 20 C (68 F). Sponging the negative periodically with cotton while it is immersed in water will hasten removal.

Black-and-White Prints

Removing Black Spots. Black spots, caused by pinholes in the negative, usually result from dust on the film at the time of exposure. Dust prevents the light of the image from affecting the sensitive emulsion in that area. When the film is developed, this tiny spot is transparent. Prints from such a negative record the transparent spot as a small, black spot.

It is much easier to correct a light spot than a dark spot. You should carefully inspect each negative for any transparent spots *before* you print it. Touch each one with opaque, using a very fine-pointed brush. Then treat the resulting white spot in the print with a brush and a bit of spotting color.

To eradicate an objectionable black spot on an otherwise excellent print, choose one of the following remedies.

Chemical Etching. Black spots can be chemically reduced with a chemical reducer such as Farmer's reducer. Apply the solution to the print surface with a pointed toothpick or a small spotting brush. The spot should clear within a few seconds; then blot it with a piece of damp cotton. It is almost impossible to reduce a spot to match exactly the density of the surrounding area and make further work unnecessary. Therefore, make the spot a bit too light, and use spotting color to match it to the surrounding area. After you have bleached the objectionable dark spots, wash the print for a few minutes in running water to remove any bleach that may remain in the print emulsion.

Physical Etching. An etching knife offers another means of eliminating black spots from prints. Physical etching is feasible only if a few tiny spots appear on black-and-white prints. Physical etching of resin-coated papers usually does not yield good results.

Remove the objectionable dark spots in the print by carefully scraping or etching, with the blade held at right angles to the surface of the print. Remove the silver densities *gradually* with a very light stroke, trying to shave off tiny layers. Practice on a scrap print. Go back and forth lightly over the spot again and again, with the point barely touching the print. Continue this etching until the spot is no longer visible and blends with the surrounding tones of the picture.

If a particular print has required a considerable amount of etching with an etching knife, the print surface may assume a slightly "excavated" appearance when viewed obliquely. Remedy this by waxing matte-print surfaces with a clear (noncolored) wax. Lacquering the print is really the best answer.

Treating White Spots. White spots are perhaps the most common type of print defect. They are caused by dust or small dirt particles on the negative carrier during the print exposure, or, less likely, by foreign matter that may have settled on the sensitive paper emulsion just before you made the print exposure.

As with black spots, the white variety is best prevented by keeping the darkroom and all items of equipment scrupulously clean. Especially important is cleaning the negative before printing. Once the white spots have appeared on a print, however,

you can remove them with a small brush and a bit of spotting color.

Spotting media can be divided into three different types: pigments, pencils, and dyes. The choice is largely a matter of individual preference, but to some extent, it is governed by the type of work to be accomplished.

Pigments. Use opaque water colors. Take up the pigment on a water-moistened brush, and make a few trial strokes with the brush on a piece of scrap paper. Deposit the black pigment (use brown for spotting sepia-toned prints) in a fine stipple of tone that is neither excessively moist nor dark.

Practice strokes should be a trifle lighter than the tone you wish to match on the print. If the marks are too light, remoisten the brush slightly, give the tip another light twirl in the spotting medium, and test the brush once more on the white paper. The primary purpose of the practice strokes is to remove excess moisture from the brush so as not to leave droplets on the print when you lift the brush from the print surface. If you want to match a dark tone, be sure the brush is well charged with the pigment; to duplicate a light tone, use a comparatively small amount of pigment. It is helpful to start with the dark print areas and proceed to the lighter areas, since the pigment deposited on the spots will become lighter as the brush becomes drier.

Shape the end of the brush to a very fine point. Remember, a small brush does not necessarily mean a fine point. Large spotting brushes should have fine points also. A brush that is too small will not hold sufficient pigment, and you will have to spend excessive time recharging the bristles and wiping away the excess. Bring the brush in contact lightly with the white spot. Touch the spot several times with just the very tip of the brush until you have deposited a sufficient amount of pigment to match the surrounding print area. It is better to add to the density a little at a time, building it up gradually, instead of trying to hide the spot all at once. Should you add the pigment too heavily, you can easily remove some with a tuft of moist cotton. Then, after the print has dried a moment, try again.

Pencils. Spotting prints with pencils is the easiest method of all to learn; it consists only of lightly touching the objectionable white spot with a sharply pointed pencil until the spot has disappeared. This method also has the advantage of speed; a brush requires occasional dampening and recharging with pigment.

When you use a pencil for spotting prints, stroke lightly so as not to dent the comparatively soft surface of the emulsion. Use the degree of pencil hardness best suited to a particular job.

Do not try to use a pencil to fill in a fairly large spot or a spot surrounded by a fairly heavy density. A heavy deposit of graphite on a print has a metallic sheen that possesses a different reflectivity from that of the rest of the print surface. It can, therefore, be easily detected. This is particularly true if you use a pencil that is too hard or a retouching stroke that is too heavy so that the pencil point flattens the natural texture of the paper. However, you can make these retouching marks practically disappear if you lacquer the print.

Dyes. Glossy paper is the most difficult of all surfaces to spot. A ferrotyped, glossy surface presents no tooth to which minute particles of pencil lead can adhere. The best answer to this problem is to use spotting dyes. The advantage of using dyes is that they sink into the emulsion, increasing the density in the areas treated, without appreciably altering the appearance of the print surface.

Another advantage of using dyes is that you can match any image tone by mixing only a few drops of dyes of different colors. For example, you can produce a wide range of sepia tones by mixing warm brown with black and, if necessary, diluting this mixture with water.

The application of the dye to the print is somewhat similar to that used in pigment spotting except that you should use a drier brush. Always test the charged brush on the margin of the print and then work up the spot gradually. Repeat this procedure until the spot has assumed the desired tone. *Do not* use an excess of dye on the brush. If you apply the color too liberally, reduce the spot by gently swabbing with a brush and warm water containing a few drops of dilute ammonia, and then blot with a tuft of dry cotton to remove the excess moisture. Dry the print before continuing.

Retouching Resin-Coated Papers. Resin-coated photographic papers contain a water-resistant layer both under the emulsion and on the back

of the paper. This feature yields somewhat different retouching characteristics from conventional black-and-white photographic papers.

Reduction of a dark area is possible by using standard chemical procedures. It is very difficult to etch prints on resin-coated paper because of the thinner emulsions and hard undercoat.

The use of liquid dyes is appropriate. Because of the thinner emulsions applied to resin-coated papers, it may take a little longer than normal to build up the desired density. Adding one or two drops of two-percent acetic acid solution aids penetration of the dye. A drop of wetting solution in the water that is used to moisten the spotting brush will also aid in the rapid application of dye. Conventional pencil techniques work very well on non-glossy papers.

Airbrush colors, for the most part, adhere well to the paper surface. When there is a problem in adhesion, add a small amount of gum arabic to the airbrush colors.

White opaque sometimes creates a different problem. The white pigment will visually match the white borders of the print, but later photomechanical separation may show differences. This is because there is an ultraviolet brightener in the resin coating of the paper, but not in the opaque.

When additional surface effects are desired, black-and-white resin-coated papers can be sprayed with the same coatings used for color prints. These coatings serve both to protect the prints and any retouching that may have been done. Interesting textured surface effects can be achieved by varying the methods of applying the coatings.

Color Negatives

Photographs that have been made on color negative film can be retouched at two stages—the original color negative or the final color print (or transparency).

Since color negative films have separate dye layers, an etching knife cannot be used for lightening areas. The kind of correction that is ordinarily produced in a black-and-white negative by etching with a knife must be done on a color *print* by adding dyes.

Black leads and colored pencils provide a practical means of retouching color negatives. The techniques are much the same as for retouching black-and-white negatives. Colored pencils are used on areas that require a change in color or a neutralization of color.

With some practice in applying the correcting colors, the effects of retouching a color negative will be easy for you to predict. Generally, less retouching is required on color negatives than on black-and-white negatives.

There are three points that you must remember in viewing color negatives made from color films:

1. As in black-and-white negatives, the densest portions of these negatives represent highlights in the original subject; the lightest areas, shadows in the subject.
2. The colors in the negatives are approximately complementary to the colors in the original subject.
3. An orange or light reddish-tan color of the colored-coupler masks is superimposed on the subject color in most color negatives.

Materials. These materials are suggested for retouching color negatives. If you do black-and-white work, you may already have some of them.

Retouching colors
Brushes
Abrasive reducer
Wetting solution
Retouching fluid
Opaque, black
Sandpaper, grade 6/0
Absorbent cotton or facial tissue
Methyl alcohol (anhydrous)

In addition to regular black leads of the same degrees of hardness as used for black-and-white retouching, the following Eberhard Faber pencils or their equivalents are recommended: Mongol number 860—red and blue (combination), or Colorama number 8056—crimson, and Colorama number 8045—victoria blue.

If Mongol pencils are used, do not moisten the tips of the leads, since they are made of water-

soluble dyes that, when wet, penetrate the emulsion and make excess color difficult to remove. The Colorama pencils are slightly softer and waxier than the Mongol pencils. Retouching dyes are available from the manufacturers of color films and papers.

Sufficient illumination for retouching color negatives is provided by a 100-watt (daylight) bulb in the retouching stand. A rheostat (dimmer switch) can be used to control the intensity of the light.

Proofs. A color proof of the negative is useful in determining the amount of retouching necessary. Black-and-white proofs made on a pan-sensitive paper are helpful when a color proof is not available. Proofs made on other black-and-white papers may be misleading because they exaggerate red areas, particularly reddish blemishes in portraits.

Pencil Retouching. If the color negative has a lacquer coating, remove this coating before retouching. Some laboratories apply lacquer to both sides of color negatives (standard roll-film sizes) after they are processed. To remove the lacquer, moisten a piece of cotton with methyl alcohol (anhydrous) and lightly rub the film surface. Apply more alcohol to fresh cotton as needed. The film will dry rapidly, and retouching can be started without delay.

Where a slight amount of correction is necessary, apply retouching fluid to the emulsion side of the negative only. In areas requiring greater correction, apply the fluid to both sides of the film.

This method of applying fluid is the same as that used in preparing black-and-white negatives. Pencils can then be used on both sides to add considerably more color or density.

The colored pencils used for retouching color negatives are somewhat softer than ordinary black retouching leads and therefore require more frequent sharpening. Use a sharp knife or razor blade to cut the wood back about an inch from the tip. Then shave the exposed colored lead down to a long, tapered point, and smooth it off with fine sandpaper.

When black leads are used for retouching roll film, slightly softer leads are recommended than for sheet film. (As an alternative procedure, dyes can be used.)

Color Technique. The major portion of a color negative is retouched with the same black lead used in retouching a black-and-white negative. Some color negatives can be retouched completely with black lead. In areas where a color must be neutralized, use colored pencils before using black leads, as recommended in the following paragraphs. The pencil color should be the opposite, or complementary, of the color *in the negative* that is to be neutralized. Do not use an extremely hard black lead over an area in which colored pencil has been applied. To do so would remove some of the previously applied colored lead. Alternatively, make color corrections on the base side, and density corrections on the emulsion side, of a color negative.

Blemishes. In a portrait negative, inspect the flesh areas for small, green spots (often faint) that represent red blemishes on the subject. Apply the red pencil until the green in the spot is neutralized—that is, no longer visible. If additional density is needed after this color correction, use the black lead to build up the added density. If the blemish is slight and no green is visible, apply the black lead alone.

If using a black pencil on a negative area causes a greenish color to appear, the green coloring of the blemish, line, wrinkle, or highlight has not been neutralized, and the red pencil should be applied to the area until the green color is eliminated. Then use the black pencil as necessary to build up density. If you have applied too much black graphite to a green blemish, remove the black-pencil work and neutralize the spot first; then reapply the black pencil to build up the density.

Lines and shadows. The technique described for the removal of blemishes also applies to objectionable lines or shadows. The green color of a line is neutralized with the red pencil. The density is then built up with black lead pencil. If the line shows no green, use the black lead alone.

It may be desirable to soften shadows without removing them completely. Shadows in which no green is apparent can be softened with black lead. If any green is present, use the red pencil first, and then the black lead merely to soften the shadow.

Veins and beards. The blue pencil is useful when the bluish color of veins or beards in a

portrait must be subdued or removed. Blue veins in the original subject will appear yellowish-orange on the negative. Apply the blue pencil over this area until the color has been neutralized. If additional density is needed after the color correction, use black lead to build up the density until it matches the surrounding area. Use a similar technique to minimize the bluishness of a man's beard.

Yellow teeth. Eagle Prisma color pencil no. 916—canary yellow—can be used to correct any excess yellow in teeth. Use the pencil sparingly and only when necessary.

Highlights. It is also possible to enlarge highlight areas, or work adjacent ones smoothly together, with black lead. If there is green in the area between the highlights to be joined, use the red pencil to neutralize the green, then black lead for additional highlight density. When the eyes are in shadow, the catchlights will be small or may not appear at all. They can be restored or enlarged with soft black lead or by applying black opaque from the point of a fine brush.

Removing Retouching Work. If it is necessary to rework the negative because of faulty retouching, you can remove previous work by adding more retouching fluid and wiping the area dry. However, if a negative has been reworked a number of times, adding more fluid may make the area excessively tacky. In this case, methyl alcohol can be used to remove the previous fluid and work. Then, retouching fluid must be applied again before new pencil work can be added.

Pinholes and Scratches. When dust is present on the film during exposure, it may cause pinholes in the resulting color negative. Such pinholes cause dark spots in a color print. The pinhole area can be covered with black opaque, applied with a spotting brush. The resulting light spot on the print can be retouched easily with dyes that match the surrounding area.

Pinholes can also be corrected by using a needle-like stylus on the *base side* of the color negative. Place the tip of the stylus (a needle held by a retouching lead holder will do the job) slightly off the center of the pinhole, and with a slight amount of pressure, push in and toward the center of the pinhole. Now lift the stylus slightly, and at the same time, push it toward the center. This operation roughens a minute portion of the base in the center of the pinhole, changing it so that it will hold back light in that area. Any light spot on the color print can easily be retouched with dyes, as mentioned above.

Minor scratches as well as surface scum can be removed with abrasive reducer. Pick up a small amount of the reducer on a tuft of cotton. Work the reducer into the cotton by rubbing the cotton against a glass or another smooth surface. With gentle pressure, rub the reducer over the area to be treated. Avoid excessive pressure when treating the emulsion side. Too much pressure can cause penetration of the top yellow layer, with subsequent loss of yellow dye. Remove any excess reducer from the surface of the negative with clean cotton.

Dye Retouching. Before a roll-film color negative is retouched, any lacquer coating should be removed. Refer to the section on pencil retouching for the lacquer-removal procedure.

Color-dye retouching is usually preferable to color-pencil retouching on roll-film negatives, since the lack of sufficient tooth may prevent a buildup of color-pencil work.

Negatives that have a gelatin layer on the base side will accept dye retouching on that surface. Retouching on the base side eliminates the opalescent appearance that would result from applying wet dyes to the emulsion side of the negative.

Red and blue retouching colors can be diluted with water to approximate the colors of the red and blue pencils. Dip the brush in dye and stroke it on water-dampened cotton, newsprint, or a paper towel to remove all excess dye; build up the dye deposit by stippling the area on the negative; allow the dye to dry for a few seconds; then apply black pencil until the density is built up satisfactorily in the area. A black pencil is preferable to black or neutral dyes, because most such dyes are not truly neutral and change the color in the retouched area.

If too much dye is applied to the base, some of it can be removed by sponging the area with water-dampened cotton. To remove the dye completely, wash the negative in 20 C (68 F) water for several minutes. Then bathe it for 1 minute in wetting solution, and hang the film up to dry before continuing retouching. When both pencil and dye retouching are planned for a single negative, apply the dyes first.

Large-Area Color Correction. Color can be added to specific areas of color negatives by applying dry retouching colors, preferably to the base side of the negative. This treatment is useful in lightening or enhancing the color of hair, clothing, and so forth, or in adding color to otherwise neutral objects. To lighten a specific area, add the same color that is seen in the negative.

Breathe on the cake of the retouching color to be used. Pick up a generous amount of dye by rubbing a tuft of dry cotton on the cake of dye. With a circular motion, transfer the dye to the desired area. Repeat this procedure if more color is needed. Smooth out the dye by buffing the area lightly with a clean tuft of dry cotton. Two dyes can be mixed over one area with this method. Dye on any overlapped area can be removed later. To lighten the applied color over the whole area, or portions of it, continue buffing the surface.

To remove unwanted dye from surrounding areas, breathe on the cake of reducer, pick up a generous amount of reducer on a tuft of cotton, and clean off the unwanted dye. With a clean tuft of cotton, smooth out the sharp edge remaining by buffing the area lightly. To clean up small areas, use cotton on the end of an orange stick. If necessary, all of the dye can be removed by wiping the area with reducer or anhydrous methyl alcohol. To remove remaining reducer, buff the area with clean cotton. The reducer should be used dry.

If more color or density is desired in the retouched area, clean the dye away from adjacent areas by the method just described, and apply steam to the negative. Steaming fixes the dye into the negative and permits more dye to be applied.

Hold the negative about 8 to 10 inches away from a steam source, such as a small electric vaporizer. Subject the retouched area to steam for approximately 30 seconds. After steaming, buff the area lightly with dry cotton. Dye that has been steamed into the negative can be removed by washing the negative in running water at 20 C (68 F) for 8 to 10 minutes. To speed the complete removal of dye, swab the dyed area on the base side of the negative with a tuft of cotton moistened in concentrated wetting solution. This removes a major portion of the dye and shortens washing time. Do not apply concentrated wetting solution directly to the emulsion of a color negative.

Use of Viewing Filters. Some color-negative retouchers find it helpful to check their work by viewing corrected areas successively through red, blue, and green color separation filters, such as the Kodak Wratten filters no. 29, 47B, and 58. Extremely deep shadows and blemishes, if successfully removed, should blend smoothly with the surrounding area when viewed through each of the filters.

Color Prints

It is a good rule to do as much retouching on the color negative as possible before making final prints, especially when a large number of prints are to be made from the same negative. When the image size is extremely small, however, retouching the color negative is not practical. In this case, correction is more easily accomplished on an enlarged print.

Most of the retouching required on a color print can be done with dyes. Sometimes, pencils with black or colored lead are used, but most of the time, liquid or dry dyes are used for correcting both small and large areas. Opaque retouching can also be utilized to perform more extensive corrections.

Equipment and Supplies. The retouching area should be properly illuminated. Color prints should be evaluated and retouched under illumination of the same color quality and intensity (at least 50 footcandles) as that under which the final prints are to be viewed. The illumination should have a color temperature of 3800 to 5000 K.

Suggested basic supplies for retouching color prints include:

Retouching colors
Finely ground white opaque
Soft colored pencils (such as Eagle
 Prismacolor)
Wetting solution
Brushes
Anhydrous denatured alcohol
A supply of newsprint (a low-grade
 absorbent paper)
Cotton
Small ceramic palette

Other items, such as equipment for airbrushing or lacquering, can be added later as the need arises.

Order of Procedures. First do all spotting that is possible using transparent liquid dye; follow that with "dry-dye" retouching; finally, make opaque corrections. The above order of retouching is important and should be followed for maximum control of the techniques. You cannot return to liquid methods after dry retouching has been added to an area.

If necessary, clean the print surface by buffing it with a tuft of cotton before you start retouching. Protect the print surface from fingerprints or perspiration by wearing cotton gloves, or by placing a piece of newsprint between your hand and the print.

Retouching Prints with Dyes. Dyes for retouching prints on color papers are available in liquid and solid form. Liquid dyes, although satisfactory for spotting prints, are not convenient to use when large areas are to be corrected. Liquid dyes are absorbed too readily by the emulsion, making it difficult to apply them evenly and to remove them if an error is made. Colors in dry, solid form can be used with a great deal of control for tinting large areas.

Spotting Technique. Follow these steps:
1. Transfer the desired dyes to a palette.
2. If it is needed, add a touch of neutral dye to the pure colored dye. The neutral dye reduces the high brilliance of the pure colors by adding density, which increases the speed of spotting. Dilute only with clear water. Keep the dilutions weak for good control; it is easier to add density than to remove excess density.

(Left) Damage such as scratches and spots can often ruin an otherwise good color photograph. (Right) Skillful retouching with wet or dry dyes, using the techniques described in this article, can repair many of these flaws.

(Left) Liquid dyes, although satisfactory for spotting prints, are not convenient for use when large areas must be corrected, as they are too easily absorbed by the emulsions. (Right) Colors in dry, solid form offer a great deal of control for tinting large areas.

3. Stroke the brush loaded with the dye mixture over newsprint, rotating the brush to form a good point. This will also remove excess dye and moisture, reducing the chance of opalescence resulting from too much moisture on the print surface.

4. Now retouch the print with the relatively dry brush, keeping the dye within the confines of the spot. Avoid working into the surrounding area. Any overlapping will result in a dark ring around the spotted area.

5. If too much color has been applied, blot it quickly with newsprint. Failure to blot may increase density beyond the desired point.

Dry-Dye Technique. Color can be added to large areas of a color print by applying *dry* retouching colors to the surface of the print. This treatment is useful in warming bluish shadows; changing or enhancing the colors of skin and clothing; adding color to otherwise neutral objects, such as gray buildings; and warming or cooling specific areas. The technique has two distinct advantages:

1. You can experiment until the desired effect is achieved before making the retouching permanent.

2. You can retouch a glossy color print without losing the glossy surface.

The emulsion surface of the print to be treated should be thoroughly dry, for moisture from any source will tend to set the dyes so that they can no longer be removed with reducer or alcohol. Preferably, the humidity should be low in the retouching area. If necessary, clean the print surface with a tuft of dry, clean cotton, or cotton moistened in alcohol. Be careful not to scratch the surface.

To apply dry dye, or to remove unwanted dye from surrounding areas, use the procedures described for working on color negatives. To make the retouching permanent, subject the retouched area to steam for 3 to 5 seconds by holding the print about 10 inches away from the steam source. Repeat if necessary. When the waxy surface marks

Retouching

caused by the dye application disappear, you have steamed the print sufficiently. Avoid applying too much steam. An electric room vaporizer is a convenient source of steam.

To build up additional dye density, alternately apply steam and more dye. *Be sure the print surface is dry before more dye is added.* The steam will set the dye already on the print and therefore allow more color to be added.

Removing Steam-Set Colors. Color set by steam cannot be removed with reducer or anhydrous alcohol. Most of the color can be removed, however, if a five-percent ammonia-water solution is applied to the area. (Combine 5 ml ammonia with 95 ml water.) Apply the ammonia solution with a tuft of cotton, rubbing in a circular motion. Be sure, however, to restrict the application of the solution to the particular area. Swab with clear water. Repeat as necessary, using a fresh tuft of cotton. It is important that all the ammonia-water solution be removed from the print. Allow the area to dry before resuming the retouching. For best results, remove unwanted dye as soon as possible.

Pencil Retouching. Much of the spotting normally required on a color print can be done with a soft, black retouching pencil. Apply the pencil in the same manner you would use for spotting a black-and-white print. Small spots in the background, dust specks, spots in shadow areas, and even small spots in highlight areas can be corrected quickly with a black pencil. When the spot is in a critical area such as the face in a portrait or the

highlighted subject in a product shot, use the appropriate pencil from a set of soft colored pencils to blend the light area with the surroundings.

First, take care of major retouching, such as large spots or off-color areas, using the dye-retouching techniques previously described. Then, give the emulsion some tooth by spraying the print with a retouching lacquer. (Retouching lacquers are made specifically for this type of pencil retouching. They contain a matting agent that prepares the print surface to accept the pencil readily. Several brands can be obtained at photo supply stores. Follow the manufacturer's instructions.)

Opaque Retouching. You can apply opaque, tinted with the desired opaque watercolor, to a color print with an artist's brush to outline and accentuate objects, introduce specular highlights, retouch spots, and so forth. One method of retouching is to use white opaque and then tint it to the desired color with a colored pencil after it has dried. Another method is to use white opaque that has already been tinted with the desired watercolor.

Airbrush. Opaque colors also can be applied with an airbrush. In the hands of an expert, an airbrush is useful for changing larger areas of color prints that need a change in density and/or color. (*See:* AIRBRUSH.)

Special Problems. Spots on color prints can generally be corrected by following these suggestions.

Spots. Black spots on a color print are usually due to minute pinholes in the color negative. The correction can best be made on the negative by placing white or black opaque in the pinholes. This will prevent any light from passing through the holes, resulting in white spots rather than black spots on the print. Then eliminate the white spots by using spotting techniques.

When black spots do occur on the print, apply a very small amount of white opaque to the black spots, and if the opaque dries too white, apply colored pencils to match the color of the surround-

A retouching pencil can be used for most of the spotting required on color prints. The technique is the same as that used on black-and-white prints.

ing area. Or, treat the black spots with white opaque that has been tinted with the desired opaque watercolor. Spray the opaqued area with lacquer to give it protection as well as to match surface reflections. When lacquers are applied over opaque, there is an increase in density, so you must allow for this. For an idea of how much increase in density there will be, touch the opaqued area—after it has dried—with anhydrous denatured alcohol. The moment the alcohol touches the opaque, you will have a good idea of how much density increase will take place. Since these black spots are relatively small, opaque can be used over such areas after the print has been lacquered.

Highlights. Lighting and subject placement sometimes produce highlights on the print that distort a facial line or body line, or accentuate a crooked nose, bald spot, or deformity. In this case, blend the highlights into the adjacent area using a dye that matches the surroundings. Blend from the edges toward the center of the highlight.

Catchlights. When eyes are in shadow, the catchlights may be small or completely absent. To enlarge or restore them, mix white opaque with a small amount of water and apply it with the tip of a brush. If white opaque makes the catchlights too brilliant, dull them by stippling with an extremely soft pencil.

Hairline. If hair is out of place or occurs in an area darker than the hair itself, you can correct it by the spotting technique. When the hair is darker than the surrounding area, you have a choice of airbrushing or applying heavy oil color. If you elect to use heavy oil color, make sure you apply several coats of retouching lacquer first. Applying the lacquer over the print before you apply the oil color should help to prevent the oil color from attacking the dye image and will also give some tooth to the surface of the print for better adhesion of the color.

Scratches. Surface scratches that have removed one or more dye layers of the paper emulsion can be repaired by the spotting technique.

The accompanying drawing represents a cross-section of a print on color paper. A red scratch is caused by the removal of the top, cyan-dye layer. Add cyan dye of the proper concentration to match the adjacent area. A yellow scratch is caused by the removal of both the cyan and magenta dye. Add magenta dye, followed by cyan dye, to match the adjacent area. For best results, make sure that the dilution of the dye is correct. Do not add neutral dye, as density is not a problem here.

After the dye has been applied correctly, the scratch will still show by reflected light. An application of lacquer will cover the scratch and will result in a very satisfactory finished print.

Reflections. To reduce large-area reflections from shiny surfaces, first build up the basic color density by using the dry-dye technique. Be sure to set the dye with steam; then blend sharp edges and add details using the spotting technique.

Off-Color Areas. The correction of off-color areas on a print can be achieved by either the dry-dye or the spotting technique. The factor determining the choice is the size of the area. For small areas, use the spotting technique; for large areas, the dry-dye technique.

To control or neutralize an off-color area, refer to the chart below, and choose the correct color to be used on the off-color area. Note that orange dye, rather than yellow dye, is used to neutralize blue, and that a purple mixture rather than blue is used to neutralize yellow.

To neutralize a color, use the opposite color dye.

Red ←→ Cyan
Green ←→ Magenta
Blue ←→ Orange
Purple* ←→ Yellow

*Purple is a mixture of blue and magenta.

A cross-section of a print on color paper. A red scratch is caused by the removal of the top, cyan-dye layer. A yellow scratch is caused by the removal of both the cyan and magenta dye.

Red scratch Yellow scratch

Cyan dye
Magenta dye
Yellow dye
Resin coating

Paper base

Color Transparencies

The techniques described here relate *only* to slides or transparencies to be used for *viewing purposes*. These methods are not generally suitable for transparencies to be used for photomechanical reproduction. You should consult the film manufacturer for detailed techniques on retouching specific transparency materials intended as originals for color separation.

Retouching Small Spots. Usually, light areas of an original transparency can be filled in readily with pencil or dye, but dark areas must be blended with the surroundings to make them less obvious, or they can be bleached and then retouched.

Eliminating small dark areas by partially removing density in all three dye layers with an etching knife is impossible. When it is attempted, the successive layers are exposed, one at a time, depending upon the depth of the etch. In a neutral area, for example, the removal of the top layer will leave a blue spot; further etching, a cyan spot.

Generally, the aim of retouching small dark areas should be to blend them by adding color to the surroundings, making them less apparent.

Use of Pencils. There are several types of colored pencils on the market that are suitable for retouching, such as Eagle Prismacolor or Eberhard Faber Colorama pencils. Pencil retouching, which should be done after any bleaching or dyeing, can be applied to either the base or the emulsion side of the transparency if a tooth on the surface has been provided. Use lintless tissue or absorbent cotton to spread several drops of retouching fluid with a circular motion over the portion of the transparency to be corrected. A somewhat thicker application is necessary than in the case of ordinary black-and-white retouching. Allow the retouching fluid to dry for a few minutes before applying the color. Sharpen the pencils to a long tapering point with fine sandpaper or emery cloth. Select the proper color, and bring the area to the required density and color with a series of pencil strokes. If sufficient color cannot be applied, turn the transparency over and repeat the above operations. When the pencils are applied to the emulsion side, take care not to damage the emulsion. Where a great amount of color must be added, use dyes.

Small light areas and pinholes can be corrected with an extremely soft black lead in the same manner. If it is necessary to remove the retouching completely, wipe the area with denatured alcohol.

Area Correction. Areas of a transparency may require the addition of color in order to improve the overall effect. For example, a background color may be too light to contrast sufficiently with the principal subject. A darker color can be produced by using dyes, colored overlays, or masks. Hue changes can also be made, but areas can be lightened only by bleaching techniques.

Color, in the form of dyes, can be added to the *base side* of color transparencies to alter or enhance the color of skin, hair, clothing, background, and so forth. The following techniques can be used on transparencies that will not be duplicated by photomechanical means.

Dry-Dye Techniques. The simplest and most effective method of adding color involves the use of retouching colors, supplied as jars or dry-dye cakes. These are applied to the transparency in dry form with the aid of cotton tufts. One of the big advantages of this dry-dye technique is that you can experiment freely until you get the desired effect in color and density. Mistakes are easily remedied. After you have achieved the desired corrections, you make them permanent with a simple application of steam. Use the same methods described for dry-dye retouching of color negatives.

Use of Overlays. Rather than being applied directly to an original transparency, with consequent risk of damage, retouching can be applied to an overlay, such as a sheet of fixed-out black-and-white film (treated with retouching fluid if the work is to be done with pencils), which has been taped to the back of the original. If large areas are being retouched, it is preferable to use dyes rather than colored pencils.

Another method for local correction involves the use of transparent, colored overlays. Such materials are available in different hues and concentrations from art-supply stores. The sheet that gives the desired effect in the area to be changed is selected and attached on the reverse side of the transparency with masking tape. The color can then be removed from other areas of the overlay sheet by use of a stylus and color-remover solution. Sheets in various densities of gray are also available to darken an area of the transparency.

Photographic Color-Balance Correction. The final method for retouching a color transparency involves making a contact color separation negative from the transparency. From a negative, a contact positive gelatin relief film (usually termed a "matrix") is made, dyed, and transferred to the base side of the transparency. It provides overall correction for an off-balance original without the limitations inherent in the use of a color filter over the transparency or the application of a small amount of dye to the transparency. Frequently, a transparency that may have been made at considerable expense, but is unusable because of poor color balance, can be salvaged by this procedure. To carry out this type of correction, the equipment and materials normally used in the making of color prints by the Kodak dye transfer process are needed.

• *See also:* Airbrush; Restoring Photographs.

 Reversal Processing

The reversal process forms a positive image directly—in other words, a reproduction that looks like the original subject. It is used in the production of positive black-and-white transparencies, positive line reproductions in the graphic arts field, and color motion pictures, transparencies, and prints.

Although proper control of exposure and development in negative processing is desirable if you wish to obtain a good-quality negative, some variation in exposure or processing does not prevent the use of the negative for making prints. The range of contrast provided in photographic papers and the possibility of changing the printing exposure permit corrections of some errors in negative making. In other words, there is considerable exposure and development latitude in the use of most negative materials.

This is not the case in reversal processing, because a good-quality image can be obtained only when the exposure and first development are correctly balanced. Any variation from this balance will degrade the picture quality. Because of this dependence on the exposure-development balance, as well as possible image degrading effects

in the other processing steps, reversal processing requires very careful control

The illustration (following page) shows a comparison of the two processing systems with respect to the basic steps. In negative and print processing, the exposed silver halides are developed, and then the undeveloped silver halides are removed by the fixing bath.

In reversal processing, the exposed silver halides are developed as before, then this negative silver image is removed in a bleach bath, and the remaining silver halides are developed to form a positive image. This can be done by exposing them to light and then using a conventional developer. However, in some processes, the re-exposure is not necessary, because special chemicals called *fogging agents* can be put into developers to convert all of the remaining silver halide to silver without the use of light.

In reversal color processes, it is not necessary to remove the negative silver image before the second development. Instead, it can be left while the color developer produces a positive image consisting of silver and dye. Then the silver of both the negative and positive images is removed, leaving the desired image of colored dyes. This is frequently an advantage, because when the negative silver image is removed before the second development, the bleach bath must not affect the silver halides that are needed to form the positive image. When the silver is not removed until after the second development, the bleach bath is not limited by this requirement. However, this is possible, of course, only when the final positive image is composed of dyes, not silver.

Bleach Baths

The purpose of the bleach bath is to convert the negative-image silver formed in the first development either to a soluble silver salt that can readily diffuse from the emulsion into the bath, or, in color processing, to a silver salt that can be dissolved in a subsequent bath.

A commonly used bleach bath in black-and-white reversal processing contains potassium dichromate and sulfuric acid. The silver image is converted to the soluble silver sulfate compound, most of which diffuses from the emulsion into the bath. The subsequent water rinse removes the residual silver sulfate and bleach bath chemicals

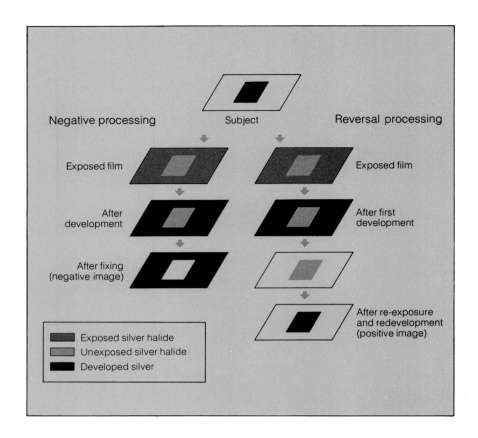

from the emulsion. The chemical reactions in the bleach bath may be expressed as follows:

$$6 \text{ AG} + \text{K}_2\text{Cr}_2\text{O}_7 + 7 \text{ H}_2\text{SO}_4 =$$

silver image potassium dichromate sulfuric acid

$$3 \text{ Ag}_2\text{SO}_4 + \text{Cr}_2(\text{SO}_4)_3 + \text{K}_2\text{SO}_4 + 7 \text{ H}_2\text{O}$$

silver sulfate chromic sulfate potassium sulfate water

Chemically, this is just the reverse of the development reaction, because the metallic silver is oxidized to silver sulfate by the dichromate in acid solution, while the potassium dichromate is reduced to chromic sulfate. Insufficient bleaching results in an undesirable filling-in of the picture highlights, that is, some of the negative-image silver may be left in the emulsion.

The agent used in bleach baths for color processes should be capable of oxidizing the silver in the presence of a halide without attacking the dye image. Oxidizing agents, such as potassium permanganate or potassium dichromate, usually attack the dye image. A common bleach bath used after second development in color processing contains potassium ferricyanide and potassium bromide. The oxidizing agent converts the image silver to silver bromide, which is then removed by fixing in hypo. The reaction of the ferricyanide with the image silver can be shown as follows:

$$\text{Ag}^\circ + \text{Fe(CN)}_6^{=-} + \text{Br}^+ \rightarrow \text{AgBr} + \text{Fe(CN)}_6^{==}$$

The metallic silver is oxidized to silver ions, which immediately combine with the bromide ions to form silver bromide, and the ferricyanide is reduced to ferrocyanide. The silver bromide is dissolved in a subsequent fixing operation.

Rinse Baths

It is important to avoid contamination of the various baths used in reversal and color processing. Consequently, it is necessary to make use of rinse baths between some processing steps.

Rinses are used to remove the chemicals absorbed by the emulsion in one bath in order to avoid undesirable effects in a succeeding bath. For this basic purpose, plain running water is quite efficient. Certain chemicals can be added to a rinse to make it more effective in stopping the action of the previous bath and in neutralizing or removing certain of the chemicals.

In some reversal processes, following the dichromate bleach used to remove the image silver formed in the first development, a solution of sodium sulfite or sodium bisulfite is employed to react with any residual dichromate that would interfere with the action of the second development. A rinse bath used for this purpose is known as a "clearing bath." The chemical composition of this bath depends upon the processing cycle, particularly the type of bleach bath used. It is therefore imperative to use the clearing bath or other rinse baths specified in any particular process.

In the black-and-white reversal process, practically all of the silver halides are exposed and developed in the first and second developers. Therefore, a fixing bath is not required for removal of undeveloped silver halides as in negative-positive processing cycles. Following second development, however, a rinse bath is required to neutralize the alkali from the developer and to harden the gelatin in the emulsion to make it more resistant to subsequent handling. The bath used for this purpose is frequently a conventional acid hardening fixing bath.

Control of Reversal Processing

No one series of reversal processing solutions can be used to obtain direct positive images on all photographic materials. The process must be worked out in detail with respect to solution composition and the times of treatment in each solution for a specific product. Special reversal-type emulsions are manufactured for black-and-white applications, and the processing procedure worked out by the manufacturer should be followed closely. (See the article DIRECT POSITIVE PROCESSING for the complete description of a black-and-white reversal process.)

The exposure must be correct. Too much exposure produces a thin picture in which highlight detail is lost, as, for example, in the fine tonal range in the face of a person. Since the positive image must be formed from the silver halides left after the negative image has been developed, it is obvious that overexposure will result in the removal of too much of the silver required for the positive image. Similarly, too little exposure will leave too much silver for the positive image, and it will be too dark.

The first development is critical, and it is essential that instructions be followed closely for time of development and agitation. Overdevelopment and underdevelopment give results similar to overexposure and underexposure. The time of development at a specific temperature will vary somewhat according to the method of processing, e.g., tray, reel and tank, small tanks, or rewind processing equipment, because of the differences in the effective agitation. The published instructions should be considered as a starting point and guide. A few trial-and-error experiments may be necessary to determine the slight variation required to obtain acceptable results with any particular equipment. However, in those cases where the manufacturer has prepared instructions for reversal processing in specific equipment, good results should be obtained if all of the factors are carefully controlled according to specifications.

In most of the steps following the first development, the chemical action should go essentially to completion. Therefore, in black-and-white processing, the control of time and temperature in these steps is not as critical so long as the following three general rules are observed:

1. Do not allow one chemical to contaminate another.
2. Use adequate washes where they are called for.
3. Allow the full recommended time of treatment in each of the solutions.

In color processing, variations in the conditions of any of the steps are likely to have some effect on the color balance between the three final dye images. Therefore, within the limits recommended for the particular process, the temperature, time, and agitation must be carefully controlled in all steps.

Replenishment of Solutions

Replenishment of the developers and other solutions can be accomplished successfully if adequate tests can be made. For this reason, replenishment usually is practical only for large-volume continuous-processing operations. For the amateur, it is preferable to use fresh solutions each time, because exhausted solutions are almost certain to cause unsatisfactory results.

• *See also:* COLOR FILM PROCESSING; COLOR PRINTING FROM TRANSPARENCIES; DIRECT POSITIVE PROCESSING.

Rights

Legal advice on one's rights as a photographer must come from a lawyer, but here are the two main aspects of these rights in simplified form:

1. A photographer has the *right to photograph* any subject he or she wishes, except where restrictions are in force, such as on Indian reservations or military installations, in theaters or courtrooms, or because of copyrights or other laws. (*See:* LEGAL ASPECTS OF PHOTOGRAPHY.) Thus a photographer may take pictures of strangers on streets or in parks, or snap just about anywhere he or she does not invade private property. However, a photographer often *does not* have the right to use pictures of people (and sometimes of pets or property) for publication or display without permission in the form of signed releases.

2. A photographer has the *right to restrict* the use of his or her own photographs for commercial or even friendly purposes. In other words, mere possession of a slide or print *does not* give the individual or company whose hands it is in, the right to use it in printed material or on display, without the owner's specific permission.

Such permission involves definite rights that may be sold or given away.

The Right to Photograph

This topic is covered in the article LEGAL ASPECTS OF PHOTOGRAPHY. Related information can be found in the articles AGENCIES, PICTURE; BUSINESS METHODS IN PHOTOGRAPHY; and MODEL RELEASE.

Briefly, a photographer may feel free to take pictures where legal or privacy restrictions are not involved, but ethical photographers try to respect the feelings of others in various ways.

Events with a newsworthy slant usually are not covered by the laws of privacy. News is almost anything of interest to a relatively wide public. If a photographer comes across an automobile accident or a fire, he or she has the right to take pictures and sell them to the news media. If in doubt, he or she should shoot the scene or event, and let experienced editors make the final decisions about publication.

Publication Rights

Distinguishing between and designating the rights to photographs being sold may be a straightforward, reasonable matter, or it may be complex and awkward. The difference depends on how carefully a photographer stipulates the type of rights he or she is selling, and how conscientiously a client defines and adheres to those rights. Difficulty arises most often when photographers fail to state the rights they intend to sell, or fail to specify limited usage at the time they make arrangements with a client for an assignment or a stock picture, and later when they send a bill.

Definition of Rights

Exclusive Rights. The photographer sells the rights to reproduce (or otherwise use, as in an exhibition or via television) an image or series of images, to a buyer exclusively, often for a specific time period, or within a certain area, or perhaps for a particular purpose. For example, you might sell exclusive rights to a landscape slide to a postcard publisher for six months or a year, with options to extend the time. This means that you agree not to sell the same images or very similar ones to any

other client for the length of time agreed upon, and according to other terms that may apply.

All Rights. If work is done for hire and all rights are transferred, there is usually a transfer of ownership. Depending upon the situation, it may not be good business practice to sell all rights to pictures, which in the advertising field is called a "buy out," and in other fields may be designated a "flat payment" arrangement. Such deals usually include a request for negatives which are then owned by the buyer, just as original slides are owned by the all-rights client.

When buyers of photographs want all rights as a condition of sale, photographers may agree when the pictures have no future sales possibilities, when the price is right, or when other special conditions prevail.

First Rights. The photographer sells the right to reproduce a picture or pictures in one edition of one publicaton, or in specified related publications in an agreed-to area, and at the same time agrees not to allow any *prior* publication of the same or similar pictures in any other publication in the area involved. First rights are often granted with a time limit, such as six months or a year, after which the photographer is free to sell the same picture elsewhere. A first-rights agreement may also include a specific time *after* publication (such as 30, 60, or 90 days) during which the photographer will restrict publication of the same work elsewhere.

One-Time Rights. The photographer sells the rights to reproduce pictures once, in one language of one edition of one publication in a specific agreed-to area, where the buyer is only interested in his own category of publication. One-time rights can be sold simultaneously to an assortment of markets, for purposes such as postcards, calendars, and publicity. Remember that stipulating one-time rights on a bill usually is not enough unless the where-and-how limitations are also stated.

Distribution Rights. These are usually specified in addition to publication rights in order to define where and by what media publications may be distributed. For instance, books, posters, or magazines may be distributed in the United States and Canada only, or just in English-speaking countries. Book publishers often contract for rights to distribute certain editions in particular geographic areas.

Promotion Rights. The photographer sells the rights to use photographs in the promotion and advertising of a publication in which his or her pictures appear. This covers the right to use a picture from inside a book in advertisements for it.

Rights for What Usage?

It should now be clear that *how a photograph is used* is vital in determining the rights sold and the charges made for the work. It is the photographer's responsibility to discover where and how pictures are going to be used before he or she quotes a price or determines what rights are most appropriate to apply. Also, this information should be included on the bill and may also be spelled out in correspondence with a client. The goal is to avoid misunderstanding about rights sold, how pictures will be used, and what payment is mutually determined. This is just as important among friends or old clients as it is with strangers and new accounts.

Here are the important categories in which photographs may be purchased for use. Photographers' rights—and charges—vary considerably between classifications, based on value to the client and residual value to the photographer.

Advertising. Rights and rates are predicated on national and local circulation, or broadcast ratings, of magazines, newspapers, brochures, television, or other types of media. It may be logical to charge more for a picture used in a national magazine ad than if the same shot were run in a local weekly newspaper. Detailed limits and agreement about rights is therefore important.

Magazines. There are all kinds of magazines, so rates and rights are often based on circulation, page rates, assignment rates, and similar factors. One might stipulate first rights for an assignment, and one-time rights for a stock photograph.

Books. Publishers usually have definite schedules for how and where their books will be sold, and they define the rights they prefer accordingly. Royalty payments to the photographer are made on a first-rights sale basis, but modifications are possible.

Annual Reports. This is a very specialized field in which rights may be limited to a single issue of a report, but contract may be made to sell additional rights for advertising or promotion.

Personal Portraits and Personal File Prints. Chances are that pictures made for individuals will be placed on walls or pianos, and will never be reproduced. If in doubt, specify "for personal use only, not for reproduction" on your bill. Such images are legally owned by the buyer whose use of them can be limited. Though the photographer retains negatives, he or she may not sell or display prints without the permission of the sitter.

File Prints. Prints of pictures a photographer owns may be given, or sold for a nominal fee, to individuals or companies, for personal use and reference, but not for publication or display. For instance, he or she takes pictures of a championship Little League team for a magazine or newspaper, and later gives prints to team members and the coach as a courtesy, to thank them for their cooperation. Possession of such pictures does not include the right to reproduce them. The photographer might explain this, but it is also important for him or her to use a rubber stamp on the backs of prints and edges of slide mounts that reads to the effect of: "Reproduction or publication prohibited without written permission of the photographer." The following may also be stamped on: "File print only—not for reproduction." In addition, this stamp may say "Copyright © 19__ (year); The Photographer's Name."

Miscellany. You may come across other categories such as exhibition, instruction booklets, posters, greeting cards, brochures, and counter display cards. Learn as much as you can about a client's intentions, and be specific when designating how and where pictures may be used within the limits of the rights you sell.

Rights Mean Ownership

Photographers' rights should be protected to assure continued ownership of their work, as well as to provide fair payment. A photographer new in the business is often insecure and may sometimes learn self-protection the hard way. The new photographer is so pleased to have his or her picture published that little thought may be given to handing over negatives or signing away all rights to slides. It takes experience to discover that pictures have a life of their own, and that over a long period of time you can expect a profitable potential from the best ones. Photographs may sell over and over again to similar and different markets. One stock image might sell 50 times in a dozen years if that subject is in demand, and sometimes you cannot predict which shots will be popular.

Ownership of your work also requires that you be certain that clients return borrowed slides, prints, and negatives after use. This stipulation also goes on your bill and may only be cancelled by pre-arrangement with the client.

Copyright Protection. The best means of maintaining rights to your pictures is through copyright (see the article COPYRIGHT). The revised federal copyright law that went into effect in 1978 provides for protection of *photographs at the moment you expose them on film.* Formerly, they were not protected by federal copyright law until published, though an "intent to copyright" status was available.

The new law means that the photographer automatically owns the copyright to his or her pictures, unless he or she signs a specific agreement to the contrary. This applies whether you are a hobbyist or a working professional. The average person may never feel the necessity to copyright a picture, but those in the business of photography should have confidence in knowing they own copyright to their work, unless it is otherwise arranged. Transfer of a material object (print) does not in itself transfer ownership of the copyright, *or vice versa.* However, "work made for hire" is an agreement to sign over both copyright and ownership of photographs, in essence selling all rights. If you are a photographer on salary, chances are your employer owns all rights to your pictures.

In other creative fields, songwriters or playwrights seldom sign away full ownership of their work because they know they may share a greater income if a song or play becomes a hit. The same potential pertains to photographs.

In Summary. Photographs are such a common commodity that masses of people are inclined to take them for granted. Therefore, professional photographers, or anyone selling images even as an avocation, should understand their rights, in order to sell pictures for specific purposes, according to well-specified terms to which everyone involved agrees. It may take only a few shocks to become a

"veteran" quickly. Begin early to inform yourself so you may discuss rights (and related rates) with clients. They are usually definite about what they expect from photographers, and your expectations should be equally clear.

• *See also*: AGENCIES, PICTURE; BUSINESS METHODS IN PHOTOGRAPHY; COPYRIGHT; LEGAL ASPECTS OF PHOTOGRAPHY; MODEL RELEASE; SELLING PICTURES.

 Ring-Around

A ring-around is an organized display of the results obtained from tests run with controlled variations in exposure, development, or other photographic factors. It usually consists of a normally produced image—positive or negative, black-and-white or color—surrounded by a ring of images that shows the results of the variations. The array is usually organized so that the degree of variation increases step by step outward from the center.

A ring-around has its greatest value in showing the composite effect of two variable factors—for example: exposure and development, exposure and filtration, or time in bleach and time in toner.

The ring-around in the article COLOR PRINTING FROM NEGATIVES shows variations in exposure and filtration. The same approach can be used to investigate the effect of exposure and filtration changes on either black-and-white or color film; in such cases, processing should be held constant. Other ring-arounds can be made to explore the relationship between lighting ratio or subject contrast and printing-paper contrast, with exposure and development held constant.

Planning a Ring-Around

Careful planning is required to produce a ring-around that contains useful information. Follow these major steps:

1. Identify two variables and hold all other factors constant. Use fresh materials and solutions, unless one of the variables is aging or keeping.
2. Use a typical subject under typical working conditions. If landscapes are usually photographed, a ring-around of a portrait subject under electronic flash illumination will not be very informative. It is often useful to include a gray scale, a neutral test card, or standard color patches.
3. Produce the center "normal-normal" image by using as little variation as possible from the manufacturer's recommendations for the material (unless normal procedures are different—for instance, a personal exposure index and development procedure that is consistently used).
4. Produce the variations in steps that are easy to control precisely, and use a consistent method. For example, for exposure variation, change the lens aperture in regular half- or full-stop steps, rather than changing the shutter speed. Development variations are more accurately made by changing time than temperature, unless temperature is one of the variables being investigated.
5. Include an identification card in the scene, marked with the variable factors; mark each print and keep detailed notes. Each image should be accurately and easily identifiable.
6. When the ring-around is complete, examine the results under typical viewing conditions. It is sometimes useful to make a mask so that only one image at a time can be viewed.

A Black-and-White Negative Ring-Around

The following discussion relates to producing a black-and-white negative ring-around that can serve as a guide for planning other kinds of tests.

This procedure should provide one negative that has the correct exposure and development for the photographer's printing conditions. The exposure and development of the center negative should be as close to normal for those conditions as can be measured or estimated.

Exposure. If the typical subject is a frontlit, outdoor subject, normal exposure will be 1/ASA speed at $f/16$, or its equivalent. Thus if an ASA 125 film is used, the shutter speed will be 1/125 sec.

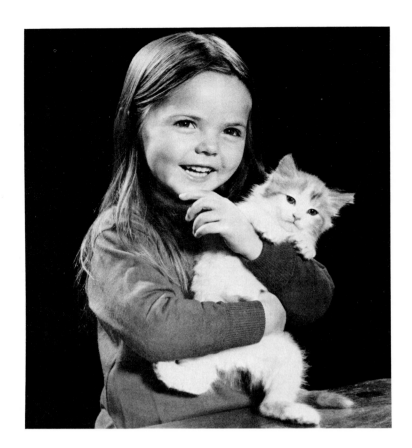

A ring-around is an organized display of the results from controlled variations in photographic factors. It usually consists of a normally produced image, such as this, which is the basis for exploring the composite effect of a number of photographic factors.

RING-AROUND PLAN FOR TEST EXPOSURES AND DEVELOPMENT

1 2 stops more exposure with 30% less development	**2** 2 stops more exposure with 15% less development	**3** 2 stops more exposure with normal development	**4** 2 stops more exposure with 15% more development	**5** 2 stops more exposure with 30% more development
6 1 stop more exposure with 30% less development	**7** 1 stop more exposure with 15% less development	**8** 1 stop more exposure with normal development	**9** 1 stop more exposure with 15% more development	**10** 1 stop more exposure with 30% more development
11 Normal exposure with 30% less development	**12** Normal exposure with 15% less development	**13** Normal exposure with normal development	**14** Normal exposure with 15% more development	**15** Normal exposure with 30% more development
16 1 stop less exposure with 30% less development	**17** 1 stop less exposure with 15% less development	**18** 1 stop less exposure with normal development	**19** 1 stop less exposure with 15% more development	**20** 1 stop less exposure with 30% more development
21 2 stops less exposure with 30% less development	**22** 2 stops less exposure with 15% less development	**23** 2 stops less exposure with normal development	**24** 2 stops less exposure with 15% more development	**25** 2 stops less exposure with 30% more development

Using the typical, normally produced image (see facing page), a ring-around can show the interaction among photographic variables. In the series above, variation in exposure and development are illustrated. The normal exposure and development image is the center one.

If the typical subject is an interior setting with flashbulb or nonautomatic electronic flash, compute the *f*-number by using the guide number (GN) and distance for the prevailing conditions. A 10-foot distance makes the computations convenient. With automatic flash, follow the instructions for the particular unit being used.

With either incandescent illumination (generally, studio lights), or outdoor subjects under other than the conditions described above, use an exposure meter to determine the normal exposure.

The ANSI (ASA) film speed, as given on the instruction sheets packaged with the film, can be used when the film is developed to a time near those found in the development timetables in the instructions. If, however, the film is developed for much less than the table time in order to achieve lower contrast, the film speed used to calculate exposure will probably have to be lowered in order to avoid underexposure. On the other hand, if the film is developed for a time much greater than the table time in order to raise the negative contrast, a higher film speed can be used. The effects of decreased and increased development can be seen in a ring-around.

Development. The development times given in the film instructions or data sheets are designed to produce average-contrast negatives. This type of negative generally has the right characteristics to print on contrast grade 2 paper with a diffusion enlarger. If printing is going to be done with this type of enlarger, use the times given in the data sheet for the film-developer combination and for the method of development and temperature that is most convenient. This is for the *normal development time* in the ring-around.

Negatives for printing on contrast grade 2 paper in condenser enlargers must be softer (have less contrast) than negatives for diffusion enlargers. For the normal development time in a ring-around for condenser enlargers, less development time should be given. With various film-developer combinations, the amount varies from about 30 to 50 percent less; so for negatives to be printed on condenser enlargers, start with 40 percent less time than that given in the film instruction sheet.

A more exact normal development time for negatives to be printed on condenser enlargers can be found by using the development dial procedure

given in the fifth edition of the *KODAK Darkroom DATAGUIDE* (Kodak pub. No. R-20). Use the adjustments for condenser enlargers.

Examples of Time Changing. To find the development time changed by a percentage figure *less* than the table time, subtract the percentage change from 100 percent, move the decimal point two places to the left, and multiply the time by this amount. If the development time is 8 minutes and you want to decrease it by 30 percent:

$$100\% - 30\% = 70\%$$
$$70\% = 0.70$$
$$0.70 \times 8 \text{ min} = 5.6 \text{ min, or about } 5\tfrac{1}{2} \text{ min}$$

To find the development time change by a percentage figure *increase* over the table time, add the percentage change to 100 percent, move the decimal point two places to the left, and multiply the time by this amount. If the development time is 11 minutes and you want to increase it by 30 percent:

$$100\% + 30\% = 130\%$$
$$130\% = 1.30$$
$$1.30 \times 11 \text{ min} = 14.3 \text{ min,}$$
$$\text{or, } 14 \text{ min and } 18 \text{ sec (round to } 14 \text{ min)}$$

Once the normal exposure and normal development time have been selected, the exposure and development times of each of the negatives in the ring-around can be calculated. In order to save time, the inner three rows of negatives (nine in all) that represent 1 stop under- and overexposure and 15 percent under- and overdevelopment can be made; if the results provide a usable negative, the outer ring will not have to be made.

When sheet film is used, each of the nine negatives is given the exposure and development calculated as above.

If 35 mm or roll film is used, it is just as easy to give the entire range of exposure up to 2 stops under and over. The 3 rolls are developed at 15 percent under, normal, and 15 percent over. To make the full ring-around, the additional film to be developed must be exposed 30 percent more and less than normal.

When the negatives are entirely processed, washed, and dried, they should be printed on

contrast grade 2 paper or selective-contrast paper with a Kodak Polycontrast filter PC2 or equivalent. Be sure that the prints are processed according to directions—especially that they are developed for the recommended time.

Evaluating Results

The prints are laid out and judged for quality; the one with the best contrast and amount of shadow detail will provide the correct film speed and development time.

It sometimes happens that none of the prints shows the right combination of exposure and development. The closest print available may be slightly deficient in shadow detail (which relates to film speed) or in contrast (which relates to development time).

If the negative that is closest to the desired result is like a negative in the next to the outer row, and exposure or development time must be increased, then one or more negatives should be made like those in the outer row just beyond the close negative.

Sometimes, the correct exposure or the correct development to produce a negative with the right contrast and the right amount of shadow detail falls between two of those negatives in the original ring-around. For example, the exposure is correct but the contrast is just a little too low in the normal-exposure and normal-development negative, but the contrast is a little too high in the normal-exposure/15-percent-overdeveloped negative. In this case a development time halfway between the two will probably be just right, so a normal-exposure negative should be tried with 7 to 8 percent overdevelopment.

The negative exposure and development should be judged, first, by comparison with the negatives in the illustration, and then, primarily by the shadow detail and the contrast of the prints made on medium-grade paper with an enlarger. In this way, an exposure adjustment and a developing time can be found to produce negatives that will easily produce high-quality prints with the correct contrast. If a number-graded paper is used, aim at making negatives that will print well on grade 2 paper. If a single-grade paper is used, such as Kodak Ektalure paper, aim for negatives that will print with the right contrast on that paper.

Ektalure paper, for example, has a contrast equivalent to a hard or No. 3 contrast grade; negatives that print well on it have a lower contrast than negatives developed to print well on medium-grade papers.

• *See also*: BLACK-AND-WHITE PRINTING; COLOR PRINTING FROM NEGATIVES; CONTRAST; DEVELOPERS AND DEVELOPING; EXPOSURE TECHNIQUES.

Rodinal

One of several proprietary developers (others include Azol, Certinal, Activol) that are based upon a sodium salt of p-aminophenol. These are all extremely active developers and are used at dilutions of from 1:50 to 1:100.

Generally, the preparation of p-aminophenol developers involves combining p-aminophenol hydrochloride or sulfate with a solution of potassium metabisulfite and adding sufficient sodium hydroxide solution to dissolve the resulting precipitate.

Rudolph, Paul

(1858–1935)
German mathematician and optician

Rudolph worked with Ernst Abbe, at Zeiss, and in 1889 calculated the first anastigmats to be produced from the new Jena glasses. These included an early form of the Protar lens having a total of four elements, two in each half, and of unsymmetrical construction, and then the more modern symmetrical Protar having four elements in each half.

Later, Rudolph attempted a fast anastigmat called the "Planar" (not to be confused with the modern Zeiss Planar, which is of different construction). This lens was not entirely successful and was superseded by Rudolph's greatest design, the Tessar, which is the basis, with variations, of a great many modern lenses.

About 1920, Rudolph designed the Double Plasmat, which was produced in large numbers by the Hugo Meyer works of Goerlitz.

• *See also:* LENSES; OPTICS.

Sabattier Effect

The Sabattier effect produces an image that is partly negative and partly positive in a photograph. Another characteristic of a Sabattier effect image is a line around the edges of subjects in a picture. Color pictures with this effect may show vivid, unnatural colors. The Sabattier effect is produced by re-exposing the film or paper to light while it is in the developer; essentially, it is a darkroom-produced effect.

Solarization and Sabattier Effect Compared

True solarization is caused by extreme overexposure—about 1000 times the amount required to produce a normal negative image with normal development. Solarization produces a reversal of the image, and both positive and negative images will be visible on the film and in the finished print. Years ago, solarization used to occur quite regularly in long time exposures taken at night. The lights in the scene would be so overexposed that they would reverse and produce a positive image on the negative. Solarization is very difficult to achieve today because films have been improved to the point where this reversal is almost impossible to produce. The Sabattier effect is often incorrectly called solarization because these two techniques produce such similar-looking images.

The Sabattier effect was first described in 1862 by the French scientist, Armand Sabattier. He called it a "pseudosolarization reversal," which he observed when a developing collodion wet-plate negative was exposed to white light.

The Sabattier effect produces both a negative and a positive image on the same film, but this effect is achieved by re-exposing the film during development rather than extreme overexposure in the camera. The already-developed image acts as a negative through which the rest of the light-sensitive silver in the film is exposed. This produces some reversal of the image and the result is part positive and part negative. If re-exposure is long enough, the resulting positive will develop to a greater density than the original negative image.

Identifying the Sabattier Effect

There is a simple way to determine whether a picture has been made by solarization or by the Sabattier effect. The Sabattier effect produces a narrow line or rim of low density, called a Mackie line, between adjacent highlight and shadow areas. The Mackie line occurs because there is always an increased concentration of bromide ions in the emulsion at the boundary separating a completely developed area from one that is just developing. The bromide along these boundaries greatly retards development, forming a more or less clear line. When this negative is printed, the Mackie line will appear as a black outline around the principal image contours. The Mackie line is not very evident on prints made when the Sabattier effect is produced while processing the paper.

Basic Requirements

The Sabattier effect can be produced on either film or photographic paper. Any white-light source can be used for the re-exposure step. The easiest light to use is a safelight positioned right over the sink. You must remove the safelight filter in order

(Top) A normally exposed color transparency. (Center) The Sabattier effect was used to bring out detail missing in the original. Note improved rendition of the pilings under the dock. (Bottom) Sabattier effect as evident in a color transparency exposed through a 40 C filter. Photos by Barbara Jean.

to use the light for re-exposure. The most difficult part of the Sabattier effect is determining the length of the re-exposure. If the same light source is always used, kept at the same distance from the film or paper for each exposure, and good records are kept, you will be able to determine the best re-exposure time for a situation after a few experimental exposures.

It is possible to produce dramatic pictures by the Sabattier effect with any film or photographic paper, but there is an advantage to working with film rather than paper. After producing a negative with the Sabattier effect, any number of prints can be made from that negative. If the Sabattier effect is used on paper, you may not be able to produce another print that is exactly the same. The films and papers discussed here have produced good results, but equally good results can probably be achieved with any number of films or papers after some experimenting. The information given here is simply a guide to getting started in the darkroom; the process can be adjusted to meet a specific situation.

Major Controls in the Process

Three variables affect the amount of reversal: (1) the amount of re-exposure, (2) the extent of development after re-exposure, and (3) the time during development when the re-exposure takes place. If the reversal effects are too strong, reduce the re-exposure or develop the film longer before giving the re-exposure.

If you want to obtain more reversal of tones, increase the re-exposure or make the re-exposure earlier in the development. As a rule of thumb, re-expose the film or paper at about one-third the development time, or when a light image is visible. Stop agitating 10 seconds prior to re-exposure and allow the film or paper to settle to the bottom of the developer tray. After re-exposing, continue the development to the normal development time for the first exposure and use continuous agitation.

To get the best results with the Sabattier effect, use fresh developer and stop bath solutions. With experience, you will learn to pull the film or paper from the developer when you see the effect you want. A fresh stop bath is a necessity for stopping the action of the developer quickly and preserving the image that is seen in the developer.

The Sabattier Effect in Black-and-White

Prints. A few subjects will produce interesting pictures when the Sabattier effect is tried directly on a print; however, most prints simply look as though they have been accidentally fogged. With Farmer's reducer, highlights can be brought out in these prints just as with other black-and-white prints. (*See:* REDUCTION.) If you are not happy with the results, try printing the negative or slide onto Kodak commercial film 6127 or Kodalith ortho film 6556, type 3, as described in following sections of this article.

Film. Negatives made with the Sabattier effect have a high fog level and are difficult to judge visually. It is important to make a print before judging the effects. These negatives will usually print better on a higher-than-normal contrast paper.

Films Exposed in the Camera. The Sabattier effect can be tried directly on films exposed in the camera, but since it takes so much experimenting to get the proper re-exposure, there is a chance of ruining the film. Also, most camera films are panchromatic and must be developed in total darkness, so the effect cannot be seen until development is complete. It is much easier to process the camera film in the normal way and then print it onto a sheet of film, such as Kodak commercial film. If the commercial film is ruined during the processing, little is lost; the original image is still in good condition and can be used to print as many additional sheets of film as necessary until you achieve the proper results.

If you plan to try the Sabattier process on film exposed in the camera, be sure to expose at least three negatives at the same exposure and of the same subject. If roll film is used, expose the whole roll of the same subject at the same exposure; then cut the roll into three parts for the processing experiment. Process one sheet of film or part of a roll at a time and make a print from it to determine any changes that might be made in processing the second sheet or portion of the roll. With this method, a good result will probably be achieved by the third sheet or the end of one roll of film.

Films Exposed in the Darkroom. Printing a negative or slide onto a sheet of film in the darkroom and trying the Sabattier effect on the sheet film rather than on the original film is the

Prints given the Sabattier effect tend to look dark and as if they had been fogged. The technique is better suited to films. (Top) A straight print. (Center) The Sabattier effect on the same image. (Bottom) Print after treatment with Farmer's reducer to lighten the highlights.

The Sabattier effect can be produced in the camera. This print was made from a 4" × 5" negative. The background was dodged during exposure so it would be underexposed with normal processing. Developer was allowed to run off diagonally; then the print was exposed to room light, put in the stop bath, and fixed. Photo by Allan Paul Luftig.

safest way to experiment with this process. If the darkroom experiments are attempted on the original image, it can be ruined. However, if the original image is saved and used to print onto other films, you can experiment without damaging the original film.

Films made for copying continuous-tone originals can often be processed under a safelight, so you can see what you are doing. More important, you can watch the image develop and pull the film out of the developer when you see the results you want. This is the one time when it is permissible to pull the film out of the developer too soon or leave it in longer than the recommended time. With experience, you will be able to judge the development visually and control the process by removing film from the developer at just the right moment and placing it in a fresh stop bath to immediately stop the action of the developer.

Continuous-Tone Effect

Kodak Plus-X pan film is suitable for in-camera use. For darkroom work, Kodak commercial film 6127 is a good film to use for the Sabattier effect if a continuous-tone result is desired. It is easiest to start with a color slide that will produce a negative image on the commercial film. The Sabattier effect will bring out the detail in the shadow areas of the slide, so select a picture that has interesting shadow detail. If a negative is used as the original image, contact-print the first sheet of commercial film onto another sheet of film to convert the image to a negative. Or, interesting results can be achieved by trying the Sabattier effect on the positive commercial film. Try it. If the results are not desirable, take the process one step further by making a negative.

If the original exposure is made properly, a full image will be visible on the commercial film after 40 seconds of development. The film will turn almost black in a few seconds after re-exposure. Resist the temptation to pull this film from the developer before the full development time, because the film will clear and become much lighter after fixing. Once you are familiar with how a well-exposed film looks in the developer, you can visually judge the development and pull the film at the right moment.

High-Contrast Effect

High-contrast graphic arts ortho films produce dramatic results with the Sabattier effect. The Mackie line around the image becomes very evident with these films. By adjusting the re-exposure time, a very high-contrast image can be produced that also includes some gray tones in the re-exposed areas.

Using a long re-exposure or extending the development time so that the re-exposed image is the same density as the original will produce a black film with the subject outlined in a clear Mackie line. To achieve only an outline of the subject, start with a high-contrast original—an image that has been printed onto ortho film. Print this film onto another sheet of ortho film and re-expose the second film during the development.

These dense negatives require long exposure times in printing, and time can be saved in making prints by contact-printing the film with the Sabattier effect onto another sheet of ortho film. When this second film is printed onto paper, a black print with the subject outlined in white will result. To produce a white background with the subject

With high-contrast films, the Sabattier effect produces an outline of the image. Photo by Barbara Jean.

outlined in black, contact-print the second ortho film onto a third sheet of ortho film, and then print that film on paper.

Process the film in lith developer. Wait until the last minute to mix the two stock solutions together and use only a small amount of developer, because it is highly active and oxidizes very quickly. The developer will exhaust itself in a few hours if it is mixed and not used, so never try to store the developer once the two solutions have been mixed together.

To keep results consistent, discard the developer after three sheets of film and mix up fresh developer. The developer can be used for more than three sheets of film if the processing time is increased. Since you can watch the film developing, continue the development until you see the results you want.

Agitate the film continuously in the developer prior to re-exposure but *do not* agitate the film *after* re-exposure, otherwise, the re-exposed areas will have a mottled or streaked appearance. This phenomenon is called "bromide drag," and is caused by the heavy concentration of bromide produced during the development of the high-density areas of the film. Bromide drag can be prevented and a more vivid Mackie line can be obtained by not agitating.

The Sabattier Effect in Color

The Sabattier effect gives even more dramatic results in color than in black-and-white. In addition to creating a negative and a positive image outlined with a Mackie line, the Sabattier effect creates new and vivid colors. The colors produced look unreal and have no relation to the "normal" colors in the original subject.

By using white light for both the original exposure and re-exposure steps, brilliant colors can be created, or colored filters can be placed over the light source during these exposures. A great variety of combinations can be obtained by using white light for one exposure and a filter for the other.

The filters listed below produce good results. Experiment with other filters as well, using the filter data as a guide to the color range. The color listed in the right-hand column is the color that filter produces with a black-and-white original with re-exposure during development. When printing from a color negative or slide, the color in the film acts as a filter and the color produced by the first exposure also acts as a filter during the re-exposure, so the final results might not always be exactly the color expected.

Filter No.	Color of Filter	Color Filter Produces
40Y	Yellow	Blue
40M	Magenta	Green
40C	Cyan	Red
29	Deep red	Cyan
61	Deep green	Magenta
47B	Deep blue	Yellow

Sabattier Color Prints. To achieve the Sabattier effect in prints being processed on a mechanical color processor, it is necessary to take the print off the drum for the re-exposure step. In taking the print off the drum, keep the blanket and print together and lay them on the back of a darkroom tray with the blanket against the tray and the print facing emulsion-side up. Re-expose the print and then put it back on the processor. For easier handling, keep the print and the blanket together at all times. Continue processing in the normal way.

Sabattier Color Slides. Slides produced by the Sabattier effect often show extremely vibrant

A 4 × 5-inch film was given the Sabattier Effect on ortho film. That film was then copied onto 35 mm high-contrast film to produce the slide at top left, which was then used to produce all the other slides in this series. All original exposures were one minute at f/8; re-exposures were all 30 seconds at f/8. Filters for original exposures and re-exposures are given with each picture. ▶

No. 40Y; No. 29.

No. 40C; white light.

No. 40M; No. 29.

No. 40Y; white light.

No. 29; white light.

No. 61; white light.

No. 47B; white light.

No. 29; No. 61.

No. 47B; No. 29.

No. 47B; No. 47B.

No. 29; No. 29.

No. 61; No. 61.

No. 47B; No. 47M.

No. 47B; No. 61.

Sabattier Effect

colors throughout. This method also offers the opportunity to turn black-and-white negatives into color slides by starting with an image printed on a high-contrast lith film. Continuous-tone, black-and-white, and color negatives usually do not produce good results. To obtain the Sabattier effect from a black-and-white or color negative, print the negative onto lith film and use this film as the original. It does not matter whether the image is negative or positive—both will work.

The process of creating the Sabattier effect in a slide involves the use of a color print film and the film-processing chemicals recommended for it.

The temperature of the chemicals is not as critical in this process as it is for making regular transparencies, but a higher temperature produces more grain in the slides. Use 8 ounces of each chemical if 5″ × 7″ trays are used, and discard the developer after processing six sheets of film. If this process is compared with the processing steps recommended on the chemical instruction sheet, you will see that the rinsing steps between the chemicals have been eliminated. This keeps the process as short as possible and will not harm the film as long as the chemicals are discarded after processing six sheets. Agitate the film continuously throughout the process (except just prior to and during re-exposure) by tipping up first one side of the tray and then tipping up the adjacent side.

An almost unlimited variety of colors can be created in these slides by using different combinations of colored filters for the original exposure and for the re-exposure. For the greatest amount of control in using filters and in determining the exposure, use an enlarger for both the original exposure and the re-exposure.

Gang-Printing Slides. Place as many 35 mm slides as will fit onto the film in a printing frame. In the dark, place a sheet of film such as Kodak Vericolor print film in the frame with the emulsion side toward the 35 mm slides and the glass of the frame. Expose the film to the light from the enlarger, with or without a colored filter over the enlarger lens. It is very important to keep track of the exposure time and the filter number in order to duplicate results later.

After the film has developed for about three-quarters of the total time, re-expose it to the light from the enlarger, with or without a filter over the lens. Again, keep track of the exposure time and the filter used. Finish the process and then judge the film over an illuminator. Remember to judge the density of this film just as you would a print—if the film is too dark, it needs less exposure; if it is too light, it needs more exposure.

To save a great deal of time, make a test strip on the first film. Make the test strip in the usual way during the original exposure; during the re-exposure, expose half the film for 30 seconds and the other half for 1 minute with the enlarger just high enough to cover an 8″ × 10″ area. This type of test strip should enable you to produce well-exposed slides on the second film. Keep track of the filter combination and exposure used for each film so that the results can be duplicated in the future. One easy way to code the film is to cut off one or more corners before exposing the film.

By using white light for both exposures, or using a 40Y yellow filter for the original exposure and a 40C cyan filter for the re-exposure, good results will be achieved.

• *See also*: REDUCTION; SOLARIZATION; SPECIAL EFFECTS.

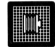

Safelights

The term "safelight" is used to describe darkroom illumination that does not fog a particular light-sensitive material under the conditions in which it is correctly handled and processed. The word "safe" is a relative term. Most sensitized photographic materials will become fogged if left exposed to a safelight for an indefinite period of time. Since photographic materials vary in both speed and sensitivity to light of different colors, the exact color and safe intensity of various safelights must differ to give maximum safe illumination for each type of material. Some high-speed panchromatic materials (sensitive to all colors of light) do not permit the use of any safelight.

Most safelights employ a filter to transmit only a portion of the various wavelengths emitted by an ordinary, low-wattage tungsten lamp. Some safelights use a special cold-cathode or sodium vapor tube, which emits only a very narrow band of

wavelengths to which most black-and-white photographic papers have little or no sensitivity. Such safelights produce a great deal of illumination, so that a darkroom equipped with this type of safelight is visually much brighter than one equipped with filter-type safelights; however, they are considerably more expensive than conventional safelights.

Ordinary incandescent bulbs that have been colored with various dyes, or colored sleeves for use over fluorescent tubes are also available. They should be regarded as an expedient for use only when economy in equipment is the most important factor. In general, the savings they permit is not great, and they are subject to significant variations in manufacture and use. They should be tested at frequent intervals for safety under actual working conditions.

Because filter-type safelights are by far the most widely used, this article concentrates on their selection, use, and testing. The recommendations for various Kodak sensitized materials will apply in most cases to materials with similar characteristics of other manufacturers. Similarly, equivalent safelight filters of other manufacturers may be used with Kodak materials. The only way to be sure that a given safelight is in fact safe for a particular material is to make a practical test, as described later in this article.

Safelight Lamps and Filters

There are three basic parts to a safelight lamp:

1. The housing, which holds both bulb and filter.
2. The filter, which filters out light of some colors and transmits others.
3. The bulb, whose recommended intensity (wattage) is partially determined by the sensitivity of the material to be handled; 25-, 15-, or 7½-watt bulbs are normally used with safelights.

Safelight filters are made so that the light they transmit lies outside the normal color-sensitivity range of the photographic materials handled in their light. However, the color sensitivity of most emulsions does not cut off abruptly at a particular

wavelength in the spectrum; most emulsions have reduced sensitivity to light of colors outside their normal range. This means that most papers and films have some sensitivity even to colors of light transmitted by the safelight filters that are listed for use with them. In these cases, filters are listed that give maximum transmission in colors to which the eye is quite sensitive, but to which the emulsion is relatively low in sensitivity. *Therefore, it is always necessary to keep the exposure of photographic materials to safelight illumination to a practical minimum.*

Filter Colors, Transmission

The color of a recommended safelight filter is not always selected to be the "safest" because of its transmission characteristics. For example, a red safelight filter is often safer for photographic papers than the amber filter listed for use with them. However, visual judgment of print density and of factors affecting personal safety are frequently made under safelight illumination, and most workers find they can consistently make

A red safelight filter is often "safer" than the recommended amber filter. However, many workers feel they can make better judgments under amber light than under red light.

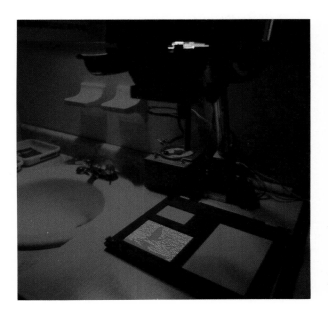

better judgments under amber than under red safelight illumination. Thus, although the visual working conditions are improved by the use of the amber safelight filters, the safety margin to the paper is lowered somewhat.

The visual appearance of a safelight filter is only a partial indication of the transmission characteristics. High-quality safelight filters are made to precise spectral transmission and absorption standards that relate to the spectral sensitivities of photographic materials. It is not generally safe to use colored bulbs or other improvised safelights. They may appear to be the right color, but they may actually emit light (or other form of radiant energy) that will fog a photographic emulsion. It is nearly impossible for the human eye to distinguish "safety" in a safelight.

Safelight filters gradually fade as they are used. Fading means that they transmit more light of colors they are supposed to absorb. For this reason, it is important to test and change them periodically. For example, if the lamps are used 8 to 12 hours a day, change the filters yearly. It is a good idea to put a replacement date sticker on the safelight housing. The illumination level will remain more consistent if the bulbs also are changed periodically; with time, bulbs blacken and give off less illumination. Safelight tests should be made with new bulbs.

Safelight Installation

There are several different types of safelamps to suit various applications and meet a variety of situations.

In darkrooms where materials are handled that have different safelight requirements, the safelight filters can be changed to suit the materials as necessary. Where general darkroom illumi-

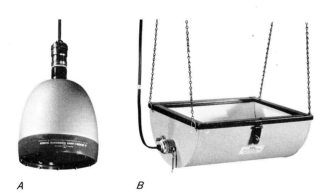

A B

Safelights are manufactured to suit various applications and meet a variety of darkroom situations. Whatever design is selected, it is important to test the filters periodically and replace the bulbs as they begin to darken. Safelight tests should be made with new bulbs. (A) General purpose lamp for use over sinks and benches. (B) Lamp on chain can be used with light directed up or down. (C) Lamp for mounting on wall or beneath a shelf. (D) Two-way lamp for wall-mounted socket. (E) Plastic lamp for amateur darkroom can be screwed into any lamp socket.

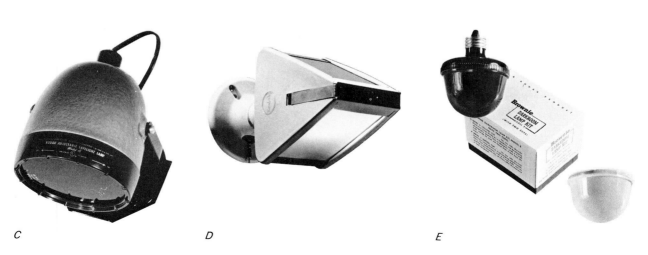

C D E

Safelights

nation is provided by ceiling safelights, such as the Kodak utility safelight lamp, this may not only be a nuisance, but may cause costly delays in production. In such a case, it may be advisable to have two sets of safelights wired to separate switches, which will provide a convenient and fast way to change from one illumination to another. Safelights that provide local illumination—at the developing sink, for example—also can be installed in duplicate, or can be left single because it is easier to change the filters.

With the darkroom thus equipped, the illumination can be changed quickly from a normal printing room to a panchromatic paper printing room, or even to a film processing room, by the throw of a couple of switches or, at the most, by changing filters in safelamps that are at a convenient height.

Placement of Safelights. In general, safelight filters and bulb wattages are designed so that direct safelamps must be placed no closer than 1.2 metres (4 feet) from the work surfaces. In black-and-white printing rooms and other areas where general safelighting is possible and useful, the lamps should be placed so that the general illumination is evenly distributed over the entire area. Individual lamps can then be placed where the greatest safelight illumination is needed—at the developing sink, for instance. Avoid a situation where pools of relatively bright light appear against a dark, unilluminated background. This combination is not only difficult to work in but can be fatiguing to workers' eyes.

It is advisable to consider safelight illumination when the darkroom is painted. Paint the ceilings white for use with indirect safelights. Darkroom walls should be painted a light color, preferably a color similar to that transmitted by the safelight filters to be used. A light tan or buff is suitable for a black-and-white printing room, for example. Paint the wall area immediately behind each enlarger a matte black to avoid possible reflection of white light from the enlarger onto the paper.

Good, general indirect illumination is provided by the use of Kodak utility safelight lamps hung filter side toward the ceiling. In large rooms with white ceilings, allow one lamp for every 6 square metres (64 square feet) of ceiling area. For the work areas where more concentrated light is required, use ceiling-hung lamps where convenient, or lamps such as the Kodak adjustable safelight lamp for · ceiling, wall, or shelf mounting. A number of these lamps can be used, provided the filter, bulb, and distance requirements are met, and provided they are spaced at least 2.5 metres (8 feet) apart.

Avoid placing a direct safelight where its rays will fall directly on an enlarging easel. A relatively high level of safelight illumination here will make visual exposure, dodging, and cropping assessment more difficult, can interfere with exposure calculators, and will decrease the safe time limit at which paper can be exposed to safelight illumination in this location.

Whatever the arrangement may be, do not leave either exposed or unexposed paper under safelight illumination any longer than necessary. Lighttight drawers conveniently located in the enlarger benches are very useful for storing in-work sensitized materials for short periods of time. After normal printing exposure, subsequent exposure is more critical, especially on the emulsion side.

Selecting Safelights

Total-Darkness Materials. Because of their sensitivity to light of all colors, the following types of films, papers, and plates *must be handled in total darkness:*

> Panchromatic films and plates
> Negative color camera films
> Reversal color camera films
> Duplicating color films
> Reversal color papers
> High-speed infrared films

A suitable safelight can be used for orientation purposes in darkrooms where such materials are processed, but not for working illumination. A suitable orientation safelight can consist of a Kodak adjustable safelight lamp equipped with a No. 3 (dark green) filter and a 7½-watt bulb located at some distance from where the above products are handled, and placed so that no direct light from the safelight lamp shines toward the product being handled.

Safelights for Panchromatic Films. Most black-and-white panchromatic films are processed by time-and-temperature methods in complete darkness or in lighttight tanks. There may, however, be occasions when some inspection during development is desirable. A No. 3 (dark green) safelight filter can be used for this inspection in a suitable housing with a 15-watt bulb and no closer than 1.2 metres (4 feet) from the film. The inspection can take place *when the film has been in the developer one-half the normal developing time. This inspection time should not be longer than a few seconds.* Your eyes should be allowed to become adapted to the dark prior to the inspection. The purpose of the inspection is to permit lengthening or shortening the development time to compensate for considerable underexposure or overexposure. The judgment required for success in this type of manipulation takes considerable experience. Although such treatment is sometimes needed, it should be recognized that the contrast of greatly underdeveloped films is quite low, while the contrast of considerably overdeveloped films is very high.

Safelights for Blue-Sensitive and Orthochromatic Films. Both of these types of films are usually handled under red safelights, the particular safelight filter being determined by the spectral sensitivity and the speed of the particular film. See the instruction sheets packaged with the film for specific listings.

Safelights for Black-and-White Papers. Black-and-white papers are developed in processors by time-and-temperature methods or by inspection in trays. To aid in the judging of print density during tray development, the level of safelight illumination is generally higher at the tray position than anywhere else in the darkroom. This illumination must still be safe for the maximum length of time required for development, so that the print quality is not affected. Too long an exposure to even proper safelight illumination, or exposure for the normal length of time to an unsafe illumination, will result in changes to the photographic image that may be harmful. A following section describes a method for testing the condition of the safelights at a developing station.

Unsafe illumination can be caused by an incorrect safelight, by a faded safelight filter, by the use of a bulb of too high wattage, by positioning the safelight too close to the developer tray (less than 1.2 metres [4 feet]), or by having too many safelights. Excessive safelight exposure not only can cause poor print quality by degrading the highlights, but can also cause a lowering of print contrast. It can also increase the speed of the paper. Because the amount of safelight exposure is a variable, if it exceeds the safety time it can cause difficulty in controlling the density and contrast of prints.

Excessive safelight exposure of a print can go undetected because it causes changes in contrast or density before it shows up as fog in the white borders. This is because exposure is cumulative in effect. Consequently, if a borderline safelight condition exists, the prints may show a variable loss in quality, or changes in density and contrast for no apparent reason.

Safelight Exposure

There are two types of safelight exposure. When a photographic material receives a low-level, overall exposure prior to its main exposure, the low-level exposure is technically called a hypersensitization exposure. When the low-level exposure is from a safelight, it can be called a safelight pre-exposure because it comes before the main exposure. When the low-level exposure comes after the main exposure, it is technically a latensification exposure; it can be called a safelight post-exposure when it comes from a safelight.

The safety time for both types of safelight exposure is the maximum time that does not cause a noticeable or harmful change in the photographic image. The safety time for safelight pre-exposure is often different than the safety time for safelight post-exposure in the same material, but both types can cause contrast and density changes, and they may be additive. The safety time must be found by the user for each darkroom condition with each material used. When an increase in density occurs as a result of safelight exposure in areas that receive no white-light exposures, such as borders in a print, the increase is called *safelight fog.*

Certain black-and-white papers have increased printing sensitivity as a result of dye sensitization,

which makes these papers more liable to exposure by the wavelengths of light transmitted by the safelight filters normally used with papers. Fast, warm-image-tone papers, selective-contrast papers, and panchromatic papers are examples. To protect against image quality change or safelight fog, special filters or small-wattage bulbs may be listed for these papers. Any special safelight instructions are indicated in the instruction sheets packaged with these papers. (Some types of packaging do not contain instruction sheets.) The recommendations for safelight filters to be used with specific Kodak photographic materials are based on tests using procedures described in ANSI Standard PH2.22-1971.

Because of all the variables involved, the final decision on whether safe conditions exist or not must rest on the user of the photographic material. The information provided here is designed to help in the making of that decision. Following the safelight filter, bulb, and distance listings given for each sensitized product, the user should test each darkroom situation to decide if the working conditions are indeed safe for the length of time the product is handled under safelight exposure. The following section can serve as a guide in making such a test.

Testing Safelights for Black-and-White Papers. Before starting the test:
1. Install a new bulb of the correct wattage in each safelight housing.
2. Check to be sure that no white light is entering the darkroom through doorways, pass-through covers, and so forth. Correct any leakage. Remember, it takes at least 10 minutes for your eyes to become adapted to the dark so that you can see all the light leaks.
3. Be sure no white light is escaping from the enlarger or from the safelight lamps.

Step 1. With only the safelights on, choose the location where paper is handled in which the illumination is brightest. This will usually be at the developing station. Get a flat piece of stiff cardboard to cover the developer tray.

Step 2. Set up the enlarger with a negative carrier but no negative in it, and an easel to make an exposure on a section of paper masked as shown in the Step 4 illustration as "First exposure to enlarger."

Step 3. Turn off all lights and run a test to find what exposure is required to produce a light gray

Step 4

Step 5

Step 6

Safelight Test Procedure

tone after standard processing. (Process without safelights.) This tone should have a reflection density of .25 to .50 (.15 to .40 above the paper base density). Measure with a reflection densitometer or by visual comparison with the labeled gray scale steps in Kodak publication No. R-19, *KODAK Color DATAGUIDE,* or R-28, *KODAK Professional Photoguide.*

Step 4. First Expsoure to Enlarger. Turn off all lights. Cut a corner from a fresh sheet of paper for orientation, and expose under the enlarger for the time and at the *f*-number found in Step 3. Label this area "Post-." (Illustration labeled Step 4.)

Step 5. Safelight Exposure. With the lights still off, place the cardboard on the developing tray or other area where the safelight was found to be the brightest. Place the paper on the cardboard and, using an opaque card, give a series of exposures to the safelight. Cover about one fourth of the paper with the opaque card for the zero exposure, and give all the exposed part of the paper a 1-minute exposure. Move the card to cover one half of the paper and give the rest 2 minutes exposure. Cover all but one fourth, and give the last area 4 minutes exposure. The four steps will have received 0, 1, 3, and 7 minutes exposure. (Illustration labeled Step 5.)

Step 6. Second Exposure to Enlarger. Using the cut corner as a guide, give the second enlarger exposure to the other section of the paper, and label this area "Pre-."

Step 7. Process the paper in the dark.

Step 8. Evaluate the Test. The accompanying illustrations show three possible results of the tests. Some products are more sensitive to one sequence of exposures than the other; this test can show any difference.

Evaluating the Test. In the first test illustrated, *A,* no added density shows on either side as a result of the safelight exposure. This represents conditions with a safety time of at least 7 minutes.

A potentially unsafe condition is shown in *B.* The paper fogged at 7 minutes exposure to the safelight. This is shown by the density in the area exposed 7 minutes to the safelight, but that had no enlarger exposure, as in the center section and the borders. The paper also shows signs of image change at 1 minute in the pre-exposure area, and at 3 minutes in the post-exposure area. When results like this are obtained, it means that the material must be handled very carefully, both before and after the enlarger exposure. If the

Test No. (a)

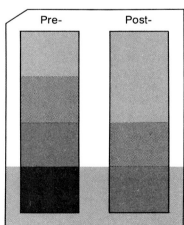

Test No. (b)

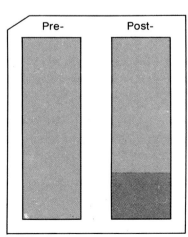

Test No. (c)

Evaluation of Safelight Tests

safelight filter is an old one, such results could indicate filter fading; replacing the filter could give a longer safety time. If the filter is a new one, several steps can be taken to extend the safety time: use a lower wattage bulb; move the safelight lamp to a greater distance; use only dim, indirect safelighting for handling; and develop for half of the total time with the safelight off. From the test results, you know what the safety time limit is, and your print quality will not be affected if you limit safelight exposure to this time.

A more typical test result is shown in *C*. The paper is safe up to 7 minutes of pre-exposure to safelight, and up to 3 minutes of post-exposure. No fogging shows. This indicates that conditions are safe if the total safelight exposure time is 3 minutes or less.

Tests for Other Types of Products. The safelight test is directly adaptable to papers and films that are exposed in the darkroom and tray-processed. It also can be adapted for materials that are handled in different ways.

Blue-sensitive and orthochromatic films are sometimes loaded into holders and later processed under safelights. A test similar to the test for paper can be devised in which a piece of Kodak neutral test card mounted on a very black background is photographed to provide the gray-tone exposures. Give about 1 stop less exposure than the meter calls for on both the pre- and post-exposures. With normal processing of continuous-tone films, this should give a transmission density of around 0.4, against which the safelight exposure (if any) will readily show up. The black background should not result in any appreciable density over the gross fog level. The safelight pre- and post-exposures should be given on cards placed at the loading station and over the developing tray.

Safelight Precautions. When you have found a safety time for your conditions, limit the time of safelight exposure of your photographic material to this time. As with black-and-white papers, the exposure to safelight illumination of all other materials will show up in image areas that have received additional exposure before safelight fog will show up in the borders. For this reason an image quality change resulting from safelight

exposure may go unnoticed unless the safelight test is performed correctly. The coin test sometimes recommended for testing safelights is misleading because it does not test for the added effects of safelight plus the main exposure, and so will test only for fog.

It is a good idea to establish good working habits by keeping safelight exposure to a minimum. Store paper in lighttight containers, even under safelight conditions, and make a habit of handling paper with the emulsion side down (away from the safelights).

Arrange the safelights so that the enlarger easel receives very little safelight illumination by having the enlarger in the fringe illumination of a safelight. When developing prints, insert the paper into the developer emulsion-side down, and then turn the paper emulsion-side up when experience tells you the image has become visible. A combination of the safelight test and your practical experience will guide you in determining how much

Important Facts About Safelights

1. No safelight is completely safe for an indefinite period of time.
2. Specific safelight filters are designed for specific types of papers and films.
3. Some photographic materials must be handled in total darkness.
4. Filters fade with use.
5. Poor safelight conditions can show as a loss in photographic quality before actual fog appears.

Therefore,

1. Use only the safelight filter, bulb size, and distance recommended for the film or paper being used.
2. Test safelight conditions at regular intervals.
3. Replace safelight filters when it is necessary.

safety time you have with your particular working conditions.

Safelights for Color Materials

Color films for use in cameras must be handled in total darkness; there are no safelight filter recommendations for these products.

Color films used for duplicating color transparencies must also be handled in total darkness. Check the instruction sheet packaged with the film. In the same manner, check the instructions packaged with papers for safelight recommendations.

The safelight test described for black-and-white papers can be adapted to those color products that have safelight listings.

• *See also:* DARKROOM, AMATEUR; DARKROOM, PROFESSIONAL.

Scaling Print Sizes

Scaling, proportion, and cropping are closely related terms. Scaling is generally applied to the calculation involved in fitting artwork or photographs to a graphic arts layout and relaying this information to the printer. The photographic question is twofold: If the width of a picture is reduced by a certain amount, how high will the image be? And, if a print is to be reduced by a certain percentage, what length and width will achieve this end?

A scaling dial—a kind of circular slide rule—is available in art-supply stores. Photographers who frequently have to answer questions of scale or proportion may find one of these devices invaluable. Scaling print sizes can also be accom-

A proportion wheel can be used for scaling photographs. By setting the inner disk to the actual size, the reduction or enlargement of the photo can be read from the outer dial. Small window gives both the percentage of the original print size and the number of times reduction.

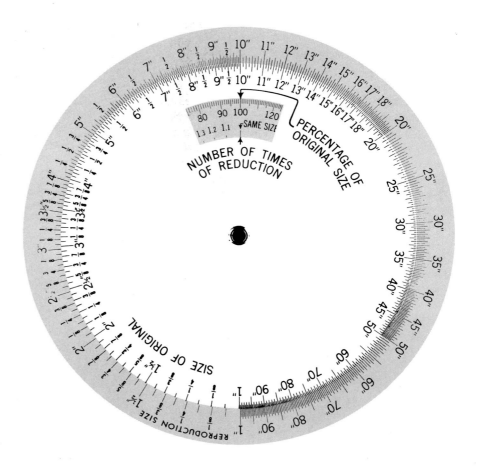

Photographs always enlarge or reduce along their diagonal. Draw the original dimensions of the print either full-size or to scale. Then draw a diagonal line across the print. By erecting a perpendicular line from one dimension (known), the second dimension can be determined as shown.

plished with a simple proportional equation since the reduction, or enlargement, of one dimension of a photograph automatically changes the other dimension.

$$\frac{\text{Original height}}{\text{New height}} = \frac{\text{Original width}}{\text{New width}}$$

In an 8″ × 10″ print, for example, if the new width is to be 5 inches—assuming it is a horizontal picture—the new height will be 4 inches.

$$\frac{8}{4} = \frac{10}{5}$$

This equation also holds true if the reduction is to be calculated in percentages. A pocket calculator that figures percentages is useful, but it is not essential.

A simpler, nonarithmetical method relies on the fact that photographs always enlarge or reduce along their diagonal. Either a ruler or a draftsman's scale can be used to draw the original dimension of the print (full size or to scale) and a diagonal line as shown in the accompanying diagram. Then by erecting a perpendicular line at the new dimension that meets the diagonal, the second dimension can be measured from the intersection of the diagonal and the perpendicular. Additional information on scaling photographs for the graphic arts industry is available in books on printing and graphic arts production.

• *See also:* GRAPHIC ARTS PHOTOGRAPHY; PHOTOMECHANICAL REPRODUCTION; PRINTS, MOUNTING.

Scheimpflug Principle

Maximum image sharpness of a given object plane is achieved when projections through the image plane, the object plane, and the plane through the optical center of the lens (perpendicular to the axis) all intersect at a common point. This is known as the Scheimpflug principle, or condition, after Theodor Scheimpflug, who first analyzed the optical geometry of the alignment. Using this principle makes it easy to set up a camera with lens and back movements for maximum sharpness

(Top) When the subject plane (A) is not parallel to the plane through the lens (B), the image is formed in a plane that does not correspond to the normal angle of the film plane (C). (Bottom) Tilting or swinging the camera back brings the film into alignment with the image; this alignment corresponds to the Scheimpflug principle, which states that subject, lens, and image planes intersect at a common point. However, the back movement is in a direction that increases linear distortion. In addition, subject points (a, d) that do not lie within the depth of field (colored zone) are not sharp in the image. The film alignment with the image plane only makes certain that the unsharpness of such points is not exaggerated.

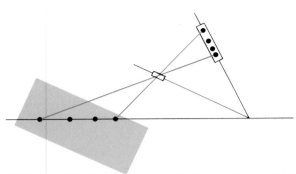

Tilt/swing of the lens has two effects: it places the depth of field so that it covers all important subject points, and it shifts the image plane so that Scheimpflug alignment of the film produces maximum sharpness with significantly less distortion. (An extreme lens tilt/swing may also require a shift—not shown—to keep the circle of coverage centered on the film area.)

along a desired subject plane with little or no trial and error.

As the preceding diagrams illustrate, achieving sharpness in this manner does not permit correction of linear distortion because the film plane is not brought parallel with the subject plane. In practice, the lens can be moved to place the image plane at a different angle and to take advantage of the available depth of field, both of which help minimize the degree to which the back must be moved.

• *See also:* CAMERA MOVEMENTS; KEYSTONING; PERSPECTIVE; VIEW CAMERA.

Scheiner Speeds

Scheiner speeds is an obsolete system of film-speed ratings used in Germany and Austria and for a time, in modified form, in England. The system was based on exposing the film to a step wedge in a sensitometer, then developing the sample, and determining the exposure that produced a just barely visible image. The speed figure, then, was derived by using this exposure value in the following formula:

$$\text{Scheiner speed} = C - (10 \log E)$$

where: C is an arbitrary constant to fit resulting numbers to the scale of the exposure meter, and E is the exposure required to produce the first visible image. Therefore, Scheiner speeds, being on a logarithmic scale, were doubled or halved on every third number; a speed of 27 indicated a film twice as fast as one of 24 and half of one rated at 30. To prevent confusion with linear scales, Scheiner numbers were followed by a degree mark, thus Scheiner 27°, Scheiner 21°, and so on.

The Scheiner system was never considered satisfactory for two reasons. The first is that the appearance of a barely visible density is not an exact criterion; one person may see a density, while another may not. Secondly, the production of a barely visible density does not relate to the conditions for picture-making, where differentiation of tones is the true necessity. Thus, a film with a very long toe, on which there is little differentiation of tone, would have an artificially high rating on the Scheiner scale.

• *See also:* SPEED SYSTEMS.

Schlieren Photography

Schlieren photography is a tool for investigating the flow of gases. This is used in aeronautical engineering, where a knowledge of the flow patterns of air over surfaces is important for aircraft speeds approaching and surpassing the speed of sound. In the study of ballistics, schlieren photography discloses valuable information about shock waves accompanying projectiles. The combustion engineer uses the schlieren method in studying how fuels burn, and investigations of heat transfer are aided by the ability of schlieren photography to show the paths taken by air passing over a hot surface. Movements of the surface of liquid and convection currents within liquids during heating and cooling can also be recorded by using variations of this technique.

Schlieren methods do not interfere with the subject being observed. Normal motion of gases is not impeded, as is the case when Pitot tubes or yaw heads are inserted in the gas stream to detect flow direction. This is particularly valuable at high gas

velocities, where shock waves set up by probes in the stream may seriously distort the data.

The sensitivity of the schlieren method can be made surprisingly great. It can easily detect temperature differences as small as 6 C (about 10 F) in an air stream. This is adequate to disclose the currents of heated air rising from a person's fingers. Conversely, the sensitivity can be reduced to the point where the exhaust of a liquid-fueled rocket with a total temperature of more than 2690 C (about 4900 F) can be recorded to show the presence of shock waves and other flow phenomena.

The equipment needed is relatively simple and can be used under widely varying experimental conditions. The sensitivity of the system can be varied at will to suit test requirements, the results are not difficult to interpret, and quantitative measurements can be obtained under idealized test conditions.

General Principle of the Schlieren Method

The schlieren method depends upon refraction of the narrowly defined edge of a light beam by gradients in the refractive index of the gas through which the beam of light passes. Its name "schlieren" is translated as "optical inhomogeneity." In a typical system, a limiting diaphragm, usually a straightedge, is so adjusted with respect to the edge of the light beam that refraction in one direction adds to the total illumination, and refraction in the other direction subtracts from it. Thus, an image is formed wherein the variations in brightness depend upon differences in the gradients of refractive index in the light path.

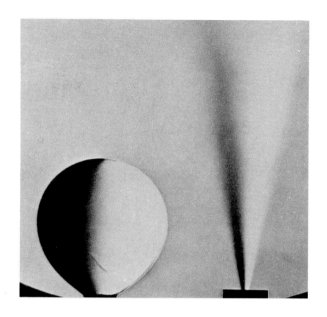

Measuring the photographic density of points in the image of a helium-filled soap bubble makes it possible to compute the amount of helium in the freely expanding jet.

The accompanying diagram shows the simplest type of schlieren system. Light from the source, which is preferably a line rather than a point, is focused by the condenser to form an image. A limiting diaphragm, generally straight rather than circular, is placed parallel to this image of the light source and intercepts part of it so that the resultant beam has a sharply defined edge. This beam then passes through the schlieren head, which focuses it

The simplest type of schlieren system. Light from a source is focused by the condenser to form an image. A limiting diaphragm, placed parallel to this image, gives the image a sharply defined edge (first knife-edge). This beam passes through the schlieren head which focuses it through the schlieren field onto a second knife-edge. The attenuated beam of light can then be recorded on photographic film.

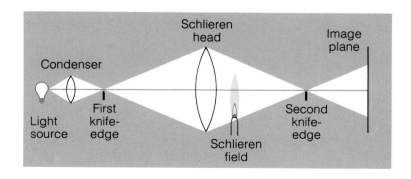

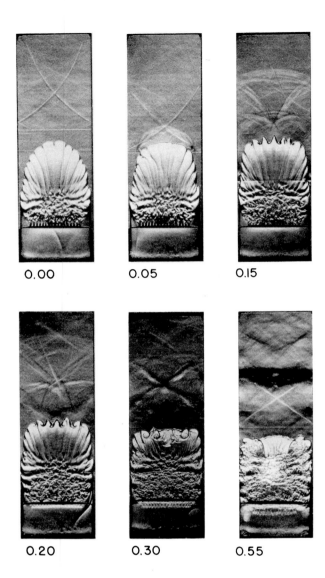

0.00	0.05	0.15
0.20	0.30	0.55

Interaction between a shock wave and a flame (butane-air mixture ignited at bottom of combustion chamber) that is initially distorted by passage through a wire grid. Photo courtesy G. Markstein, Cornell Aeronautical Laboratory for Office of Naval Research, Project SQUID.

the two knife-edges. However, if a gradient perpendicular to the plane of the knife-edges exists, the beam will be refracted so that it either adds to or subtracts from the light normally present on the screen. Thus, a schlieren field is reproduced in various tones on the film. Opaque objects appear in silhouette.

Arrangement of Schlieren Components

Single-Element Systems. Many possible combinations of elements can be assembled to form schlieren systems. The simplest would be a system with a lens of good optical quality serving as the schlieren head. Because lenses of adequate quality generally are not available in sizes more than a few inches in diameter, it is more convenient to use first-surface concave spherical mirrors. Such mirrors must be accurately ground so that imperfections in the surface are not confused with the image produced by the schlieren field. Usually, mirrors of a grade suitable for telescopes are satisfactory. Common specifications call for mirrors contoured within 0.1 wavelength of sodium light.

The accompanying illustration shows two typical schlieren systems using a single mirror as the schlieren head. That on the left is essentially the basic schlieren system shown in the previous diagram, with a mirror substituted for the lens. However, because the light source and the camera cannot both be perpendicular to the mirror, some coma is introduced by the skewness of the components. Another minor shortcoming is that the schlieren field must be placed well out in the converging beam from the mirror, thus limiting the size of the field as compared with the size of the mirror.

The schlieren system on the right in the illustration uses a prism—a first-surface mirror would do equally well—to bring the central axis of the light source nearer to that of the camera. Although coma is reduced by this expedient, its main purpose

through the schlieren field onto the second knife-edge. By adjusting the position of this second knife-edge so that it is exactly parallel with the first knife-edge, and by inserting it partially into the beam of light, a gate is provided that can intercept a large part of the luminous flux. This attenuated beam of light then passes to a photographic film where it can be recorded.

If there are no gradients in refractive index within the schlieren field, the amount of light reaching the film is fixed by the relative position of

Schlieren Photography

is to permit the light beam to pass twice through the schlieren field, thus doubling the sensitivity of the system over the more conventional arrangement at the left of the same illustration. Because the two light paths through the field are not exactly coincident, the resolution of the image is somewhat impaired.

Many different modifications of high-sensitivity schlieren systems can be devised, with the light beam passing through the schlieren field as often as desired. As the number of paths becomes greater, however, the resolution of the image usually is poorer.

Two-Element Systems. The accompanying diagram illustrates a schlieren system based on the use of two schlieren heads. Although mirrors are shown, good-quality lenses could be used.

This system is the most popular of all schlieren systems. It has the unique advantage that parallel rays of light pass through the schlieren field, thus producing an image of superior resolution. Further, because the light source and the camera are placed on opposite sides of the light path between the mirrors, coma is cancelled. Another advantage is that the schlieren field is located away from the mirrors.

In fact, the least permissible separation of the mirrors is about twice their focal length in order to provide space for the schlieren field between the entrance and exit cones of light. On the other hand, since the light beam is parallel between the two mirrors, they can be separated as far as desired. This is particularly useful with wind tunnels where it is not convenient for the schlieren head to be near the field, or with explosion or high-temperature combustion phenomena where the schlieren head must be protected from damage.

The accompanying photograph shows a typical two-mirror parallel-path schlieren system in operation. The mirrors used here were 12 inches in diameter and had an equivalent focus of 96 inches. Spacing them 28 feet apart provided ample space for conveniently locating the phenomena to be studied.

Accessory Equipment

Light Sources. Any light source of adequate brightness can be used for schlieren systems. Depending on the application, either intermittent or continuous sources of light can be employed. Generally, the source should be of high brightness and small dimensions so that it can be focused

A two-mirror Schlieren system in use. Photo courtesy of Battelle Memorial Institute.

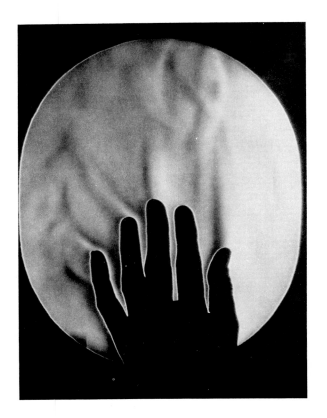

(Above left) Warm air currents rising from fingers in still air. Temperature difference estimated to be 5 C (10 F). (Above right) Typical heated air flow pattern from hot soldering iron. (Left) Stream turbulence from four impinging jets of helium. All photos courtesy of Battelle Memorial Institute.

accurately at the first knife-edge. Sources as small as a 25-watt zirconium arc lamp may be used, but more intense sources are generally desirable. Other continuous sources are the tungsten-filament lamp, the high-pressure mercury-vapor lamp, and the xenon-discharge lamp. For simpler schlieren systems where flash exposures are not necessary, a slide projector can be used as the light source. Intermittent sources are the spark and the flashtube, both of which provide brief, high-intensity flashes that can be electrically triggered. Sparks offer high luminance, small size, and very brief duration. While usually larger in size than sparks,

Schlieren Photography

flashtubes offer high intensity, brief duration, and better efficiency of conversion of electrical energy into light.

Mounting Supports for Equipment. Because the alignment of schlieren systems is critical, it is generally necessary to provide solid support for the components. Where the systems are relatively small and the components can be mounted rigidly on a steel framework or a rigid table, it is usually necessary to provide for only minor adjustments. For larger systems, however, where the space between components is relatively great, the equipment should be located in the basement or in a location where building vibration is not serious. The components shown in the photograph of the two-mirror schlieren system in operation were mounted on pedestals weighing 318 kilograms (700 pounds) and fitted with heavy-duty casters to permit locating them where required. Once in position, three jackscrews lifted the pedestals from the casters, firmly anchoring the components in place. Once properly aligned, this system could be used indefinitely without further adjustment.

Knife-Edges. The first knife-edge in a schlieren system serves mainly to define a sharp boundary in the light beam. It must be placed approximately parallel to the image of the light source if a rectangular source is used. Generally, it intercepts about half the light beam, to assure a well-defined boundary. It should be mounted on a firm support.

The second knife-edge is used to adjust the sensitivity of the system. Because it must be able to rotate around the beam, move transversely with the beam, or intercept the beam at different positions, its mount must be adjustable in three directions. Slides with gibs, as on the tool carriage of lathes, together with fine-pitch screws, usually are provided to furnish the necessary precision of adjustment. Rotation around the light beam may be done with a simple worm-gear arrangement.

New safety razor blades make excellent schlieren knife-edges, and are commonly used. Although straight knife-edges are often employed because they permit observation of schlieren effects predominantly in a single direction, circular diaphragms can be used where polarization of the schlieren effects is not important. In this type of system, a circular diaphragm defines the edges of the light beam passing to the first schlieren head. Another circular diaphragm at the focal point of the second schlieren head serves to obstruct rays having sufficient angular deviation. Being circular, the diaphragm intercepts strongly diffracted rays in any direction. In some systems, the objective lens of the camera may serve as a second diaphragm, but such systems usually are not very sensitive.

Adjustment of the Schlieren System

Good schlieren photographs of high sensitivity can be made only when the system has been properly aligned and adjusted. Although this is not as difficult as adjusting an interferometer, for instance, care taken here will be repaid with photographs of better definition, improved contrast, and adequate sensitivity.

The first step is to obtain a sharply focused image of the light source on the first knife-edge. This knife-edge is inserted far enough into the beam at the point of best focus so as to intercept about half the incident light. In the case of the two-element parallel-beam system, the first schlieren mirror is then placed exactly one focal length away and so positioned as to receive all the diverging beam from the knife-edge. The reflected beam from the mirror then will have uniform, parallel rays. If the emergent beam is not parallel, the mirror must be repositioned. This mirror must also be adjusted so that the reflected beam makes the smallest possible angle with the diverging beam from the first knife-edge.

The second schlieren mirror is then placed so as to receive the bundle of rays from the first mirror, and at least two focal lengths away from the first mirror for convenient field location. By tilting this second mirror slightly, the converging beam coming from it is deflected slightly to one side, the angle preferably being the same as that between the first knife-edge and the first mirror. The second knife-edge is then placed precisely at the focal point of the second mirror and rotated so that its edge is exactly parallel to the sharply defined edge of the light beam.

Proper positioning of the second knife-edge can be checked by observing the image on the ground glass while moving the knife-edge slightly. When properly located, moving the knife-edge

Turbulent bunsen flame, exposure 13 microseconds. Photo courtesy of Battelle Memorial Institute.

gradually into the light beam will produce a uniform darkening of the image area. If the image area darkens nonuniformly in the direction of motion of the knife-edge, the position of the knife-edge should be shifted along the beam until uniform darkening is obtained. If darkening is nonuniform in a direction perpendicular to the motion of the knife-edge, the edge must be rotated until this condition is corrected.

Photographic Materials

In general, photographic emulsions having moderate speed and contrast serve well for recording schlieren images. For flash photographs or in extremely high-speed schlieren photography, faster films may be required.

Preferably, negatives are developed to moderate contrast, but contrast requirements will depend largely on the nature of the subject. In general, the

darkest part of the field should provide enough exposure to show a noticeable density in the developed negative image.

Color Schlieren Photography

The addition of color to the schlieren technique can improve the evaluation of density gradients produced in the test area. Using a two-mirror parallel-beam schlieren system, a constant-deviation dispersion prism is placed between the white-light source and the first schlieren head. The usual second knife-edge is replaced with a slit at the focus of the second schlieren head. This slit is adjusted so as to pass only light of a particular color. The remainder of the schlieren system is conventional.

In operation, the slit is adjusted with respect to the main beam so that a monochromatic, uniformly illuminated field is produced when there is no gradient in refractive index in the schlieren field. For example, the slit may be adjusted so that the background is yellow when no gradients are present. Then a compression wave would appear red and a rarefaction wave would appear green, the shift from the background color being dependent upon the angular deviation caused by refractive-index gradients.

The image produced by this system with relatively long exposure times is comparable with that of the conventional schlieren system, except that the usual differences in illumination intensity are replaced with changes in color.

Another method of making schlieren photographs in color involves a set of color filters in the form of three strips of different colors (such as red, yellow, and blue) ,to replace the second slit. The image of the light source falls on the central strip. If this is yellow, the yellow rays proceed through the system to the film. When the air in the test area is undisturbed, the film is uniformly flooded with yellow color. Variations in the air density cause rays to fall on the red or blue sections of the filter, forming a colored image on the film.

Scientific Photography

Scientists do a great deal of conventional photography as a recording method to document their work. They also use conventional photographic materials in more or less unconventional ways. In addition, photographic manufacturers have responded to the demands of science for extraordinary photographic materials to fulfill unique functions in research.

Photography extends the limited capabilities of human perception. Human vision is limited to processing about ten pictures per second, while the suitably equipped camera can record many thousands of images per second. The eye sees only what is "visible." The photographic process can capture wavelengths that are invisible to the eye. Infrared, ultraviolet, and x-rays can expose suitable photographic emulsions. In addition, photographic emulsions can record the energy of charged nuclear particles.

The scientist taxes the capabilities of photographic systems. The researcher and the instrumentation engineer work with photographic scientists and engineers to find new methods and materials to record transient events, to detect weak radiation, and to define phenomena outside direct human observation. Those new to the fields of scientific photography and photorecording will find

A katydid, camouflaged by leaflike wings, is completing the process of laying an egg. After applying mucilage to the primary vein of the leaf, she guides the egg into place with her mouth, positioning it beneath the previous egg. Photo by Howard L. Kessler, APSA.

the following information useful in getting started. Specific answers to the questions posed must come from scientific papers, trade literature, and manufacturers' catalogs.

Sensitometry, Image Structure, and Special Sensitivity

The appearance and utility of a photographic record are closely associated with the sensitometric and image-structure characteristics of the plate or film used to make the record. Sensitometry is concerned with the measurement of the response of photographic materials to electromagnetic radiation. Image-structure properties and image effects determine the extent to which a photographic material can faithfully record information.

The degree to which optimum sensitometric characteristics are realized, as well as the structure of the image obtained, depends on the manner in which the material is exposed, processed, and evaluated. There is no unique relationship between exposure and ultimate density because the observed density is influenced by additional factors. The wavelength of the exposing light and the type of developer used are among the factors that contribute to the nature of the image. The type of measuring instrument used to examine the image will affect the magnitude of the values obtained. Similarly, the resolution of detail in the image will depend on the spectral quality of the exposing radiation, the contrast of the subject, the

From the photograph at left, archeologists determined how Egyptian goldsmiths assembled the mask for the mummy of King Tutankhamon some 33 centuries ago. Gamma rays penetrated the mask and were recorded by x-ray film. Radiograph courtesy of the Laboratories of the Louvre Museum.

manner in which the product is exposed, the optical system, processing conditions, and the technique of evaluation.

The importance of following processing recommendations and of establishing proper, standardized processing techniques cannot be overemphasized. In scientific and industrial photographic applications, where the investment in personnel and equipment can be very high, results of an otherwise well-conceived and well-executed operation can be compromised, or lost entirely, if the final photographic step—processing the exposed plate or film—is not conducted properly.

For most work, the processing techniques recommended for general photographic work are adequate. However, where accuracy is of high importance, as in photographic photometry, processing procedures must be followed carefully.

Photographic emulsions on glass possess a number of important characteristics that are not found in sensitized materials that feature a different support. For example, glass is flat, rigid, and highly resistant to the action of chemicals. It has great dimensional stability. As a base for photographic emulsions, it is especially advantageous when it is necessary to hold multiple images in register, or when it is essential to maintain size accurately in the presence of changing temperature and humidity. Thus, although glass is relatively heavy and somewhat fragile, its unique properties are valuable in fields such as photogrammetry, astronomy, oceanography, and missile tracking, as well as in the design of instrumentation and precise photographic systems.

Exposure and Speed Values

Exposure Equation. The exposure equation can be of considerable help when studying the feasibility of a particular photographic system or the suitability of a recording material, even if some of the values in the equation have to be estimated. Usefulness is increased if the photorecording system can be simulated in order to obtain an arbitrary constant that reflects many fixed variables in a given situation. For example, a time series of exposures can be made of an unusual scene or display using one film in a conventional 35 mm hand camera set at $f/4$. Results of the test might establish that a somewhat slower, finer-grain emulsion of similar spectral characteristics would yield

This bullet, moving at 1150 feet per second, was photographed with a burst of electronic flash lasting one third of a millionth of a second. Photo by Edgerton, Germeshausen & Grier, Inc.

improved contrast and resolution. By substituting the speed values of alternate photographic materials in the exposure equation, the investigator might elect to use a 16 mm motion-picture camera with an $f/1.4$ lens and to operate it at 64 frames per second.

Thus, it can be economical in terms of time and money to run initial tests with existing equipment and, with a readily available film, make thoughtful application of the exposure equation, and then predict the success that may be expected by using alternate avenues to perform the task at hand.

Using the Camera-Exposure Equation. Calibration of the exposure-calculating dials, or scales, on photographic exposure meters is based on the fundamental camera-exposure equation:

$$te = \frac{kN^2}{BS}$$

where: te is the exposure duration in seconds, N is the relative aperture of the camera lens ($f/2.8$, $f/5.6$, $f/8$, and so on), B is the average scene luminance in footlamberts, S is the ASA speed of the photographic material, and k is a constant, which takes into account the arbitrary magnitude of the several parameters and such variables as spectral convolutions and transmission losses in the

optical system. For typical camera situations and white-light sources, k can be assumed to have a value of 3.33 when scene luminance is given in footlamberts. (If B is in candles/ft$^2$, then k = 1.06.)

Although this equation is valid for exposure meters marked for ASA speeds and is valid only for continuous-tone pictorial photography, it may prove useful to investigators who have access to specialized devices that can measure the radiant power emitted, reflected, or transmitted by a scene or object to be photographed but that do not have integral exposure calculators.

To illustrate, assume that:

$$N = 8 \ (f/8)$$
$$b = 4.5 \text{ footlamberts}$$
$$S = 160 \text{ (ASA speed}$$
$$\text{or meter setting)}$$

Substitution in the camera-exposure equation gives:

$$te = \frac{3.3 \times 8^2}{4.5 \times 160} = \frac{213}{720} = 0.296, \text{ or}$$

approximately $^3/_{10}$ second. If the radiant power is measured in terms of energy incident *on the scene,* the exposure equation takes the form:

$$te = \frac{CN^2}{IS}$$

where: I is the irradiance, or illuminance, and C is a constant that performs the same function as k in the preceding equation but that also includes the average reflectance or transmittance of the object or scene to be photographed. In conventional picture-taking, if the illuminance is given in footcandles, C has a value of approximately 20.

A more comprehensive treatment on the subject of exposure computation appears in the *SPSE Handbook of Photographic Science and Engineering.*

Exposure Determination—Non-Camera Systems

Not all photographic recording situations involve a camera or a camera-type arrangement; therefore, using meter setting values and calculating exposures with an exposure meter is not applicable. There are two basic approaches to calculating an exposure, and each one must be considered only as a guide to exposure determination.

Trial-and-Error Method. As in many scientific investigations in which there are few clues to go on, trial-and-error provides an orderly method for determining proper exposure of a photographic material. The procedure is simple. First, select a plate or film on the basis of such parameters as spectral sensitivity, contrast, resolving power, granularity, availability, and cost. Second, make a series of test exposures under actual conditions of use, using a *geometric* progression of exposure times, for example, 1, 2, 4, 8, 16, 32, 64. For a rough determination, you can use 1, 4, 16, 64, 256, and so on. Using a geometric progression will minimize the time required to conduct such an empirical determination.

Finally, develop the test samples following recommended processing procedures and evaluate the results to determine the optimum exposure level. If a coarse series is used initially, it may be worthwhile to run a second exposure series in order to refine the determination.

Using a Photometer. Carefully calibrated devices are available for measuring the illuminance incident on a light-sensitive cell. In addition, some exposure meters, although usually not so precise, are marked to indicate illuminance directly in footcandles or metre-candles. If there is reasonable compatibility of the source, photocell, and photographic material in terms of spectral characteristics, and if the meter is sufficiently sensitive, a trial exposure time can be determined for a material that has been selected with other characteristics in

mind. Alternatively, if the illuminance level and the maximum tolerance exposure duration are known, available exposure (using $E = It$) can be determined. Thus, the slowest plate or film that is likely to respond satisfactorily can be selected.

Detection of Weak Signals

There is a small number of scientific applications that may require photographic materials with characteristics that are impractical to include in the manufacturing process. As a result, investigators in the field—especially photographic astronomers—have explored ways to alter selected existing materials in order to improve their inherent recording capabilities and, hence, to do a better job. The photographic characteristic that has received most attention is emulsion sensitivity, or speed.

Focus on speed is not new, a fact that is borne out by the perennial appearance of articles in popular and scientific literature. During the early years of photography, the number of emulsions was limited, as was their capability for making stop-action photographs or for recording subject matter under low levels of illumination. Venturesome photographers experimented with different devel-

oper formulations and tried other ways to eke out a bit more speed, usually at the expense of image quality.

Today, a number of high-speed photographic products are available for scientific applications. More importantly, perhaps, we have a sounder understanding of the role of the photographic emulsion as a detector of very weak signals, as distinct from a recorder of conventional photographic images. It is now known that high speed is not the sole or even the most important criterion in selecting a photographic material for signal detection. Placed in proper perspective, however, high sensitivity can be valuable, and this discussion concludes with a review of methods for increasing the effectiveness of certain materials by increasing their speed. It is helpful to start by considering the process of image formation in silver halide emulsions.

The selection of a photographic material and possible application of means for increasing its speed should be based on an assessment of the image-recording situation. In scientific photogra-

Over the course of 2000 years, fragments of the Dead Sea Scrolls blackened to illegibility (near right). When photographed on infrared film, under infrared radiation which is reflected by leather and absorbed by carbon ink, legibility was restored (far right). Photo by Palestine Archeological Museum of Jerusalem.

Perhaps no aspect of scientific photography calls upon more technological disciplines than these familiar images of the first moon landing. Technologies involved include optics, electronic imaging, long-distance microwave transmissions, computerized image-enhancement, and conventional photography. Photo by NASA.

phy, the detection of weak signals frequently means situations involving low levels of radiation, although there are cases where a weak signal is derived from a source of high intensity that is present only for a very short period, for example, a few nanoseconds. From a recording standpoint, either case may present a challenge.

It is essential to establish at the outset whether the signal of interest exists in the virtual absence of background noise (high signal-to-noise [S:N] ratio) or in the presence of significant background noise (low signal-to-noise ratio). For convenience of discussion, we refer to a recording condition of high S:N ratio as a "Class I" situation, while a condition of low S:N ratio characterizes a "Class II" situation.

An example of Class I recording is the photography of stars or nebulae through interference filters. Filter attenuation severely limits the amount of radiation that reaches the plate or film, while the narrow bandpass of the filter effectively excludes most extraneous background radiation, or noise. Other Class I applications include photography with telescopes of large focal ratio (small relative aperture, large *f*-numbers) and certain kinds of spectrography. A classic example of Class II recording is limit detection of faint stars with telescopes of large aperture and low focal ratio, since the background is typically stronger than the signal.

Selecting a Photographic Material

Each investigator usually has some ideas about the properties of the material that will do the job. The investigator may be quite knowledgeable, photographically speaking, and may have ex-

hausted the possibilities of finding a regular off-the-shelf product. Or, he or she may be one of many scientists and engineers who believes that a particular problem can be solved by using a photographic emulsion as a recording device, but who really doesn't know where to begin the process of reviewing the published data.

To readers fitting either category, a "what-to-do" and "how-to-do-it" approach to product selection is suggested. Because the potential user of the photographic material must necessarily provide some of the input on which to base a recommendation, the accompanying outline will raise many questions.

HOW TO SELECT A PHOTOGRAPHIC MATERIAL FOR SCIENTIFIC APPLICATIONS

What to Do	How to Do It
1. Determine what type of image is to be recorded. a. Is the image that of an object or scene, or is it merely a signal—a stellar image or an emission line? b. If an object or scene, what illuminance range does it represent—long or short? Is the subject moving or stationary? c. If a signal, is the signal weak or strong? Must it be detected in the presence of background noise?	1. Assess the recording situation. Determine if the signal of interest exists in the virtual absence of background noise (high signal-to-noise ratio) or in the presence of significant background noise (low signal-to-noise ratio).
2. Determine spectral sensitivity required. a. Is a panchromatic emulsion necessary or will a blue- or blue-green-sensitive emulsion work? b. Is there a spectral region of particular interest (a laser wavelength or narrow bandwidth, perhaps)?	2. Review the spectral sensitizings available. Refer next to the spectral sensitivity curves. Compare the curves for several potentially suitable products in the spectral region of interest. Compare and note log sensitivities at this region.
3. Determine emulsion speed required. a. Is there plenty of light (or radiation); is it very weak? b. Is the light level known in metre-candle-seconds, in ergs/cm$^2$, or some other unit?	3. Refer to the Meter Settings or speed values. If dealing with "white" light (tungsten or daylight) in a camera or similar optical-imaging system, use an exposure meter (1) if one is available and can be placed in a measuring position, (2) if the light level is sufficient to be recorded, or (3) if the criterion for determining the meter setting is applicable. If the recording situation does not involve a camera or camera-type arrangement, use a photometer and calculate exposure using data provided in the form of published D-log E curves. Or, make an exposure series under actual or simulated conditions. If the illumination is monochromatic, or nearly so, or if the radiation falls in a region for which a photocell is not available, calculate a first-approximation exposure by (1) using spectral sensitivity data, if available, or (2) making an exposure series.
4. Examine image-structure characteristics. a. Is the application especially demanding in terms of granularity, resolving power, or contrast? b. Is MTF data required?	4. Examine image-structure data. Consider the data in terms of emulsion speed, noting that in general as speed increases, contrast and resolving power tend to decline and granularity increases. Examine the characteristic curves for an indication of the changes in contrast, speed, and fog that can be introduced by adjusting development time during processing. Examine MTF curves, if available.
5. Review physical characteristics. a. Are the requirements for rigidity and dimensional stability such that a photographic plate is required, or would sheet material also work? b. Must the material be available in roll form—16, 35, or 70 mm—for use in a film transport system? Are perforations required? What type? c. Is an antihalation-backed product required?	5. Consider using a photographic plate instead of film (except when long lengths are required). In most situations, a plate can be used instead of a sheet film and vice versa. Sheet films can be cut readily to meet an unusual size, but so also can glass plates be cut with a little practice. Don't overlook cutting 35, 70, or 100-mm wide films to yield small-size sheets. Check all specifications for size and antihalation backing. Try to select a standard size.
6. Consider time and product-availability factors. a. Must the work be undertaken within a few days or at most a few weeks? b. Are the photographic equipment and exposure conditions fixed, or can they be readily modified to accept a different format (a sheet film instead of a plate, for example)? c. Is delivery two to four months after placing an order acceptable?	6. Look first to regular, commercially available products with standard specifications (size, support type, antihalation backing, etc). Consult a professional dealer for up-to-date information. Consider next factory-stocked items. These can usually be supplied within a few weeks. As a last resort, consider special-order products that may have a delivery time of up to several months.

The entries in the left-hand column may be all that some readers will require in order to organize a systematic review of the data obtained. The information in the right-hand column offers additional suggestions and clues for interpreting the data.

• *See also:* AERIAL PHOTOGRAPHY; ASTROPHOTOGRAPHY; BIOMEDICAL PHOTOGRAPHY; CATHODE-RAY TUBE RECORDING; CLINICAL PHOTOGRAPHY; DENTAL PHOTOGRAPHY; ECLIPSE PHOTOGRAPHY; ELECTRON IMAGING; ELECTRON MICROGRAPHS; ELECTRON MICROSCOPE; INFRARED PHOTOGRAPHY; MEDICAL PHOTOGRAPHY; MICROPHOTOGRAPHY; OSCILLOGRAPH RECORDING; PHOTOGRAMMETRY; PHOTOMACROGRAPHY; PHOTOMICROGRAPHY; RADIOGRAPHY; RADIOLOGY; STEREO PHOTOGRAPHY; STOP-MOTION PHOTOGRAPHY; STROBOSCOPIC PHOTOGRAPHY; THERMAL PHOTOGRAPHY; TIME-LAPSE PHOTOGRAPHY; ULTRAVIOLET AND FLUORESCENCE PHOTOGRAPHY; X-RAY.

Further Reading: Arnold, C.R., P.J. Rolls, and J.C.J. Stewart. *Applied Photography.* New York, NY: Focal Press, 1971; Blaker, A.A. *Field Photography.* San Francisco, CA: Freeman Publishers, 1976; ———.*Handbook for Scientific Photography.* San Francisco, CA: Freeman Publishers, 1977; Brown, F.M., H.J. Hall, and J. Kosar. *Photographic Systems for Engineers.* Washington, DC: Society of Photographic Scientists and Engineers, 1966; Engel, C.E., ed. *Photography for the Scientist.* New York, NY: Academic Press, 1968; Thomas, Woodlief, ed. *SPSE Handbook of Photographic Science and Engineering.* New York, NY: Wiley Interscience, 1973.

Screened Negatives and Prints

Screening Exposure

Most photomechanical reproduction methods require that a continuous-tone image be broken into a series of dots for the preparation of printing plates. This is accomplished by copying the original through a halftone screen pattern on film or glass onto an extremely high-contrast film. The screen throws a shadow pattern on the emulsion being exposed. The size of the image dots formed through the screen depends primarily on the fineness of the screen, the brightness of various areas of the original image, and the exposure.

There are two types of halftone screens. One type is the glass screen, which has two sets of black-ruled lines at right angles to each other. A glass screen is placed at a precise distance in front of the film emulsion when the halftone exposure is made. The other type of screen is called a contact halftone screen. The pattern on a contact screen is a variable density pattern.

The image is enlarged or reduced to the desired size of the final reproduction at the time of the screening exposure; later changes in magnification would change the size of the dot pattern and the quality of the reproduction. A single screened image is required for black-and-white reproduction; four separate images taken through color separation filters are required for color reproduction. The screening exposure may be made by contact-printing methods, by copying the original in a camera, or by projecting the continuous-tone image in an enlarger. For black-and-white halftones, a secondary (flashing) exposure to plain light through the screen is required to make certain that there will be some dot pattern in the deepest shadow areas so that they will print properly in the ink reproduction. Often a third exposure (bump exposure) is given of the image without the screen to provide better highlight tone separation.

Printing Materials

High-contrast "litho" or graphic arts films and papers are used because continuous-tone reproduction does not work in a screened image, but a clear, sharp image of every halftone dot is required. That is, the criterion is not light dot or dark dot, but big dot or little dot. Screened images may be made on either film base or paper base materials and may be either positive or negative, depending upon the stage at which screening takes place and the kind of printing process to be used.

Photographic Procedures

Screened prints are combined (pasted up) in precise position along with reproductions of type and line art on layout sheets ("mechanicals") so that all elements can be photographed onto a single master negative from which the printing plate is prepared. Screened images on film (halftone negatives) are combined (stripped in) with the other elements on film so that the master negative can be exposed by contact printing in a vacuum frame. Again, the procedure used is determined by the ultimate method of reproduction.

High-quality screened images depend on:

1. Even illumination of the original being copied.
2. Precise alignment of the screen and the litho emulsion.
3. Critical focusing with a process lens especially corrected for flatness of field at photomechanical reproduction ratios, generally 1:1 to 10:1.
4. A screen completely free of dust, dirt, and blemishes, which could interfere with the pattern.
5. Precise exposure—too little or too much will destroy detail and degrade quality in the highlight or shadow areas of the reproduction.

The nature of halftone screens and use of screened images are discussed in the articles GRAPHIC ARTS PHOTOGRAPHY and PHOTOMECHANICAL REPRODUCTION. The term "screen print" (sometimes "screened print") refers to a serigraph, an image produced by forcing ink through a fabric stencil. (*See:* SCREEN PRINTING PROCESS.)

Screen Printing Process

The screen-printing process is a combination of photography and graphic arts. The original image is a negative or slide, and in the darkroom this image is enlarged onto a high-contrast film, such as Kodalith ortho film. The image is then transferred from the high-contrast film onto a fine-mesh screen material. There are a number of methods used for making the mask on the screen. This article covers a typical method—the use of Hi-Fi green presensitized photo film. For information on other methods of screen printing, refer to the *Further Reading* list at the end of this article.

Once the photographic image has been transferred to the screen, the photographic process ends and the graphic arts process begins. The screen image is printed onto paper by forcing inks through the screen stencil with a hard rubber squeegee while the screen is in contact with the paper. The final image looks as if it had been painted with poster paints.

Any number of images can be applied to create a multicolored final image, but each color must dry

A photo silk-screen print made with two screens. One screen printed the rose-colored background and the other screen printed the purple areas. Photo by Richard V. Stoecker.

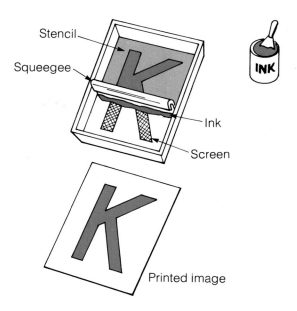

The "screen" in screen printing is a fine mesh stretched over a frame. Early screens were made of silk, but today nylon and other fabrics—even stainless steel—may be used as well. A stencil, special ink, and a squeegee are also parts of the screen-printing process.

Stencil

Squeegee

Ink

Screen

Printed image

thoroughly before the next is printed. It is necessary to make a separate screen stencil for each image that is to be printed.

Cleaning the Screen

Use a screen with a 14–17 mesh. Ready-made screens on wooden frames can be purchased in graphic arts supply stores or the fabric can be purchased and stretched to make screens.

Good results in screen printing depend on a clean screen, so wash the screen with Serascreen SPC enzyme or Foto-Film remover. Rinse well and apply degreaser with a soft scrub brush. Neutralize the screen by rinsing with an acetic-acid solution (one capful of 28 percent acetic acid in a gallon of water). Allow the screen to dry. After the screen has been cleaned, *do not touch the fabric*. The slightest trace of oil will keep the Hi-Fi green from adhering properly to the screen.

Preparing the Photographic Image

Any well-exposed negative or slide can be used as the original image. If a negative image is used, the final screen stencil will be a positive image; a positive original image produces a negative screen stencil. If desired, when a positive image (a slide) is used, the Kodalith film positive can be contact-printed to another sheet of Kodalith film to convert the image to a negative.

The size of the image in the screened print will be the same as the image on the Kodalith film, so enlarge the image to exactly the size that is needed. The degree of enlargement is very important when more than one image is applied in a screen print—particularly if the images are to be registered.

After the image has been transferred to Kodalith film, black out any dust spots with an Eberhard Faber Thinrite Marker 690 black, or Kodak opaque.

High-Contrast Images. For a high-contrast image that will produce concentrated areas of color

in the final screened print, print the negative onto Kodalith ortho film 6556, type 3.

Continuous-Tone Images. To produce an image similar to a continuous-tone image—one with varying degrees of color density in a photo screen print—the original image must be enlarged onto Kodalith Autoscreen ortho film 2563 (Estar base). This film has a built-in dot pattern and will allow the reproduction of shades of one color.

Transferring the Image to Hi-Fi Green

Hi-Fi green presensitized photo film is easy to use because it can be handled in normal room light. However, avoid exposing it to sunlight or bright fluorescent lights. After exposure to an ultraviolet light source—such as a sunlamp, photolamp, or arc lamp—and development, the exposed areas of the image can be washed away in warm running water (not over 46 C [or 115 F]). Then the sticky side of the film will adhere to the screen. Hi-Fi film has a plastic backing that can be easily peeled away after the film is dry. After the backing is removed, the Hi-Fi film acts as a mask on the screen; ink will flow through the screen only in those areas where the Hi-Fi film has been exposed and washed away.

Exposure. Place a sheet of Hi-Fi film and the film positive resulting from the previous step in a

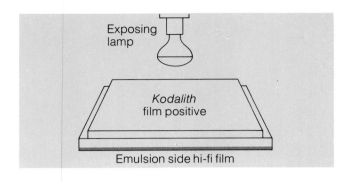

Exposing lamp

Kodalith film positive

Emulsion side hi-fi film

(A) Place the Hi-Fi film under your film positive with the plastic backing on the Hi-Fi film toward the film positive and the light source. (See illustration at left.) (B) A sunlamp is one of several lights you can use to expose the Hi-Fi film. (C) Develop the exposed Hi-Fi film with the plastic side of the film toward the bottom of the tray and use just enough developer to cover the film.

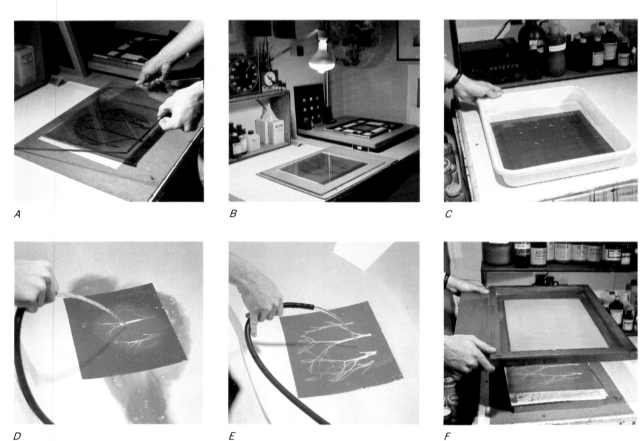

A

B

C

D

E

F

(D) Place the Hi-Fi film in a clean tray or the bathtub. Rinse until the design is clearly visible and the water clean. (E) A fully rinsed film should look like this. (F) Place the Hi-Fi film, emulsion up, on a platform of boxes. Their dimensions must match the opening in the screen frame. Lower the screen over the film with one slow, even movement. (See illustration at right.)

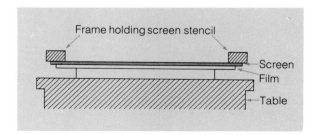

Frame holding screen stencil

Screen
Film
Table

Tape

Heavy paper Tape Tape

G

H

I

(G) Pat the screen with paper towels to absorb excess water, and force the adhesion of the film to the screen. Do not touch the screen with your hands. (H) Let the screen dry thoroughly; then peel off the plastic backing. (I) The screen is ready for printing. Paper is held in position with heavy paper Z's. (To make Z's, see illustration above).

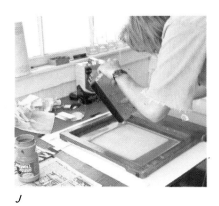

J

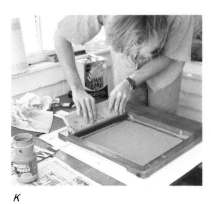

K

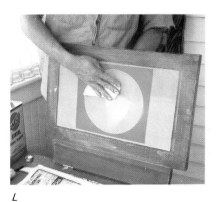

L

(J) Pour the ink and squeegee it over the surface of the screen. (K) Immediately lift the screen and set the paper aside to dry. (L) Excess ink or cleanup is done with paper towels or rags and turpentine.

Screen Printing Process

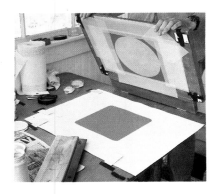

To produce multiple-colored screen prints, a separate screen must be used for each color and each screen must be printed separately. Each color layer must dry thoroughly on the paper before the next color can be printed over it. All photos on this and the two preceeding pages by Bob Clemens.

printing frame as shown in the accompanying diagram. The plastic backing on the Hi-Fi film should be toward the film positive and the light source. Always make the exposure through the Kodalith film positive and through the plastic backing sheet to the emulsion of the Hi-Fi film. The emulsion side feels tacky when touched with a wet finger. Expose the film using the accompanying table as a guide for the first exposure. Make a test strip of various exposures, develop the film, and then select the best exposure.

The longer the exposure, the thicker the resulting mask will be. Too long an exposure will close up the fine lines; too short an exposure will produce

Screen Printing Process

Lamp-to-Copy Distance	Photolamp No. 2 (New)	Photolamp No. 2 (Used 3 hrs)	Sunlamp (250-watt)
10 inches	2 min	3 min	2 min
20 inches	8 min	12 min	5 min
40 inches	32 min	48 min	20 min

a mask that is thin and lacks strength. A faint image will be visible after exposure.

Development and Wash Out. Develop the exposed Hi-Fi film in Inko #201 liquid or Ulano A and B powder-type developer. Follow the mixing and developing instructions given on the developer package. Protect the developer from strong light by covering the tray when it is not in use. *Never bottle used developer, because it forms a gas;* discard the developer at the end of each working session.

Place the plastic side of the Hi-Fi film toward the bottom of the tray, and use just enough developer to cover the film. *Do not touch the sticky side of the film after it is in the developer, because the emulsion will come off.*

Immediately after development, transfer the Hi-Fi film to a clean wash tray. Using a mild spray of warm water (not over 46 C [115 F]), wash the film until the design is clear and the water running off the film is clear. Tip the tray so that the stream of water washes over the film and runs out over the bottom edge of the tray. Finish the wash by rinsing the film with cold water for 30 seconds.

Adhering the Film to the Screen. To provide good contact all over the surface of the screen, use several photographic-paper boxes to build up a platform that is just slightly smaller in surface area than the screen that will be lowered over it. Refer to the accompanying diagram. Place the wet Hi-Fi film on the platform with the emulsion side up.

NOTE: It is important to keep the film wet if there is any delay between the wash-out step and adhering the film to the screen.

Hold the screen in position over the film and platform, and gently lower the screen down over the film with one slow and even movement. Any side-to-side movement after the screen is in contact with the film will blur the image. Place paper towels over the screen and pat them down to absorb the excess water; then pat the surface of the screen with a wad of paper towels to force the adhesion of the Hi-Fi film to the screen. *Do not touch the screen with bare hands.*

Let the screen dry thoroughly and then gently peel off the plastic backing. Clean the screen with turpentine to remove the adhesive.

Printing

Registering the Image. To help register the image in printing, attach the screen frame to a tabletop or large sheet of wood with loose-pin hinges. (These hinges will come apart when the center pin is pulled out.)

Take a sheet of paper for printing, and place it in position under the screen. Fold strips of heavy paper or light cardboard into a Z-shape and tape the Z's to the table with masking tape. Place two Z's to guide one edge of the paper and two Z's to guide an adjacent edge. The Z's will hold the paper in place during printing and will help register the image in successive prints. (See the accompanying diagram.)

Inking Procedure. Tape strips of tissue paper around the edges of the screen in any area where the Hi-Fi film does not completely cover the screen, or use a blackout that will not be affected by the ink.

Tape 1½-inch squares of cardboard to each corner of the screen frame. These cardboard squares lift the screen off the paper and will help prevent speckles of ink from getting onto the paper.

CAUTION: Printing with screen inks must be done in a well-ventilated room. Inhaling the fumes from screen ink may cause light-headedness and

giddiness, followed by a severe headache. If a lot of screening is to be done, it is a good idea to invest in a gas mask.

There are many screen inks available from graphic arts suppliers, which come in a great variety of colors. Some inks are transparent and others are opaque; colors of the same type of ink can be mixed to produce different shades.

With the paper in place under the screen, pour the ink along the edge at one end of the screen and squeegee the ink over the surface of the screen once. Be careful in lifting the squeegee so that the ink does not drip onto the screen. Lift the screen and remove the paper to dry. If a quick-drying ink is used, it is best to have a helper to remove the prints; then you can begin printing the next sheet. Work fast so that as many sheets as possible will be printed before the ink begins to dry and blocks up the screen.

Cleaning Procedure. When the process is finished, scrape off the excess ink and save it in a tightly covered jar. Clean the screen carefully with paper towels or rags soaked with turpentine. To make sure the screen is completely clean, hold it in a vertical position and rub both sides of it at the same time with paper towels.

Applying Several Colors

To produce color-screen prints, each color must be allowed to dry thoroughly before applying the next color. A separate screen must be made for each color or image; this is where the hinge and Z-system of registering is valuable. Fit each screen with the same size hinges in exactly the same position on the frame so that each screen will fit onto the baseboard or table.

After printing the first color, remove the Z's. Select a dry print made in the first step and place it on the table. Attach the second screen to the table; then lower the screen and move the paper under it until the second image is in its proper position over the first image. Tape the Z's in place to guide two edges of the paper. As each sheet of paper is slipped into the Z's, it will automatically be registered so that the second image will go in place. Register any additional colors and images in this same way.

Print the second image and any additional images in the same way as the first. Always print the background image first and work from the background toward the foreground with each image.

The final product of the screen printing process looks as if it had been painted with poster colors. Photo by Richard V. Stoecker.

Screen-Printing Supplies

Screen-printing supplies are available from art and graphic arts suppliers, or they can provide information as to where to obtain them.

• *See also:* GUM-BICHROMATE PRINTING; HIGH CONTRAST; SPECIAL EFFECTS.

Further Reading: Biegeleisen, J.I. *Screen Printing.* Cincinnati, OH: Watson-Guptill, 1971;—— and J.A. Cohn. *Silk Screen Techniques.* New York, NY: Dover Publications, Inc., 1958; Caza, Michel. *Silk Screen Printing.* Florence, KY: Van Nostrand Reinhold, 1973; Elliot, Brian. *Silk-Screen Printing.* New York, NY: Oxford University Press, 1971; Fossett, R.O. *Screen Printing Photographic Techniques.* Cincinnati, OH: Signs of the Times Publishing Co., 1973; Jaffe, H.L. and Eric Vietze. *How a Screen Print is Made.* New York, NY: American Federation of Arts, 1970; Kosloff, Albert. *Photographic Screen Printing.* Cincinnati, OH: Signs of the Times Publishing Co., 1976;——. *Screen Printing Techniques.* Cincinnati, OH: Signs of the Times Publishing Co., 1976; Marsh, Roger. *Silk Screen Printing.* New York, NY: St. Martin's Press, 1974; Rainey, Sarita and Burton Wasserman. *Basic Silkscreen Printmaking.* Worcester, MA: Davis Publications, Inc., 1971; Ruggles, Joanne and Philip. *Darkroom Graphics.* Garden City, NY: Amphoto, 1975.

Selling Pictures

The general public has an appetite for somewhat sentimental subjects, and picture buyers are more than willing to purchase photographs such as this well-executed image of two kittens. Photo by Joseph Schneider.

The way photographs are sold depends largely on the type of photography involved. To describe selling methods, the photographic business can be divided into two broad categories:

1. The photographer produces and sells photographs to a customer in response to a request or an order. Often, the order is accompanied by a deposit, so that the photographer is reimbursed for expenses if the pictures are refused or unclaimed.
2. The photographer produces pictures on a speculative basis with a view to selling them in appropriate markets at a later date.

Selling Photographs on an Assignment Basis

The first category is the largest; it includes the whole field of professional photography, which includes portraiture, commercial, advertising, illustrative, and display work.

Portraiture is usually a retail business. It is sold by independent studios or those located in department stores. Sometimes portrait stands are set up in shopping malls, but these usually specialize in child photography. Another outlet for inexpensive portraits is the self-service, coin-operated auto-machine often found in bus stations, shopping malls, and sometimes in the offices of the American Automobile Association.

Commercial photography comprises a major part of the photographic trade. Most commercial work is produced and sold by commercial studios that tend to specialize in some particular phase of photography, such as advertising, catalog work, fashion, automobile, and food photography. These aspects of photography have been discussed in other articles in these volumes.

Selling Photographs on a Speculative Basis

The second category comprises those photographers who produce pictures without a specific assignment or an order and hope to market the results later on. Some freelance photographers operate in this way, as do many others who sell their work to newspapers, magazines, picture agen-

cies, advertising agencies, and so forth. The keynote in speculative photography is to provide the kind of pictures that a particular market requires, but it's rather an uncertain way of making a living. Consequently, the work is usually done on a spare-time basis by amateurs and others with photographic interests. If you elect to do this kind of photography, here is some helpful information on how you may sell your photographs to some of these markets.

Selling to Magazines

Seeing pictures published in magazines (or books) is a powerful impetus to many advanced amateurs who aspire to fame and fortune. Keep in mind that there is little reward unless you study the needs of publications that seem most appropriate to your interests and aptitudes.

Accessible to the serious photographer is a vast array of magazines. Choose as targets those which specialize in subjects you enjoy shooting, such as travel, gardening, sports, or hobbies. Study the magazines thoroughly before submitting pictures. Strange as it may seem, the editors of a periodical like *Popular Science* sometimes receive unsolicited pictures of babies or other unlikely subjects. Time and postage are wasted when the seller is not adequately aware of the topics preferred by publications. Alert yourself to a magazine's needs as defined weekly or monthly by what you see in its pages.

In addition to personal familiarization with specific magazines, see the section Further Reading at the end of this article. Other potential buyers of photographs, such as book publishers, stock photo agencies, and ad agencies are also listed in these books, as well as brief descriptions of what specific markets want. In this way, you can supplement your knowledge of magazines through direct study, keeping in mind that guidebook information becomes dated when personnel and policy change.

News and Feature Coverage. Events and people with news value are both easy and difficult to sell to magazines. They are easy when you direct them to the right market *before* another photographer's pictures turn up. For instance, an exciting car race with a novel twist, such as the first woman driver in your area, may sell quickly to an automotive publication, which might even pay more than average—if you ask. The difficulty arises from the number of photographers who may cover such a race. You must shoot efficiently, process film quickly, and deliver pictures as soon as possible. Some big-city newspapers may process your film if you can convince them you have newsworthy images.

Queries. The average photographer sells completed pictures in the non-spot-news feature category, because the competition may be limited or non-existent. Once a few publications begin buying, use tear sheets of your published pictures to introduce yourself to new editors. At this point, you may begin to sell *ideas.* When a potential story or specific coverage of a subject is described on paper *before it is shot,* this communication is called a *query* through which an editor can decide if the idea is worth buying and printing. Ideally, the editor gives you an assignment, which means a day rate, and expenses are guaranteed according to arrangements specified or negotiated. Thus, the best way to sell a feature story or newsworthy topic is by query. Presumably you will get an assignment.

In this regard, you should understand that response to a query may suggest *speculation,* which should not be confused with an assignment. When an editor says, "I'd like to see the pictures you shot of __, and if they are what we want, we will buy them because we're interested in that subject," beware. You are being asked to speculate, and the risk is all yours. The editor is not obligated to pay for anything, and unless you feel you (a) want the experience, and/or (b) there is an assortment of markets for the pictures, avoid speculation. You can ask the editor to pay all or a portion of your expenses as a gesture of goodwill, though this does not mean a commitment to buy. Once you are selling, even irregularly, editors should not be given the right to specify what they want without some financial involvement. Speculation is a non-professional practice. However, originating and shooting a picture project (called an independent production) is a fine photographic tradition based on personal convictions.

Presentation to Magazines. After talking with editors on the phone, visit local publication offices to introduce yourself and your work. (*See:* PORT-FOLIO.) If convenient, deliver pictures taken on an

Action and adventure photographs are often in demand. This example of a tense moment in the rapids is particularly saleable because duplicating the actions shown is a most unlikely prospect. Photo by Norman Schumm.

There is something in this picture of a speed skater that epitomizes the sport. Buyers would be likely to look favorably at a sports action photo such as this. Photo by Doris Barker.

(Left) Familiar subjects are often saleable subjects, particularly when thoughtful photography achieves a viewpoint that has strong masses and lines, and top-notch technical quality. Photo by Arthur Underwood. (Below) This photograph, which also includes the Golden Gate Bridge, is a well-executed street scene. However, as a photograph of the Golden Gate Bridge, it is probably not saleable, and no other element in the picture holds any great interest that would attract a potential buyer. Photo by Martin Taylor.

assignment. Otherwise, send your work by mail or United Parcel Service. Prepare it according to the following procedures.

Edit Photographs Carefully. Mark black-and-white contact sheets, and have enlargements made of pictures that tell your story. Project color slides to determine the best ones for submission.

Picture Sequence. Place the pictures in sequence if that is appropriate. Black-and-white prints should be 8″ × 10″ with ¼-inch borders, unless otherwise ordered. Place color slides in transparent plastic sheets.

Number Each Print and Slide. On separate sheets of paper, write whatever captions are required and number the captions to correspond to the number on the prints and slides. Add background information on separate sheets if it is expected.

Mailing. Pack your pictures, captions, and so forth, between sheets of corrugated cardboard that resists bending. Secure everything in position with rubber bands. Place the cardboard and pictures in a mailing envelope marked "Photographs: Do Not Bend" on both sides.

Return Envelopes. If you are sending unsolicited pictures to a magazine, also send a self-addressed, stamped envelope (SASE). First-class

Selling Pictures

mail is preferred over parcel post for faster delivery.

Correspondence. Include a letter, which may be short, to the editor; it becomes a friendly bridge across the distance that separates you.

Certifying or Insuring the Package. Certify the package (or insure parcel post), and pay for a return receipt. Whether solicited or not, it is important to be able to trace your pictures if they stray or are lost. Irreplaceable color prints or negatives should be registered or insured for a reasonable value. Again, get a return receipt card to indicate when the package was delivered and to whom.

Allow several weeks before calling or writing about unsolicited material. Some magazines work quickly, and some slowly, whether pictures are eventually rejected or not. Phone calls are often effective after three or four weeks with no word, but remember that tact is part of salesmanship.

Rates and Rights. Marketing guides offer basic rates paid by magazines, but when you sell pictures, the editor will usually suggest the price. If the figure seems unsatisfactory, negotiate for more, and if that fails, you may ask for return of the pictures. Compromise will usually then prevail. Magazines normally pay on the basis of circulation, but rates are not consistent, and some magazines with giant circulation pay less than ones with smaller circulation.

If possible, sell only first publication rights, or one-time rights if the material has been published before. (*See:* COPYRIGHT; RIGHTS.)

A System. Rejection goes hand in hand with selling photographs. Do not become discouraged. Have an alternative in mind in case your work comes back. Keep a 3″ × 5″ file card for each story or picture you submit, and note on it the market, date sent, and date returned. A lot can be learned from a few sentences of explanation an editor may write with the return of your material. Printed rejection slips are irritating, but a fact of life. If you get one and want more information, call and ask politely. You may get an illuminating reply.

Sales to Book Publishers

First, familiarize yourself with the kinds of picture books or illustrated books being published by doing some research in libraries and book stores. Check the spring and fall announcement issues of *Publishers Weekly* (separate issues for children's books), stocked at most libraries. You will be amazed at the great variety of picture books in print. You may be inspired as well.

Next, think of a vital idea or two that absolutely require photography, and make a book proposal as follows:

1. Write an outline in which you list chapter headings with 50 to 100 words under each to describe the contents of the chapter. A catchy title for the book is an asset.

2. Write one chapter as an example to show editors your ability. Team up with a writer if you feel you do not want to write.

3. Take some sample photographs (as many as necessary for diversity) to give a visual impression of what the publisher may expect. Do not photograph the whole book unless (a) it happens in a limited time and doing so is expedient or necessary, or (b) there is no other way to approach a subject that defies verbal description.

4. Present the pictures as 8″ × 10″ black-and-white prints, 3″ × 5″ color prints, or slides in plastic sheets. All should be numbered, captioned separately, and in sequence. Color prints are useful to preserve one-of-a-kind slides, and because some editors may respond to them more easily than slides.

5. Send the material well packed as noted previously. Heavy packages may be accompanied by a check for return postage and insurance; publishers will usually supply the return envelope or readdress yours. Certify, insure, or register all book submissions for safety and peace of mind.

6. Keep a record of where book proposals go, as you do for magazine stories.

Originating a book project is only one means of selling pictures for books. You may also arrange

Cityscapes that manage to capture the essence of a particular place are often marketable. This picture of the ornamental iron work and cast iron pillars makes it clear that the locale is the city of New Orleans.

Ordinary people going about their everyday work are good photographic subjects. The old lady and her cow are common place enough to her neighbors, but the photograph has an exotic character that would interest a picture editor. Photo by Dr. David Mills.

with a writer to illustrate a book in whole or part. If you tell publishers that you are available and send samples of your work, chances are nothing will happen because far fewer photographs are purchased for books than for magazines, and known professionals have the edge. However, if you have unusual subjects in your files, you may

get better attention. Read book publishers' requirements in the market guides, and aim your material as precisely as possible toward companies that seem to publish books related to your ideas. Be prepared to wait patiently for replies on proposals or queries (also useful in this field). Book editors may seem excruciatingly slow, averaging 5 to 6

weeks for responses. Tactful inquiries about your material, after a reasonable interval, are worth the trouble.

Contracts and Royalties. No business agreements between photographers and buyers are more varied than book contracts. Here are a few main points to be aware of:

1. The basic royalty for a book is 10 percent of the selling price of the book except in special cases where royalties are paid on the net, or discounted, price. Author and photographer often split 5 percent and 5 percent. After 7500 to 10,000 copies have been sold, the royalty usually escalates to 12 percent or 15 percent, but arrangements vary.

2. An advance against royalties ranges from $500 to $5000 and up, depending on the sales potential of the book, the publisher, and the author/photographer's prestige and/or powers of persuasion.

3. Each contract includes a deadline or delivery date for the author/photographer. Ask the publisher for a publication deadline of 12 to 18 months after acceptance, if one is not incorporated in the contract.

4. Reprint rights, paperback royalties, promotional budgets, and many other items are usually incorporated in book contracts. Inquire about a sample book contract from the Author's Guild, 234 West 44th St., New York, NY 10036. If you do sell a book, some of the literary agents listed in market guides would be happy to help you negotiate a contract for a small commission.

While the above information is intended to be helpful, in complex situations you may be well advised to consult an attorney.

Selling To Newspapers

Metropolitan newspapers usually rely on staff photographers for most of their pictures, and only occasionally buy from freelance photographers. Accidents and special events may result in picture sales if you photograph and deliver quickly, but newspaper rates are notoriously low, so ego-satisfaction is often greater than the check involved.

Small-town and weekly newspapers may be more inclined to buy from outsiders because they usually have limited staffs. Their payments are also low, but such publications can provide good exposure and experience and can lead to sales in larger markets.

Sunday supplements locally edited may be receptive to freelance photography, but national Sunday supplements operate like newsstand magazines and should be approached similarly. Writing capability helps in these markets, as it does with many magazines and in selling books. Association with a writer is a worthy way to sell your pictures and enhance a career.

Photography Magazines

You will not get rich selling to photography magazines, but they are good showcases for your work, and many editors read them. Send limited, well-edited portfolios of pictures, perhaps centered on a theme. Innovation and experimentation are valued and will distinguish you from the crowd if the work is published. You sell one-time rights and get your pictures back, just as you would from any other publication.

Contests

Trying to sell photographs through contests presents a risk in that your photographs may never be returned, and you may not win either. Read contest rules thoroughly, and if pictures are returned, win or lose, take a chance. If you stand to win $25 and a certificate, weigh the advantages of such a "sale" with care. There are some worthwhile contests, but the rewards have to be more than seeing your name in print; that rarely builds a commercial following.

Selling Stock Photography

It may seem that if you have a large file of travel pictures or special subjects, such as children, farming, skin diving, or insects, that you should be able to sell readily to publications who would contact you often if they knew your inventory.

Such is usually not the case. Selling stock pictures from a private file takes enormous patience, and a thorough system of promotion, which most aspiring photographers are unable to manage. Magazine and book publishers will accept detailed lists of what is in your files, but unless you update the list three or four times a year, it will be filed and forgotten.

Therefore, it is preferable to sell through a photographic stock agency where publications and ad agencies make daily requests. Inquire at several agencies listed in market guide books, and compare terms. Keep duplicates of all color slides, and send black-and-white prints, not negatives. Be prepared to wait quite a while for sales, unless you add to the quantity of images regularly, and the total grows into the thousands. At an agency with a million or more images on file, your work may be requested infrequently, merely by the law of averages. Having special subjects like foreign royalty or Philippine tribesmen might help sell your work, but pictures of well-known places are needed much more regularly.

Agency contracts often require that you leave pictures for a specified number of years. Read such agreements carefully, and do not put yourself in a situation that might prove awkward. Weigh the assets of steady sales against the liabilities of agency restrictions. An agency usually takes 50 percent of a sale. This may seem unfair, but agency overhead is high, and they make sales you would not otherwise make. Again, it is wise to seek legal advice before signing any contracts.

There are a few assignment agencies that sell picture stories and get work for photographers they represent, but newcomers are not likely to make connections until they have been published to some extent. If you happen to photograph a news subject, however, you may submit the work to such an agency with short notice. Agency expertise is well worth the commission for timely photographs. (*See:* AGENCIES, PICTURE.)

Other Markets

Advertising Agencies. Advertising agencies may interview unknown photographers, but jobs are rarely given to newcomers because too much is at stake, and experienced photographers are usually available. Nor do agencies buy stock pictures from individuals very often. Thus, beginners are advised to skip the advertising market, except on a local basis where you may know people, products, and services. (*See:* ADVERTISING AGENCIES.)

Record-Album Covers. If you are acquainted with a performer and take pictures of him or her or a group, you may sell to recording companies, but otherwise this is not a readily accessible market.

Selling in Galleries. In recent years, photography as art has become a profitable approach to a limited number of people, most of whom sell through galleries, decorators, and department stores. Color prints are more popular than black-and-white prints, but the best-quality prints are relatively expensive, which makes a $100-per-print-and-up selling price common. This limits sales possibilities, but if art photography is your interest, research local outlets and offer work on consignment. If it sells, you will get your percentage, and if not, you may replace prints with new ones.

Depending on the type of scene or print desired, a market for fine black-and-white pictures can be developed in your area by careful presentation and promotion. Art increases in value as the artist's reputation grows. Prices, therefore, depend on intangibles and might be left to experts in galleries and museums. If you sell directly to customers, make a local price survey first.

Tips on Selling Pictures

Selling photographs involves many ramifications, pleasures, and surprises. In order that the surprises not all be unpleasant, it is important to:

1. Be thoroughly familiar with markets and prices; solicit only those most likely to need your type of photography or subject.
2. Develop your skills in the direction of markets that pay reasonably well, if doing so is within your frame of interest. Avoid being contrived just to become commercial, because artificiality shows.
3. Learn the art of selling; maybe take a course in salesmanship.
4. Practice the science of keeping records from the start. Use a simple columned ledger for income and expenses. Con-

The interiors of public buildings and churches should not be overlooked as picture subjects. These magnificent murals and ornate goldwork make a worthwhile—and saleable—photograph. Photo by Norm Kerr.

sult an accountant about taxes. Keep up-to-date negative, slide, and print files with numbers of each item you sell or submit.

5. Find dignified ways to promote yourself through newspapers, displays, photo magazines, and charitable enterprises. Bylines are helpful, but people tend to forget your name under a photograph, while they remember a story *about* you in the media.

6. Avoid being apologetic about your photography. You simply undermine yourself, often without cause. At the same time, do not overstate your abilities, either, knowing you cannot meet exaggerated claims.

When you take pictures for enjoyment, for friends, and for profit, there is plenty of satisfaction in professionalism.

• *See also:* ADVERTISING AGENCIES; ADVERTISING PHOTOGRAPHY; AGENCIES, PICTURE; BUSINESS METHODS IN PHOTOGRAPHY; CAREERS IN PHOTOGRAPHY; COPYRIGHT; NEWS PHOTOGRAPHY; PORTFOLIO; RIGHTS.

Further Reading: Ahlers, Arvel W. *Where and How to Sell Your Photographs.* Garden City, NY: Amphoto, 1975; Bensusan, Arnold E. *So You Want to Be a Photographer.* New York, NY: British Book Center, 1975; Gibson, Joe A. *How to Sell Every Photograph You Take.* San Angelo, TX: Educator Books, Inc., 1970; Hammond, Bill. *How to Make Money in Advertising Photography.* Garden City, NY: Amphoto, 1975; Holden, Stan. *Twenty Ways to Make Money in Photography.* Garden City, NY: Amphoto, 1977; Hymers, Robert P. *Professional Photographer in Practice,* 4th ed. New York, NY: International Publications Service, 1973, Linick, Andrew S. *Picture Profits: Let Your Camera Make Money for You.* Middle Island, NY: Linju-Ryu-Karate Assn., Inc., 1976; McDarrah, Fred. *Photography Marketplace.* New York, NY: R.R. Bowker Co., 1978. Milar, Melissa and William Brohaugh, eds. *1978 Photographer's Market.* Cincinnati, OH: Writer's Digest Books, 1977; Nicholls, George. *Picture If You Can: A Book About Advertising Photography.* New York, NY: International Publications Service, 1973; Perry, Robin. *Photography for the Professionals.* New York, NY: Livingston Press, 1976.

Sensitometry

Sensitometry is the measurement of the response of photographic emulsions to exposure and processing. Its basic methods, devised by Hurter and Driffield in the 1870's and 1880's, are the very foundation of the science of photographic materials. While few photographers—except perhaps those in highly scientific work—need to make sensitometric evaluations of their materials, all photographers need the information that sensitometry produces. It is available in practical form in film and developer instructions and data sheets, processing manuals, and similar sources. The general methods of sensitometry and kinds of information they produce are described here. The articles in the list of cross references at the end of this article explain specific topics in greater detail and indicate the practical uses of sensitometric data.

Basic Procedures

There are four steps in sensitometry; as in all scientific testing, precise control is essential:

Step 1. The emulsion to be evaluated is given a series of exposures. Usually, the exposures are to the same light source but differ in intensity by a constant factor such as $\sqrt{2}$ or $2\times$ (for the equivalent of half-stop or full-stop differences, respectively). When spectral sensitivity is being investigated, intensity and time are kept constant, but the wavelength composition (color) of the energy differs across the exposed area.

Step 2. The emulsion is processed in a standard, repeatable manner. When a fundamental characteristic is being established—ASA speed, for example—all black-and-white films are developed identically so that the results will be directly comparable. Standard processing for color materials is that established by the manufacturer. When response to processing variations is being investigated, identically exposed samples are developed to different degrees (by controlled differences in time, temperature, or agitation) or are given identical handling in different developers.

Step 3. The processed image is measured to determine the amount of silver or dye deposited as the result of each exposure in the series. A transmission densitometer is used to measure film-base materials, a reflection densitometer for opaque materials such as printing papers. The density of an area is a measurement of how much light is transmitted or reflected in comparison with how much light falls on the area. A microdensitometer is used to measure areas smaller than 1 mm$^2$. Because color materials consist of three emulsion layers of different color sensitivities, each area is read three times, through special corresponding red, green, and blue filters so that the density in each layer is measured separately.

Step 4. The results are interpreted. In most cases, the measured densities are plotted on a graph in relation to their corresponding exposures, producing a characteristic curve of the response to the variable being investigated (usually exposure). The accompanying diagrams show the information that can be derived from such curves. Graphs of microdensitometer measurements and spectroscopic exposures produce other kinds of data, as shown.

The Value of Sensitometric Data

Sensitometry is a scientific laboratory method of investigation. It establishes the fundamental response characteristics of materials under completely controlled conditions. The information obtained indicates whatever is unique about each material and makes possible meaningful comparisons among materials of the same type. Without sensitometry there would be no standards of performance, no way to predict results under variant conditions, and no way other than trial-and-error to determine proper exposures and processing. This was the state of photography before Hurter and Driffield first published the results of their work in 1891.

Limitations of Sensitometry

The laboratory precision of sensitometry is a major limitation in trying to apply the results directly to practical photographic situations. Photographers must realize that actual studio or field conditions are distinct departures from laboratory test conditions, and so the response of materials will depart from laboratory-determined results. This does not reduce the value of sensitometry. An

Deriving Sensitometric Information

Data from conventional densitometer readings produce characteristic curve graphs. Illustrations 1, 2, and 3 are curves for negative materials. Positive emulsion curves are usually plotted with maximum exposure at left, so they begin at maximum density and descend to a minimum as exposure decreases. Density is a logarithmic value; the logarithm of the exposure is used to make curves that can be easily interpreted.

Illustration 1. Typical curve for a negative emulsion indicates:

A. Minimum density (film-base-plus-fog density; "gross fog").

B. Speed point, from which speed rating and minimum *printable* density may be calculated; these two points are not always identical. Usually about 0.10 density units greater than the gross fog value.

C. Maximum practical *printable* density, which cannot be located on the curve without knowledge of the printing material to be used; it is not usually encountered in practice.

D. Maximum possible density with the development given.

E. Solarization region, loss of density in response to exposure beyond necessary maximum; seldom encountered in modern films.

F. Overall possible density range of film as developed. Rarely encountered.

G. *Printable* density range; negative density range.

H. Useful possible exposure range; although additional exposure can produce more density (C–D), it is beyond the practical printable range and therefore meaningless. This is usually considered to be about a density of 2.5.

I. Brightness range of optical image, which cannot be determined from curve but, when known, determines *J*.

J. Latitude, the difference between *H* and *I*. Increased exposure to the subject will shift *I* to the right; any exposure that keeps *I* within the limits of *H* is usable, although not necessarily optimum.

K. Gamma, inherent contrast, derived from the slope of the middle (straight-line) portion of the curve.

L. Maximum density of a subject whose maximum exposure is the right end of *I*. The density range of a negative is the difference between *B* and *L*.

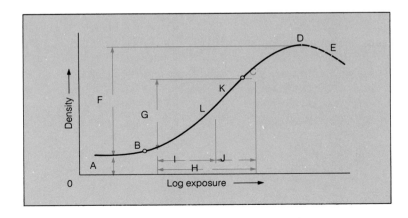

Illustration 2. This is a typical family of curves for a single emulsion developed for increasing (A–D) time (or temperature) in a given developer. A family of curves for an emulsion processed in different developers would be similar, but not so closely matched in shape in most cases.

Illustration 3. A comparison of response of two different emulsions processed in the same developer is shown here. All the information described in illustration 1 can be derived from each curve in illustrations 2 and 3.

Illustration 4. These are graphs of microdensitometer readings taken across the magnified images of very small image areas. Color lines represent ideal response, or possible plot of data from large-area densitometer readings; while the black curve is the actual density curve. Actual traces would. produce a slightly jagged line as the result of grain.

 A. Irradiation—scatter of energy from a highly exposed area into an adjacent slightly exposed area; an edge without edge effect.

 B. Edge effect—excess and deficient densities caused by developer action at the border of two areas of very different exposure levels.

 C. Line spread function—the irradiation to each side of a narrow line of high exposing intensity.

Illustration 5. This is a microdensitometer trace across an area of apparently uniform density; a statistical average (root mean square) of these density variations provides a measure of granularity.

Illustration 6. A spectrogram is shown here. The exposing white light was dispersed by a prism or diffraction grating into a spectrum (blue to red, L–R); a graduated neutral density filter varied the intensity. A single exposure produces a density record that shows the emulsion's relative sensitivity to each wavelength (color).

intelligent interpretation of sensitometric data can guide the photographer in using materials effectively. For example, a comparison of the characteristic curves for two films will show (among other things) which has the greater inherent contrast and which has the greater speed. That enables the photographer to make a selection for photographing a high-contrast subject where plenty of light is available, but a small *f*-stop must be used to obtain depth of field. However, the curves cannot predict what the actual contrast of the negatives of the subject will be.

Sensitometric exposures are made in no-flare conditions, usually by contact exposure through a transmission step tablet (a scale of neutral density steps on a film base). An actual photograph is made under conditions where flare is unavoidable. Every lens produces some flare; the camera interior may not be dead black, or there may be a light leak; a lens shade may not be used; the subject may

be in highly reflective surroundings; some flare is even produced by reflections from the film surface. All these factors will reduce the contrast of the image falling on the film. Contrast may also differ because the film is not of the same emulsion batch or has been stored differently than the laboratory samples. And even if the same developer is used, the quantity, the precise temperature, and the agitation are sure to differ somewhat from those used in the sensitometric tests.

In spite of this, unless most or all of these factors are present and contribute to a total effect, the differences between real-situation and laboratory-test results will seldom be beyond correction by a moderate change in exposure—say up to one stop—or development, or perhaps in both. Thus, the reasonable approach is to use sensitometric data to select the material best suited to a given general range of subject-exposure-processing conditions, and then to conduct a few practical tests

under the actual conditions in order to determine the best handling of that material when the quality of results is of critical concern.

In black-and-white photography, the "zone system" method of making practical determinations of exposure and development has become widely used. The original system, which has its roots in sensitometry, was developed to the greatest extent by Ansel Adams, and has been the basis of many imitations, adaptations, and variations with a wide variety of names. The essentially invariable nature of color processing generally limits the practical control of color materials to changes in exposure and filtration.

• *See also:* BASE DENSITY; BRIGHTNESS RANGE; CHARACTERISTIC CURVE; CONTRAST; CONTRAST INDEX; DENSITOMETRY; DEVELOPMENT; EXPOSURE; GRAININESS AND GRANULARITY; IMAGE EFFECTS; SPECTROGRAPHY; SPEED SYSTEMS; TONE REPRODUCTION; WEDGE SPECTROGRAM; ZONE SYSTEM.

Further Reading: Eastman Kodak Co. *Basic Photographic Sensitometry Workbook,* pub No. Z-22. Rochester, NY: Eastman Kodak Co., 1977; Lobel, L. and E.M. DuBois. *Basic Sensitometry.* Garden City, NY: Amphoto, 1967; Meier, Hans. *Spectral Sensitization.* Belmont, CA: Pitman Publishing Corp., 1968; Todd, Hollis N. *Photographic Sensitometry: A Self-Teaching Text.* New York, NY: John Wiley and Sons, 1976; ————— and Richard Zakia. *Photographic Sensitometry.* Dobbs Ferry, NY: Morgan and Morgan, 1974; Vieth, Gerhard. *Sensitometric Testing Methods.* New York, NY: Hastings House, 1974; Wakefield, George L. *Practical Sensitometry,* rev. ed. Dobbs Ferry, NY: Morgan and Morgan, 1973.

Sharpness

The overall subjective impression of clear, distinct detail in a photographic image is called definition. A large part of the impression of detail is given by the perception of the borders or edges of the elements in the picture, which is called sharpness. Several measurable factors contribute to sharpness—the most important are acutance, resolution, and contrast—but image sharpness itself is a psychovisual impression that cannot be measured directly. Sharpness classifications or categories can be established by averaging large numbers of individual judgments, but these provide only a relative scale; there is no exact way to rank the sharpness of images that fall within a given classification by measuring any objective factors.

The Perception of Sharpness

Resolving power is the limit of the ability of a lens-film combination to record fine, closely spaced details. Although it is often assumed that resolving power is an indication of the ability of a material to produce sharp pictures, it is not true that a series of photographs will necessarily be ranked in the same order for sharpness as for resolving power. By using certain combinations of lenses and films, it is possible to make two photographs, one of which has a higher resolving power but a lower sharpness than the other. Moreover, some developers reduce sharpness markedly while affecting resolving power very little.

Most viewers would consider this photograph to be sharp; but sharpness is in fact a psychovisual judgment that cannot be measured directly.

Acutance and Sharpness

(A) An ideal negative image would show an abrupt change between the low density of a dark subject area and the high density of an adjacent bright subject area. (B) Because of image spreading, the border is actually recorded as a sloping density change. The average gradient of the slope, calculated from readings taken at small intervals across the transition zone, is acutance or edge sharpness. (C) A narrower transition zone has a steeper gradient, and the border appears sharper. (D) When two borders have the same shape, the one with greater contrast differences will appear sharper, even though their measured acutance is the same. (E) The edge effect produces abnormal density differences at the border, creating Makie lines of increased contrast in a print and thus increasing the impression of sharpness.

For almost all observers, the contrast difference across the border of adjacent details has a greater effect on the impression of sharpness than the actual resolving power does. How *rapidly* the transition in density difference occurs between the two areas provides a measurement of edge sharpness called acutance. For areas of similar acutance, the *degree* of contrast difference (how great the density difference) between the areas largely determines how sharp the edge seems, that is, how distinctly it is perceived. These differences are explained in the accompanying diagrams. They are the result of the combined effect of a variety of factors, including subject luminance difference, flare, emulsion contrast, granularity, spread function, and development.

It should be remembered that the sharpness of a recorded image is affected by many factors in addition to the film. Lens aberrations, camera or subject movement, and lens focus are the primary causes of any unsharpness of the exposing image.

Modulation Transfer Function

The measurement of modulation transfer functions (MTF) involves the use of sine-wave targets. A sine-wave target is similar to a resolving-power target of alternating black-and-white lines, except that it has continuously changing values instead of go, no-go values. A sine-wave target is one in which the transmission varies sinusoidally with distance.

If you measure the transmissions of a sine-wave target with a microdensitometer and plot the transmission against distance, you get a sine-wave curve. As with resolving-power targets, sine-wave targets are arranged in a series of changing frequencies. The frequency of a given target is given in cycles per millimetre, rather than in lines per millimetre. A cycle is one complete sine wave.

The reason for using sine waves is that both lenses and film tend to make sinusoidal images of repeated patterns as image sharpness decreases. If a bar target (resolving-power target) is used, the loss in contrast as the detail gets finer is not consistent as the lens and/or film gradually changes the bar image to a sine-wave image. When the target is sinusoidal in transmission to start with, the loss in contrast becomes a direct measure of the loss in the ability of the lens or film to record fine detail as the frequency in cycles per millimetre gets higher.

Lens images can be measured directly. The lens is set up to image a sequence of sine-wave targets in the focal plane. A microscope is focused on the focal plane to enlarge the image. A long, narrow photoelectric cell is used to scan the illuminance of the enlarged image of the targets. The electrical output shows the losses between the peaks and valleys of the target image as the detail gets smaller.

A

B

Max.

Density

Min.

C

D

Modulation Transfer Function

(A) A sinusoidal test target; the bars and spaces decrease in width in mathematical progression. (This reproduction may have changed the target characteristics slightly.) (B) Image of the sinusoidal target as recorded on photographic emulsion. The bright target spaces created the greatest density, seen here as black. The light spreads at the edges into the dark bar areas, resulting in additional decreases in their width (white stripes) in the image. (C) A microdensitometer tracing of the image reveals that the contrast (density differences) between adjacent areas decreases and the spacing narrows. (D) If the system imaged detail perfectly, the microdensitometer tracing would be at maximum density with full bar-space widths across the whole range. The decrease shows the loss in detailed contrast as the detail becomes finer.

The modulation of the target (object) is given by the equation:

$$M_o = \frac{I_{o\,max} - I_{o\,min}}{I_{o\,max} + I_{o\,min}}$$

where: *I max* is the illuminance of the brightest area (the valleys in the sine wave), and *I min* is the illuminance of the darkest target areas (the peaks in the sine wave).

The modulation of the image of each target is found by the equation:

$$M_i = \frac{I_{i\,max} - I_{i\,min}}{I_{i\,max} + I_{i\,min}}$$

where: *I max* is the intensity of the peak readings of the photocell in the image, and *I min* is the minimum readings. The *modulation transfer* factor for each frequency is

$$MTF = \frac{M_i}{M_o}$$

The modulation transfer factors are plotted, usually on a logarithm scale, to make the modulation transfer *function* curve.

With lenses, there are obviously different curves at different field angles and at different lens openings. Common practice involves measuring the

2232

lenses on axis, at an angle equivalent to the format edge and at an angle equivalent to the format corner. Usually these three positions are measured at minimum and maximum lens openings and at the opening that produces the highest factors—usually about two to three stops down from the maximum opening.

The modulation transfer factors of film must be found photographically. A lens with extremely high resolving power is used to image sine-wave targets on film. The lens used for such imaging is specially made and is used just on the axis to get the highest possible image quality. The test film is developed, and the images of the sine-wave targets are measured on a microdensitometer.

A step scale is imaged along with the targets, and a characteristic curve is plotted from the image of the step scale. Using this curve, the density values of the peaks and valleys of each of the test targets can be converted into exposure values. The object exposure values are those of areas large enough to be unaffected by the size of the detail. The image exposure values are calculated from the densities of the peaks and valleys of the targets. The modulation of the object (target) is calculated by the equation:

$$M_o = \frac{E_{o\ max} + E_{o\ min}}{E_{o\ max} - E_{o\ min}}$$

while the image modulation of each frequency is calculated by:

$$M_i = \frac{E_{i\ max} + E_{i\ min}}{E_{i\ max} - E_{i\ min}}$$

As before, each modulation transfer factor is M_i/M_o and the modulation transfer function is the curve formed when the factors at various frequencies are plotted.

An MTF of 1.0 is where the contrast of the image equals the contrast of the object. Where the response is half, the MTF is 0.5. If the factor values are multiplied by 100, the values are called sine-wave percent responses. Both MTF's and percent response values are usually plotted on a logarithmic scale, as are the spatial frequencies.

The modulation transfer factor at each frequency of a lens-film system is found by multiplying the factor for the lens by the factor of the film at that frequency. The system factors form the system modulation transfer function curve.

There is no exact correlation between the resolving power of a film and the modulation transfer function of the curve. However, the high-contrast resolving power of black-and-white films usually falls where the MTF value is between 0.25 and 0.35, while with color films, the high-contrast resolving power is at a frequency where the MTF is between 0.05 and 0.10. This rule of thumb applies to general-purpose, moderate-contrast camera film.

The Effects of Exposure and Development on Sharpness

Excessive density in a negative, caused either by overexposure or overdevelopment, reduces the sharpness because halation and irradiation effects are increased. On the other hand, thin densities also reduce sharpness because the contrast is lowered. This is caused in underexposure by the lowering of the exposures along the toe of the characteristic curve. When caused by underdevelopment, the lower contrast index reduces the contrast of the image. Best sharpness results at correct exposure levels with a moderate degree of development.

It should be noted that, although fine-grain developers may reduce the graininess of an image, they generally do not enhance sharpness. Some developers of this type dissolve part of the exposed halide crystals during development, which reduces the local contrast so important to sharpness. They also completely dissolve some of the finest crystals. Such developers are suitable for use with emulsions of normal thickness, but better sharpness is achieved in any event with the generally finer grain and higher contrast typical of thin-emulsion films developed in a normal or edge-enhancing (acutance) developer.

Acutance Developers. Certain formulas increase sharpness, and some standard developers can produce increased acutance when suitably diluted. They work by increasing the edge effect, which enhances the contrast at image edges. Light and dark Mackie lines are formed, which makes the edges more apparent. Such developers generally work best with thin-emulsion films and when agitation is kept to the minimum required to avoid uneven development.

Kodak developers D-76 and Microdol-X produce improved acutance when diluted. D-76

developer is diluted 1:1, while Microdol-X developer is diluted 1:3. A diluted developer must be discarded after one use; it cannot be saved and replenished.

A classic formula, the Beutler acutance developer, is the following:

Solution A

Water	500 ml
Metol	10 g
Sodium sulfite (anhydrous)	50 g
Water to make	1 litre

Solution B

Water	500 ml
Sodium carbonate (anhydrous)	50 g
Water to make	1 litre

For use, take 1 part A, 1 part B, and 8 parts water. Combine immediately before use. Develop 8 to 15 minutes at 20 C (68 F). Discard used developer after use. Use plain water as a rinse after development rather than an acid stop bath because sodium carbonate and acid release carbon dioxide in the emulsion, which may cause pinholes in the image.

Achieving Optimum Sharpness

In addition to the camera, lens, and film, a great many factors contribute to sharpness. Letting even one of these get out of control can reduce sharpness; failing to consider most or all of them will make sharpness almost impossible to achieve. The following list gives the steps to take in order to get really sharp pictures.

Steps to Optimum Sharpness

1. Use a highly corrected lens.
2. Be sure the lens surfaces are absolutely clean.
3. Use the deepest possible lens shade to minimize chances of flare.
4. On a view camera, be sure that the lens board and the back are adjusted for maximum sharpness and are locked securely in place. (*See:* SCHEIMPFLUG PRINCIPLE.)
5. With a single-lens reflex camera, lock the mirror out of the exposure path manually after focusing, if possible.
6. Focus critically, using a magnifier.

7. Use a cable release to avoid any camera movement in response to finger pressure on the shutter release.
8. For black-and-white, use a fine-grain, thin-emulsion film that has inherently high contrast. Use a color film with a slow-speed rating.
9. Use the minimum exposure time required to expose properly.
10. Use a high-acutance developer (black-and-white films).
11. Develop only as much as required to achieve normal printing contrast. With a given film, this will vary according to the contrast range of the subject.
12. Be sure the enlarger is mounted so as to be free of vibration.
13. Make certain that the negative stage, lens board, and paper easel are parallel. When there is a choice, use a glass-type negative carrier.
14. Use a highly corrected enlarger lens.
15. Focus on the grain pattern in the projected image, using a magnifier.
16. Use a smooth-surface paper.
17. Adjust the exposure so that the image develops fully within the recommended processing-time range of the paper.
18. Be sure that the developer is at the recommended temperature so that full tonality is produced.

• *See also:* CONTRAST; DEVELOPMENT; DIFFRACTION; EDGE EFFECT; FORMULAS FOR BLACK-AND-WHITE PROCESSING; RESOLVING POWER; SCHEIMPFLUG PRINCIPLE.

Short Lighting

With short lighting (sometimes known as "narrow" lighting), the main light illuminates fully the side of the face turned away from the camera. This lighting is generally used for the average oval face of either a man or a woman. It tends to emphasize facial contours more than broad lighting and, in

conjunction with a comparatively weak fill-in light, can be used as "strong" or "masculine" lighting especially adaptable for low-key portraits. Short lighting has the effect of narrowing the face and, therefore, can be used effectively as a corrective lighting technique for round or plump faces.

• *See also:* BROAD LIGHTING; LIGHTING; PORTRAITURE.

Shutters

A shutter is a device that opens the lens aperture or uncovers the film to make an exposure for an accurately timed interval, and then closes automatically. There are two major classes of modern shutters, based on the position in the camera-lens system. A shutter located at the diaphragm plane of the lens is known as a between-the-lens shutter; one located directly in front of the film is a focal-plane shutter. Most shutters are spring-powered and are controlled by mechanical linkages. However, in recent years, an increasing number of shutters have used electronic circuits to energize electromagnets for the control of speeds, and some have used electromagnets in place of springs to provide actuating power.

Some very specialized shutters use electrical charges to vary the transmission of a material in the image path for exposure control; others use electromagnetic fields to create a controlled blocking of the path of exposing energy. These devices are used for scientific and technical purposes, such as very-high-speed photography; they have no present applications in ordinary cameras.

Between-the-Lens Shutter

A variety of shutter types can be used within the lens. The simplest type is a rotating disc with a hole in it, which is caused to pass across the lens aperture by the action of a spring. Such shutters usually have only a single speed (about 1/40 sec.) and are generally found in the simplest, most inexpensive cameras.

More complicated shutters have a group of blades that open and close from the center, like the diaphragm of the lens itself; they are commonly called leaf or blade shutters. Although placed in a single housing for convenience, the shutter and diaphragm blades form separate mechanisms. Both are located as close as possible to the narrowest portion of the optical path through the lens so that the least amount of blade travel is required to open the aperture fully.

In shutter operation, the blades open fully at all speeds; they close immediately at the fastest speed. Some slower speeds are achieved by slowing the blade movement throughout an open-immediately-close cycle; the slowest speeds are obtained by delaying the blades in the fully open position for an appropriate interval.

Two types of mechanisms are commonly used to operate the blades of a between-the-lens shutter. In the first type, pressure on the release lever first tensions the shutter spring, then further pressure releases it to make the exposure. In some cases, the lever is moved upward to set the spring and then is depressed to release the shutter.

In more elaborate shutters, a separate cocking lever is used to tension the shutter spring; usually this lever has an additional position that opens the blades fully for through-the-lens viewing and focusing. A separate lever is used to release the blades after focusing and, after recocking, to make the exposure. The advantage of this system is that much less pressure is needed to trip the shutter, so there is less danger of shaking the camera. In addition, the speed range can be extended both faster and slower than that of the simpler shutter because more than one timing mechanism can be incorporated. The original shutter of this type was known as the "Compound" because it had one method for varying the tensions of the shutter spring for speeds of 1/25 to 1/200 sec., and a second pneumatic blade-retard system for speeds from 1 sec. to 1/10 sec.

Although the Compound shutter was a precision mechanism, the pneumatic cylinder, which controlled the slow speeds, tended to become unreliable with age and wear. This shutter was superseded by the Compur shutter in 1912, and subsequently by modern types such as the Copal shutter. These use a gear train and escapement, as in a watch, for timing the slow speeds.

Blade Shutter Speed. There is a practical limit to the maximum speed a blade shutter can achieve. The blades open to the full diameter of the lens at

every speed, regardless of the diaphragm aperture setting, so that the distance traveled is determined by the size of the lens. In addition, inertia must be overcome at the closed and open positions, which means that the blades do not travel constantly at maximum speed. In small-diameter lenses such as those used with 35 mm cameras, these and related factors generally limit shutter speeds to a maximum of 1/500 sec. Lenses used for large-format photography have large diameters, which may limit the maximum speed to 1/125 or even 1/60 sec. Some lenses for small-format use have been made with blade shutters that attain exposures up to 1/1000 sec., but these are exceptional.

Advantages of Between-the-Lens Shutters. Although the inclusion of a shutter increases the cost of a lens, this method has three distinct advantages over a focal-plane shutter. First, only a between-the-lens shutter can be synchronized with flash at all speeds, because it opens fully each time. Second, the fully open characteristic also makes it possible to record moving subjects without distortion. Finally, it is impossible to make a focal-plane shutter to cover a large format that can produce precise, even exposures, or attain high speeds. In this case, a shutter at the much smaller lens diameter is the only practical solution.

Focal-Plane Shutters

The earliest focal-plane shutter was a curtain that ran between two spring-driven rollers and covered the film plane of the camera. A slit in the curtain exposed the film as the curtain moved from one roller to the other; changing the spring tension produced various speeds.

The exposure speed of a focal-plane shutter can also be changed by using a different slit size. The Graflex camera, a single-lens reflex camera made in sizes up to 5″ × 7″, had a continuous focal-plane shutter curtain with four narrow slits, ⅛″, ⅜″, ¾″, and 1½″ in width. When the mirror was down in viewing position, or the dark slide was in place in the film holder, any slit could be rolled into position to expose the film. The spring drive had six tension positions; thus the photographer had a choice of 6 × 4, or 24, speeds from 1/10 to 1/1000 sec. An additional full-format opening in the curtain allowed for time exposures.

Today, focal-plane shutters are used in many cameras of 6 × 9 cm (2¼″ × 3¼″) format and smaller. They consist of a two-piece curtain of rubberized cloth, synthetic material, or flexible metal. The two-piece construction is used to obtain any required slit width. When the shutter release is pushed, the first curtain begins to move, uncovering the film plane; a moment later, the second curtain follows after the first, forming a slit of the necessary width for the selected shutter speed.

At speeds of 1/60 sec. or slower in most cameras, the first curtain completely uncovers the film before the second curtain begins to move. These speeds are suitable for use with flash of very short duration, such as electronic flash. At higher shutter speeds, the curtains travel at a constant rate, and the exposure is determined by the size of the slit formed. A long-peak flash must be used with these speeds so that the light is at full intensity for the entire travel of the slit across the film; a short-peak flash would expose only that portion directly behind the slit at the instant of firing, leaving the rest of the picture underexposed. (*See:* SYNCHRONIZATION.)

In modern focal-plane curtain shutters, the two pieces overlap after exposure so that as the shutter is rewound from side to side (or bottom to top), the film will not be double-exposed whether or not a dark slide is in place or a mirror is in viewing position to cut off light from the lens.

Some cameras use a focal-plane shutter such as the Copal Square, which is composed of metal blades that move outward from the center to create a rectangle, and close again.

A major advantage of a focal-plane shutter is that it permits any lens to be used with the camera. For that reason, it is the most widely used shutter system with medium- and small-format, interchangeable-lens cameras. In addition, it permits reflex viewing and focusing without the need for an additional shutter to protect the film after the mirror is raised, as would be the case until a between-the-lens shutter had closed to make ready for the exposure.

Focal-Plane Shutter Speed. A focal-plane shutter can achieve higher exposure speeds than a between-the-lens shutter and can do so at a slower rate of travel. This is because each portion of the

Grand Prix of the Automobile Club of France, 1912, photographed with a focal-plane shutter camera by Jacques Henri Lartigue. The speed of the car moved the image of the wheel enough to produce oval distortion as the shutter slit moved downward across the inverted image. The background elements lean to the left because the camera was being panned to follow the car during the exposure.

film is exposed only for the instant that the shutter slit is directly in front of it.

For example, a slit 6.25 mm (¼″) wide is $1/16$ the width of a 100 × 125 mm (4″ × 5″) film. If the slit travels across the width of the film in 1/30 sec., the actual exposure of each portion is $1/16 × 1/30 = 1/480$, or effectively, 1/500 sec. The rate of travel is 25 mm (1″) in 1/120 sec.

The blades of a between-the-lens shutter must move four times as fast to produce the same exposure. Each blade travels half the diameter of the maximum lens opening to open, and returns across half the diameter to close the shutter. Thus, in a lens of 25 mm (1″) diameter, each blade must travel the distance in 1/500 sec. to produce the

same exposure. The fact that the focal-plane shutter moves only one-quarter as fast greatly reduces the problems of powering the shutter and of controlling it precisely. And, if the focal-plane shutter moved at the same rate as the blade shutter, it would produce an exposure four times faster—in this case, 1/2000 sec.

In practice, the highest focal-plane shutter speeds are achieved with small-format cameras because the distance to be traveled is very short. The narrow dimension of a 35 mm frame is approximately 25 mm (1″). A slit that is 5 mm (³/16″) wide could take 1/400 sec. to cover that distance in order to produce an equivalent exposure of 1/2000 sec.

Image Distortion

The fast shutter speeds required to photograph rapidly moving subjects sharply use narrow focal-plane shutter slits. However, this means that as the slit is traveling across the film, the image of the moving subject is changing position within the frame. As a result, the top of the subject may be exposed at one relative frame location, the bottom at another location, and intervening portions of the subject at intermediate frame locations. This in turn distorts the shape of the subject in the recorded image, as shown in the accompanying diagram.

It is not practical to calculate what shutter speed produces a given degree of distortion, because the effect is dependent upon the interaction of subject speed and direction with shutter slit width, and upon rate and direction of travel. When distortion is desired for expressive effect, it is best to experiment with various shutter speeds. In referring to the diagrams or in attempting to visualize the kind of distortion that will result, remember that the image is inverted in the camera. With a small-format camera, the direction of shutter travel can be changed simply by turning the camera to a vertical position or inverting it.

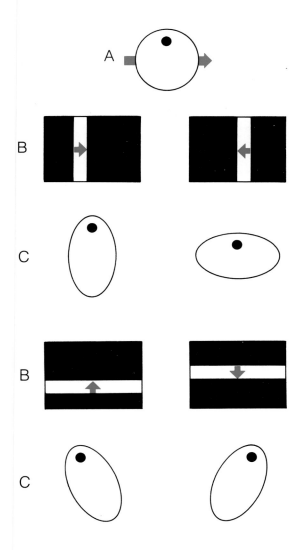

A narrow focal-plane shutter records a distorted image of a rapidly moving object. (A) Subject and direction of movement. (B) Direction of movement of shutter slit. (C) Resulting image in print or slide. Because the image is inverted in the camera, an upward-moving slit records the top of the subject first; the lower portions are displaced across the frame, producing a backward lean. A downward-moving slit exposes the bottom of the subject first, producing a forward lean.

When an undistorted, sharp image of a rapidly moving subject is required, it is necessary to use electronic flash with a focal-plane shutter or to use a between-the-lens shutter.

Shutter Speeds and Controls

Manual Shutter Control. On most cameras and lenses, shutter speeds are selected by turning a dial or indicator to a marked number. Most speed-setting controls click into the marked positions; some also have click settings at intermediate positions. The standard progression of marked speeds provides a halving (or doubling) of exposure, in the same way that *f*-number settings do. The standard progression is: 1 sec., 1/2, 1/4, 1/8, 1/15, 1/30, 1/60, 1/125, 1/250, 1/500, and—on some focal-plane shutters—1/1000, 1/2000 sec.

NOTE: Some older cameras and lenses are marked with the progression: 1 sec., 1/2, 1/5, 1/10, 1/25, 1/50, 1/100, 1/250, 1/500. sec.

Often, to increase legibility, only the denominator of fractional speeds is marked; for example, 1/30 sec. may be marked 30. Other marked shutter settings may include *T*, *B*, and one or more flash synchronization symbols. *T* means "time exposure"; when the shutter is released, it will remain open until the release is pushed a second time. At the *B* or (pneumatic) "bulb" setting, the shutter remains open as long as the release is held depressed; it closes when pressure is removed from the release. The required or maximum speed for electronic flash synchronization is usually marked on the speed-setting control of a focal-plane shutter, either by a colored dot or by a broken arrow that looks like a lightning symbol. Some shutters are also marked with a bulb symbol at the optimum speed for synchronization with flashbulbs.

On some small-format, focal-plane-shutter cameras, speeds longer than one second may be set on a separate slow-speed control. The usual range is 2, 4, 8, and 16 sec. Often this control is located along with a delayed-action release mechanism, which fires the shutter a selected number of seconds after the release has been pushed. This feature not only allows the photographer to get into the picture if he or she wishes, but makes it possible to start a machine, add elements to the scene, or otherwise control the timing and content of the picture.

Most shutters are designed to be released by finger pressure on a lever or button. They usually also have a socket to accept the threaded plunger of a cable release in order to avoid the vibration from finger pressure, or to allow the photographer to move away from the camera. Various remote control or accessory delayed-release devices may also be screwed into this socket.

Automatic Shutter Control. An increasing number of medium- and small-format cameras incorporate metering and exposure control systems that automatically select or adjust the shutter speed according to the brightness of the subject. In so-called aperture-preferred, or aperture-priority, systems, the photographer selects a lens aperture, and the control system selects the shutter speed. When the control system incorporates electromagnetic release of a focal-plane shutter, it can produce an intermediate speed such as 1/69 or 1/326 sec., if that is what is required for a particular situation.

In fully automatic cameras, both the lens aperture and the shutter speed are determined by the meter control system. Some cameras provide only this operation; others permit it to be selected as one of several optional operating modes.

Shutter Performance

Effective Exposure Time. An ideal shutter would open instantly to let 100 percent of the exposing light pass and would close instantly at the end of the selected exposure time; actual shutters cannot achieve this perfection. A between-the-lens shutter uncovers the center of the aperture first and takes a measurable amount of time to reach a full opening that lets all the light through; similarly, it reduces the light progressively as it closes. Thus, the shutter is not 100 percent efficient, and the actual exposure time is not the interval from first opening to last closing. Instead, as the following diagrams show, the effective exposure time is the interval between the half-open and half-closed positions. When the lens diaphragm is closed to a small stop, the shutter takes as long to open and close, but it clears the available opening sooner and leaves it open longer. This provides an increase in shutter efficiency, and its effect may have to be compensated.

Lens Apertures	Shutter Speeds (sec.)		
	1/125	1/250	1/500
f/1.4–5.6	None	None	None
f/8	None	None	⅓ stop
f/11	None	⅓ stop	⅔ stop
f/16 and smaller	⅓ stop	⅔ stop	1 stop

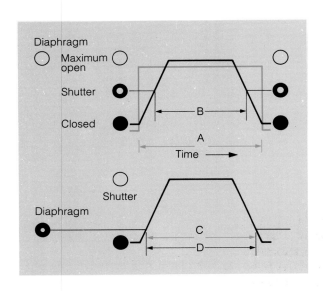

Blade Shutter Performance

(Top) An ideal shutter (colored line) opens and closes instantly for maximum light transmission during the entire open interval (A). The actual shutter (black line) uncovers full aperture opening progressively. True, or effective, exposure speed is interval (B) between points at which shutter transmit 50 percent of maximum light. (Bottom) When the diaphragm is closed to a small aperture, the shutter clears the opening soomer, so the maximum light is transmitted for a longer time (C). The effective shutter speed is the interval (D) between the half-transmission points of the maximum possible at that aperture.

Corrections for Faster Blade Shutter Speeds and Small Apertures. Blade shutters at faster shutter speeds and small lens apertures tend to give more exposure than is indicated by the shutter speed/f-number combination. This is not a manufacturing defect but is due to the inertia of moving parts and the geometry of the lens-shutter-diaphragm structure. It usually occurs in daylight photography with fast films and causes overexposure of up to one stop. You can find correction factor in these situations by running an exposure series on a fast transparency film such as Kodak Ektachrome 200 (daylight). This effect does not occur with focal-plane shutters. The table above gives an example of the type of correction that may be necessary.

• *See also:* DIAPHRAGM; HIGH-SPEED PHOTOGRAPHY; SYNCHRONIZATION.

Sidelight

When a light source is placed at the same height as the subject, and at right angles to the camera-subject axis, it is called a sidelight. Sidelight is mainly useful as an auxiliary light source; it is seldom satisfactory as placement for a main or key light.

When the main light is placed alongside the subject in a portrait, the effect is to light exactly half the face, leaving the other half in shadow. This seems to cut the face in half, and among some portrait photographers it is called "the hatchet light." If the sidelight is not at exact right angles to the subject, but somewhat forward of this position, then there will be some spill light on the far side of the face. The shadow of the nose will extend sideways directly across the face, and the effect is unpleasant. Most portrait photographers avoid the sidelight for this reason.

Sidelight can be used in commercial photography to bring out the shape of an object; usually some fill light is used on the shadow side to keep it from being completely black. Certain square or cubical objects are best shown by such lighting.

Sidelight does have some uses in portraiture; occasionally, a fill light is placed to one side and at face height, where its function is merely to soften the shadow side of the face. More often, the sidelight is placed not at exact right angles to the subject-camera axis but somewhat behind the subject, and in this position it is known as a "kicker." It produces a highlight along the edge of the face, which separates the face from the background and gives definition to the shape of the face itself. Often, in fact, a kicker light is used on each side of a subject and is valuable in photographing subjects with broad faces. If the kickers are brighter than the key light, they produce a line of light on each side of the face, which makes the face look thinner in the final print. In such a picture, of course, standard portrait lighting is used, and the kickers are merely auxiliary light sources used to produce the desired highlights.

In glamour and fashion photography, this "double kicker" version of sidelight is used as the main light; a soft fill light is used at camera position and brings out the facial features dimly, also producing a catchlight in the eyes. Then a kicker is placed at each side only slightly behind the subject, so the sides of the face are brightly illuminated. The effect is interesting but must be used with discretion; it suits some subjects better than others.

• *See also:* LIGHTING; PORTRAITURE; PRODUCT PHOTOGRAPHY.

Silhouettes

A silhouette is a picture, usually a portrait of a person, in which the image is solid black against a white background. (Silhouette is also a term used in the graphic arts for backgroundless photographs. *See:* BACKGROUNDS, ELIMINATING.) The silhouette was invented by Etienne de Silhouette, who was French Minister of Finance, *circa* 1759. He made little portraits with black paper and

scissors as a hobby. It was taken up and widely practiced, and even today you may occasionally run across a silhouette artist who makes these portraits in the original manner. Characteristically, the image is almost always in profile.

Silhouettes are easy to make with a camera. Basically, it is merely necessary to pose the sitter in profile against a white background, making sure that all the light is on the background and none

This silhouette was made by copying the original negative on high-contrast film and recopying the resulting positive again on high-contrast film to obtain this negative image.

Silhouettes are images without middle tones. They are readily made by placing the subject in front of an evenly illuminated white background and keeping all illumination on the far side of the subject—the side away from the camera. Use of a colored filter over the lens of the camera can completely change the mood of a silhouette.

strikes the near side of the sitter. The easiest way to do this is to stretch a sheet across a doorway and light it from behind. Position the sitter and camera in the adjacent room in front of the sheet, with no light in this room at all. It is important to evenly light the sheet; the lamp should be some distance away from the sheet, or several lamps can be used for more even illumination. Flash lighting can be used by means of an extension cord to fire the flash unit from the camera.

Focus the camera on the profile of the sitter, and use an exposure just sufficient to secure a solid background on the negative. Use a high-contrast film for best results. Develop the negative quite fully and make the print on a high-contrast paper.

If sufficient contrast is not attained, it may help to make the most contrasty print possible and

then fill in any light spots on the subject's face with India ink. After this, copy the print, again on high-contrast film, for a final negative.

Silhouettes can be made from well-chosen photographs by a process of increasing the contrast until all middletones are eliminated. First print the original negative on high-contrast film, such as Kodalith ortho film or a similar "litho" film. After developing, fixing, washing, and drying the positive, print it on another piece of the same high-contrast film, which produces a negative image containing nothing but highlights and shadows. Again, some retouching may be needed, and this may be done either on the intermediate positive or the negative; often you will find that retouching is needed on both.

• *See also:* BACKGROUNDS, ELIMINATING.

Silver Bromide

Principal light-sensitive component of negative emulsions and fast enlarging-paper emulsions. In emulsion making, it is formed by mixing a solution of silver nitrate with a solution of potassium bromide and gelatin under controlled conditions.

Formula: AgBr
Molecular Weight: 187.80

Yellowish crystals or powder that darkens on exposure to light. It is insoluble in water, alcohol, and most acids, slightly soluble in ammonia, and soluble in sodium thiosulfate solutions or potassium cyanide solution.

Silver Chloride

Principal light-sensitive component of slow contact-paper emulsions. In the making of the emulsions, the silver chloride is prepared by combining a solution of silver nitrate with a solution of potassium chloride and gelatin. Depending upon how the emulsion is prepared, either printing-out or developing-out emulsions can be made.

Formula: AgCl
Molecular Weight: 143.34

White powder, darkens upon exposure to light. It is insoluble in water, alcohol, or dilute acids. It is soluble in solutions of ammonia, alkali cyanides, thiosulfates, and certain other salts.

Silver Halides

A generic term referring to salts of silver with the halogens—bromine, chlorine, or iodine. (Silver fluoride finds no use in photography.) Silver bromide, silver chloride, and silver iodide are currently used, singly or in combination, in most commercially important photographic materials.

Silver Iodide

One of the silver halides. Although silver iodide is not itself very sensitive to light, small amounts added to silver bromide increases its sensitivity.

Formula: AgI
Molecular Weight: 234.80

Light yellow powder, insoluble in water. It dissolves in hydrogen iodide when heated, and in solutions of ammonia and alkali cyanides. It is also soluble in thiosulfates.

Silver Nitrate

The silver salt most used in photography, in emulsion making, intensifiers, and sensitizing of paper and cloth.

Formula: AgNO$_3$
Molecular Weight: 169.89

Colorless, flat crystals, very soluble in water, soluble also in glycerin, and slightly soluble in ether and alcohol.

CAUTION: Caustic, poison, handle with extreme care and do not allow it to touch the skin; it causes burns and black stains.

Silver Recovery

The unique properties of silver make it an essential ingredient of light-sensitive photographic emulsions, and no adequate substitute for silver in making these emulsions has yet been discovered. The demand by industry for silver has increased steadily over a number of years, and at the present time, the supply of newly-mined metal fails to meet this demand. The only way to make up this deficiency is to recover used silver wherever it is possible to do so.

The photographic industry is the largest user of silver; it consumes almost one third of the metal used by industry, and it is estimated that at least two thirds of this amount is potentially recoverable. Aside from conserving a valuable natural resource, silver recovery is a profitable undertaking, and it may be necessary as an effluent-management procedure.

Sources of Recoverable Silver

In photography, there are two main sources from which silver can be recovered. The principal source is spent processing solutions, mainly fixers and bleach-fixers. The other source is waste unprocessed films and papers and discarded black-and-white negatives, film positives, and prints. Remember that processed color materials do not contain any silver and, therefore, have no silver recovery value because all of the silver that was in the emulsion is retained in the fixing bath or the bleach-fix bath, as the case may be.

Recovery Potential

Each type of photographic material has a certain silver recovery potential, which depends largely on the silver content of the emulsion. The amount of this potential that can be realized in a recovery system depends on several factors:

1. In processing black-and-white materials, the percentage of the emulsion exposed and developed to a metallic silver image. The more silver that is developed, the less goes into solution in the fixer, and so less is available for recovery.
2. The efficiency of the recovery system. In practice, most silver recovery equipment is less than 90 percent efficient, and poor maintenance reduces this value considerably.
3. Varying amounts of silver-bearing solution are carried out of a processing tank on the surfaces of the film or paper being processed. The silver in such solution is, of course, lost for the purpose of recovery unless steps are taken to recover silver from the wash

water. See the section on recovering silver from wash water in this article. Factors that affect solution carry-out, or carry-over, are machine speed, film or paper area, incorrect adjustment or absence of squeegees and drive belts.

Recovering Silver from Waste Photographic Material

The recovery of silver from scrap photographic materials, except processed color negatives, transparencies, and prints, is a worthwhile procedure, provided sufficient material is available for treatment. Suitable waste includes discarded x-ray films, microfilms, files of black-and-white negatives, and collections of prints. Unprocessed sensitized material of practically any kind also contains silver.

Generally, the value of scrap for silver recovery is expressed in troy ounces per pound of material, although 1 pound of scrap usually contains only a small fraction of an ounce of silver. The value varies according to the type of photographic material, which largely determines the silver content, and on the base weight of the film or paper. Batches of heavy base material yield less silver per pound.

The recovery of silver from scrap material is generally outside the expertise of photographic processors, and they could not justify the purchase and operation of the necessary equipment, nor could they generate sufficient scrap material to make the operation economically feasible. On the other hand, the recovery of silver from processing solutions is a comparatively simple matter well within the competence of any photographer or photographic processor, as will be described later in this article.

Selling Waste Material

Many smelters, reclaimers, and refiners—known collectively as silver services—buy any kind of silver-containing waste from the photographic process. However, the material must be offered in sufficient quantity, and it must be clean and free from cardboard or other non-photographic wastes. For a listing of companies that offer silver services see Kodak publication No. J-10B, *Directory of Silver Services*.

Recovering Silver from Photographic Solutions

There are three principal methods of recovering silver from processing solutions: metallic replacement, electrolytic plating, and chemical precipitation. Of the three methods, metallic replacement and electrolytic plating are the most often used. Chemical precipitation is an efficient method, but it is less desirable than the others from a practical standpoint.

Metallic Replacement

Silver recovery by metallic replacement is achieved through the use of chemical recovery cartridges, which are containers of varying capacity packed with steel wool. As silver-containing solution passes through the steel wool, silver is removed and replaced with iron from the steel wool. Thus, silver is precipitated, and iron replaces it in the solution. Note that solutions treated in this way have no further photographic use because they contain a high concentration of iron. An exception to this statement is bleach-fix regeneration, used in some color processes. Addition of iron to bleach is needed to maintain the activity of the solution.

The capacity of a chemical recovery cartridge to recover silver is governed by the amount of steel wool available for silver/iron exchange reaction. The most common cartridge size has a capacity of 5 U.S. gallons and is capable of recovering the silver from 200 U.S. gallons of solution at a flow rate of 300 ml per minute. These are average quantities; they vary with different sizes of cartridges and with different solutions.

Chemical recovery cartridges can be connected in series to avoid silver loss by an exhausted or malfunctioning unit. These cartridges can also be used as a tailing, or secondary, device in connection with an electrolytic silver recovery installation. In this mode, the cartridge provides backup recovery capacity if the main unit becomes overloaded or if it is desired to reduce the concentration of silver in the effluent from a processor.

Advantages of Silver Recovery by Metallic Replacement. This recovery method has several advantages over other procedures, which may make it the first choice in some circumstances; at present, it is the most practical silver recovery method in bleach-fix systems. The advantages include relatively low initial cost, simple installa-tion, reasonable recovery efficiency, and low maintenance cost. Moreover, the monitoring of such a system requires no complex analytical procedures. A simple test with silver estimating test paper is used to determine when a cartridge is approaching the point of exhaustion, which occurs when the silver concentration reaches 1 gram per litre of effluent.

Electrolytic Silver Recovery

In this method of recovery, silver is removed from a solution by passing a direct electrical current between two electrodes, an anode and a cathode. The electrodes are suspended in the solution, and silver is deposited on the cathode in a nearly pure form called flake silver. The cathode is removed periodically, and the silver can then be stripped off.

Electrolytic recovery installations can be operated in two ways. One way is to desilver the solution overflow as it leaves the processing machine and allow the desilvered effluent to flow to the sewer. This method can be used for flow-through or batch operation. The other way is to remove silver from the solution in a continuously recirculating in-line system at approximately the rate at which silver is added by processing a sensitized material.

A modification of the circulating mode is to collect solution overflow from several processors, desilver it in an electrolytic cell, and then reconstitute the desilvered fixer for reuse.

Silver Concentration with Electrolytic Equipment. An in-line silver recovery unit can maintain the silver concentration in a recirculated system between 500 mg and 1000 mg per litre. When used as a secondary, or tailing, unit, a concentration of 10 mg to 50 mg per litre can be achieved.

Advantages of Silver Recovery by Electrolysis. The process is clean and it yields silver flake of about 92 to 98 percent purity, which keeps refining costs to a minimum. Also, electrolytic recovery permits the reuse of fixer in some applications, and results in more efficient washing because less silver is carried over into the wash water.

Silver Recovery by Chemical Precipitation

A number of chemicals can be used to precipitate silver in solution. The most commonly used are

sodium sulfide and sodium borohydride. Although the recovery efficiency of precipitation is high—as little as 1 mg per litre of silver is possible—the physical characteristics of the process are less attractive. An acid fixer must be neutralized before adding the precipitant; otherwise, dangerous quantities of hydrogen sulfide gas will be liberated. The process is slow, because the precipitated silver sulfide consists of very fine particles that take a long time to settle. Moreover, the labor required to deal with a large volume of solution is greater than that needed to operate any of the other methods. The precipitated silver sulfide is in the form of a sludge that must be sent to a silver refiner to extract the silver.

If labor costs can be disregarded, the sulfide precipitation method of silver recovery can be very economical, because the initial cost of equipment is low and practically all of the silver is recovered. Moreover, the method is useful as a tailing procedure when silver must be reduced to the minimum in the effluent.

Recovering Silver from Silver Solvent Bleach

Solvent bleaches, such as the sodium dithionate bleach used in black-and-white reversal processes, contain silver in a form that cannot be removed by the usual methods of recovery. The silver can be precipitated, however, by using sodium chloride as the precipitant. In this case, the precipitate is silver chloride that can be sold to a refiner, or it can be dissolved in a fixer and the silver recovered by electrolysis as metallic silver.

Recovering Silver from Wash Water

A great deal of silver is carried over into wash water on the surfaces of photographic materials. This silver is wasted unless steps are taken to recover it. The silver in water can be recovered by the metallic replacement or the electrolytic plating process, but since the procedure is not usually an economical one, it is often used as a step in effluent management.

Miscellaneous Methods of Silver Recovery

The following methods of recovery have been tried experimentally, but none of them have been used commercially as yet: hydrogen peroxide precipitation, ion exchange by means of resins, electromagnetic radiation, and galvanic devices. The latter have been marketed, but they are suitable only for very small quantities of solution.

Silverware and Jewelry, Photographing

Photographing silverware, jewelry, and other highly polished metal objects presents special problems to the photographer. The surfaces of such objects become invisible, in effect, and we see not the surface, but the objects reflected in it. In a way, it is like photographing a mirror, but it is more difficult because these items usually have complicated shapes. This causes the reflections to be broken up and to distort the shape of the reflected object as to make it nearly unrecognizable.

Using a Tent

One approach to photographing highly reflective objects is to place the item in an environment where there is simply nothing that can be reflected in its surfaces. This is not completely possible, of course; the camera, the lighting equipment, and the photographer must all be in the room with the item being photographed.

With a tent, a solution is possible. Surround the subject with a tent made of white paper, translucent plastic, or cloth. If the tent is evenly illuminated from outside, it becomes in effect a large, uniform light source, completely surrounding the subject, and the subject's surface will reflect it uniformly.

A gap must be provided in the tent for the camera lens, but the best location for this gap may not be immediately apparent. Experiment until the reflection of this one dark spot falls on some part of the subject where it does least damage to the rendition of the overall shape.

It is not usually desirable to eliminate all reflections because their absence may make the object appear dull and lacking in contour. Carefully placed gaps in the tent, or strips of black paper inside the tent, can provide controlled, useful reflections. The object, gaps, or black strips can be moved until they appear as dark lines on the bright surface, which will emphasize the shape.

When the tent is made of translucent plastic, thin paper, or cloth and illuminated from outside, it is not necessary to illuminate it uniformly. The lights can be arranged and moved to produce the required degree of modeling in the subject, exactly as if the same object were being photographed

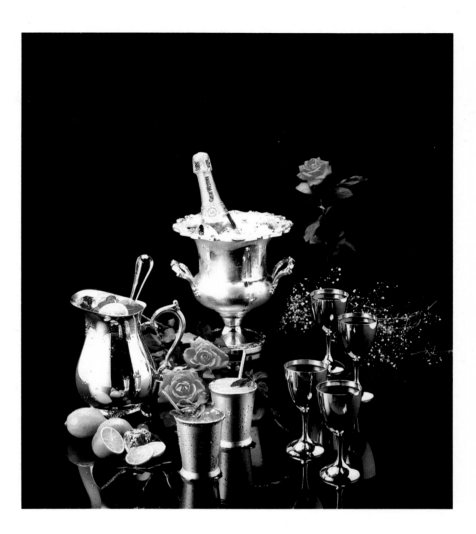

Photography of highly polished objects such as these probably requires more thought and experimentation than any other subject. While a tent will eliminate all reflections, expert photographers plan for black reflections to give emphasis to shape and contour. Photo by Michael Waine.

without a tent. The tent provides control of reflections, but does not interfere with the lighting for form and texture. (*See:* TENT LIGHTING.)

Other Methods

The use of a tent which completely surrounds the subject is not always necessary; it is required mainly with round pieces or objects of very complicated shapes. Simple flat objects, such as medallions, plaques, and such, are often photographed with nothing more than a large white card in front, which will provide a uniform, overall reflectance from the flat, polished surface. A small hole is cut in the card for the camera lens, and the card position and that of the subject are varied until the

reflection of this black spot falls in some area where it is unnoticed.

Many such objects of simple shape with only a single polished surface can be photographed without a tent if the studio itself is small and entirely painted white. If there are objects within range that reflect in the polished metal surfaces, a shift of camera position or the subject itself will usually eliminate any recognizable reflections.

Spraying. A matting spray of wax is often the answer to difficult lighting problems involving shiny objects. When sprayed, objects have less glaring highlights and more shadow detail. Spraying is easier and less time-consuming than setting

up a tent. But more important, spraying works better when matte-surface foreground objects need strong directional and undiffused lighting. Sometimes a tent makes it difficult to photograph textures on other objects in the picture.

Be careful of using a matting spray indiscriminately on all types of shiny objects, since the spray may chemically attack some plastic objects and plastic coatings. However, it is usually satisfactory for most metal objects and can be wiped off easily with a cloth after the picture has been taken.

Remember this basic principle: A matting spray may be the best answer when the subject is composed of both matte subjects and shiny metal objects with curved surfaces.

Liner. Another rapid way of simulating the result of a tent is through the use of a cosmetic liner such as Elizabeth Arden's screen and stage makeup No. 12. The purpose of the application is similar to that of a matting spray—namely, to provide a matte surface to the subject that will broaden and diffuse otherwise specular highlights.

The liner is easily applied with a wide camel's-hair brush wherever desired and in whatever quantity is necessary to control the highlights. The amount to be applied depends on the surface texture of the subject. A slightly matte or "brushed metal" surface needs but a slight amount of the liner, whereas a highly polished chromium surface would need a heavier application. In this latter case, it may be necessary to brush out or smooth the liner using an ordinary lintless cloth so that the liner coating will be as even as possible.

This technique is suitable for subduing reflections on plastic, glass, and leather subjects as well as those of polished metal.

Two Special Problems

Diamonds. The internal color reflections of the diamond shown in the accompanying illustration are the most important features to capture. Diffuse and complete tent lighting would have resulted in specular reflections being cast by most of the external facets, and these would have washed out the colors. So a modification of tent lighting was established. (See the accompanying diagram.) A large reflector from a studio light was placed in front of the camera lens to provide a 180-degree source of light containing symmetrical

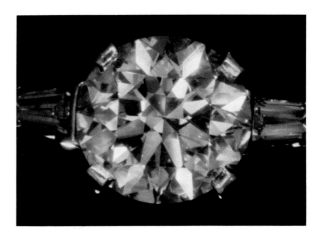

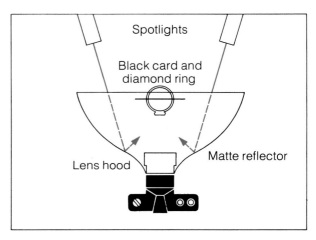

Modified tent lighting was used to capture the color of this diamond and to reduce specular reflections without completely diminishing the gem's sparkle.

components from the two hot spots from the spotlights.

Color of Metal. Another problem in photographing jewelry is that of obtaining a good rendition of the color of metal. In the photograph of the gold ornament cast from a mold taken from an orchid, diffuse, slightly angled, frontal lighting provided for capturing the form of the metal. But in order to photograph gold as gold, a golden color must be reflected by the gold surfaces. (Extraneous light-toned surfaces are reflected from shiny, colored metal and exhibit their own color mixed

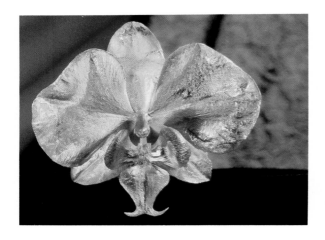

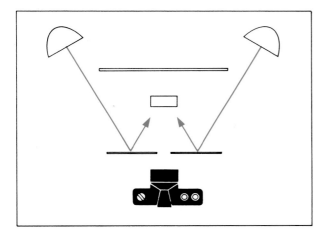

Diffuse frontal lighting brings out the delicate lines of this fine casting; color rendition was improved with a gold-colored reflector card.

Appropriate metallic colors can be used for photographing other metals. However, aluminum foil should be avoided when silver is photographed; it has a high blue reflectance that impairs the rendition of silver color. Shiny lead foil or selected gift papers would be better to use in this instance.

• *See also:* GLARE AND REFLECTION CONTROL; LIGHTING; TENT LIGHTING.

Single-Lens Reflex Camera

In a single-lens reflex (SLR) camera, viewing and focusing utilize the same lens that actually takes the picture. This eliminates parallax so that the subject may be precisely framed even at the closest distances. It also makes it possible to use virtually any focal-length lens that can be fitted to the camera without having to change or adjust the viewing/focusing system.

In all SLR cameras, a mirror reflects the lens image upward to a viewing screen. The first such cameras accepted large-format plates or films and were direct descendants of the camera obscura. (*See:* CAMERAS.) Until recently, the most widely used large-format SLR camera was the Graflex, which was made in sizes up to 5″ × 7″. Today, the classic method of directly viewing the image on the screen is used in medium-format cameras such as the Hasselblad, Rolleiflex SL66, Bronica, and Mamiya RB67, all of which use 120/220 roll films.

Although the viewing screen image is upright, it is reversed right for left, which may cause some confusion when first using a camera of this type. Lateral reversal can be corrected by a prism located above the viewing screen. This arrangement also reflects the image at a right angle so the photographer's eye can be positioned behind, rather than above the camera. Most medium-format SLR cameras have accessory prism finders that provide this kind of viewing.

The SLR design that incorporates a five-sided prism (pentaprism) viewing system for upright, laterally-correct images overwhelmingly dominates 35 mm cameras today and is used in some medium-format cameras as well. A typical penta-

faintly with the color of metal.) The diagram shows the setup used.

The photograph was made by directing the camera through a hole in a large card covered with gold-colored paper. Direct illumination was kept off the subject by means of the background. The gold-tinged illumination from the card provided a diffuse yellow lighting. Exposure meter readings in such a setup can be obtained by passing the meter through the hole. Care must be taken in placing the meter so that the direct light from the lamps does not shine on it.

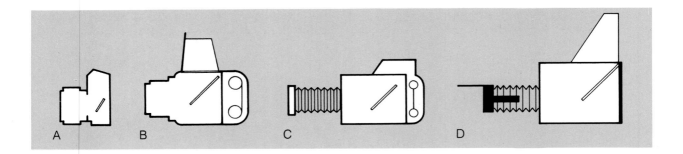

(A,B) Shown are 35 mm and some medium-format cameras. (C) Medium-format camera. (D) Large-format camera.

prism reflex viewing system is illustrated in the article PRISMS.

Mirror Movement

When the picture is taken, the mirror must move out of the image path. In almost all SLR cameras, the mirror is hinged at its top edge and is spring-actuated to travel upward when the shutter release is pushed. This blacks out the image in the viewfinder. Most 35 mm SLR cameras incorporate an instant-return mechanism so that the mirror is again in viewing position a fraction of a second after the shutter has closed. In such cameras, the instant of blackout is virtually unnoticeable except at the very slowest shutter speeds.

In many medium- and large-format SLR cameras, the mirror remains up after the exposure is completed and is repositioned for viewing only when the shutter is cocked again, or when a separate mirror-position control is operated.

There are two inherent problems in a moving-mirror viewing system—camera movement and noise. A variety of methods are used to damp or cushion the shock of a mirror snapping up out of the way and instantly returning to its viewing position. Objective tests show that under almost all conditions a moving-mirror camera produces less sharp pictures than an equivalent model that does not have a rapidly moving mirror. The sharpness problem is amplified by hand-held camera operation and the use of a small-format negative; both are the prime features of 35 mm cameras.

It must be noted that at normal shutter speeds—say faster than 1/25 sec.—with lenses up to roughly twice normal focal length, the effect of mirror movement on the sharpness of a hand-held photograph is slight, and the overall sharpness will certainly be acceptable in most situations. However, "acceptable" is a qualitative criterion; when maximum sharpness is required, the effect of mirror movement must be eliminated. Many SLR cameras permit the mirror to be locked out of viewing position manually before the shutter is released in order to eliminate residual vibration during the exposure. Of course, this requires that the camera be mounted on a tripod or other firm support so that its alignment will not be disturbed after the image is framed and focused. Otherwise, a camera without a moving-mirror viewing system must be used.

The combined noise of mirror and shutter movement varies among SLR cameras, but it is almost always greater than that of a non-SLR camera, which produces only shutter noise with each exposure. In most situations this is a minor factor, but it may become significant when photographing weddings, solemn ceremonies, broadcasts, film or recording sessions, and other situations in which slight extraneous noise is objectionable.

SLR Shutters

Most SLR cameras have focal-plane shutters that protect the film from unwanted exposure even when the mirror is in the non-viewing position.

SLR CAMERA EXPOSURE

Focal-Plane Shutter	Between-the-Lens Shutter
1. Mirror down; shutter closed.	1. Mirror down; lens shutter open (for viewing); capping shutter closed.
2. Shutter release is pushed; mirror rises.	2. Shutter release is pushed; lens shutter closes.
3. Focal-plane shutter opens and closes.	3. Mirror rises.
4. Mirror returns to viewing position.	4. Capping shutter opens.
	5. Lens shutter opens and closes.
	6. Capping shutter closes.
	7. Mirror returns to viewing position; lens shutter opens.

However, some medium-format SLR cameras use lenses with built-in shutters. These permit electronic flash synchronization at all shutter speeds, whereas focal-plane shutters usually synchronize with electronic flash only up to 1/60 or 1/125 sec. But, because each must carry its own shutter, such lenses are more expensive than their equivalents for a focal-plane-shutter camera. In addition, the camera mechanism and the sequence of operation are more complicated because a "capping" shutter is required behind the mirror to protect the film. The accompanying chart shows that the operating of a focal-plane-shutter SLR camera is far less complex.

• *See also:* CAMERAS; FOCUSING SYSTEMS; PRISMS; RANGEFINDER; SHUTTERS; SYNCHRONIZATION; VIEWING AND FOCUSING.

Sky Filter

The first sky filters—not to be confused with skylight filters—were specially made filters in which the upper half was yellow and the lower half clear glass. Placed over the lens with the tinted portion on top, the sky filter darkened the blue sky, causing the clouds to stand out while leaving the lower half of the image unfiltered.

Sky filters were widely used with orthochromatic films. When panchromatic films came into use, a trend toward more dramatic skies using deep yellow to red filters caused a lessening of demand for sky filters. However, sky filters continue to be used by motion-picture photographers seeking special effects such as impending storms.

Recently, still photographers have made use of a variety of newly introduced sky filters manufactured in such shades as gray, blue, tan, purple, pink, green, and yellow. They retain the characteristics of the original sky filter and are used primarily to filter the light from the sky. They provide unusual effects when used singly or in combination. Manufacturers usually call for underexposure of from ½ stop to a full stop when these filters are used in automatic cameras. When using a manual camera, measure the foreground with an exposure meter and give the exposure indicated by the meter.

Cromofilters are graded half-color filters that darken and add color to overly bright areas of a scene, allowing correct color balance and exposure for darker areas. They can be used to make photos more true-to-life, to make colors richer and more spectacular, and to achieve special effects. Photo courtesy of Cromofilter(T).

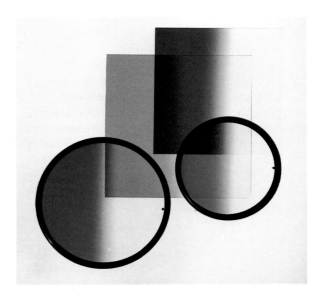

(Top) A correct exposure for foreground yields a washed-out sky with no detail. (Center) A G2 filter darkens sky and picks up dramatic cloud detail without affecting foreground exposure. (Bottom) The use of a T2 filter adds unusual coloration. Photos courtesy of Cromofilter(T).

The gray, or neutral density, sky filters can be used with color films to prevent overexposure of the sky area while giving adequate exposure to the foreground. The neutral color of the filter avoids a color shift in the sky area.

• *See also:* FILTERS.

Skylight Filter

This very pale pink or colorless filter is widely available as a glass camera filter or as a gelatin filter such as the Kodak Wratten filter no. 1A. When used with color films, a skylight filter reduces the bluishness of scenes photographed in open shade or on heavily overcast days. It also reduces the bluishness of distant scenes.

The skylight filter may be kept on the camera lens at all times to protect the lens from dirt and scratches. Of course, the filter must be cleaned before taking a picture, or replaced if scratched. However, a filter is much less expensive than a lens.

Because a skylight filter absorbs ultraviolet radiation and only a small amount of blue light, no increase in exposure is necessary when the filter is in place.

While the reduction of bluishness minimizes the impression of haze in the scene, more effective haze filters with increased ultraviolet and blue absorption are available, such as the Kodak Wratten filter nos. 2A, 2B, 2C, and 2E, which are more effective with black-and-white films as well.

• *See also:* FILTERS.

Slave

An electronic flash unit can be fitted with a photoelectric tripping device, so that it is triggered by the light emitted by another electronic flash unit. In this way, a scene can be lighted by a number of flash units, without the need of interconnecting wires or cables. Because the time delay in the trigger circuit is very short, usually only a few microseconds, the slave units fire almost simultaneously with the master unit. This is well within

the open time of a shutter set at 1/60 or 1/100 sec., as is usually required for electronic flash.

Slave units have been offered for use with ordinary chemical flash lamps, or flashbulbs. Since these lamps take an appreciable time to reach their peak illumination, there is a noticeable delay between the firing of the main flash and the slave. The system is practical only when used at "open-flash" settings—that is, when the shutter is set at "T," opened manually just before flashing, and closed after all flashes have gone off. For certain special types of work where intense, portable sources are needed, such as architectural photographs of large interiors, this system is, indeed, quite practical. It obviously cannot be used where there is any danger of subject movement. Electronic flash slaves can be used to photograph the fastest moving subjects.

• *See also:* FLASH PHOTOGRAPHY; MULTIPLE FLASH.

Slide Presentation

The popular 35 mm slide projector is without·a doubt one of the most versatile audiovisual devices currently available. Its use is limited, for the most part, only by the creative imaginations of those making slide presentations. Yet the slide projector in essence does only two things: It projects a large image from a small piece of transparent film, and it can be programmed to project other images in a predetermined sequence.

Slide presentations can be very simple: a few charts and graphs to illustrate a lecture, or a tray of one's vacation slides. They also can be extremely complicated, with as many as 3 projection screens and 6 projectors—or 9 screens and perhaps 24 projectors. The audience may consist of a few graduate students at a lecture, or friends visiting for an evening. Yet, slide presentations are regularly given in large theaters; and there is no obstacle to making a slide presentation for a crowd filling every seat in Madison Square Garden. (*See:* MULTIMEDIA; SLIDES AND FILMSTRIPS.)

Slide presentations almost always have a component of sound in addition to the projected photographic image. This may consist of a live speaker's voice as he or she speaks from a lectern. Since slide projectors may be operated by remote control, the speaker can change the transparencies, pacing the screen images to the content of the speech. The speaker can also use the slides as a set of visual reminders of the main points made.

A slide presentation can, of course, be made with an audio tape as simple or elaborate as desired. Narration by either one or several voices can be recorded. Music and sound effects can be incorporated. The slides may be changed manually as the tape proceeds; an audible cue can indicate slide changes to be made or an inaudible cue can change the slides automatically.

With dissolve units—devices that control the projector lamps—slide projectors can operate so that there is a smooth transition from one image to another, without the dark interval otherwise seen with single-projector presentations. In fact, the entire show can be preprogrammed with dissolves at desired intervals, to reveal quick cuts or to give the illusion of motion.

Slides can be made from several media, such as photography *and* artwork or line art *and* colored translucent material. In theory, any image that can be photographed can be included in a slide presentation. (*See:* PROJECTION, AUDIOVISUAL.)

Whatever the source of the slides, they should be of the same format. Unless screens are set up for *vertical* images, the best practice is for all slides to be in the *horizontal* format—with greater width than height. When formats are mixed, there will be either a fall-off of vertical images at the top and bottom of the screen or an area of unused screen at the sides of the vertical image.

For the same reason, square-format super-slides, if mixed with standard rectangular-format slides in 2″ × 2″ mounts, should be rephotographed to the rectangular format. A slide presentation that has *all* super-slides solves the vertical/horizontal problem, and this format is especially suited to square-shaped screens.

When preparing a slide presentation, you should give careful consideration to mounting the slides in something *other* than cardboard. Simple plastic mounts are less likely to jam than cardboard; however, as with cardboard mounts, the transparency is unprotected. A better choice is either a protective glass-and-plastic mount or an

A B

C D

E F

A thoughtful arrangement of slides into a simple narrative sequence adds impact to what might otherwise appear to be merely a collection of snapshots. Although the photographs in this sequence were actually taken on several different occasions, the continuity tells the story of a single, complete day at the track. When choosing photographs for a sequence, the best practice is to use the same format—horizontal or vertical—for all the slides in the presentation. Photos by Norm Kerr and Lee Howick.

G

H

I

J

K

L

all-glass mount. (*See:* SLIDES AND TRANSPAREN-
CIES, MOUNTING.) Bear in mind that with thicker
slide mounts, the slide presentation is limited to the
80-slide capacity of the Kodak Ektagraphic univer-
sal slide tray. This need not be an obstacle, for a
well-designed slide presentation requiring more
than 80 slides can be planned to allow a change of
slide trays as often as desired.

• *See also:* AUDIOVISUAL PLANNING; BLACK-AND-
WHITE SLIDES AND TRANSPARENCIES; DUPLICATE
SLIDES AND TRANSPARENCIES; FRONT PROJEC-
TION; SLIDES AND TRANSPARENCIES, MOUNTING;
MULTIMEDIA PRESENTATIONS; PROJECTION,
AUDIO VISUAL; PROJECTION SCREENS; PROJEC-
TORS; REAR PROJECTION; TELEVISION, SLIDES
FOR.

Slides and Filmstrips

Both slides and filmstrips are similar enough to be discussed in one article. Both media originate with photographic transparencies—most often 35 mm color. Both require skill in action photography, preparation of artwork, the use of a copystand and duplicating slides, and the addition of narration and music.

Since the finished product—slide show or filmstrip—takes so many forms—35 mm, 16 mm, 8 mm, coils, cartridges, cassettes, and multi-screen—this article will concentrate on the shared attributes of slides and filmstrips.

The Script

In a few cases, slides and filmstrips may be prepared directly from an approved planning board. (*See:* AUDIOVISUAL PLANNING.) These situations are in the minority. For the vast majority of productions, a detailed written script is a necessity. It is as desirable to have an experienced writer prepare the script as it is worthwhile to have any important task assigned to a professional. Attempts at savings in the cost of script preparation may well be the cause of budget overruns or amateurish productions. A script is a production blueprint; a detailed script is a good investment of production money.

The scriptwriter should demonstrate that he or she is an *audiovisual* writer. Although there may be considerable controversy as to what makes up a good script, certain weaknesses are readily apparent. For example, a script for a slide or filmstrip presentation that consists mainly of narration, with scanty placement of pictures, can generally be rejected. Similarly undesirable is a script so poorly prepared as to require total transformation by the producer.

The Budget

Completion of the script makes it possible to prepare a proposed budget. The budget should be realistic and provide for such items as the cost of talent (including lost production time, narration, music, recording, and so forth), cost of duplicating after approval of the master set (both slides and tape), cost of special labeling and binding, and rental or purchase of equipment for use. Contingencies such as illness of a key individual, unusually prolonged bad weather, rephotographing bad shots, or other occurrences that can delay production and increase costs should also be included.

When the final script and budget receive the necessary approvals, the director, or responsible person, prepares a script or shot breakdown. In the script, shots are listed in their order of appearance in the presentation; the shot breakdown places them in the sequence most convenient for shooting. Though it is sometimes feasible to make all shots in the same order in which they will appear in the completed presentation, this procedure can waste time and money. A shot breakdown facilitates out-of-sequence shooting.

Preparations for Photography

Preparations for photography may be extremely complex or relatively simple, depending on the scope of the presentation. Scheduling, location shooting, travel, lighting, talent releases, sound recording, and laboratory work can involve hundreds of detailed functions when an ambitious slide show is being produced.

Even for a very modest show, minimal basic preparations in advance of photography will result in savings of time and money.

Locations should be scouted and prepared. Preliminary shooting can be accomplished for the planning board and possible approval. Simple backdrops can be produced and erected to eliminate cluttered and undesirable backgrounds. If props are to be used, they can be ordered and placed in their designated positions. Working space for the camera and lighting can be cleared, if necessary.

Any models who are to appear in the shots should be briefed in advance as to time, place, and suitable clothing.

Each supervisor of a department where shooting may take place should be made aware of the schedule in order to avoid unexpected disruption of normal activities.

A written release should be obtained in advance from each person who will be recognizable in the scene. Legal model release forms are available and should be a requirement. If any model is

less than 21 years of age, a parental signature must also be secured. (*See:* MODEL RELEASE.)

At this stage of production, it becomes the duty of those who have been assigned various responsibilities for the success of the production to make sure that all of the details are planned and executed properly—on schedule.

Slide and Filmstrip Formats

Audiovisual (slide) presentations commonly use groups of 50 × 50 mm (2″ × 2″) mounted slides made on 35 mm film, or a long strip of 35 mm film that consists of a series of single-frame (often called half-frame) pictures.

Slides in 50 × 50 mm (2″ × 2″) mounts are not necessarily limited to the popular format

Frame dimensions for film exposed in a conventional 35 mm camera. (Left) This is standard unmasked size for 35 mm slides. (Right) Frame dimensions for film exposed in a single-frame camera.

The Most Common Slide Formats in Use

135

126

135—Half Frame

*127—Super-slide
(38 × 38 mm)
828 (26.2 × 38 mm)*

(22.9 × 34.2 mm) obtained by exposing 35 mm film in conventional 35 mm cameras. 50 × 50 mm mount designation refers only to the outside dimension of the slide mount. There are several film sizes with a variety of formats that can be mounted in slide mounts with dimensions of 50 × 50 mm. However, the mounts need not be limited to this size. Transparencies in mounts measuring 70 × 70 mm (2¾″ × 2¾″) and 83 × 102 mm (3¼″ × 4″) are sometimes used.

The majority of filmstrips are made in the standard 35 mm half- or single-frame format; however, various other formats are used with specialized audiovisual equipment for wide-screen effects.

35 mm films suitable for audiovisual purposes are sometimes available in 30.5 m (100-foot) rolls in addition to standard 20-, 24-, or 36-exposure magazines. Long rolls are accepted by some kinds of specialized equipment; they may also be used as a bulk-loading supply for reusable magazines.

Titling Techniques

Regardless of whether a title is written with colored chalk on a black background or on an acetate cel with transfer letters, consider the following:

Standardize the size of all artwork and the location of the working area on the artwork.

There may be special requirements, such as in preparing titles for television application.

The copy must be large enough for the message to be legible.

Plan the title layout with simplicity and clarity of thought.

Make titles simple and effective.

Keep the background simple as well as uncluttered.

Artwork Standardization

The standardization of format and size of artwork can reduce the cost of producing a presentation. There are other benefits to standardization. One advantage is that the artist can work with a few readily available pens, brushes, guides, and sizes of type. He or she can quickly develop a feel for the size of lettering and artwork elements that will produce legibility. Therefore, standard-size artwork becomes easier and faster to prepare than the alternative—an assortment of various sizes and shapes. Standard sizes simplify the stocking of mounting boards and paper stock. Making the artist's and photographer's jobs less time-consuming can increase productivity without increasing cost.

A standard size for artwork and a specified location for the field size on the artwork can expedite the photography and consequently increase the photographer's output. When working with artwork of random sizes and formats, the photographer must repeatedly adjust the camera-to-artwork distance, the focus, and the exposure settings. Conversely, it will be possible for the photographer to set lights, camera distance, focus, and exposure only once for each assignment, rather than once for each individual piece of artwork, if:

The artwork is all the same size.

The working area on every piece of artwork has the same dimensions.

The working area is an identical location on each piece of art.

Provision is made for placing each piece of artwork in the same position on the copy stand.

Storage and Retrieval. Adopting a uniform 250 × 300 mm (10″ × 12″) artwork size offers savings in cost and time. Storage of this size requires no expensive equipment of odd dimensions; letter-size office filing cabinets or desk drawers will serve. Artwork can be stored on edge and segregated into categories with standard separators. The material is readily accessible; the possibility of damage or loss is reduced.

Artwork Sizes and Formats. It is possible to specify a single standard size for the majority of artwork. If it should become necessary to produce a larger or smaller piece of artwork, an adjusted working area or field size will be required. For example, if an existing drawing is to be used in a piece of art and it is too large to fit into the standard 150 × 225 mm (6″ × 9″) working area, it is suggested that a larger working area be selected having the same height-to-width ratio as shown in the accompanying format table. The lettering will also have to be enlarged to meet the $1/50$ rule.* For example, if the working area is enlarged to 200 × 300 mm (8″ × 12″), the letter size should be a minimum of 4 mm ($5/32$″).

Mount Size. The recommended primary standard for the artwork is 250 × 300 mm (10″ × 12″). The working area sizes suggested in this section and the formats suggested for typewritten copy will fit this size mount. It accepts the common 203 × 254 mm (8″ × 10″) photographic print. The mount allows a margin outside of the suggested working area to provide for safe handling, pin registration holes or field marks for camera alignment, production notations, and attachment of acetate cels or other overlays.

The usable area of the artwork, including the background, must fill a space somewhat larger than the information area if background edges are not to show when the visual is being photographed. It is good practice to extend the usable area at least 13 mm (½″) beyond the information on all sides. A better practice is to extend the usable area

*See item 3 in the section Legibility—Requirements.

ARTWORK TEMPLATES* FOR FORMATS AT DIFFERENT HEIGHT / WIDTH RATIOS

Height / Width Ratio	Minimum Useable Area	Information Area
1 : 1	175 × 175 mm 7 × 7 in	150 × 150 mm 6 × 6 in
2 : 3	175 × 250 mm 7 × 10 in	150 × 225 mm 6 × 9 in
3 : 4	175 × 225 mm 7 × 9 in	150 × 200 mm 6 × 8 in

*The outside dimensions for the template should be 300 × 250 mm (12 × 10 in).

25 mm (1″) beyond the information area. Avoid drawing a line or a border around the information area. This complicates camera framing and slide mounting.

Construction and Use of the Artwork Template

To prepare the template, which will be used for each format, start with a 250 × 300 mm (10″ × 12″) piece of lightweight card stock or heavy paper. Keeping the area centered within this card stock, mark off the dimensions of the section to be removed for the particular format that will be used—150 × 225 mm (6″ × 9″) for 35 mm slides.

If artwork for more than one format is to be created, this is a good time to make a template for each one. To consistently align the artwork in the proper position for photography, construct an L-shaped guide against which the artwork can be placed. If these format/size recommendations are adopted, it is necessary to observe only one minimum size requirement.

The accompanying diagram illustrates the 150 × 225 mm (6″ × 9″) artwork area for a 35 mm slide with a safe area mask for television placed over it. Unless recommended guidelines are followed, some of the original image will be lost in the television chain and in the receiver during transmission. From this illustration it is clear how much visual area (shaded portion) may be lost in the television system. The shaded amount is not always the same; it will vary with such things as receiver adjustment and line voltage. To help provide minimum loss, any essential information

must be confined to a central area, as indicated in the illustration. The usable portion of the art should extend to a minimum area of 175 × 250 mm (7″ × 10″).

Where possible, it is recommended that the finished artwork be reviewed in color and black-and-white on the telecine chain before the broadcast. This procedure will indicate any changes in the artwork (contrast, separation of tones, and color) needed to make it acceptable for broadcasting. If it is not acceptable, the artwork must be revised to take these elements into account.

Legibility

Requirements. Once the objectives and the strategy of a presentation have been planned, consideration can be given to the size of the anticipated audience, as well as to any unusual features of the projection facilities. Only *then* should the artwork be designed and created. If a presentation is to be successful, original art must be prepared with the people in the rear seats in mind.

> Artwork can be planned and executed to permit the visuals to be legible when projected.
>
> It is worthwhile to establish uniform sizes for artwork and make these standard.

Loss of visual area (shaded portion) of a 35 mm slide projected for television.

TV scanned area from 35 mm slide approx. 140 x 187 mm (5½″ x 7½″)

35 mm slide "safe title area" 113 x 150 mm (4½″ x 6″)

29 mm (1³/₁₆″) radius

150 mm (6″)

225 mm (9″)

Although the letter height can ordinarily be a *minimum* of $1/50$ the height of the information area, for average back-row viewing distances, the use of a larger letter height ($1/25$ or larger) is strongly encouraged.

To be legible, lines, letters, and symbols should contrast adequately with the background; there must be distinct separation of tones, and the colors selected should be bright and work well together. Tonal contrast is particularly important when preparing artwork for television where the television receiver may display the colored artwork in a black-and-white mode.

Letters and symbols should be bold and simple, with no small openings that tend to fill in when projected. All elements such as lines, letters, symbols, and figures require a size large enough to be seen easily by everyone in the audience. Therefore, these elements have to be at least a certain minimum size on the screen, the size depending on the height of the artwork area in relation to its distance from the farthest viewer.

In *typical* viewing situations—screen-to-viewer distances ranging from short (in small conference rooms or in homes), through medium (in class and meeting rooms), to long (in large auditoriums and theaters)—the *maximum* viewing distance should be about *eight* times the height of the projected image. To put it another way, if the projected material is legible for the farthest viewer who is seated eight times the projected image height from the screen, it will be legible for all other members of the audience. This maximum viewing distance (expressed as 8H) can be used in determining the minimum size of significant detail in the material to be projected.

Testing Existing Material For Legibility. When material that was not designed for projection (printed graphs, charts, and so forth) is to be converted to a projected visual, remember that contrast, colors, and viewing distance may change, but the requirements for legibility will remain the same.

Note that 8H viewing is a generally accepted standard. If the letter size suggested for 8H viewing is doubled, the projected image will be legible from twice the distance, or 16H. The 8H concept also assumes average or slightly lower-than-average eyesight of the viewer. For 8H viewing, legibility can be judged by an average viewer by looking at the material to be copied from a distance eight times its height. For example, consider a printed table that is to be photographed for projection. If the table is 88 mm (3½ inches) high, it should be viewed from 8 times that height (0.7 metre or 28 inches) to see if it is readable. If it is, the type size will be suitable for copying and projection.

The same principle applies to larger work. A wall chart or a map 1.2 m (4 feet) high requires legibility at a distance of 9.6 m (32 feet) if it is to be acceptable as a projected image for 8H viewing ($4 \times 8 = 32$ feet). If the material is not legible at the test distance, it should either be redrawn or discarded.

Subject content as well as image size affects legibility. If the work being photographed is complex, reduce the information to the essential elements, limit the text, and enlarge the letter size. Rearranging the information can help define the point you are making for the audience.

It is a mistake to believe that enlarging the physical dimensions of a transparency improves legibility at practical viewing distances. *Transparency size* is *not* a determining factor; it is the size of the detail on the screen than is significant.

Sizes of Letters, Symbols, and Lines. Letter size of lowercase characters is specified as the height of the letter *excluding* ascenders or descenders (the "tails" on p's, q's, b's, and so on). When determining letter size or specifying it for artwork, measure the smallest letter to be used. If the artwork height is 150 mm (6 inches), letter height for 4H viewing is 1.5 mm ($1/16$ inch); for 8H viewing, 3 mm ($1/8$ inch); and for 16H viewing, 6 mm (¼ inch).

In no case should the specified minimum size be construed as a restriction on the use of larger sizes. Bolder or bigger treatment is often advantageous to increase emphasis and strengthen impact.

When printer's type is being considered or specified, characters on a printed proof should be measured. Point sizes can be misleading; 18-point type may be suitable for uppercase copy, but the same copy in lowercase can require the use of 24-point type. Typefaces also vary; 9-point might be suitable in one style, but not in another.

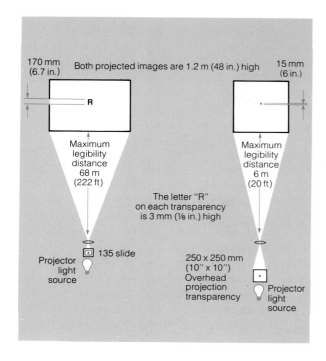

170 mm
(6.7 in.)

Both projected images are 1.2 m (48 in.) high

15 mm
(6 in.)

R

Maximum
legibility
distance
68 m
(222 ft)

Maximum
legibility
distance
6 m
(20 ft)

The letter "R"
on each transparency
is 3 mm (⅛ in.) high

135 slide

Projector
light
source

250 x 250 mm
(10" x 10")
Overhead
projection
transparency

Projector
light
source

Comparison of legibility distance of same-size letter on different-size transparencies.

Dry-transfer lettering systems (Deca-Dry, Letraset, Prestype) are sheets of letters that can be transferred to the artwork by burnishing. A wide selection of type styles is available in different point sizes, and most art-supply stores have catalogs showing the letters in actual size.

Legibility of Typewritten Copy. A typewriter offers one of the simplest and quickest means for producing legible copy. All that is required is the use of a smaller information area and close-up photography to include only this area. If the artwork information area to be used is 75 mm (3 inches) high and the legibility requirement is for 8H viewing, elite type in all capital letters is the smallest acceptable size.

As with other types of artwork, the minimum usable area should extend somewhat beyond the information area. In the case of typewritten material, a minimum usable area of at least an additional 6 mm (¼ inch) on all four sides can be obtained by simply including more of the paper on which the message is typed. The 75 mm (3-inch) height

provides 8H legibility for all copy from standard typewriters, including elite and pica type; yet it offers a large enough area for direct artwork for simple charts, graphs, and diagrams.

For the 75 mm (3-inch) high format, copy should be limited to 9 double-spaced lines.

Title Layout

The successful arrangement of type with pictures or other decorative elements depends to a great extent upon the artistic taste of whoever does the work. It has been common practice in title layout to use formal or symmetrical balance; however, much can be said in favor of informal balance, because it helps to solve the problem of precise centering when aligning the title. The accompanying illustrations show examples of a formally balanced title, as contrasted with an informal lettering arrangement. Whichever arrangement is decided upon, the layout, composition, subject matter, and related elements should be created with regard to *simplicity* and *clarity*.

(Below) A formal, or symmetrical title layout. (Bottom) An informal lettering arrangement.

Three-Dimensional Title Letters. Three-dimensional title letters of ceramic or plastic are available from most camera stores in many styles and sizes. They are relatively inexpensive and can be used repeatedly.

Title letters that have no pin or fastener on the back are easiest to use. Simply place them on colored-paper backgrounds for copying. The use of dark, soothing background colors will provide good contrast and avoid the dazzling effect that can be caused by lighter, brighter colors.

Illuminate block-letter layouts with a small floodlight or a single spotlight equipped with a focusing attachment. The effect obtained from a sharp-edged shadow, usually placed at the lower right of each letter, is three-dimensional and less static than that of evenly illuminated letters or flat artwork. By placing the letters on a sheet of glass that has been propped 175 to 200 mm (7 to 8 inches) above the background material, you can control independently the levels of illumination on the letters and on the background.

Acetate Cels. A cel is a transparent sheet of cellulose acetate carrying the word or symbol message that is placed over a color print, a color photograph, or some desirable background to be used as a title and then photographed. These cels are usually punched to fit a peg registration board. Successive cels can then be positioned accurately during artwork and photography. Dry-transfer letters are easy to apply and give the impression of a neat, professional printing job. Because the word message is on the transparent cel and not on the background, the same background can be used again with different cels.

For interesting photographic effects, you can shoot through a cel to a three-dimensional background, focus on the lettering (word message), and have an out-of-focus background, or even place the cel in front of an image projected on a piece of white paper. Sidelighting white cel letters will produce white letters against the projected background; not lighting them will produce black letters.

Acetate cels can also be used effectively if a map, chart, floor plan, cartoon, or picture is too busy to be satisfactory for an original slide. Place a cel over the original; trace the outline of the desired portion of the subject material with a broad-nib pen and acetate ink. When the ink is dry, turn the cel over and color the opposite side. You can use colored felt-marking pens or special colors made for use on acetate. Colors can be added or completely removed without disturbing the crisp black lines on the opposite side of the cel. When the cel has been completed, select a satisfactory background and photograph it.

Photographing Titles and Artwork

Reflection Copy. Many techniques associated with the photographing of titles and artwork are similar to those encountered in more familiar types of close-up photography, and most of them are related to lighting, alignment, and focusing.

Copying stands for use with 35 mm cameras are obtainable from most camera stores. This kind of stand is usually an upright column mounted on a copyboard. The camera is attached by means of its tripod bushing to an arm-and-collar assembly that slides up and down on the column. A pair of lamps to illuminate the original may also be mounted on the column at a suitable distance from the copyboard.

A copyboard for occasional work can be made from a sheet of soft board. The surface should be painted black. It should never be white because that part of the board not covered by the original will reflect too much light into the lens. As a result, the copy negative will lack sufficient contrast, and troublesome reflections may be introduced. (*See:* COPY STAND.)

***Kodak Ektagraphic* Visualmaker.** The Kodak Ektagraphic visualmaker is a complete visual production kit that can produce excellent color slides or color prints. It can be used for extreme close-ups of flat copy or of three-dimensional objects. The camera supplied with the visualmaker can also be used separately off the copy stand.

The kit includes a Kodak Instamatic X-35F camera, film, a Kodak Ektran II electronic flash, a carrying case, and two copy stands. Each stand has its own built-in, prefocused supplementary lens and a reflector that provides the necessary amount of light from flash to illuminate subject properly.

Operation is easy. Just lock the camera into position on top of one of the copy stands (either the 203 × 203 mm [8″ × 8″] or 76 × 76 mm [3″ × 3″] size), position the visualmaker on the

subject, and shoot. You can have an almost unlimited selection of color visual materials without bothering with focus, exposure, or framing.

Artwork Template. An artwork template is helpful in preparing artwork to be copied, and it is useful in positioning that material for copying. It becomes a frame when preparing artwork. Simply place the template over the material on which the work is to be prepared and use the opening in the template to define the area that will appear on the screen.

Camera Alignment. Attach the camera to the stand so that the film plane is parallel to the copyboard. The center of the copy or mask should be directly under the center of the lens. Mark the position of the mask on the board to simplify realigning it later. Better still, place register pins in the copyboard to position the mask and copy edges. First position the mask on the copyboard, and then place two pins along the long edge of the mask on the support-column side, and one at the left end of the mask.

After the proper camera height, supplementary lens, and focus setting have been determined for the camera and lens, mark this information on the mask to which it applies and make a camera height index mark on the support column.
NOTE: With many single-lens-reflex cameras, a pocket flashlight shone through the eyepiece will project an image of the ground glass on a sheet of white paper placed on the copyboard. In a darkened room, this can be used for alignment, focus, and framing of the camera.

Placing the Lights. Light distribution is very important in copying. Typically, two lamps are used in copying, and they should be in suitable reflectors if they are not supplied with built-in reflectors. Orient the reflection copy so that its longer dimension is parallel with an imaginary line between the two lamps. The angle between lens and lamp axes should be about 45 degrees for ordinary copying. If a 45-degree lighting angle shows up the surface texture, however, move the lamps closer to the lens axis. Angle or "feather" the lights to obtain even illumination.
NOTE: Lamps placed too close to the copy may cause objectionable reflections or flare near the outer edges; position them carefully.

Light Distribution. No specular reflections should be visible in the camera viewfinder. The light distribution should be even over an area of the copyboard that is larger than the area occupied by the slide mask. Evenness of illumination can be controlled by moving the lamps farther away from the copy surface and by angling or feathering the lights. Check the evenness of light with an incident-light meter.

When one lamp in a set of four copying lights burns out, a new replacement lamp will usually be brighter than the remaining three. To avoid adjusting the new lamp to get uniform illumination, all four lamps can be replaced and the three older ones kept for future replacements. In copying with color films it is especially important to follow this procedure, because new lamps have a higher color temperature than those that have been burning for some time. Such variation in color temperature would be reflected as an uneven color quality over the picture area.

Controlling Reflections. Reflections that degrade quality and, in severe cases, obliterate areas in the copy, arise in two ways:

1. Light from the lamps is specularly reflected into the lens by the reflection copy, especially if it has a rough, creased, or curved surface.
2. Light reflected by the copy or its surroundings strikes the front of the camera so that an image of the camera is seen on the copy. This situation is caused by glossy or glass-covered copy. A glossy print on a large white background will show such an image in its shadow areas.

Reflections of the first type can sometimes be avoided by careful lamp placement or by treating the surface of the copy by applying a matte lacquer. Reflections of the second type can be eliminated by painting the copyboard matte black, by masking with black paper any white areas surrounding the original, and by covering the camera front (except for the lens) with a black card. Also, the room should be dark. The best method of controlling reflections is with polarized light. (*See:* POLARIZED-LIGHT PHOTOGRAPHY.)

Using Exposure Meters in Copying. It is important that the lights be adjusted so that the illumination over the copy area is even. To determine exposure for copying, use either an incident-light meter held in the plane of the original material being copied or a reflected-light meter, taking the reading from a gray card with 18 percent reflectance, which has been substituted for the original. Use the gray side of the Kodak neutral test card for this purpose. If the proper gray card is not available, a reflected-light reading can be made from a matte white surface of 90 percent reflectance, such as the back of a sheet of double-weight white photographic paper. The meter reading will be much higher. Compensate by setting the meter calculator at $1/5$ the normal film-speed number.

The film speeds for copying line work are intended for trial exposures. The exposure for line work is affected by the reflectance of the lines or dark areas of the original and the inherently short exposure latitude of high-contrast films. To obtain the best contrast between the background and the lines, use the maximum exposure possible that will not cause filling-in of lines on the negative.

Adding Sound to Slides or Filmstrips

The script controls the entire operation. It contains the narration and cues for slide changes and background effects. If only a section at a time is recorded, you can listen to the results to be sure all is well. When using background music, stop at the natural pauses in the music so that the breaks are not noticeable.

Synchronizing Sound and Slides. One simple method of synchronizing sound and slides is for the projectionist to change slides by following the cues on the script while listening to the tape. Another approach is to use audible cues recorded on the tape. Most people are familiar with the beep tones sometimes used to indicate a slide change. Unfortunately, the beep tones may detract from the presentation. If audible cues are used, pick the least distracting sound—like the gentle tap of a pencil.

The smoothest, most professional show has inaudible cues on the tape that automatically change the slides. Several tape-recorder/projector synchronizers are available (through stores specializing in audiovisual equipment) that trigger the advance mechanism on slide projectors in response to cue signals put on the tape. Only projectors with remote-control outlets can be used, because the synchronizing equipment operates the projector via its remote-control outlet. The Kodak Carousel sound synchronizer can be used admirably with a stereo tape recorder and most Kodak Ektagraphic and Carousel slide projectors.

If an automatically synchronized slide-tape program is produced, keep in mind that all potential users may not have a remote-controlled projector and a synchronizer. So always include a script that is cue-marked for slide changes when the program is sent out to other users.

The same arrangement is suitable for filmstrips, with the Kodak Ektagraphic filmstrip adapter fitted on the projector in place of the projection lens.

Tape Equipment. A survey of the tape equipment field will show numerous models varying in price and features. It is recommended that you select one of the several makes of cassette units designed specifically to control projectors such as the Ektagraphic and Carousel slide projectors. In addition to providing sound, these recorders have a special built-in circuit that usually permits use of a separate control track on the tape.

Some cassette recorders have no special circuit for handling control signals separately from sound recordings on the tape. However, many of those capable of recording and reproducing stereo sound can control slide projectors and also provide sound, when connected with an external slide-synchronizing device.

• *See also:* Audiovisual Planning; Back Projection; Black-and-White Slides and Transparencies; Close-Up Photography; Copying; Front Projection; Multimedia Presentations; Projection, Audiovisual; Projection Cabinets; Projection Screens; Rear Projection, Slide Presentation; Slides and Transparencies, Mounting; Television, Slides for; Titling; Transparencies.

Further Reading: Eastman Kodak Co. *Effective Lecture Slides,* pub. No. S-22. Rochester, NY: Eastman Kodak Co., 1974; ———. *Planning and Producing Slide Programs,* pub. No. S-30. Rochester, NY: Eastman Kodak Co., 1975; ———. *Printing Color Slides and Larger Transparencies,* pub. No. E-96. Rochester, NY: Eastman Kodak Co., 1976; Q, Mike and Pat. *The Manual of Slide Duplicating.* Garden City, NY: Amphoto, 1978; Rothschild, Norman. *Making Slide Duplicates, Titles, and Filmstrips,* 3rd ed. Garden City, NY: Amphoto, 1973.